YALE UNIVERSITY PRESS
PELICAN HISTORY OF ART

FOUNDING EDITOR: NIKOLAUS PEVSNER

RUDOLF WITTKOWER

ART AND ARCHITECTURE IN ITALY
1600–1750

REVISED BY JOSEPH CONNORS AND JENNIFER MONTAGU

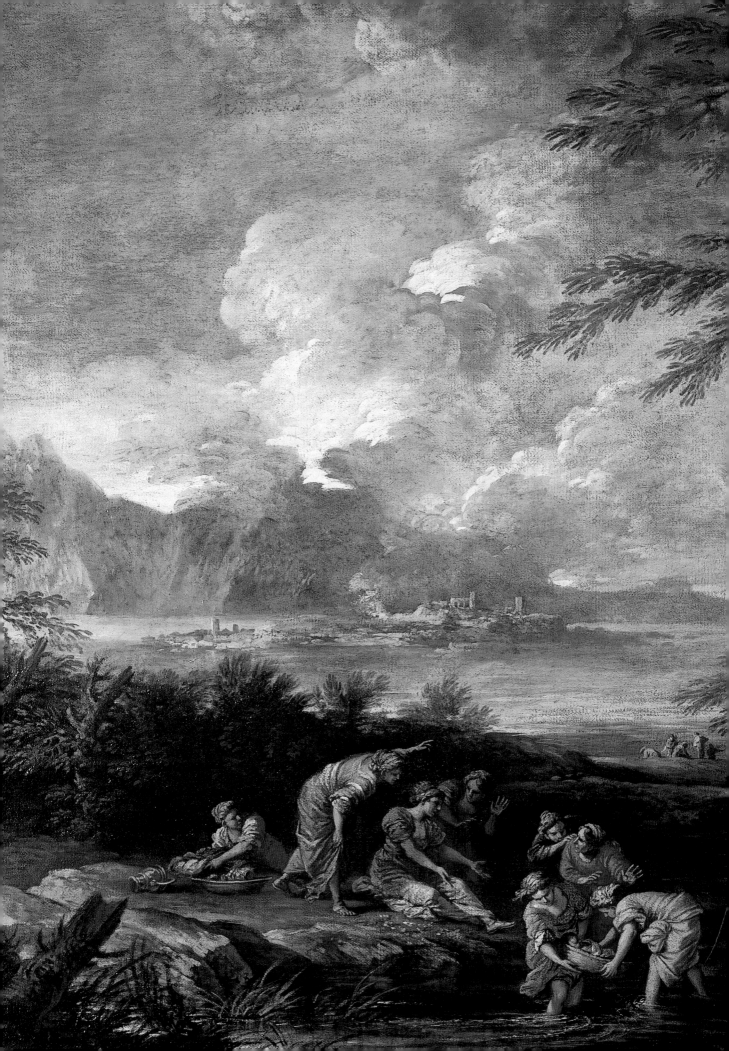

Rudolf Wittkower

Revised by Joseph Connors and Jennifer Montagu

Art and Architecture in Italy 1600–1750

VOLUME TWO

The High Baroque 1625–1675

Yale University Press — New Haven and London

To
My Wife

First published 1958 by Penguin Books Ltd
Sixth edition, revised by Joseph Connors and Jennifer Montagu,
first published 1999 by Yale University Press
10 9 8 7 6 5 4 3 2 1

Set in Monophoto Ehrhardt by Best-set Typesetter
Printed in Singapore
Designed by Sally Salvesen

TITLE PAGE: Salvator Rosa, *Landscape with the Finding of Moses*,
Detroit, Institute of Fine Arts.

Library of Congress Cataloging-in-Publication Data

Wittkower, Rudolf.
 Painting in Italy, 1600–1750 / Rudof Wittkower, revised by
Joseph Connors and Jennifer Montagu
 p. cm.
 Updated ed. of: Art and architecture in Italy, 1600 to 1750.
 Contents: [1] Early Baroque – [2] High Baroque – [3] Late
Baroque.
 Includes bibliographical references and index.
 ISBN 0-300-0789-0 (cloth 3 vols. : alk. paper), ISBN 0-300-
07889-7 (paper 3 vols. : alk. paper), – ISBN 0-300-07939-7 (paper:
v. 1 : alk. paper) – ISBN 0-300-07940-0 (paper : v. 2 : alk. paper) –
ISBN 0-300-0741-9 (paper : v. 3 : alk. paper)
 1. Art, Italian–History. 2. Art, Modern– 17th–18th cen-
turies–Italy. I. Connors, Joseph, II. Montagu, Jennifer. III.
Wittkower, Rudolf. Art and architecture in Italy, 1600–1750. IV.
Title.
N6926.W5 1999
759.5–dc21 98-49066
 CIP

Contents

Principles Followed in the New Edition

TEXT: Unchanged, except for some dates of artists for which new secure documents have emerged; these have been incorporated where we are aware of them, but no serious attempt has been made to check those given in the previous edition. These changes have not been noted, except where they invalidate a statement in the text, in which case a starred note is provided. Dates of works of art have not been similarly changed; however, where newly-found documentation (concerning dates, or other facts) makes the text seriously misleading, this has been indicated with a starred note. Such notes have been kept to the minimum. Cross-references to other volumes are cited in the form (II: Chapter 4, Note 27).

NOTES: Unchanged, except for artists' dates (as for the Text); a few starred notes correct the more misleading errors. Some references, now omitted from the Bibliography, have been expanded. The bibliography in the Notes is now badly out of date: for artists given individual bibliographies these should be consulted; more recent information on most of the others can be found through the general books listed either under the relevant art, or the relevant region. The same applies to the works.

BIBLIOGRAPHY: The bibliography for all three parts starts on p. 123 of volume III. Wittkower felt that his bibliography was already long enough; we have therefore tried to limit the inevitable extension by eliminating many works cited in earlier editions, even though these may be important for historiography. This applies particularly to articles dealing with a limited aspect of an artist, or a few works, where these have been adequately covered by a later monograph. This decision was the more easily taken in the realisation that almost everything that has been deleted from the bibliography is still cited in the Notes; it is the more easy to justify where there is a good modern work with a full bibliography, but it has been somewhat relaxed where more recent literature may be hard to find. Frequent references are made to reviews; almost invariably, these are critical, because these are the ones that add significant new material, or point out short-comings that the reader should be warned about; in many cases this is unfair, and the same book may have been well received by some, or even most other reviewers. However, some books do deserve harsh judgement, while meriting inclusion in the bibliography for their illustrations, or simply because they are the only studies available. It should be noted that, perhaps inadvisably, we have omitted theses published from microfilm. (1) Arts: Wittkower's text very rarely mentions prints or drawings; we have added nothing on prints, and even on drawings (where there have been innumerable publications) we have tried to select the more important and reliable, such as the major museum catalogues covering this period, and the most important exhibition catalogues. The same principle has been applied to

the Regions. Museum catalogues of paintings have not been included – with one exception. (2) Artists: The principles upon which Wittkower distinguished between those artists for whom summary bibliographies were provided only in the Notes, and those listed in the Bibliography, are not clear. In the case of artists of some importance, on whom a good monograph now exists, we have decided to add them. On the other hand, a number of relatively minor figures formerly included in the Bibliography (and some not so minor) can best be studied either through the general books, or from the *Dizionario biografico degli italiani* or the *Dictionary of Art* (published by Macmillan), and they have been omitted. Artists mentioned by Wittkower only in the notes, or omitted altogether, have not been included, even where there is a good modern monograph (with one exception). Because of the abundance of new publications, it has not been possible to list articles with the generosity of previous editions. Where there is a recent monograph, articles are listed only if they add substantial new information (not, for example, those that only publish one or two new works), or if they provide important factual information on works dealt with at some length in the text; however, sometimes a recent article is cited, where it points to earlier bibliography. Where there is no good monograph, a selection of the more important articles is given. As Wittkower said very little about drawings, books or exhibitions of drawings by artists whose drawings are not discussed in the text have only very seldom been included. However, for some artists catalogues of their drawings constitute virtual monographs, and these have been cited. For many Genoese and Neapolitan artists, while there are numerous articles dealing with individual aspects or a few works, more useful references can be found through the general works on those cities. For other centres some general books, e.g. *I pittori bergamaschi*, contain what are in effect brief monographs, and references have been given also under the individual artists.

ILLUSTRATIONS: One hundred illustrations have been added to this edition. The first priority was to illustrate those works which Wittkower describes, or specifically comments upon, so that the reader can better follow the text, The second priority was to give a better indication of the work of some of the major artists who had been rather inadequately represented, and, finally, an attempt has been made to flesh out the personalities of some of those artists dismissed in a brief sentence or two in the text. In the captions to these new illustrations account has been taken of new locations, which occasionally differ from those given in the text, and also changes in the dating confirmed by newly published documents, or authorised by more recent studies; captions to the original illustrations have not been changed. References to illustrations in other volumes are given in the form [III: 23] to indicate plate 23 of volume III.

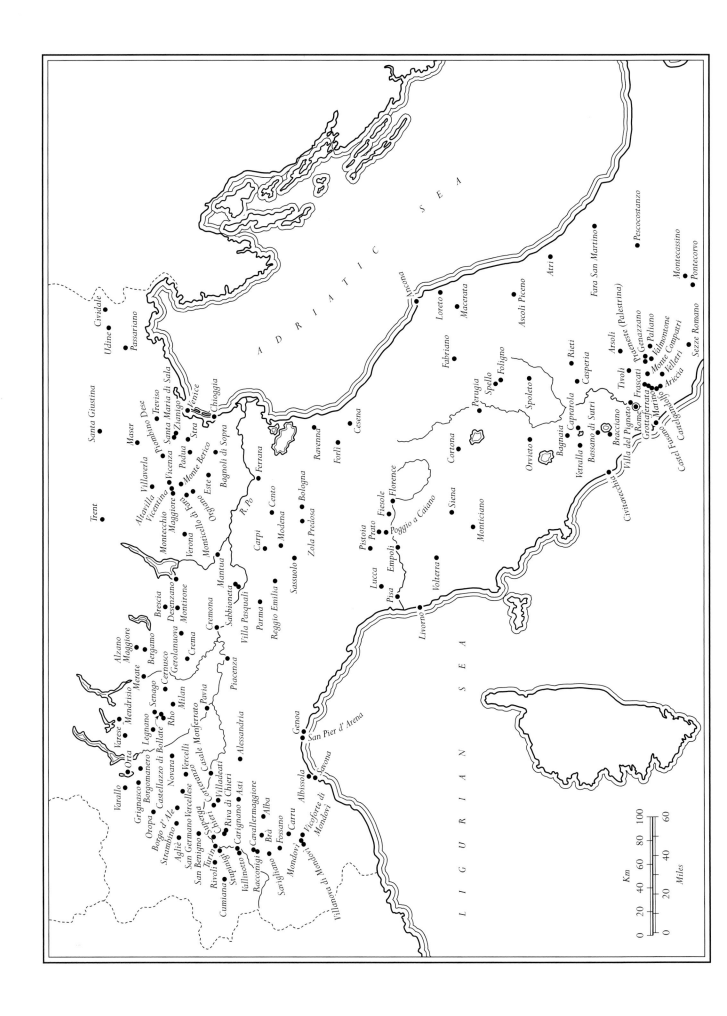

ADRIATIC SEA

LIGURIAN SEA

Cividale
Udine
Passariano
Santa Giustina
Maser
Piombino Dese
Treviso
Santa Maria di Sala
Zianigo
Stra
Venice
Chioggia
Altavilla Vicentina
Villaverla
Vicenza
Padua
Monte Berico
Bagnoli di Sopra
Montecchio Maggiore
Brda
Monticello di
Otrsio
Este
Trent
Verona
Mantua
Ferrara
R. Po
Carpi
Cento
Bologna
Modena
Zola Predosa
Sassuolo
Ravenna
Forlì
Cesena
Reggio Emilia
Parma
Villa Pasquali
Sabbioneta
Cremona
Piacenza
Montirone
Crema
Gerolanuova
Desenzano
Brescia
Bergamo
Alzano Maggiore
Merate
Cernusco
Senago
Rho
Milan
Pavia
Legnano
Castellazzo di Bollate
Mendrisio
Varese
Orta
Varallo
Oropa
Grignasco
Borgomanero
Borgo d'Ale
Strambino
Aglié
San Germano Vercellese
Novara
Vercelli
Casale Monferrato
Alessandria
Cortanzo
Villadeati
Asti
Cavallermaggiore
Superga
Chieri
Riva di Chieri
Carignano
Turin
Rivoli
Cumiana
Stupinigi
San Benigno
Vallinotto
Raccongi
Brà
Alba
Carrù
Villanova di Mondovì
Mondovì
Vicoforte di Mondovì
Fossano
Savigliano
Albissola
Savona
Genoa
San Pier d'Arena
Livorno
Pisa
Lucca
Empoli
Volterra
Pistoia
Prato
Fiesole
Florence
Poggio a Caiano
Siena
Monticiano
Cortona
Perugia
Spello
Foligno
Spoleto
Orvieto
Bagnaia
Capparola
Rieti
Casperia
Veralla
Bassano di Sutri
Bracciano
Villa del Pigneto
Civitavecchia
Grottaferrata
Marino
Castelgandolfo
Castel Fusano
Rome
Frascati
Tivoli
Arsoli
Praeneste (Palestrina)
Genazzano
Paliano
Valmontone
Monte Compatri
Velletri
Ariccia
Sezze Romano
Fabriano
Ascoli Piceno
Macerata
Loreto
Ancona
Atri
Fara San Martino
Pescocostanzo
Montecassino
Pontecorvo

Km
0 20 40 60 80 100
Miles
0 20 40 60

ADRIATIC SEA

Francavilla
Fontana
Oria
Manduria
Lecce
Nardò
Galatone
Gallipoli

Barletta

Gravina

Cantanzaro

Km
0 20 40 60 80 100
Miles
0 20 40 60

Pescocostanzo

Caserta

Naples

Montecassino
Pontecorvo

Arsoli
Praeneste (Palestrina)
Tivoli
Genazzano
Paliano
Frascati
Valmontone
Monte Compatri
Rome
Velletri
Grottaferrata
Marino
Ariccia
Sezze Romano
Castel Gandolfo
Castel Fusano

Bracciano
Villa del Pigneto

Civitavecchia

TYRRENIAN SEA

Messina

Catania

Syracuse
Noto

Ragusa
Modica

Caltanisetta

Palermo
Bagheria
Monreale

Partanna

Trapani

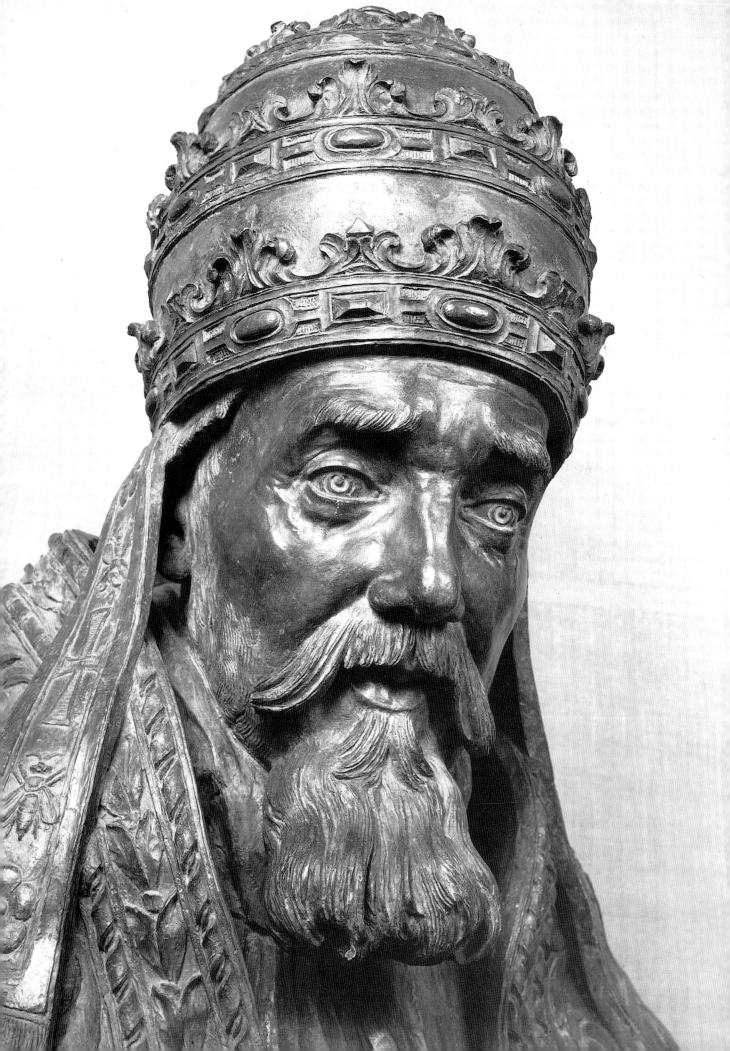

Introduction

The second part of this book, with the generic title 'The Age of the High Baroque', comprises many different artistic tendencies; but the period receives its imprint from the overpowering figure of Bernini, who for more than half a century dominated Italian artistic life at the focal point, Rome. His success was made possible because he had the good fortune to serve five popes who showed the highest regard for his genius.

The new era begins with the pontificate of Urban VIII (1623–44), whose strong but refined features survive in a number of magnificent busts by Bernini [1]. Quite different from the austere popes of the Counter-Reformation, Urban saw himself as a Julius II re-born. In his early youth he had written poems in Latin and Italian modelled on Horace and Catullus.[1] As pope he revived the humanist interest in learning and surrounded himself with a circle of poets and scholars, and superficially his court assumed something of the freedom and grandeur of his Renaissance forerunners. But it would be wrong to see either Urban's reign or those of his successors simply in terms of an increasing secularization. On the contrary, Urban VIII confirmed the decrees of the Council of Trent, and not only maintained the peace with the Jesuits but regarded them as his foremost allies in consolidating the results of the Counter-Reformation. The words with which he registered the memory of St Ignatius in the Roman martyrology are characteristic of his attitude: 'On the 31 July is celebrated in Rome the feast of St Ignatius, Confessor, Founder of the Society of Jesus, illustrious for his holiness, his miracles, and his zeal in propagating the Catholic religion throughout the world.'[2] It is equally characteristic that the Pamphili Pope Innocent X, Urban's successor (1644–55), was attended on his death-bed by none but the general of the Jesuit Order, Padre Oliva, who was also on intimate terms with Bernini.

Once again, therefore, the question asked in the first chapter of this book arises during the new period; did the Jesuits and, for that matter, any other of the vigorous new Orders such as the Carmelites and Theatines take an active part in shaping not only their own but also the papal art policy? No one can doubt that a considerable change occurred in artistic interpretation of religious experience; but it was not a change in one direction. The bow stretches from an appealing worldliness [203] to tender sensibility [114], to sentimental and mawkish devotion,[3] bigoted piety [167], and mystic elation [9, 10] – sufficient evidence that we face the artists' reactions to the protean temper of the age rather than a deliberate policy. In actual fact, religious institutions accepted whatever was in the power of the artists to offer.

Seicento Devotion and Religious Imagery

One must probe into the religious tendencies which developed in the course of the seventeenth century in order to gain an understanding of the character and diversity of religious imagery.[4] During the first half of the century, casuistry and, in its wake, the various forms of probabilism became the widely accepted patterns of theological thought and conviction, principles to which the masses of the faithful reacted by laxity of morals.[5] It would be difficult to assert that morality sank to a lower level than ever before; what took on a new and morally perilous aspect was that the Church now not only connived at, but even supported, individual decisions of convenience at variance with the letter and the spirit of dogmatic religion. This was the hard core of probabilism. To be sure, in the second half of the century probabilism lost ground, but a public figure such as Padre Oliva, General of the Jesuits from 1664 to 1681, gave it his full support.

At the same time quietism, a new form of mysticism, swept through Spain, France, and Italy. Its chief prophet was the Spanish priest Miguel de Molinos (d. 1697), whose *Guida spirituale*, published in 1675, took Rome by storm.[6] Molinos, it is true, ended his life in prison; yet quietism had come to stay. Catholic historians describe it as a perversion of the mystical doctrine of interior quiet. Molinos's 'soft and savoury sleep of nothingness' of the soul in the state of contemplation led, in the view of traditional ecclesiasticism, to the exaltation of an empty consciousness and consequently to immoral apathy. In contrast to 'classical' mysticism, quietism was theological rather than metaphysical, obscurantism rather than enlightenment, an escapist form of devotion produced at will rather than a spontaneous condition of sublime union with God.

It seems not far-fetched to conclude that the mentality which informed probabilism and quietism found an echo in religious imagery. Much that strikes the modern observer as hypocritical piety in Seicento pictures stems no doubt from the general attitude towards confession and devotion at the time of the Catholic Restoration.

It must also be emphasized that in the course of the seventeenth century the Order of the Jesuits itself went through a characteristic metamorphosis: under the generals Muzio Vitelleschi (1615–45), Vincenzo Caraffa (1645–9), and Giovan Paolo Oliva, mundane interests in wealth, luxury, and political intrigue, and a frivolity in the interpretation of the vows replaced the original zealous and austere spirit of the Order. Moreover, the Catholic Restoration had led to a consolidation of doctrine and authority, expressed by the glamour of the High Baroque papal court, which vied with those of the absolute monarchies. As a result of such developments one finds, broadly speaking, that inside the Church the anti-aesthetic approach to art of the period of the militant Counter-Reformation was now replaced by an aesthetic appreciation of artistic quality. This readiness to

1. Gianlorenzo Bernini: Bust of Urban VIII, 1640–2. Bronze. Detail, Spoleto, Cathedral

discriminate, which began under Pope Paul V, coincided in the pontificates of Urban VIII, Innocent X, and Alexander VII (1655–67) with the maturity of the great Baroque individualists, Bernini, Cortona, Borromini, Sacchi, and Algardi, who received full official recognition.

The turn to aestheticism in official religious circles is one of the distinguishing marks of the new era. Even if the arts remained an important weapon in the post-counter-reformatory arsenal, they had no longer the sole function to instruct and edify, but also to delight. Every official pronouncement bears this out, beginning with Urban VIII's well-known words, which he supposedly addressed to Bernini after ascending the papal throne. 'It is your great good luck, Cavaliere,' he is reported to have said, 'to see Matteo Barberini pope; but we are even luckier in that the Cavaliere Bernini lives at the time of Our pontificate' – an unambiguous homage to artistic eminence. To what length aesthetic appreciation was carried becomes apparent from some highly interesting documents which, though rather late, yet characterize the new attitude. A controversy arose between the Jesuits and the sculptor Legros regarding the placing of his statue of the Blessed Stanislas Kostka in S. Andrea al Quirinale, Rome.[7] The Jesuits rejected the artist's request to move the statue from the little room of the Novitiate into one of the chapels of the church, advancing the argument, among others, that there would be no relationship between the size of the figure and that of the chapel and, in addition, that the figure would interfere with the uniformity of the church, a principle on which Bernini, the architect, had insisted and which Prince Camillo Pamphili, the patron, had fully accepted.

The course taken by Seicento devotion, the 'secularization' of the Jesuit Order and the papal court, the aesthetic aspirations in clerical circles – all this would seem to militate against a resurgence of mysticism in art. Yet it happened, as is evidenced by a number of Roman sculptures and paintings roughly between 1650 and 1680, from Bernini's St Teresa [16] to Gaulli's frescoes in the Gesù [175]. The same tendency is to be found outside Rome; as proof may be mentioned only the late paintings of Giovanni Benedetto Castiglione or the works of Mattia Preti's middle period [213]. Bernini's late manner, in particular, reveals an intense spirituality at variance with the laxity of official devotion. I have pointed out that Bernini had close contacts with the Jesuits (I: p. 3) and regularly practised St Ignatius's *Spiritual Exercises*. While the *Exercises* owed their unparalleled success to the vivid appeal they made to the senses, which is also a hall-mark of Bernini's work, their practical psychology, centred in the deliberate evocation of images, was essentially non-physical.

To what extent Bernini himself and others were captivated by quietist mysticism is a question that would need further investigation. Italy produced no great mystics during the seventeenth century, but there seems to have existed a popular undercurrent which kept the mystic tradition alive. It is more than likely that Bernini had studied the writings of Dionysius the Areopagite,[8] and we have his own word for it that the *Imitation of Christ*, written by the late medieval mystic Thomas à Kempis (1380–1471), was his favourite book, from which he used to read a chapter every night.[9] It is in this direction, I believe, that one has to look in order to explain the alliance in many High Baroque works between Jesuit psycho-therapeutic directness and non-Jesuit mysticism.

Rhetoric and Baroque Procedure

Ecstasies and raptures are the psycho-physical conditions which designate the culmination of mystical activity. At many periods artists endeavoured to render not only these conditions themselves but also the visions experienced in that exalted state of perception. What distinguishes the Baroque from earlier periods and even the High from the Early Baroque is that the beholder is stimulated to participate actively in the supra-natural manifestations of the mystic art rather than to look at it 'from outside'. This is meant in a very specific sense, for it is evident that in many works from about 1640 on a dual vision is implied, since the method of representation suggests that the entire image of a saint and his vision is the spectator's supranatural experience. Bernini's *St Teresa*, shown in rapture, seems to be suspended in mid-air [15, 16], and this can only appear as reality by virtue of the implied visionary state of mind of the beholder. Or to give a later example: in Pozzo's ceiling of S. Ignazio [179] 'illumination' is granted to the saint in ecstasy, but to see the heavens open with the saint and his disciples riding on clouds – that is due to revelation granted to the spectator.[10] Scarcely known to the Early Baroque, the dual vision was often pressed home with all the resources of illusionism during the High Baroque and supported by drama, light, expression, and gesture. Nothing was left undone to draw the beholder into the orbit of the work of art. Miracles, wondrous events, supra-natural phenomena are given an air of verisimilitude; the improbable and unlikely is rendered plausible, indeed convincing.

Representations of dual visions are extreme cases of an attempt to captivate the spectator through an appeal to the emotions. It is worthwhile seeking a common denominator for this approach so obvious in a prominent class of High Baroque religious imagery. The technique of these artists is that of persuasion at any price. Persuasion is the central axiom of classical rhetoric. In an illuminating paper G.C. Argan[11] has therefore rightly stressed the strong influence of Aristotle's *Rhetoric* on Baroque procedure. Aristotle devotes the entire second book of his *Rhetoric* to the rendering of the emotions because they are the basic human stuff through which persuasion is effected. The transmission of emotive experience was the main object of Baroque religious imagery, even in the works of such Baroque classicists as Andrea Sacchi.[12] With his technique of persuasion the artist appeals to a public that wants to be persuaded. In rhetoric, Aristotle asserts, the principles of persuasion, in order to be persuasive, must echo common opinions. Similarly, the Baroque artist responded to the affective behaviour of the public and developed a rhetorical technique that assured easy communication. Thus the artists of this period made use of narrative conventions and a rhetorical language of gestures and expression that often strike the modern observer as hackneyed, insincere, dishonest, or hypocritical.[13]

On the other side of the balance sheet are the growing awareness of personal style and the role assigned to inspiration and imagination and consequently the value put on the sketch, the bozzetto, and the first rough idea, unchecked by the encumbrances of execution. These new values, often uncommitted to current rhetorical usage, were to attain prominence later.

Patronage

Nothing could be more misleading than to label – as has been done[14] – the art of the entire Baroque period as the art of the Counter-Reformation. The austere popes of the late sixteenth century and the great counter-reformatory saints would have been horrified by the sensuous and exuberant art of Bernini's age and would also have been out of sympathy with the art policy of the popes of the Catholic Restoration. It was mainly due to Urban VIII Barberini (1623–44), Innocent X Pamphili (1644–55), and Alexander VII Chigi (1655–67), and their families that Rome was given a new face, an appearance of festive splendour which changed the character of the city for good. In order to assess this transformation, one need only compare the gloomy 'counter-reformatory' palazzo type, exemplified by Domenico Fontana's Lateran palace and the family palace of the Borghese Pope Paul V, with such exhilarating structures as the Palazzo Barberini [I: 80] and the Palazzo Chigi-Odescalchi [38], or the sombre church façades of the late sixteenth and early seventeenth centuries with the imaginative and sparkling creations of a slightly later period, such as S. Andrea al Quirinale [36], S. Agnese [66], SS. Martina e Luca [87], and S. Maria della Pace [89]; one need only think of Bernini's fountains [23], of the elation experienced by generation after generation on the Piazza del Popolo [129], the Piazzas Navona and Campitelli, and, above all, of the jubilant grandeur pervading the Piazza of St Peter's [46, 47]. These prominent examples give an idea of the character and extent of papal patronage during the period under review. They also indicate that from Urban VIII's reign on the most important building tasks were handed on to the most distinguished architects, in contrast to the lack of discrimination often to be found in the earlier period; further, that the patrons sympathetically accepted personal idiosyncrasies of style and the determination of artists and architects to solve each problem on its own merits. In contrast to the equalizing tendencies of the earlier phase, the variety of manner now becomes almost unbelievable, not only between architect and architect and not only between the early and late works of one master, but even between one master's works of the same years (cf. illustration 36 with 29 and 54 with 78). Strong-willed individualists make their entry.

If all this be true, some popular misunderstandings should yet be corrected. Contrary to general opinion, most of the new churches built in Rome during this period were small, even very small, in size; the need for large congregational churches was satisfied at an earlier period. Many of the finest structures of the Roman High Baroque, and precisely those which had also the greatest influence inside and outside Italy, are monumental only in appearance, not in scale. Moreover, compared with the extension and diversity of papal, ecclesiastical, and aristocratic patronage under Paul V, artistic enterprises under the following popes were considerably more limited. It would not be possible, for instance, to list a series of frescoes between 1630 and 1650 comparable to those of the years 1606–18 (I: 46).

The High Baroque popes lavished vast sums on their private undertakings: Urban VIII on the Palazzo Barberini and Innocent X on the 'Pamphili Centre', the Piazza Navona with the family palace and S. Agnese.[15] But their primary objective, enhancing the glamour and prestige of the papal court, remained St Peter's, and it was the magnitude of this task that depleted their resources. Immediately after Urban's accession Bernini began work on the Baldacchino [18] and was soon to be engaged on the reorganization of the whole area under the dome as well as on the pope's tomb [14]. Regarding the pictorial decoration of the basilica, Urban's policy was less clear-sighted. Although Andrea Sacchi began to paint in 1625 and was kept busy for the next ten years, at first the pope also fell back on older Florentine painters like Ciampelli and Passignano; Baglione too and even the aged and entirely outmoded Cavaliere d'Arpino received commissions for paintings. But apart from Sacchi's, the main burden lay on Lanfranco's and Cortona's shoulders. Other distinguished artists such as Domenichino, Valentin, Poussin, and Vouet had their share and, in addition, the very young Pellegrini, Camassei, and Romanelli, who held out hopes of great achievement but in the light of history must be regarded as failures.[16] In any case, during Urban's pontificate the work of decoration in St Peter's never stopped, and almost every year saw the beginning of a new enterprise. The tempo slackened under Innocent X, but Alexander VII once again pursued the continuation of the work with the utmost energy. Under him the two most prodigious contributions, the Cathedra of St Peter [17] and the Piazza, took shape.

Compared with St Peter's, the patronage bestowed on the two papal palaces, the Vatican and the Quirinal, was negligible. In the Vatican Urban had rooms painted by Abbatini and Romanelli, and although the latter's frescoes in the Sala della Contessa Matilda[17] (1637–42) are not devoid of charm, it is obvious that they cannot vie with the monumental works of these years. On the whole, it can be stated that during this period the less distinguished commissions were in the hands of minor artists. This does not apply, however, to the one major operation in the Quirinal palace, the decoration of the Gallery, accomplished in Alexander's reign by all available talents under Pietro da Cortona's supervision (p. 141).

The outstanding achievement of the entire epoch remains Bernini's work in and around St Peter's, executed over a period of almost two generations. Though undertaken without a premeditated comprehensive programme on the part of the popes, this work embodies the spirit of the Catholic Restoration and, implicitly, that of the High Baroque more fully than any other complex of works of art in Rome, Italy, or Europe.[18] In ever new manifestations the perpetuity and triumph of the Church, the glory of faith and sacrifice are given expression, and these highly charged symbols impress themselves on the beholder's eye and mind through their intense and impetuous visual language.[19]

Yet, while this cycle of monumental works seemed to propound Rome's final victory, the authority of the Holy See had already begun to wane. The Peace of Westphalia (1648), ending the Thirty Years War in Europe, made it evident that henceforth the powers would settle their quarrels without papal intercession. Moreover, in the course of the century 'the authority of the Holy See' – in Ranke's words – 'changed inevitably, if gradually, from monarchic absolutism to the deliberative methods of constitutional aristocracy'. Not unexpectedly, therefore, after the age of Bernini, Cortona, and Borromini Rome could no longer maintain her unchallenged artistic supremacy. Although Rome preserved much of her old vitality, a centrifugal shift of gravity towards the north and south may be observed in the latter part of the seventeenth century: Venice, Genoa, Piedmont, and Naples began to take the leading roles.

Gianlorenzo Bernini (1598–1680)

INTRODUCTION

Few data are needed to outline the life's story of the greatest genius of the Italian Baroque. Bernini was born at Naples on 7 December 1598, the son of a Neapolitan mother and a Florentine father. We have seen that his father Pietro was a sculptor of more than average talent and that he moved with his family to Rome in about 1605. Until his death seventy-five years later Gianlorenzo left the city only once for any length of time, when he followed in 1665, at the height of his reputation, Louis XIV's call to Paris. With brief interruptions his career led from success to success, and for more than fifty years, willingly or unwillingly, Roman artists had to bow to his eminence. Only Michelangelo before him was held in similar esteem by the popes, the great, and the artists of his time. Like Michelangelo he regarded sculpture as his calling and was, at the same time, architect, painter, and poet; like Michelangelo he was a born craftsman and marble was his real element; like Michelangelo he was capable of almost superhuman concentration and single-mindedness in pursuing a given task. But unlike the terrible and lonely giant of the sixteenth century, he was a man of infinite charm, a brilliant and witty talker, fond of conviviality, aristocratic in demeanour, a good husband and father, a first-rate organizer, endowed with an unparalleled talent for creating rapidly and with ease.

His father's activity in Paul V's Chapel in S. Maria Maggiore determined the beginning of his career. It was thus that the pope's and Cardinal Scipione Borghese's attention was drawn to the young prodigy and that he, a mere lad of nineteen, entered the orbit of the most lavish patron of the period. Until 1624 he remained in the service of the cardinal, creating, with brief interruptions, the statues and groups which are still in the Villa Borghese. After Urban VIII's accession to the papal throne, his pre-eminent position in the artistic life of Rome was secured. Soon the most important enterprises were concentrated in his hands, and from 1624 to the end of his days he was almost exclusively engaged on religious works. In February 1629, after Maderno's death, he was appointed 'Architect to St Peter's' and, although his activity in that church began as early as 1624 with the commission of the Baldacchino [18], the majority of his sculptural, decorative, and architectural contribution lay between 1630 and his death.

In the early 1620s he was one of the most sought-after portrait sculptors, but with the accretion of monumental tasks on an unprecedented scale, less and less time was left him for distractions of this kind. In the later 1620s and in the thirties he had to employ the help of assistants for such minor commissions, and from the last thirty-five years of his life hardly half a dozen portrait busts exist by his hand. The most extensive works – tombs, statues, chapels, churches, fountains, monuments, and the Square of St Peter's – crowd into the three pontificates of Urban VIII, Innocent X, and Alexander VII. Although he was active to the very end, it was only during the last years that commissions thinned out.

From all we can gather, this was due to the general dearth of artistic activity rather than to a decline of his creative capacity in old age. His work as a painter was mainly confined to the 1620s; later he hardly touched a brush and preferred using professional painters to express his ideas. Most of his important architectural designs, on the other hand, belong to the later years of his life, particularly to the period of Alexander VII's reign.[1]

2. Gianlorenzo Bernini: *Aeneas and Anchises*, 1618–19. Rome, Galleria Borghese

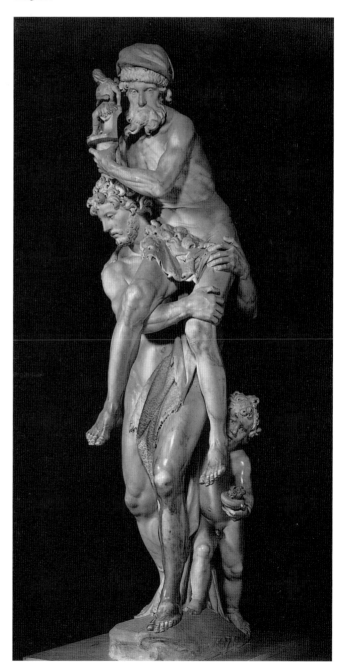

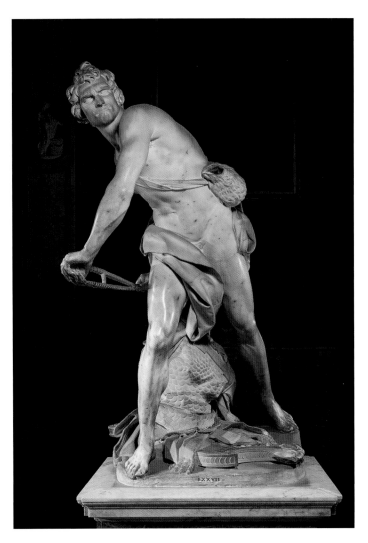

their Mannerist ties, an extraordinary freedom, an energy and perfection of surface treatment which lift them far above the mass of mediocre contemporary productions. The next phase begins with the *Aeneas and Anchises* of 1618–19 [2], the first monumental group for Cardinal Scipione Borghese. A work of this size required considerable discipline, and we see the young Bernini – probably advised by his father – returning to a composition more decidedly Mannerist than any of his previous sculptures. The screw-like build-up of the bodies has a well-established Mannerist pedigree (*figura serpentinata*), also to be found in the father's work, while the precision, vigour, and firmness of the execution clearly represent an advance beyond the earliest phase. The next statues, following in rapid succession, demonstrate an amazing process of emancipation which is hardly equalled in the whole history of sculpture. One may follow this from the *Neptune and Triton*, made to crown a fishpond in Cardinal Montalto's garden (1620, now Victoria and Albert Museum), to the *Rape of Proserpina* (1621–2) the *David* (1623) [3], and the *Apollo and Daphne* (1622–5, all for Scipione Borghese, Borghese Gallery, Rome). A new type of sculpture had emerged. Hellenistic antiquity and Annibale Carracci's Farnese ceiling were the essential guides to

3. Gianlorenzo Bernini: *David*, 1623. Rome, Galleria Borghese

4. Gianlorenzo Bernini: *St Bibiana*, 1624–6. Rome, S. Bibiana

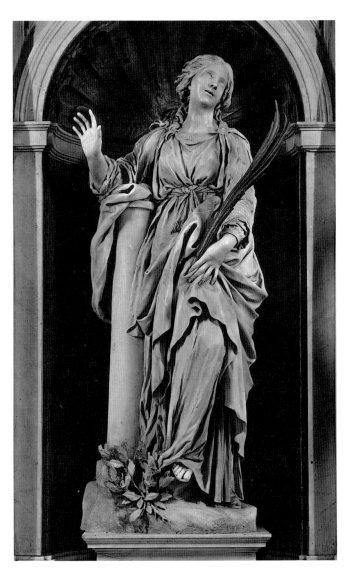

SCULPTURE

Stylistic Development

It is not quite easy in Bernini's case to ascertain with precision caesuras in the development of his style. The reason is simple: for about fifty years he worked simultaneously on a number of great enterprises and many of them were carried out over long periods, while changes and alterations were incorporated as long as the progress of the work permitted. Thus he needed nine years to finish the Baldacchino, ten years for the *Longinus*, thirteen for the Cathedra, and almost twenty for the tomb of Urban VIII. Nevertheless, his approach to sculpture underwent considerable transformations which can be associated, by and large, with definite periods of his life.

To the earliest group of works, datable between 1615 and 1617, belong the *Goat Amalthea with the Infant Jupiter and a Satyr* (Borghese Gallery), the *St Lawrence* (Florence, Contini Bonacossi Collection) and the *St Sebastian* (Lugano, Thyssen-Bornemisza Collection), and in addition the Santoni[2] and Vigevano busts (S. Prassede and S. Maria sopra Minerva, Rome). All these works show, in spite of

5. Gianlorenzo Bernini:
St Longinus, 1629–38. Rome,
St Peter's

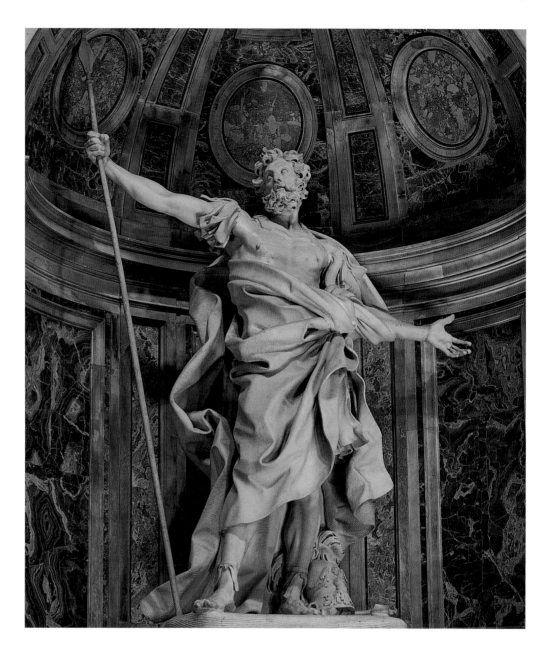

Bernini's revolutionary conceptions.[3] Some of the new principles may be summarized: all these figures show a transitory moment, the climax of an action, and the beholder is drawn into their orbit by a variety of devices. Their immediacy and near-to-life quality are supported by the realism of detail and the differentiation of texture which make the dramatic incident all the more impressive. One need only compare Bernini's *David* with statues of David of previous centuries, such as Donatello's or Michelangelo's, to realize the decisive break with the past: instead of a self-contained piece of sculpture, a figure striding through space almost menacingly engages the observer.

With the *St Bibiana* (1624–6, S. Bibiana, Rome) [4] begins the long series of religious statues which required a change of spirit, if not of sculptural principles. Here for the first time Bernini expressed in sculpture the typically seventeenth-century sensibility so well known from Reni's paintings. Here also for the first time the fall of the drapery seems to support, and to participate in, the mental attitude of the figure. Later, he increasingly regarded garments and draperies as a means to sustain a spiritual concept by an abstract play of folds and crevasses, of light and shade. The next decisive step in the conquest of the body by the dramatically conceived drapery is the monumental *Longinus* (1629–38, St Peter's) [5]. Three strands of folds radiate from a nodal point under the left arm towards the large vertical cataract of drapery, leading the eye in a subtle way to the stone image of the Holy Lance, a relic of which is preserved in the crypt under the statue. Thus the body of St Longinus is almost smothered under the weight of the mantle, which seems to follow it own laws.

A parallel development will be found in Bernini's busts. Those of the 1620s are pensive and calm, with a simple silhouette and plastic, firm folds of draperies. A long series of these 'static' but psychologically penetrating busts survives from the small head of Paul V (1618, Borghese Gallery) [6] to the busts of Gregory XV, of Cardinal Escoubleau de Sourdis (S. Bruno, Bordeaux), of Monsignor Pedro de Foix

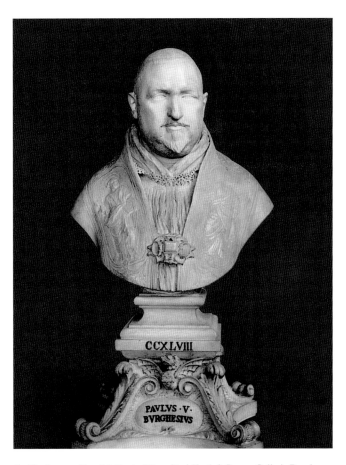

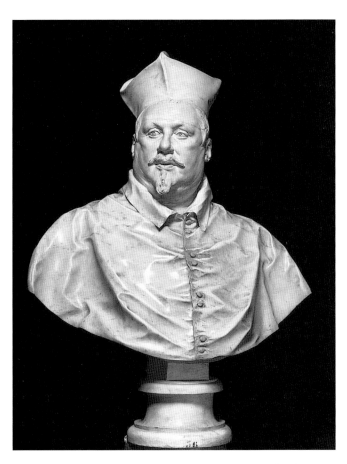

6. Gianlorenzo Bernini: Bust of Pope Paul V, 1618. Rome, Galleria Borghese

7. Gianlorenzo Bernini: Bust of Cardinal Scipione Borghese, 1632. Rome, Galleria Borghese

Montoya (S. Maria di Monserrato, Rome), to the early busts of Urban VIII and that of Francesco Barberini (Washington, National Gallery, Kress Collection), to name only the most important ones. The bust of Scipione Borghese of 1632 (Rome, Borghese Gallery) [7], by contrast, has a dynamic quality;[4] the head is shown in momentary movement, the lively eye seems to fix the beholder, and the mouth half-open, as if speaking, engages him in conversation. Similarly dynamic is the arrangement of the drapery, on which the lights play and flicker and which therefore seems in permanent movement.

Thus, with this bust and the statue of Longinus a new phase begins in Bernini's work. If one wants to attach to them a terminological label, they may be called 'High Baroque'. The new importance conferred upon the drapery as a prominent factor in supporting the emotional impact of the work will be found during the same years in paintings by Cortona or Lanfranco, and even in those of an artist like Reni. One may compare the Virgin in Reni's *Assumption* in Genoa of 1616–17 [I: 49] with that of his *Madonna of the Rosary* of 1630–1 (Bologna, Pinacoteca); only the latter shows passages of heavy self-contained drapery similar to the vertical fall of Longinus's mantle.

But Bernini did not immediately pursue the newly opened path. On the contrary, during the 1630s there was a brief pause, a classical recession, probably not uninfluenced by the increasing pressure from the camp of the more emphatic

upholders of the classical doctrine. To this phase belong, among others, the tomb of the Countess Matilda in St Peter's (1633–7) and the large relief of the *Pasce Oves Meas* inside the portico over the central door of the basilica (1633–46); in addition, the head of the *Medusa* (1636?, Rome, Palazzo dei Conservatori) and some portrait busts, above all those of Paolo Giordano II Orsini, Duke of Bracciano (Castle, Bracciano), and of Thomas Baker (1638, Victoria and Albert Museum); finally, some of Bernini's weakest works, such as the Memorial Inscription for Urban VIII in S. Maria in Araceli (1634) and the Memorial Statue of Urban VIII in the Palazzo dei Conservatori (1635–40). The contribution of assistants in the execution of all these works varies, and none can lay claim to complete authenticity.

What may be called Bernini's middle period, the years from about 1640 to the mid fifties, must be regarded as the most important and most creative of his whole career. It was during these years that the final design of the tomb of Urban VIII took shape (begun 1628, but carried out mainly between 1639 and 1647, St Peter's) [14], that he developed a revolutionary type of funeral monument (Maria Raggi, 1643, S. Maria sopra Minerva), and – most decisive – conceived the idea of unifying all the arts to one overwhelming effect while at the same time discovering the potentialities of concealed and corrected light (Raimondi Chapel, S. Pietro in Montorio, *c.* 1642–6, and Cornaro Chapel, S. Maria della Vittoria, 1647–52) [15]. During these years, too, he placed

for the first time a monumentalized rustic fountain into the centre of a square (Four Rivers Fountain, Piazza Navona, 1648–51) [24], radically revised the classical concept of beauty (*Truth Unveiled*, 1646–52, Borghese Gallery), found a new solution for the old problem of the truncated chest in busts (*Francis I d'Este*, 1650–1, Estense Gallery, Modena), and designed the new type of the Baroque equestrian monument (*Constantine*, begun 1654, but not finished until 1668, Scala Regia, Vatican) [12]. It is impossible to overestimate the significance of the ideas incorporated in these works, not only for the Roman setting but for the next hundred years of Italian and, indeed, European art.

The transition to his latest manner may be observed in the works from the early sixties onwards. With the one exception of the *Habakkuk* (1655–61, S. Maria del Popolo) [11], all his later figures show the over-long and slender limbs which he first gave to the *Truth Unveiled*. One may follow the development towards the conception of more and more attenuated bodies from the *Daniel* (1655–7, Chigi Chapel, S. Maria del Popolo) to the *Mary Magdalen* in Siena Cathedral (1661–3) [8], further to the Angels at the sides of the Chair of the Cathedra (cast in 1665) and the Angels for the Ponte S. Angelo (1668–71, S. Andrea delle Fratte [9, 10] and Ponte S. Angelo)[5] with their ethereal bodies and extremely elongated extremities. And parallel with this 'gothicizing' tendency the treatments of garments becomes increasingly impetuous, turbulent, and sophisticated. They lose more and more the character of real material and must be viewed as abstract patterns capable of conveying to the beholder a feeling of passionate spirituality. In the case of the *Mary Magdalen*, for instance, the sweep and counter-sweep of two ropes of tightly twisted folds cutting across the body sublimely express the saint's agony and suspense. Similarly, the grief of the Ponte S. Angelo Angels over Christ's Passion is reflected in different ways in their wind-blown draperies. The Crown of Thorns held by one of them is echoed by the powerful, wavy arc of the drapery which defies all attempts at rational explanation. By contrast, the more delicate and tender mood of the Angel with the Superscription is expressed and sustained by the drapery crumpled into nervous folds which roll up restlessly at the lower end.

In the early seventies Bernini drew the last consequences. One may study the change from Constantine's horse to the similar horse of the equestrian monument of Louis XIV (1669–77, Versailles), or even from the authentic bozzetto, to be dated 1670 (Borghese Gallery), to the execution of the actual work, which was nearing completion in 1673, and it will be found that between the model and the marble there was a further and last advance in the dynamic ornamentalization of form. The garments of the bronze angels on the altar of the Cappella del Sacramento (St Peter's, 1673–4)

8. Gianlorenzo Bernini: *St Mary Magdalen*, 1661–3. Siena, Cathedral, Cappella Chigi

9. Gianlorenzo Bernini: *The Angel with the Crown of Thorns*, 1668–71. Rome, S. Andrea delle Fratte

10. Gianlorenzo Bernini: *The Angel with the Superscription*, 1668–71. Rome, S. Andrea delle Fratte

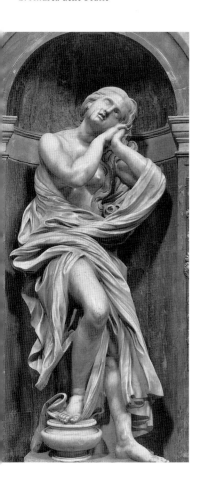
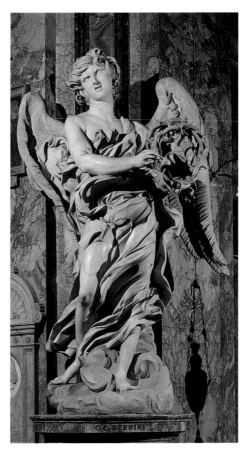
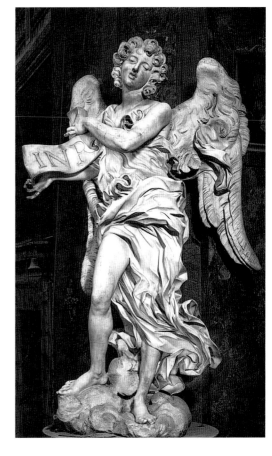

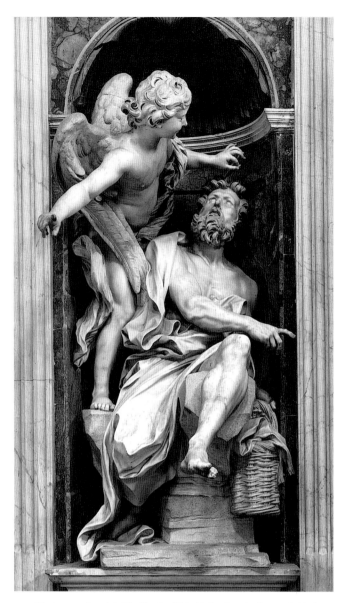

11. Gianlorenzo Bernini: *The Prophet Habakkuk*, 1655–61. Rome, S. Maria del Popolo, Cappella Chigi

which gives his late work an unequalled dramatic and ecstatic quality.

Sculpture with One and Many Views

It is one of the strange and ineradicable misapprehensions, due, it seems, to Heinrich Woelfflin's magnetic influence, that Baroque sculpture presents many points of view.[6] The contrary is the case, and nobody has made this clearer than the greatest Baroque artist – Bernini himself. Many readers may, however, immediately recall the Borghese Gallery statues and groups which, standing free in the centre of the rooms, invite the beholder to go round them and inspect them from every side. It is usually forgotten that their present position is of fairly recent date and that each of these works was originally placed against a wall. Right from the beginning Bernini 'anchored' his statues firmly to their surroundings and with advancing years found new and characteristic devices to assure that they would be viewed from preselected points.

It is, of course, Renaissance statuary that comes to mind when we think of sculpture conceived for one main aspect. Most Renaissance figures leave not a shadow of doubt about the principal view, since by and large they are worked like reliefs with bodies and extremities extending without overlappings in an ideal forward plane. Quite different are Bernini's figures: they extend in depth and often display complex arrangements of contrasting spatial planes and movements. The difference may be studied in the Chigi Chapel of S. Maria del Popolo, where Bernini designed his *Habakkuk* [11] as a counterpart to Lorenzetti's Raffaelesque *Jonah*. In contradistinction to the latter's relief-like character, Bernini's figure, or rather group, does not offer a coherent 'relief-plane', but emphatically projects and recedes in the third dimension. In addition to the contrappostal arrangement of Habakkuk's legs, torso, and head and the pointing arm cutting across the body, there is the angel turned into the niche. And it is just when we see Habakkuk in the frontal view that the angel appears most fore-shortened. But viewing the group as a whole, we note that the angel's action (his gripping the prophet by a lock of hair and pointing across the room, in the direction of Daniel's niche) is fully defined from the exact central position facing the niche, and it is only from this standpoint that all the parts, such as the combined play of the legs and arms of the two figures, can be seen as a meaningful pattern.[7] In order to perceive the body and arms of the angel fully extended, the beholder has to step far to the right; but then Habakkuk's pose and movement are no longer co-ordinated, nor does the whole group present an integrated, coherent view. Thus, once the beholder relinquishes the principal aspect, new views may appear in his field of vision, yet they are always partial ones which reveal details otherwise hidden, without, however, contributing to a clarification of the overall design.

The result of this analysis may safely be generalized; we are, in fact, concerned with an essential problem in Baroque sculpture. It appears then that Bernini's statues are conceived in depth and that the sensation of their spatial organization should and will always be realized, but that they are nevertheless composed as images for a single principal view-

show this tendency developed to its utmost limit. Parallel with this went an inclination to replace the diagonals, so prominent during the middle period, by horizontals and verticals, to play with meandering curves or to break angular folds abruptly, and to deepen crevices and furrows. Nobody can overlook the change from the *Ecstasy of St Teresa* (1647–52) [16] to the *Blessed Lodovica Albertoni* (1674, S. Francesco a Ripa) [13] or from the portrait bust of Francis I (1650–1) to that of Louis XIV (1665, Versailles) [22]. In his latest bust – that of Gabriele Fonseca (*c.* 1668–75, S. Lorenzo in Lucina) [157] – it is evident how strongly these compositional devices support the emotional tension expressed in the head.

Bernini's turn, in his later years, to an austere and, one is tempted to say, classical framework for his compositions shows that he was not independent of the prevalent tendencies of the period. But in his case it is just the contrast between violently strained plastic masses and axial control

point. One must even go a step further in order to get this problem into proper focus. Bernini's figures not only move freely in depth but seem to belong to the same space in which the beholder lives. Differing from Renaissance statuary, his figures need the continuum of space surrounding them and without it they would lose their *raison d'être*. Thus the *David* aims his stone at an imaginary Goliath who must be assumed to be somewhere in space near the beholder; the *Bibiana* is shown in mute communication with God the Father, who, painted on the vault above her, spreads his arms as if to receive her into the empyrean of saints; *Longinus* looks up to the heavenly light falling in from the dome of St Peter's; *Habakkuk* points to the imaginary labourers in the field while the angel of God is about to remove him to Daniel's den across the space in which the spectator stands. The new conceptual position may now be stated more pointedly: Bernini's statues breathe, as it were, the same air as the beholder, are so 'renal' that they even share the space continuum with him, and yet remain picture-like works of art in a specific and limited sense; for although they stimulate the beholder to circulate, they require the correct viewpoint not only to reveal their space-absorbing and space-penetrating qualities, but also to grasp fully the meaning of the action or theme represented. To be sure, it is Bernini's persistent rendering of a transitory moment that makes the one-view aspect unavoidable: the climax of an action can be wholly revealed from one viewpoint alone.

While Bernini accepts on a new sophisticated level the Renaissance principle of sculpture with one view, he also incorporates in his work essential features of Mannerist statuary, namely complex relationships, broken contours, and protruding extremities. He takes advantage, in other words, of the Mannerist freedom from the limitations imposed by the stone. Many of his figures and groups consist of more than one block, his *Longinus* for instance of no less than five. Mannerist practitioners and theorists, in the first place Benvenuto Cellini, discussed whether a piece of sculpture should have one or many views. Their verdict was a foregone conclusion. Giovanni Bologna in his *Rape of the Sabines* (1579–83) showed how to translate theory into practice and gave a group of several figures an infinite number of equally valid viewpoints. The propagation of multiple viewpoints in sculpture came in the wake of deep spiritual change, for the socially elevated sculptor of the sixteenth century, refusing to be a mere craftsman, thought in terms of small models of wax or clay. Thus he created, unimpeded by the material restrictions of the block. The Renaissance conception of sculpture as the art of working in stone ('the art of subtracting') began to be turned into the art of working in clay and wax ('modelling', which is done by adding – for Michelangelo a painterly occupation), and this sixteenth-century revolution ultimately led to the decay of sculpture in the nineteenth century. Although Bernini could not accept the many views of Mannerist statuary because they would interfere with his carefully planned subject–object (beholder–work) relationship and, moreover, would prevent the perception at a glance of one centre of energy and one climax of action, he did not return to the Renaissance limitations dictated by the block-form, since he

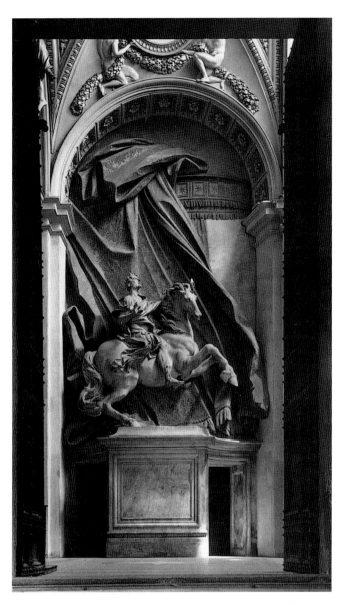

12. Gianlorenzo Bernini: *Constantine*, seen from the portico, 1654–68. Rome, St Peter's

wanted to wed his statues to the surrounding space. By combining the single viewpoint of Renaissance statues with the freedom achieved by the Mannerists, Bernini laid the foundation for his new, Baroque, conception of sculpture.

Only on rare occasions did he conceive works for multiple viewpoints. This happened when the conditions under which his works were to be seen were beyond his control. Such is the case of the angels for the Ponte S. Angelo, which had to have a variety of viewpoints for the people crossing the bridge. These angels clearly present three equally favourable views – from the left, the right, and the centre; but they do not offer coherent views either in pure profile or from the back, for these aspects are invisible to the passers-by.

During his middle period Bernini brought new and most important ideas to bear upon the problem of defined viewpoints. He placed the group of *St Teresa and the Angel* in a deep niche under a protective architectural canopy [15, 16], and this makes it virtually impossible to see the work

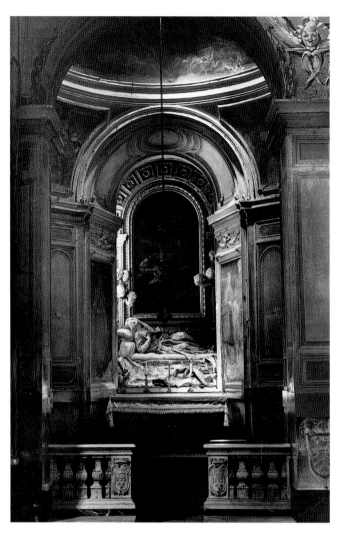

13. Gianlorenzo Bernini: The Altieri Chapel with the Blessed Lodovica Albertoni, 1674. Rome, S. Francesco a Ripa

Colour and Light

It is evident that Bernini's pictorial approach to sculpture cannot be dissociated from two other aspects, colour and light, which require special attention.

Polychrome marble sculpture is rather exceptional in the history of European art. The link with the uncoloured marbles of ancient Rome was never entirely broken, and it is characteristic that in Florence, for instance, polychromy was almost exclusively reserved for popular works made of cheap materials. But during the late sixteenth century it became fashionable in Rome and elsewhere to combine white marble heads with coloured busts, in imitation of a trend in late antique sculpture. The naturalistic element implicit in such works never had any attraction for Bernini. The use of composite or polychrome materials would have interfered with his unified conception of bust or figure. In his diary the Sieur de Chantelou informs us that Bernini regarded it as the sculptor's most difficult task to produce the impression and effect of colour by means of the white marble alone. But in a different sense polychromy was extremely important to him. He needed polychrome settings and the alliance of bronze and marble figures as much for the articulation, emphasis, and differentiation of meaning as for the unrealistic pictorial impression of his large compositions. It may be argued that he followed an established vogue.[8] To a certain extent this is true. Yet in his hands polychromy became a device of subtlety hitherto unknown.

14. Gianlorenzo Bernini: Tomb of Urban VIII, 1628–47. Bronze and marble. Rome, St Peter's

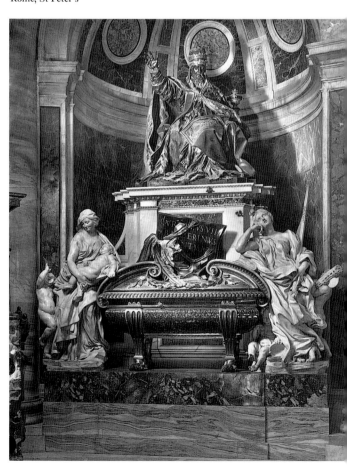

unless the beholder stands in the nave of the church exactly on the central axis of the Cornaro Chapel. Enshrined by the framing lines of the architecture, the group has an essentially pictorial character; one may liken it to a *tableau vivant*. The same is true of later designs whenever circumstances permitted. The Cathedra was conceived like an enormous colourful picture framed by the columns of the Baldacchino [17]. Similarly, the pictorial concepts of the *Constantine* and the *Blessed Lodovica* are revealed only when they are looked at from inside the portico of St Peter's and from the nave of S. Francesco a Ripa respectively [12, 13]. Indeed, the carefully contrived framing devices almost force upon the spectator the correct viewing position.

In spite of their *tableau vivant* character, all these works are still vigorously three-dimensional and vigorously 'alive'; they are neither reliefs nor relegated to a limited space. They act on a stage which is of potentially unlimited extension. They still share, therefore, our space continuum, but at the same time they are far removed from us: they are strange, visionary, unapproachable – like apparitions from another world.

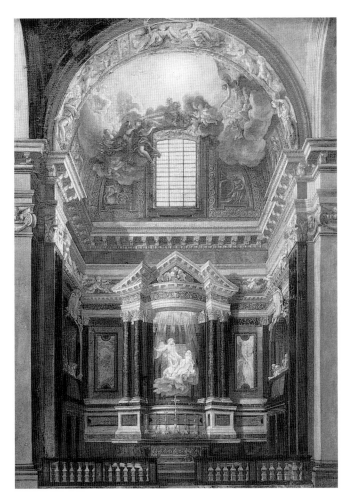

15. Gianlorenzo Bernini: The Cornaro Chapel. Eighteenth-century painting. Schwerin, Museum

Bernini's tomb of Urban VIII [14] certainly follows the polychrome pattern of the older counterpart, Guglielmo della Porta's tomb of Paul III. But in Bernini's work the white and dark areas are much more carefully balanced and communicate a distinct meaning. The whole central portion is of dark, partly gilded bronze: the sarcophagus, the life-like figure of Death, and the papal statue, i.e. all the parts directly concerned with the deceased. Unlike these with their magic colour and light effects, the white marble allegories of Charity and Justice have manifestly a this-worldly quality. It is these figures with their human reactions and their sensual and appealing surface texture that form a transition between the beholder and the papal statue, which by its sombre colour alone seems far removed from our sphere of life.

More complex are the colour relationships in Bernini's later work. The Cornaro Chapel is, of course, the most perfect example [15, 16]. In the lowest, the human zone, the beholder is faced with a colour harmony of warm and glowing tones in red, green, and yellow. St Teresa's vision, the focal point of the whole composition, is dramatically accentuated by the contrast between the dark framing columns and the highly polished whiteness of the group. Other stimuli are brought into play to emphasize the unusual character of the event which shows a seraph piercing her heart with

the fiery arrow of divine love, symbol of the saint's mystical union with Christ. The vision takes place in an imaginary realm on a large cloud, magically suspended in mid-air before an iridescent alabaster background. Moreover, concealed and directed light is used in support of the dramatic climax to which the beholder becomes a witness. The light falls through a window of yellow glass hidden behind the pediment and is materialized, as it were, in the golden rays encompassing the group.[9]

It is often observed that Bernini drew here on his experience as stage designer. Although this is probably correct, it distracts from the real problem. For this art is no less and no more 'theatrical' than a Late Gothic altarpiece repeating a scene from a mystery play, frozen into permanence. In another chapter the symbolic religious connotations of light have been discussed (I: pp. 25–6). Bernini's approach to the problem of light is in a clearly defined pictorial tradition of which the examples in Baroque painting are legion. The directed heavenly light, as used by Bernini, sanctifies the

16. Gianlorenzo Bernini: *The Ecstasy of St Teresa*, 1647–52. Rome, S. Maria della Vittoria, Cornaro Chapel

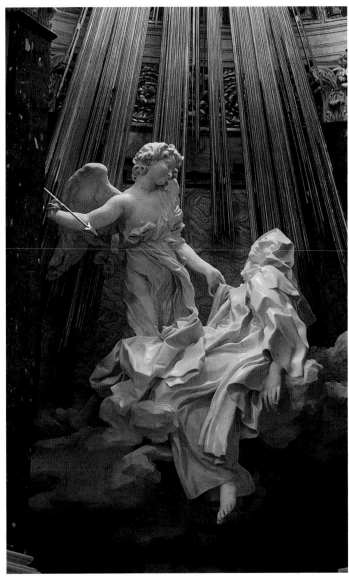

objects and persons struck by it and singles them out as recipients of divine Grace. The golden rays along which the light seems to travel have yet another meaning. By contrast to the calm, diffused light of the Renaissance, this directed light seems fleeting, transient, impermanent. Impermanence is its very essence. Directed light, therefore, supports the beholder's sensation of the transience of the scene represented: we realize that the moment of divine 'illumination' passes as it comes. With his directed light Bernini had found a way of bringing home to the faithful an intensified experience of the supra-natural.

No sculptor before Bernini had attempted to use real light in this way. Here in the ambient air of a chapel he did what painters tried to do in their pictures. If it is accepted that he translated back into the three dimensions of real life the illusion of reality rendered by painters in two dimensions, an important insight into the specific character of his pictorial approach to sculpture has been won. His love for chromatic settings now becomes fully intelligible. A work like the Cornaro Chapel was conceived in terms of an enormous picture.

This is true of the chapel as a whole. Higher up the colour scheme lightens and on the vaulting the painted sky opens. Angels have pushed aside the clouds so that the heavenly light issuing from the Holy Dove can reach the zone in which the mortals live. The figure of the seraph, brother of the angels painted in the clouds, has descended on the beams of light.

Along the side walls of the chapel, above the doors, appear the members of the Cornaro family kneeling behind prie-dieus and discussing the miracle that takes place on the altar. They live in an illusionist architecture which looks like an extension of the space in which the beholder moves.

In spite of the pictorial character of the design as a whole, Bernini differentiated here as in other cases between various degrees of reality. The members of the Cornaro family seem to be alive like ourselves. They belong to our space and our world. The supra-natural event of Teresa's vision is raised to a sphere of its own, removed from that of the beholder mainly by virtue of the isolating canopy and the heavenly light.[10] Finally, much less tangible is the unfathomable infinity of the luminous empyrean. The beholder is drawn into this web of relationships and becomes a witness to the mysterious hierarchy ascending from man to saint and Godhead.

In all the large works from the middle period on, directed and often concealed light plays an overwhelmingly important part in producing a convincing impression of miracle and vision. Bernini solved the problem first in the Raimondi Chapel in S. Pietro in Montorio (c. 1642–6). Standing in the dim light of the chapel, the spectator looks into the altar-recess and sees, brightly lit as if by magic, the *Ecstasy of St Francis*, Francesco Baratta's relief. Later, Bernini used essentially similar devices not only for the Cornaro Chapel and for the Cathedra, but also for the *Constantine*, the *Blessed Lodovica Albertoni*, and, on a much larger scale, in the church of S. Andrea al Quirinale [35].

At the same time, colour symphonies become increasingly opulent and impressive. Witness the tomb of Maria Raggi (1643, S. Maria sopra Minerva) with its sombre harmony of black, yellow, and gold; or the wind-swept colourful stucco curtain behind the *Constantine*, a motif that has not one but four different functions: as a forcible support of the Emperor's movement, as a device to relate the monument to the size of the niche, as the traditional 'emblem' of royalty, and as a fantastic pictorial element. Witness the jasper palls which he used only in such late works as the *Lodovica Albertoni* and the tomb of Alexander VII; or the altar in the Chapel of the Blessed Sacrament in St Peter's (1673–4), where coloured marbles, gilt bronze, and lapis lazuli combine into a picture of sublime beauty which expresses symbolically the immaterial perfection of the angelic world and the radiance of God.

With his revolutionary approach to colour and light, Bernini opened a development of immeasurable consequences. It is not sufficiently realized that the pictorial concepts of the mature Bernini furnish the basis not only for many later Roman and North Italian works, but above all for the Austrian and German Baroque. Even the colour and light orgies of the Asam brothers add nothing essentially new to the repertory created by Bernini.

The Transcending of Traditional Modes

Bernini's way of conceiving his large works in pictorial terms had a further revolutionary result: the traditional separation of the arts into clearly defined species or categories became obsolete and even nonsensical. What is the group of *St Teresa and the Angel*? Is it sculpture in the round or is it a relief? Neither term is applicable. On the one hand, the group cannot be dissociated from the aedicule, the background, and the rays of light; on the other, it has no relief-ground in the proper sense of the word, nor is it framed as a relief should be. In other words, Bernini created a species for which no term exists in our vocabulary.

Moreover, even the borderline between painting, sculpture, and architecture becomes fluid. Whenever given the opportunity, Bernini let his imagery flow from a unified concept which makes any dissection impossible. His own time was fully aware of this. In the words of Bernini's biographer, Filippo Baldinucci, it was 'common knowledge that he was the first who undertook to unite architecture, sculpture and painting in such a way that they together make a beautiful whole'. The Cornaro Chapel is the supreme example. We have seen how the painted sky, the sculptured group, and the real and feigned architecture are firmly interlocked. Thus, only if we view the whole are the parts fully intelligible. This is also true of Bernini's primarily architectural works, as will be shown later in this chapter. The creation of new species and the fusion of all the arts enhance the beholder's emotional participation: when all the barriers are down, life and art, real existence and apparition, melt into one.

In the Cathedra of St Peter in the apse of the basilica (1656–66) [17, 19], Bernini's most complex and, due to its place and symbolic import, most significant work, the various points here made may be fully studied. We noted before

17. Gianlorenzo Bernini: Cathedra of St Peter, 1656–66. Bronze, marble, and stucco. Rome, St Peter's

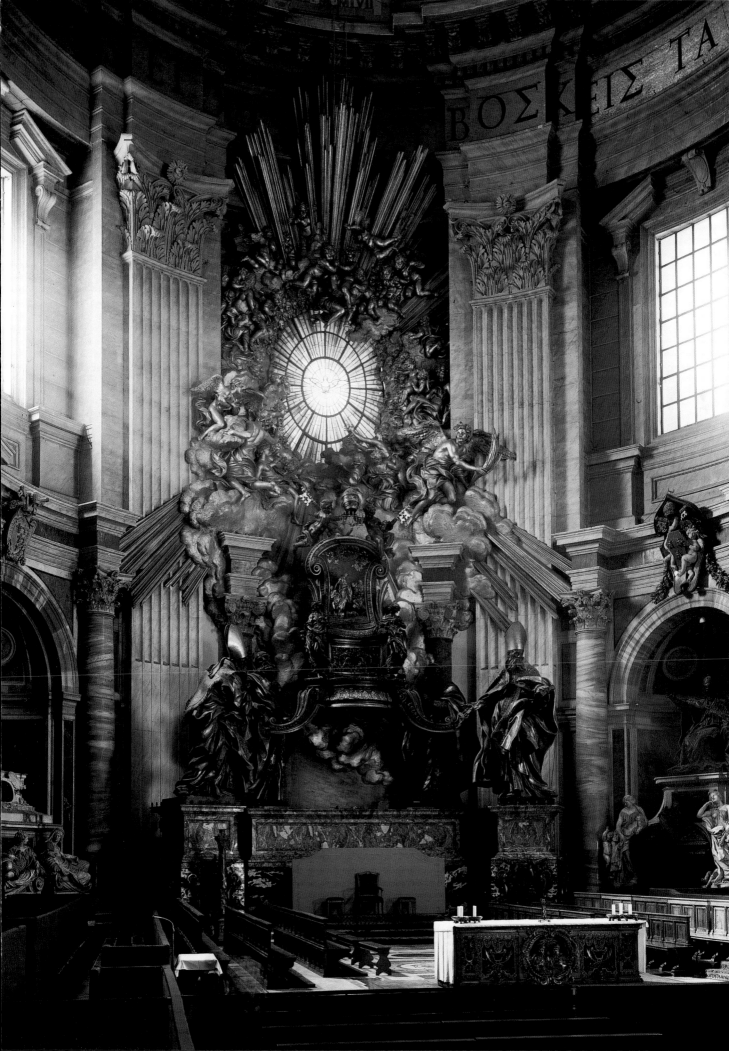

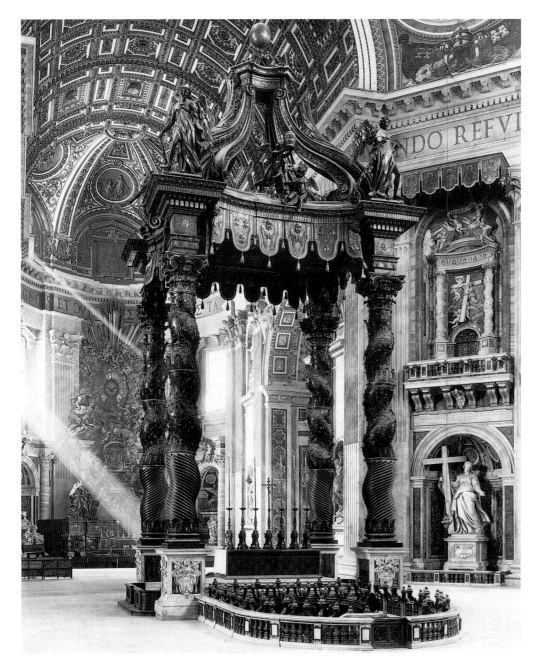

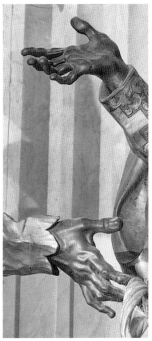

18. Gianlorenzo Bernini:
Baldacchino, 1624–33. Bronze.
Rome, St Peter's

19. Gianlorenzo Bernini: Detail
from the Cathedra of St Peter
[cf. 17]

how the whole was conceived like a picturesque *fata morgana* to be seen from a distance through the columns of the Baldacchino. Only from a near standpoint is it possible to discern the subtle interplay of multicoloured marble, gilt bronze, and stucco, all bathed in the yellow light spreading from the centre of the angelic Glory. No differentiation into species is possible: the window as well as the transitions from flat to full relief and then to free-standing figures penetrating far into space make up an indivisible whole. The beholder finds himself in a world which he shares with saints and angels, and he feels magically drawn into the orbit of the work. What is image, what is reality? The very borderline between the one and the other seems to be obliterated. And yet, in spite of the vast scale and spatial extension, the composition is most carefully arranged and balanced. The colour scheme lightens progressively from the marble pedestals to the bronze throne with gilt decorations and the

golden angels of the Glory.[11] The gilded rays spread their protecting fingers over the whole width of the work and enhance, at the same time, the visual concentration on the symbolic focus, the area of the throne. Movements and gestures, even in different spatial layers, are intimately related. Thus the nervous and eloquent hands of St Ambrose and St Athanasius, shown on illustration 19, appear like contrapuntal expressions of the same theme.

Bernini's new and unorthodox way of stepping across traditional boundaries and harnessing all the arts into one overwhelming effect baffles many spectators. Even those who rise in defence of similar phenomena in the case of modern art cannot forgive Bernini for having transgressed the established modes of artistic expression.[12] It is clear that his imagery will capture our imagination only if we are prepared to break down intellectual fences and concede to him what we willingly do before a Gonzalez or a Giacometti or a Moore.

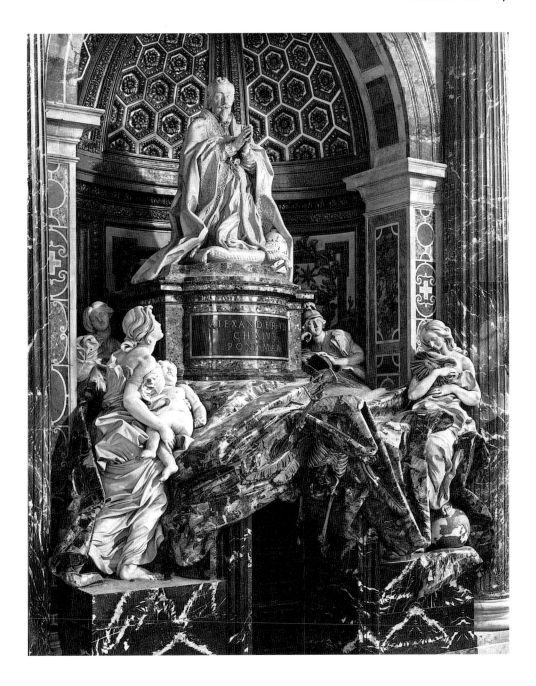

20. Gianlorenzo Bernini: Tomb of Alexander VII, 1671–8. Rome, St Peter's

New Iconographical Types

No less important and influential than Bernini's new artistic principles and, naturally, inseparable from them were the changes he brought about over a wide choice of subjects. Only detailed studies would reveal the full range of his innovations. Although deeply conscious of, and indebted to, tradition, he approached every new task with a fresh and independent mind and developed it in a new direction. He became the greatest creator of iconographical types of the Italian Baroque and his conception of the saint, of tombs, the equestrian statue, of portraiture and fountains remained unchallenged for a hundred years.

The tomb of Urban VIII [14] established the new type of the papal monument. Looking back via Guglielmo della Porta's tomb of Paul III to Michelangelo's Medici Tombs, Bernini achieved an ideal balance between a commemorative and a ceremonial monument,[13] and it is this concept that

many later sculptors endeavoured to follow with more or less success (III: pp. 58–8). In the late tomb of Alexander VII (1671–8) [20], Bernini stressed the contrast between the impermanence of life (Death with hour-glass) and the unperturbed faith of the praying pope. But this idea, which corresponded so well with Bernini's own convictions on the threshold of death, was too personal to find much following. When it was taken up during the eighteenth century, the concept had changed: Death was no longer checked by the certainty of salvation through faith and held nothing but terror for those whom he threatens with permanent extinction.[14]

At the beginning of the 1640s Bernini brought a completely new approach to the problem of smaller funeral monuments with his designs of the Valtrini and Merenda memorials, both executed by studio hands,[15] and the tomb of Maria Raggi, a work of the highest quality. He rejected the

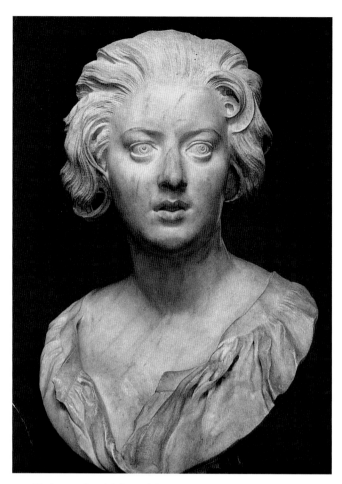

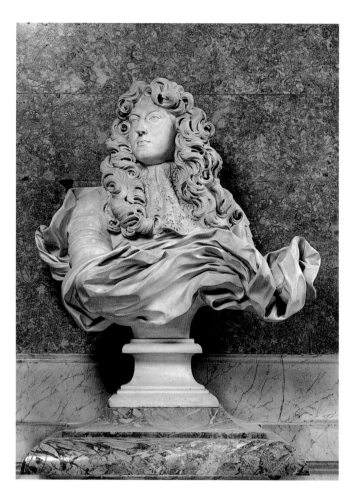

21. Gianlorenzo Bernini: Bust of Costanza Buonarelli, c. 1635. Florence, Bargello

22. Gianlorenzo Bernini: Bust of Louis XIV, 1665. Versailles, Château

isolating architectural framework; and in the Valtrini and Raggi tombs a relief-portrait of the deceased is carried by Death and by putti respectively. It was three generations later, in the Age of Enlightenment, that this type finally supplanted that with the deceased in an attitude of devotion (III: p. 61).

Equally momentous in his contribution to the history of portraiture. The *Scipione Borghese* of 1632 (p. 8) may safely be regarded as the first High Baroque portrait bust. From the mid thirties dates one of the most remarkable portrait busts of the whole history of art, that of *Costanza Buonarelli* (Florence, Bargello) [21]. It is Bernini's only private portrait bust and is therefore done without the deliberate stylization of the other works of this period. One may well believe that the stormy love affair Bernini had with this fierce and sensual woman was the talk of the town. What is historically so important about this work is that it opens the history of modern portraiture in sculpture. All the barriers have fallen: here is a woman of the people, neither beautified nor heroized, and 'contact' with her is direct and instantaneous. In his busts of King Charles I (destroyed),[16] Francis I of Este, and Louis XIV [22], by contrast, Bernini created the official Baroque type of the absolute sovereign. His intentions and procedure can be fully derived from the diary entries of the Sieur de Chantelou.[17] He approached such busts with the idea of conveying nobility, pride, heroism, and majesty. In

this he was so successful that no Baroque sculptor could ever forget Bernini's visual rendering of these abstract notions. Similarly, he gave the Baroque equestrian statue with the rearing horse a heroic quality and invested it with drama and dynamic movement not only in his *Constantine* but also in the ill-starred monument of Louis XIV which stands now, transformed into a Marcus Curtius, near the 'Bassin des Suisses' in the gardens of Versailles.

Even more radical than all these innovations was Bernini's contribution to the history of the Baroque fountain. A tradition of fountains with figures existed in Florence rather than Rome, and it was this tradition that Bernini took up and revolutionized. His early *Neptune and Triton* for the Villa Montalto (1620, now Victoria and Albert Museum) is evidence of the link with Florentine fountains.[18] With his Triton Fountain in the Piazza Barberini (1642–3)[19] [23] he broke entirely with the older formal treatment. Far removed from the decorative elegance of Florentine fountains, this massive structure confronts the beholder with a sculptural entity as integral as a natural growth. Seagod, shell, and fish are welded into an organic whole, and nobody can fail to be captivated by the fairy-tale atmosphere of such a creation.

All recollection of symmetry and architectural structure has disappeared in the Fontana del Moro in Piazza Navona (1653–5), where Bernini used the same constituent ele-

ments: maritime divinity, shell, and dolphin. But these elements are now animated by dramatic action; we witness a transitory moment in the contest between the 'Moro' and his prey. Entirely different considerations had to be taken into account for the design of the large fountain in the centre of the same Piazza [24]. Bernini had to erect a monument sufficiently large to emphasize effectively the centre of the long square without disturbing its unity. At the same time the fountain had to be related to the façade of S. Agnese without competing with it. A 'natural' rock,[20] washed by ample springs, pierced by openings in the long and short axes and crowned by the huge Egyptian needle: barrier and link, accompaniment to the towers and contrast; expansive and varied near the ground and soaring upwards hard, uniform, and thin; fountain and monument; improvisation and symbol of superhuman permanency – these seeming contradictions point to the ingenious answer Bernini found to his problem.

The number of fountains created by Bernini is comparatively small. But their effect was all the greater. Contemporaries were fascinated not only by his new, truly poetical use of realistic motives like rock, shell, and natural growth, but also by his revolutionary handling of the water itself. For he replaced the traditional thin jets by an exuberant and powerful harnessing of the elements. It was the continuous movement of the rushing and murmuring water that helped to fulfil one of Bernini's most cherished dreams: to create real movement and pulsating life.

The Role of the 'Concetto'

After the foregoing pages it hardly needs stressing that an impressionist and aesthetic appreciation or stylistic approach cannot do justice to Bernini's real intentions. It must never be forgotten that Bernini's ideas of what constitutes a satisfactory solution of a given task were dependent on humanist art theory. According to this theory, which allied painting and sculpture to poetry, a work of art must be informed by a literary theme, a characteristic and ingenious *concetto* which is applicable only to the particular case in hand. For Bernini the *concetto* was really synonymous with a grasp of the essential meaning of his subject; it was never, as so often in seventeenth-century art, a cleverly contrived embroidery. Moreover the concept he chooses for representation is always the moment of dramatic climax. This is true already for his early mythological and religious works created in the service of Cardinal Scipione Borghese.

Thus David is shown at the split-second of the fateful

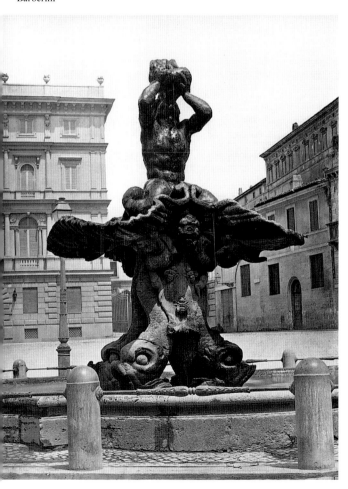

23. Gianlorenzo Bernini: Triton Fountain, 1642–3. Travertine. Rome, Piazza Barberini

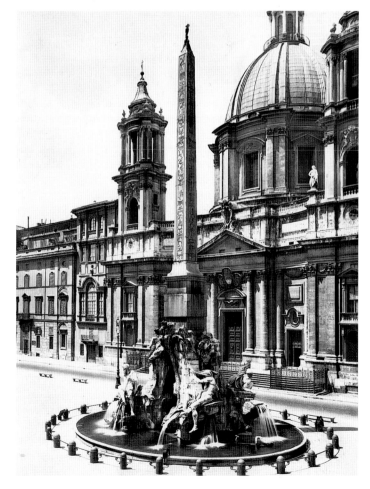

24. Gianlorenzo Bernini: The Four Rivers Fountain, 1648–51. Travertine and marble. Rome, Piazza Navona

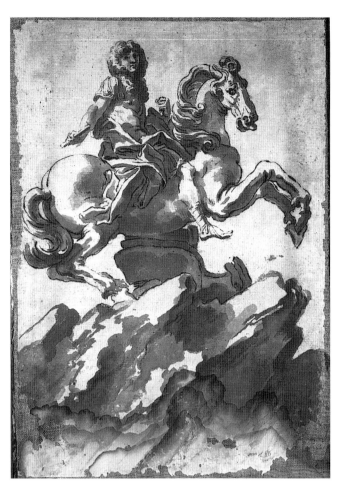

25. Gianlorenzo Bernini: Monument of Louis XIV. Wash drawing, 1673. Bassano, Museo Civico

believe that Louis XIV on horseback was devised as a purely dynastic monument. He was to appear on top of a high rock, a second Hercules who has reached the summit of the steep mountain of Virtue [25].²³ Thus this work too is a dynamic history-piece. It is an allegorical equestrian statue, but as usual with Bernini, allegory is implied, not made explicit. The naturalistic rock, the fiery horse, and the heroic rider together express in dramatic visual terms the poetic allegorical content. In a similar way, a complex *concetto* is woven into the design of the Four Rivers Fountain. The personifications of the Four Rivers, symbolizing the four parts of the world, and the dove, Innocent X's emblem which crowns the obelisk, the traditional symbol of divine light and eternity, proclaim the all-embracing power of the Church under the leadership of the reigning Pamphili pope. A further layer of meaning is hinted at by the reference, manifest in the whole arrangement, to the Rivers of Paradise at the foot of the mountain on which the Cross stands.²⁴ This monument of Catholic triumph and victory, therefore, also contains the idea of the salvation of mankind under the sign of the Cross.

A monument like the Elephant carrying the Obelisk, erected in the Piazza S. Maria sopra Minerva between 1666 and 1667, must also be understood as a glorification of the reigning pope, Alexander VII. Its typically Baroque conceit is well expressed in a contemporary poem: 'The Egyptian obelisk, symbol of the rays of *Sol*, is brought by the elephant to the Seventh Alexander as a gift. Is not the animal wise? Wisdom hath given to the World *solely* thee, O Seventh Alexander, consequently thou hast the gifts of *Sol*.'²⁵ In this case, the inscriptions, pregnant with emblematical meaning, are prominently displayed on the pedestal and form an integral part of the composition.

Finally the Cathedra Petri, which confirms by its arrangement and design in dramatic visual terms the fundamental dogma of the primacy of papacy. The venerable wooden stool of St Peter is encased in the gorgeous bronze throne which hovers on clouds high above the ground. At its sides, on a lower level, appear the greatest Latin and Greek Fathers who supported Rome's claim to universality. On the chair-back is a relief of Christ handing the Keys to St Peter; and above the chair putti carry the papal symbols, tiara and keys. Lastly, high up in the centre of the angelic Glory is the transparent image of the Holy Dove.²⁶ Thus one above the other there appear symbols of Christ's entrusting the office of Vicar to St Peter; of papal power; and of divine guidance, protection, and inspiration – the whole, with the precious relic at its centre, a materialized vision, which exhibits the eternal truth of Catholic dogma for all to see.²⁷

Working Procedure

Enough has been said to discard the idea, all too often voiced, that Bernini's magical transmutations of reality are the result of a creative fantasy run amok. Nothing could be farther from the truth. In fact, in addition to Bernini's own statements and a wealth of documents, sufficient drawings and bozzetti are preserved to allow more than a glimpse of his mind at work. His procedure cannot be dissociated from his convictions, his belief in the time-honoured tenets of

shot and Daphne at the instant of transformation. He represented both Bibiana and Longinus at the moment of their supreme tests, the former devoutly accepting her martyrdom and the latter in the emotional act of conversion, exclaiming while looking up at the Cross: 'Truly this was the Son of God.'²¹ Similarly, the *Vision of St Teresa* strictly adheres to the saint's meticulous description of the event which must be regarded as the acme of her life; for it was this particular vision that played a decisive part in the acts of her canonization. Even from the story of Daniel and Habakkuk, told in 'Bel and the Dragon' (which forms part of the Greek Book of Daniel), Bernini selected the culminating moment to which reference has already been made (p. 10). In all these cases Bernini gave a visual interpretation of the most fertile dramatic moment. The same is true of the *Constantine*, for this is not simply an equestrian monument representing the first Christian emperor, but a dramatic history-piece illustrating a precise event of his life: the historically and emotionally decisive moment of conversion in face of the miraculous appearance of the Cross.²²

But the *concetto* was not necessarily tied to factual historical events. A 'poetical' *concetto* contained no less intrinsic historical truth if chosen with proper discrimination. This applies to such works as the fountains, the equestrian statue of Louis XIV, and the Cathedra. It is a fatal error to

decorum and historical truth, in the classical doctrine that nature was imperfect, and in the unchallengeable authority of ancient art.

While preparing a work he closely attended to the requirements of decorum and historical truth. He would also be relentlessly critical when he found a breach of these basic demands. He expressed astonishment, for instance, that in his *Adoration of the Magi* the learned Poussin, for whom he had almost unreserved admiration, had given to the Kings the appearance of ordinary people. Chantelou and Lebrun defended Poussin, but Bernini insisted that one must follow the text of the Gospels where it was written that they *were* kings. In the case of the *Constantine* one can check how far he went in pursuance of historical truth. An excerpt in his own hand, now in the Bibliothèque Nationale in Paris,[28] shows that he consulted the source which contained a description of Constantine's physiognomy, namely Nicephorus's much-used thirteenth-century *Historia ecclesiastica*, of which modern printed editions existed. The relevant passage describes Constantine as having had an aquiline nose and a rather insignificant thin beard. In an extant preparatory drawing[29] Bernini made what may be called a portrait study of the emperor's features which served as basis for the execution.

Often historical truth and decorum, the appropriate and the becoming, merge into one. Such is the case when he makes St Bibiana and the Countess Matilda wear sandals, while the Discalced Carmelite Teresa appears barefoot; or when he is meticulous about the correct dress of historical and contemporary personages and reserves idealized attires for biblical and mythological figures and personifications. In certain cases, however, the demands of decorum have to supersede those of historical fact. Louis XIV never walked about in classical armour and sandals. But the dignity and nobility – in a word, the decorum – of the imperial theme required that Constantine as well as the Louis of the equestrian monument should be dressed *all' antica* and partly covered by idealized mantles, wildly fluttering in the wind.

Concern with such problems never barred him from taking classical and preferably Hellenistic works as his guide in developing a theme. Early in his career the finished work often remained close to the antique model. The Apollo of the Apollo and Daphne group does not depart far from the Belvedere Apollo nor the David from the Borghese warrior. Even the head of the Longinus is obviously styled after a Hellenistic model, the Borghese Centaur, now in the Louvre. In late works too the classical model is sometimes discernible. The face of Louis XIV's bust is manifestly similar to that of Alexander the Great on coins, and Bernini himself supplied the information that Alexander portraits, the accepted prototype of royalty, were before his mind's eye when working on the king's bust. But as he advanced in age, Bernini transformed his classical models to an ever greater degree. Nobody looking at his figure of Daniel can possibly guess that his point of departure was the father from the Laocoon group. In this case, however, the development can be followed from the copy after that figure through a number of preparatory drawings to the final realization in marble.[30] While working from the life-model, Bernini had in the beginning the classical figure at the back

of his mind, but was carried farther away from its spirit step by step. In accordance with his theoretical views, he began rationally and objectively, using a venerated antique work; not until his idea developed did he give way to imaginative and subjective impulses. When he worked himself into that state of frenzy in which he regarded himself as the tool of God's grace, he created in rapid succession numberless sketches and clay models, twenty-two in all in the case of the *Longinus*.[31]

In front of a very late work such as the ecstatic Angel holding the Superscription the conclusion seems unavoidable that he had ceased to use classical antiquity as a cathartic agent. And yet the body under the agitated folds of the drapery derives from the so-called Antinous in the Vatican, a figure that was studied with devotion in the classical circle of Algardi, Duquesnoy, and Poussin. Bernini referred to it in his address to the Paris Academy in these words: 'In my early youth I drew a great deal from classical figures; and when I was in difficulties with my first statue, I turned to the Antinous as to the oracle.' His reliance on this figure, even for the late Angel, is strikingly evident in a preparatory drawing showing the Angel in the nude.[32] But the proportions of the figure, like those of the finished marble, differ considerably from the classical model. Slim, with extremely long legs and a head small in comparison with the rest of the body, the nude recalls Gothic figures. The process of ecstatic spiritualization began during an early stage of the preparatory work.

It is, of course, necessary to differentiate between Bernini's authentic works and those executed by studio hands. This is, however, no easy task. From the early 1620s onwards the increase of commissions in size and numbers forced him to rely more and more on the help of assistants. For that reason a precise division between his own works and those of the studio is hardly possible. There is, indeed, an indeterminable area between wholly authentic works and those for which Bernini is hardly responsible. Stylistic integration depended less on Bernini's handling the hammer and chisel himself than on the degree of his preparatory work and the subsequent control exercised by his master mind. His personal contribution to the execution of works like the Baldacchino or the tomb of Urban VIII was still considerable. Later, he often made only the sketches and small models. The tomb of Alexander VII, for instance, is the work of many hands and the division of labour, revealed by the documents, anticipates that of the industrial age. Yet the work presents an unbroken stylistic unity and the assistants were no more than so many hands multiplying his own. It was only when the control slackened that dissonant elements crept in.

It would appear logical, therefore, to divide his production into works designed by him and executed by his hand;[33] those to a greater or lesser degree carried out by him;[34] others where he firmly held the reins but actively contributed little or nothing to the execution;[35] and finally those from which he dissociated himself after a few preliminary sketches.[36] The decision as to which of these categories a work belongs has to be made from case to case, more often than not on the basis of documents. But in the present context the problem had to be stated rather than solved.

PAINTING

Bernini's activity as a painter has attracted much attention in recent years,[37] but in spite of considerable efforts the problem still baffles the critics. A large measure of agreement exists about the part painting played in his life's work, although the riddle has not been solved as to what happened to the more than 150 pictures mentioned in Baldinucci's *Life* of Bernini, a figure which Domenico Bernini, in the biography of his father, raised to over two hundred. Whatever the correct number, a bare dozen pictures of this large *œuvre* have so far come to light. It is impossible to assume that most of these works have been lost for ever, and the discovery a short while ago of two indubitable originals in English collections[38] indicates that many more are probably hidden under wrong names. But their present anonymity conclusively proves one thing, namely that painting for Bernini was a sideline, an occupation, as Baldinucci expressed it, to which he attended for pleasure only. He never accepted any commissions of importance, he never signed any of his paintings, and to all appearances treated the whole matter lightly – hence the anonymity. It seems therefore not chance that half the number of pictures now known are self-portraits, intimate studies of his own person undertaken in leisure hours and not destined for a patron.

Covering a period of almost thirty years, these self-portraits give a reliable insight into his stylistic idiosyncrasies and development as a painter. They are all done with short, vigorous brush-strokes which model the forms and reveal the hand of the born sculptor. This characteristic dash of handling goes with a neglect of detail, sketchy impromptu treatment of accessories such as dress, and spontaneity of expression. Most of his portraits, sculptured, painted, and drawn, show a similar turn of the head, the alert look and the mouth half-open as if about to speak. In his early paintings dating from the 1620s he seems to have been subject to the sobering influence of Andrea Sacchi.[39] Later, about 1630, he turned towards a blond, luminous palette, probably under the impression of Poussin's *St Erasmus* of 1629 (painted for St Peter's, now Vatican Gallery) – thus falling in with the strong wave of Venetian colourism which surged over Rome in those years.[40] Later again, paintings like the self-portraits in the Prado and the Borghese Gallery[41] show darker colours and more unified tone values, and this must have been due to Velasquez's influence.[42] In fact some of Bernini's pictures of the 1640s are superficially so similar to those of the great Spaniard that they were attributed to him.

Most of the surviving pictures date from the twenties and thirties. And this for good reasons. The more the commissions accumulated, the less time he had for such recreations as painting. No picture is known from the last decades of his life. But at this period he enjoyed producing pictorial compositions, which he created rapidly with pen and ink.[43]

Thus while Bernini's own work as a painter remains somewhat mysterious, his conceptual approach to painting from the middle period onwards can be fully gauged. From that time on he employed painters, mainly of minor stature, as willing tools of his ideas. The first whom he drew into his orbit was Carlo Pellegrini (1605–49), a native of Carrara.[44] He may have started under Sacchi and was certainly influenced by him. But in 1635 he painted the *Conversion of St Paul* (Church of the Propaganda Fide) and between 1636 and 1640 the *Martyrdom of St Maurice* (for St Peter's, later Museo Petriano), certainly both from Bernini's sketches. These works show borrowings from Pietro da Cortona and Poussin, to whose light and luminous colour scale they are also clearly indebted. Moreover, the composition of the *Conversion* owes not a little both to Sacchi and, unexpectedly, to Lodovico Carracci. The *Martyrdom of St Maurice* is the more Berninesque of the two works. The master's mind is revealed as much by the highly dramatic composition, which shows three stages of martyrdom succinctly rendered on a narrow foreground stage, as by certain devices such as showing a truncated martyr's head next to that of St Maurice who is still alive or the parallel arrangement of arms whih act in opposite directions.[45]

Even before Pellegrini's death Bernini availed himself of the services of Guido Ubaldo Abbatini (1600/5–56) from Città di Castello, who began under the Cavaliere d'Arpino, but later, according to Passeri, submitted to his new master like a slave. His principal works for Bernini are the frescoes on the vault of the Cappella Raimondi, executed in collaboration with the classicizing Giovanni Francesco Romanelli (p. 134), the badly preserved frescoes on the vault of the Cappella Pio in S. Agostino, dating from *c.* 1644, and lastly those on the vault of the Cornaro Chapel.[46] In spite of his rather weak decorative talent, he perfectly suited Bernini's purpose. And as a participant in the execution of some of Bernini's grand schemes he was certainly more important than Pellegrini.

It was on the vault of the Cappella Pio that Bernini first mixed fresco and stucco: the painted angels rest on stucco clouds. Passeri was aware of the importance of this new departure and described it in the following words: 'he employed a new deceptive artifice and by means of certain parts in relief actually made true what was supposed to be mere illusion'.[47] In the Cappella Cornaro he carried the principle a step further. Not only did he use the mixture of fresco and stucco once again, now on a more lavish scale, but here the paintings of the vault penetrate far into the architecture. After what I have said about the elimination of traditional 'modes' (p. 14), it is only to be expected that Bernini would also transgress the established limitations of painting. Seeking a conceptual explanation of this phenomenon, it might be argued that, as sculpture for him was a king of pictorial art in three dimensions, painting was a sculptural art projected on to a surface; and transitions from sculpture into painting and vice versa were therefore equally justified.

It is important to realize that this approach is as far removed from Pietro da Cortona's superimpositions and overlappings as from the illusionism of the *quadraturisti* (I: p. 35). In spite of the dazzling richness of the former's designs, his definition of sculptured and painted areas always remains clear and decisive and no mixing of realities is ever intended. The *quadratura* painters, on the other hand, aimed at an illusionist expansion of real space; but the borderline between illusion and reality is not objectively abolished, it is only masked by the subjective skill of the painter.

Never again did Bernini have an opportunity to hand over

fresco work to a painter in any of his large enterprises.[48] Yet his new ideas were absorbed by Giovan Battista Gaulli, called Baciccio, an artist of much greater calibre than his previous collaborators. He came from Genoa to Rome before 1660 and was soon taken up by Bernini and deeply influenced by his ideas.[49] His greatest work, the frescoes in the Gesù (1672–83) [174], must be regarded as the fullest exposition of Bernini's revolutionary conception of painting. Here the principle of combining fresco and painted stucco and of superimposing painted parts on the architecture has been given its monumental form. In addition, the sculptural interpretation of his figures, their movements and draperies, and the urgency and intensity of their activities reveal the spirit of the late Bernini.

The Gesù frescoes are also the major Roman monument for a new departure in the organization of large ceiling decorations. The effect of these frescoes relies on the juxtaposition of extensive dark and light areas rather than on the compositional arrangement of single figures. In the frescoes of the nave the eye is led stepwise from the darkest to the lightest area, the unfathomable depth of the sky, where the Name of Christ appears amid shining rays. Bernini recommended the method of working with large coherent units[50] and employed it himself in works like the Cathedra. The method did not only satisfy his desire to create overwhelming effects and dramatic emphasis, but also appeared most conducive to communicating his mystic conception of divine light and his intense spiritualization of religious themes. Bernini's two important ideas, developed from his middle period onwards, of breaking through the frame of the painting and of embedding masses of figures in unified areas of colour found an enthusiastic following in the northern Baroque.

26. Gianlorenzo Bernini: Rome, S. Bibiana, 1624–6

ARCHITECTURE

Ecclesiastical Buildings

The year 1624 is of particular importance in the history of Baroque architecture; it was then that Bernini's career as an architect began with the commissions for the façade of S. Bibiana and the Baldacchino in St Peter's. It can hardly be denied that the little church of S. Bibiana opens a new chapter of the Baroque in all three arts: it harbours Bernini's first official religious statue and Cortona's first important fresco cycle. The design of the façade[51] is not divorced from tradition. But instead of developing further the type of Roman church façade which had led to Maderno's S. Susanna, Bernini placed a palacelike storey over an open loggia [26] – essentially the principle of the façade of St Peter's. In some modest early seventeenth-century façades of this type such as S. Sebastiano [1: 7] the palace character is almost scrupulously preserved. By comparison S. Bibiana shows an important new feature: the central bay of the ground-floor arcades projects slightly, and above it, framing a deep niche, is an impressive aedicule motif which breaks through the skyline of the adjoining bays. In this way the centre of the façade has been given forceful emphasis. It should be noticed that the cornice of the sidebays seems to run on under the pilasters of the aedicule and then to turn into the

depth of the niche. Thus the aedicule is superimposed over a smaller system, the continuity of which appears to be unbroken. The interpenetration of small and large orders was a Mannerist device, familiar to Bernini not only from such buildings as Michelangelo's Capitoline palaces, but also from the church façades of Palladio, an architect whose work he never ceased to study. All the same, Bernini's first essay in architectural design constitutes a new, bold, and individualist departure which none of the architects who later used the palace type of church façade dared to imitate.

The Baldacchino in St Peter's (1624–33) [18] gave Bernini his first and at once greatest opportunity of displaying his unparalleled genius for combining an architectural structure with monumental sculpture.[52] It was a brilliant idea to repeat in the giant columns of the Baldacchino the shape of the late antique twisted columns which – sanctified by age and their use in the old Basilica of St Peter's – were now to serve as aedicules above the balconies of the pillars of the dome.[53] Thus the twisted bronze columns of the Baldacchino find a fourfold echo, and not only give proof of the continuity of tradition, but by their giant size also express symbolically the change from the simplicity of the early Christians to the splendour of the counter-reformatory Church, implying the victory of Christianity over the pagan world. Moreover, their shape helped to solve the formal problem inherent in the gigantic Baldacchino. Its size is

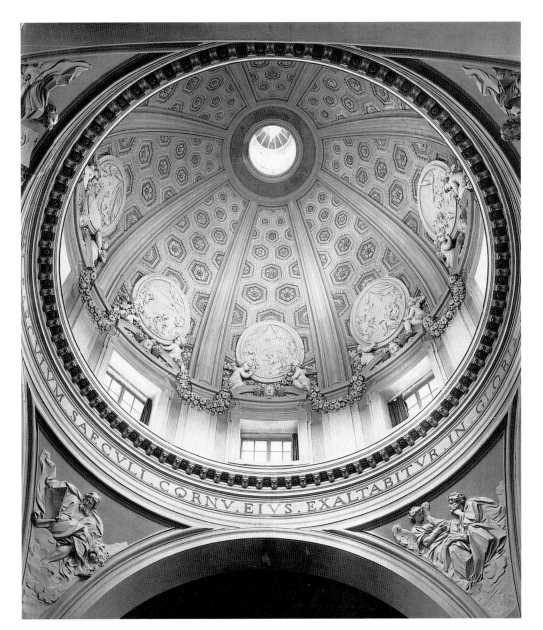

carefully related to the architecture of the church; but instead of creating a dangerous rivalry, the dark bronze corkscrew columns establish a dramatic contrast to the straight fluted pilasters of the piers as well as to the other white marble structural members of the building. Finally, and above all, only giant columns of this peculiar shape could be placed free into space without carrying a 'normal' superstructure. The columns are topped by four large angels behind which rise the huge scrolls of the crowning motif. Their S-shaped lines appear like a buoyant continuation of the screw-like upward tendencies of the columns. The scrolls meet under a vigorously curved entablature which is surmounted by the Cross above the golden orb.[54]

Every part of this dynamic structure is accompanied and supported by sculpture, and it may be noticed that with increasing distance from the ground the sculptural element is given ever greater freedom: starting from the Barberini coat of arms contained by the panels of the pedestals; on to the laurel branches, creeping up the columns, with putti nestling in them;[55] and further to the angels who hold garlands like ropes, with which to keep – so it seems – the scrolls in position without effort. In this area, high above the ground, sculpture in the round plays a vital part. Here, in the open spaces between the scrolls, are the putti with the symbols of papal power, here are the energetically curved palm branches which give tension to the movement of the scrolls and, finally, the realistic Barberini bees, fittingly the uppermost sculptural feature, which look as if they carry the orb. Critics have often disapproved of the realistic hangings which join the columns instead of the traditional entablature. But it is precisely this unorthodox element which gives the Baldacchino its particular meaning as a monumental canopy raised in all eternity over the tomb of St Peter, reminiscent of the real canopy held over the living pope when he is carried in state through the basilica.

Bernini's bold departure from the traditional form of baldacchinos – in the past often templelike architectural structures[56] – had an immediate and lasting effect. Among the

many repetitions and imitations[57] may be mentioned those in S. Lorenzo at Spello, erected as early as 1632, in the cathedrals at Atri, Foligno, and Trent and, much later, those in the abbey church at San Benigno, Piedmont (1770–6) and in S. Angelo at Perugia (1773, recently removed). Moreover, the derivations in Austria and Germany are legion; and even in France the type was widely accepted after the well-known lighter version with six columns on a circular plan had been built over the high altar of the Val-de-Grâce in Paris.[58]

Not until he was almost sixty years old had Bernini a chance of showing his skill as a designer of churches. His three churches at Castelgandolfo and Ariccia and S. Andrea al Quirinale in Rome rose almost simultaneously. In spite of their small size, they are of great importance not only for their intrinsic qualities but also because of their extraordinary influence. Modern critics tend to misinterpret them by stressing their traditional rather than their revolutionary aspect. Arguing from a purely aesthetic or pragmatic point of view, they tacitly imply that the same set of forms and motifs always expresses the same meaning. It is too often overlooked that the architecture of the past was a language of visual signs and symbols which architects used in a specific context, and the same grammar of architectural forms may therefore serve entirely different purposes and convey vastly different ideas. This should be remembered during the following discussion.

Bernini erected his three churches over the three most familiar centralized plans, the Greek cross, the circle, and the oval. The earliest of them, the church at Castelgandolfo, built between 1658 and 1661,[59] is a simple Greek cross [28], reminiscent of such perfect Renaissance churches as Giuliano da Sangallo's Madonna delle Carceri at Prato. And as in this latter church, the ratios are of utmost simplicity, the depth of the arms of the cross, for instance, being half their width. But compared with Renaissance churches the height has been considerably increased[60] and the dome has been given absolute predominance. The exterior is very restrained, in keeping with the modest character of the papal summer retreat to which the church belongs. Flat Tuscan double pilasters decorate the façade, and only minor features reveal the late date, such as the heavy door pediment and, in the zone of the capitals, the uninterrupted moulding which links the front and the arms of the church. Above the crossing rises the elegant ribbed dome which is evidently derived from that of St Peter's. But in contrast to the great model, the drum here consists of a low and unadorned cylinder, not unlike that of Raphael's S. Eligio degli Orefici in Rome, and is moreover set off against the dome by the prominent ring of the cornice. Every part of this building is clearly defined, absolutely lucid, and submitted to a classical discipline.

The same spirit of austerity prevails in the interior up to the sharply chiselled ring above the arches. But in the zone of the vaulting Bernini abandoned his self-imposed moderation [27]. Spirited putti, supporting large medallions, are seated on the broken pediments over the windows of the drum. These pediments, breaking into the dome, soften the division between drum and vault. Realistic garlands form links between the putti, and the lively and flexible girdle thus created appears like a pointed reversal of the pure geometry of the ring under the drum. This formal contrast

between rigidity and freedom is paralleled by the antithesis between the monumental Roman lettering of the inscription, praising the virtues of St Thomas of Villanova to whom the church is dedicated, and the eloquent reliefs which render eight important events of his life.[61] Since the coffers seem to continue behind the reliefs, the latter appear to hover in the wide expanse of the dome.

Whenever Bernini had previously decorated niches or semi-domes, he had followed the tradition, sanctioned by Michelangelo, of using ribs and, in the neutral areas between them, decorative roundels.[62] In Castelgandolfo Bernini retained the ribs and combined them with coffers. The classical element of the coffers seems to indicate an evenly distributed thrust (Pantheon), while the 'medieval', buttress-like system of ribs divides the dome into active carriers and passive panels. The union of these contrasting types of domical organization was not Bernini's own invention. He took up an idea first developed by Pietro da Cortona (p. 68) and, after thoroughly classicizing it, employed it from Castelgandolfo onwards for all his later vaultings and domes.[63] It was this Berninesque type of dome with ribs and coffers all'antica that was followed on countless occasions after 1660 by architects in Italy as well as the rest of Europe.[64]

S. Tomaso at Castelgandolfo is perhaps the least distinguished of Bernini's three churches in so far as the two others exhibit his specific approach to architecture more fully. The story of the new Ariccia dates back to 20 July 1661, when Cardinal Flavio, Don Mario, and Don Agostini Chigi acquired the little township near Castelgandolfo from Giulio Savelli, Prince of Albano. Here stood the old palace of the Savelli. Soon it was decided not only to modernize the palace,[65] but also to erect a church opposite its entrance. Bernini was commissioned in 1662, and two years later the church was finished [29–32].[66] Its basic form consists of a cylinder crowned by a hemispherical dome with a broad lantern. An arched portico of pure, classical design is placed in front of the rotunda [29], counterbalanced at the far end by the sacristy which juts out from the circle but is not perceived by the approaching visitor. Here also are the two bell-towers of which only the tops are visible from the square. In order to understand Bernini's guiding idea, reference must be made to another project.

From 1657 onwards Bernini was engaged on plans for ridding the Pantheon of later disfiguring additions; he also intended to systematize the square in front of the ancient building, but most of his ideas remained on paper.[67] Surviving sketches show that he interpreted the exterior of the 'original' Pantheon as the union of the two basic forms of vaulted cylinder and portico, and it is this combination of two simple geometric shapes, stripped of all accessories, that he realized in the church at Ariccia [30]. Straight colonnades flank the church, and these, together with the portico and the walls, which grip like arms around the body of the church, enhance the cylindrical and monolithic quality of the rotunda.

The interior too shows unexpected relations to the Pantheon [31]. There are three chapels of equal size on each side, while the entrance and the altar niche are a fraction larger, so that an almost unnoticeable axial direction exists.

29, 30, 31 and 32. Gianlorenzo Bernini: Ariccia, S. Maria dell'Assunzione, 1662–4.
(Above left) exterior; *(above right)* plan; *(below left)* engraving of section; *(below right)* view into dome

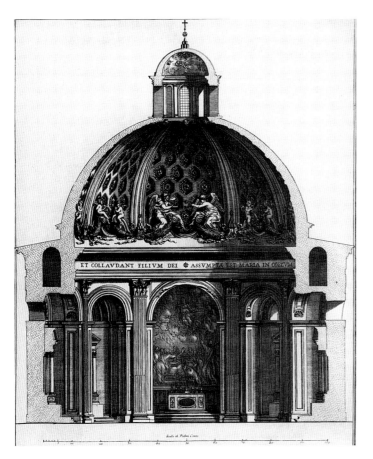

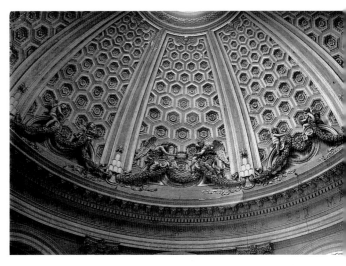

But the impression prevails of eight consecutive niches separated by tall Corinthian pilasters, which carry the unbroken circle of the entablature. As Andrea Palladio had done before in the little church at Maser, so here Bernini reduced the design to the two fundamental forms of the cylinder and hemisphere, and, as in Maser, the Corinthian order is as high as the cylinder itself. In contrast, however, to Palladio's rhythmic alternation of open and closed bays, Bernini gave an uninterrupted sequence of openings. The structural chastity of Ariccia was due to an attempt at recreating an imaginary Pantheon of the venerable Republican era. Bernini believed that the ancient building had originally been one of heroic simplicity and grandeur. Much later, Carlo Fontana, who in about 1660 worked as Bernini's assistant, published a reconstruction of the supposedly original Pantheon which is remarkably close to the interior of Ariccia.[68]

But in the zone of the dome [32], which again shows the combination of coffers and ribs, we find a realistic decoration similar to that at Castelgandolfo: stucco putti and angels sit on scrolls, holding free-hanging garlands which swing from rib to rib. What do these life-like figures signify? The church is dedicated to the Virgin (S. Maria dell' Assunzione) and, according to the legend, rejoicing angels strew flowers on the day of her Assumption. The celestial messengers are seated under the 'dome of heaven' into which the ascending Virgin will be received; the mystery is adumbrated in the *Assumption* painted on the wall behind the altar.[69] Since the jubilant angels, superior beings who dwell in a zone inaccessible to the faithful, are treated with

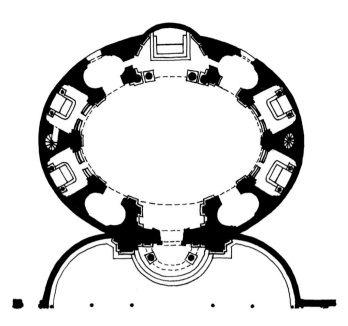

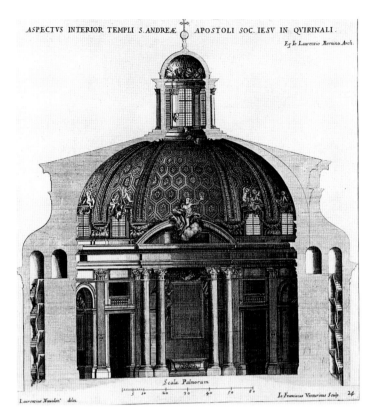

33, 34 and 35. Gianlorenzo Bernini: Rome, S. Andrea al Quirinale, 1658–70. *(Above left)* plan; *(above right)* engraving of section; *(below right)* view towards the altar

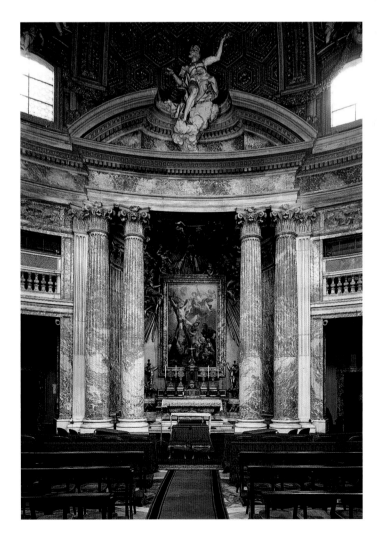

extreme realism, they conjure up full and breathing life. Thus whenever he enters the church the worshipper participates in the 'mystery in action'. As in Castelgandolfo, the dedication of the church gives rise to a dramatic-historical interpretation; the entire church is submitted to, and dominated by, this particular event, and the whole interior has become its stage.

By and large, the Renaissance church had been conceived as a monumental shrine, where man, separated from everyday life, was able to communicate with God. In Bernini's churches, by contrast, the architecture is no more and no less than the setting for a stirring mystery revealed to the faithful by sculptural decoration. In spite of their close formal links with Renaissance and ancient architecture, these churches have been given an entirely non-classical meaning. Obviously, Bernini saw no contradiction between classical architecture and Baroque sculpture – a contradiction usually emphasized by modern critics who fail to understand the subjective and particular quality with which seemingly objective and timeless classical forms have been endowed.

By far the most important of the three churches is S. Andrea al Quirinale, commissioned by Cardinal Camillo Pamphili for the novices of the Jesuit Order [33–6]. Building began simultaneously with the church at Castelgandolfo – the foundation stone was laid on 3 November 1658 – but it took much longer to complete this richly decorated church.[70] Antonio Raggi's stuccoes were carried out between 1662 and 1665, while other parts of the decoration dragged on until 1670. The particular character of the site on which most of the convent was standing induced Bernini to choose an oval ground-plan with the transverse axis longer than the main axis between entrance and altar. This in itself was not without precedent. There

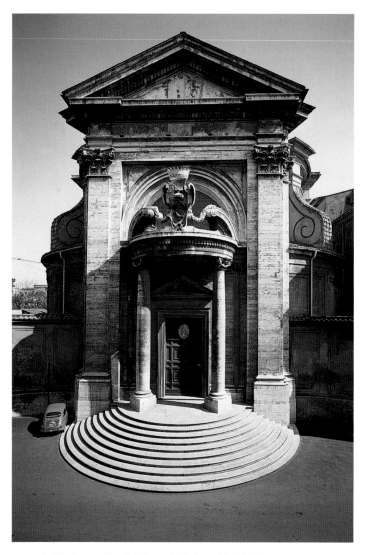

36. Gianlorenzo Bernini: Rome, S. Andrea al Quirinale, 1670–71

in the human sphere, the church glows with precious multi-coloured dark marble. Above, in the heavenly sphere of the dome, the colours are white and gold. The oval space is evenly lit by windows between the ribs which cut deep into the coffered parts of the dome. Bright light streams in from the lantern, in which sculptured cherubs' heads and the Dove of the Holy Ghost seem to await the ascending saint. All the chapels are considerably darker than the congregational room, so that its uniformity is doubly assured. In addition, there is a subtle differentiation in the lighting of the chapels: the large ones flanking the transverse axis have a diffused light, while the four subsidiary ones in the diagonal axes are cast in deep shadow. Thus the aedicule is adjoined by dark areas which dramatically enhance the radiance of light in the altar chapel.

In S. Andrea Bernini solved the intractable problem of directions inherent in centralized planning in a manner which only Palladio had attempted before the Baroque age.[72] By means of the aedicule, which is an ingenious adaptation of the Palladian device of the columned screen – a unique occurrence in Rome – he created a barrier against, as well as a vital link with, the altar chapel. He thus preserved and even emphasized the homogeneity of the oval form and, at the same time, succeeded in giving predominance to the altar. Translated into psychological terms, the church has two spiritual centres: the oval space, where the congregation participates in the miracle of the saint's salvation; and the carefully separated altar-recess, inaccessible to the laity, where the mystery is consummated. Here the beholder sees like an apparition the band of angelic messengers bathed in visionary golden light bearing aloft the picture of the martyred saint,[73] assured of his heavenly reward for faith unbroken by suffering.

It hardly seems necessary to reaffirm observations made in the first part of this chapter: here the whole church is subject to a coherent literary theme which informs every part of it, including the ring of figures above the windows which consists of putti carrying garlands and martyrs' palms, and nude fishermen who handle nets, oars, shells, and reeds – symbolic companions of the fisherman Andrew. Through its specific connexion with sculpture, the architecture itself serves to make the dramatic *concetto* a vital experience.

For the exterior of S. Andrea, Bernini made use of the lesson he had learned from Francesco da Volterra's S. Giacomo degli Incurabili.[74] In both churches the dome is enclosed in a cylindrical shell, and in both cases the thrust is taken up by large scrolls which fulfil the function of Gothic buttresses. But this is as far as the influence of S. Giacomo goes. In the case of S. Andrea, the scrolls rest upon the strong oval ring which encases the chapels. Its cornice seems to run on under the giant Corinthian pilasters of the façade and sweeps forward into the semicircular portico where it is supported by two Ionic columns. The portico [36], surmounted between scrolls by the free-standing Pamphili coat of arms of exuberant decorative design, is the only relieving note in an otherwise extremely austere façade. Yet this airy porch must not simply be regarded as an exhilarating feature inviting the passers-by to enter; it is also a dynamic element of vital importance in the complex organization of the building. The aedicule motif framing the portico is taken up inside,

was Fornovo's S. Maria dell' Annunziata at Parma (1566),[71] and Bernini himself had used the type much earlier in the little church in the old Palazzo di Propaganda Fide (1634, later replaced by Borromini's structure). What is new in S. Andrea, however, is that pilasters instead of open chapels stand at both ends of the transverse axis. As a result, the oval is closed at the most critical points where otherwise, from a viewpoint near the entrance, the eye would wander off from the main room into undefined subsidiary spaces. Bernini's novel solution permits, indeed compels, the spectator's glance to sweep round the uninterrupted sequence of giant pilasters, crowned by the massive ring of the entablature, until it meets the columned aedicule in front of the altar recess [103, 104]. And here, in the concave opening of the pediment, St Andrew soars up to heaven on a cloud. All the lines of the architecture culminate in, and converge upon, this piece of sculpture. More arrestingly than in the other churches the beholder's attention is absorbed by the dramatic event, which owes its suggestive power to the way in which it dominates the severe lines of the architecture.

Colour and light assist the miraculous ascension. Below,

37. Gianlorenzo Bernini: *Rome, Palazzo di Montecitorio*, begun 1650

on the same axis, by the aedicule framing the altar recess. But there is a reversal in the direction of movement: while in the exterior the cornice over the oval body of the church seems to move towards the approaching visitor and to come to rest in the portico, the point nearest to him, in the interior the movement is in the opposite direction and is halted at the point farthest away from the entrance. In addition, the isolated altar-room answers in reverse to the projecting portico, and this is expressive of their different functions, the latter inviting, the former excluding the faithful. Thus outside and inside appear like 'positive' and 'negative' realizations of the same theme. A word must be added about the two quadrant walls forming the piazza.[75] They focus attention on the façade. But more than this: since they grip firmly into the 'joints' where the oval body of the church and the aedicule meet, their, concave sweep reverses the convex ring of the oval and re-inforces the dynamic quality of the whole structure.

Genetically speaking, the façade of S. Andrea is related to that of S. Bibiana. It might almost be said that what Bernini did was to isolate and monumentalize the revolutionary central feature of S. Bibiana and to connect it with the motif of the portico with free-standing columns which Pietro da Cortona had first introduced in S. Maria della Pace [88]. And yet this façade is highly original. In order to assess its novel character I may refer to the Early Baroque façade of S. Giacomo degli Incurabili.[76] Here the façade is orthodox, deriving from Roman Latin-cross churches, so that on entering this oval church one is aware that the exterior and the interior are not co-ordinated. In the case of S. Andrea al Quirinale nobody would expect to enter a Latin-cross church. Bernini succeeded in expressing in the façade the specific character of the church behind it: exterior and interior form an entirely homogeneous entity.

Secular Buildings

Bernini's activity in the field of domestic architecture was neither extensive nor without adversity. In the Palazzo Barberini, his earliest work, his contribution was confined to adjustments of Carlo Maderno's design and to decorative features of the interior such as the door surrounds.[77] The façade of the Collegio di Propaganda Fide facing the Piazza di Spagna was an able modernization of an old palace front (1642–4), but he acted only as consulting architect.[78] His share in the design of the Palazzo Ducale at Modena and the execution of the Palazzo del Quirinale – a work of many brains and hands – is relatively small.[79] A number of designs remained on paper,[80] while some minor works survive: the decoration of the Porta del Popolo on the side of the Piazza, occasioned by the entry into Rome of Queen Christina of Sweden (1655); additions to the hospital of S. Spirito (1664–6) of which at least a gateway in the Via Penitenzieri close to the Square of St Peter's survives;[81] the renovation of the papal palace at Castelgandolfo (1660); and finally an 'industrial' work, the arsenal in the harbour of Civitavecchia (1658–63), consisting of three large halls of impressive austerity.[82] Setting all this aside, only three works of major importance remain to claim our attention, each with an ill-starred history of its own, namely the Palazzo Ludovisi in Piazza Montecitorio, the Palazzo Chigi in Piazza SS. Apostoli, and the projects for the Louvre.

Bernini designed the Palazzo Ludovisi, now Palazzo di Montecitorio [37], in 1650 for the family of Pope Innocent X.[83] In 1655, at the Pope's death, little was standing of the vast palace, and it was not until forty years later, in 1694, that Carlo Fontana resumed construction for Innocent XII. Although Fontana introduced some rather pedantic academic features, Bernini's façade was sufficiently advanced to prevent any flagrant distortion of his intentions.[84] The entire length of twenty-five windows in subdivided into separate

38. Gianlorenzo Bernini: *Rome, Palazzo Chigi-Odescalchi*, begun 1664. With N. Salvi's additions, 1745

units of 3-6-7-6-3 bays which meet at obtuse angles so that the whole front looks as if it were erected over a convex plan. Slight projections of the units at either end and the centre are important vehicles of organization. Each unit is framed by giant pilasters comprising the two principal storeys, to which the ground floor with the naturalistic rock formations under the farthest pilasters and window sills serves as a base. Apart from these attempts at articulation, the palace is essentially tied to the Roman tradition deriving from the Palazzo Farnese.

In the summer of 1664, not long before his journey to Paris, Bernini designed the palace which Cardinal Flavio Chigi had purchased in 1661 from the Colonna family

[38].[85] The volte-face here is hardly foreshadowed in the façade of the Palazzo Ludovisi. Bernini placed a richly articulated central part of seven bays between simple rusticated receding wings of three bays each. More decidedly than in the Palazzo Ludovisi, the ground floor functions as a base for the two upper storeys with their giant composite pilasters which stand so close that the window tabernacles of the *piano nobile* take up the entire open space. This finely balanced façade was disturbed in 1745 when the palace was acquired by the Odescalchi. Nicola Salvi and his assistant Luigi Vanvitelli doubled the central part, which now has sixteen pilasters instead of eight and two entrance doors instead of one. The present front is much too long in rela-

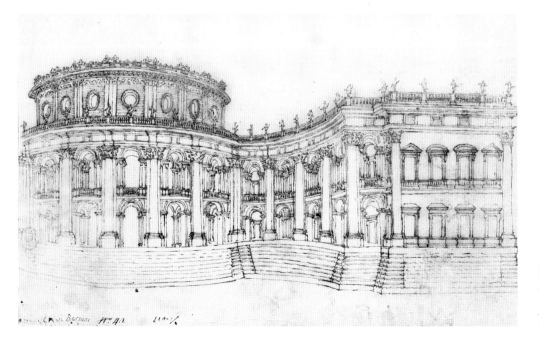

39. Gianlorenzo Bernini: Project for the Louvre, 1664. Drawing. London, Courtauld Gallery

40. Gianlorenzo Bernini: First project for the Louvre, 1664. Plan

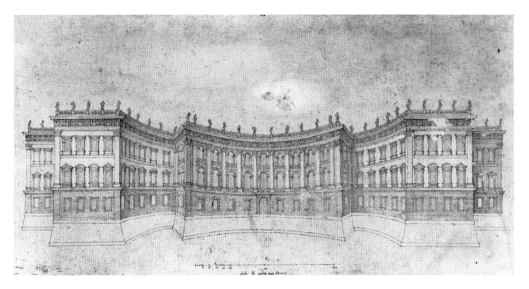

41. Gianlorenzo Bernini: Project for the Louvre. Drawing. Stockholm, Nationalmuseum

tion to its height and, standing between asymmetrical wings, no longer bears witness to Bernini's immaculate sense of proportion and scale. This, however, does not prejudice the revolutionary importance of Bernini's design, which constitutes a decisive break with the traditional Roman palace front. The older type, with no vertical articulation, has long rows of windows horizontally united by means of continuous string courses. Precedents for the use of the colossal order in palace façades existed. In Michelangelo's Capitoline Palaces and Palladio's Palazzo Valmarana at Vicenza the colossal order rises from the ground. On the other hand, a few buildings in Rome before Bernini have a colossal order over the ground floor, and in Northern Italy the type is not rare.[86] But when all is said and done, such comparisons throw into relief rather than diminish Bernini's achievement. The relation of the ground floor to the two upper tiers; the fine gradation from simple window-frames to elaborate, heavy tabernacle frames in the *piano nobile* – deriving from the Palazzo Farnese – to the light and playful window surrounds of the

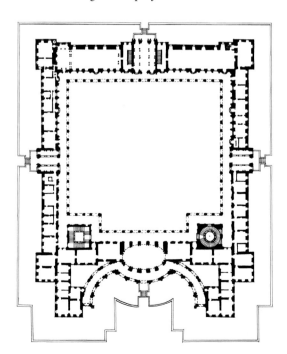

second storey; the rich composite order of the pilasters; the powerful cornice with rhythmically arranged brackets crowned by an open balustrade which was meant to carry statuary; the juxtaposition of the highly organized central part with the rustic wings; and, lastly, the strong accentuation of the entrance with its free-standing Tuscan columns, balcony and window above it, the whole unit being again dependent on the Palazzo Farnese – all this was here combined in a design of authentic nobility and grandeur. Bernini had found the formula for the aristocratic Baroque palace. And its immense influence extends far beyond the borders of Italy.[87]

Bernini's third great enterprise, the Louvre, turned out to be his saddest disappointment. In the spring of 1665 Louis XIV invited him to come to Paris and suggest on the spot how to complete the great Louvre *carré* of which the west and south wings and half of the north wing were standing.[88] The east wing with the main front was still to be built. Great were the expectations on all sides when Bernini arrived in Paris on 2 June of that year. But his five months' stay there ended in dismal failure. The reasons for it were many, personal as well as national. And yet his projects might possibly have been accepted had they answered the purpose for which they were made. Before he travelled to France, he had already sent two different projects to Colbert, in whose hands as 'Surintendant des Bâtiments' rested all proceedings connected with the Louvre.

Although Bernini always worked on the whole area of the *carré*, the focus of his design was, of course, the east façade. The first project of June 1664, contemporary with the design of the Palazzo Chigi-Odescalchi, is unexpected by any standards [39].[89] He created an open rectangle with two projecting wings of four bays each, between which he placed a long colonnade consisting of a convex centre between two concave arms [40]. The convex part of the colonnade follows the shape of the oval vestibule, above which is a grand oval hall going through two storeys. Its second storey with circular windows, articulated by double pilasters and decorated with French lilies standing out against the sky-line, rises above the uniform cornice of the whole front. In this façade Bernini followed up the theme of the Palazzo Barberini, an arcaded centre framed by serene wings, and applied to it the

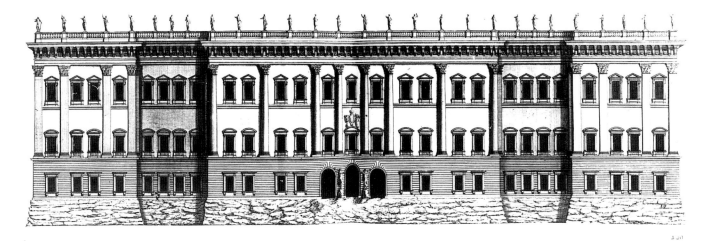

Principale Entrée du Chasteau du Louvre du coste de St Germain, du desseing du Cavalier Bernin

42. Gianlorenzo Bernini: Project for the Louvre. Engraving by Marot

theme of Roman church façades with a convex centre between concave arms (S. Maria della Pace, S. Andrea al Quirinale). But for the details of the colonnade he turned to the festive architecture of northern Italy and combined the colossal order of Palladio's Loggia del Capitano at Vicenza with the two-storeyed arcade of Sansovino's Library at Venice.[90] The result was a palace design which has an entirely un-Roman airy quality, and though it remained on paper it seems to have had considerable influence on the development of eighteenth-century structures.

The second project, dispatched from Rome in February 1665 and preserved in a drawing at Stockholm [41],[91] has a giant order applied to the wall above a rusticated ground floor. One may regard this as a novel application of the Palazzo Chigi-Odescalchi design, but for the wide sweep of the concave centre part Bernini was probably indebted to an unexecuted project by Pietro da Cortona for the Piazza Colonna in Rome.[92] The third project designed in Paris survives in the engravings by Marot which were carried out under Bernini's watchful eyes [42]. He now returned to the more conventional Roman palazzo type, and in the process of re-designing the east front he lost in originality what he gained in monumental appearance.[93] He was still faced with the typically Italian problem of harmonizing length and height in this front of prodigious extension; he therefore subdivided the traditional block shape into five distinct units, thus developing the scheme first evolved in the Palazzo di Montecitorio. The central projection showing the ideal ratio of 1:2 (height to length, without the basement which was to disappear behind the moat) is emphasized not only by its size of eleven bays but also by virtue of its decoration with giant half-columns. This motif is taken up in the giant pilasters of the wings, while the receding sections have no orders at all. Following the example of the Palazzo Farnese, Bernini retained much plain wall-space above the windows of the *piano nobile* as well as the traditional string course under the windows of the top storey. Instead of arranging the order as a simple consecutive sequence, he concentrated four half-columns in the central area, a device to emphasize the entrance.[94] This palace was to rise like a powerful fortress from the 'natural' rock;[95] this concept too was, in a way, anticipated in the Palazzo di Montecitorio.

Bernini's third east façade was the answer to previous criticism voiced by Colbert. But in spite of vital changes from one project to the next, Bernini clung with the stubbornness only to be found in a genius averse to any compromise to all the features which he regarded as essential for a royal residence although they were contrary to French taste and traditions. He retained the unifying cornice, the unbroken skyline, and the flat roof; to him a façade was a whole to which the parts were subordinated; it could never be the agglomeration of different structural units to which the French were accustomed. Moreover, in compliance with southern conceptions of decorum he insisted, in spite of Colbert's repeated protests, on transferring the King's suite from the quiet south front, facing the river, to the east wing, the most stately but also the most noisy part of the building.[96] Among his other unacceptable proposals was the idea of surrounding the *carré* with arcades after the fashion of Italian courtyards; such arcades were not only unsuitable in that they excluded the light from the rooms behind, but they also seemed aesthetically repulsive to the French.[97] Finally, he never abandoned the typically Italian staircases in the four corners of the *carré*, placed there in order not to interrupt the alignment of rooms, and their disposition as well as their enclosure by badly lit wells appeared contrary to common sense to the French, who had solved the problem of easy communication between vestibule, staircase hall, and living rooms.[98]

When Bernini returned to Italy he had not given up hope that his plans would be carried out. The French architects were bitterly antagonistic. Colbert was irresolute, but the king had taken a liking to the great Italian and supported him. Actually, the foundation stone of Bernini's Louvre was laid three days before his departure from Paris. Back in Rome he worked out a new project, the fourth, in which he

made the one concession of reducing the much criticized height of the *piano nobile*.[99] In May 1666 he sent his assistant, Mattia de' Rossi, to Paris to supervise the execution. But meanwhile the king's interest had shifted to Versailles, and that was the signal for Colbert to abandon Bernini's plans.

By this decision Paris was saved the doubtful honour of having within its walls the most monumental Roman palazzo ever designed. Splendid though Bernini's project was, the enormous, austere pile would forever have stood out as an alien growth in the serene atmosphere of Paris. In Rome, the cube of the Palazzo Farnese, the ancestor of Bernini's design, may be likened to the solo in a choir. In Paris, Bernini's overpowering Louvre would have no resonance: it would have cast an almost sombre spell over the gaiety of the city.[100]

The Piazza of St Peter's

While he was in Paris, Bernini's greatest work, the Square of St Peter's, was still rising. But by that time all the hurdles had been taken and, moreover, Bernini had a reliable studio with a long and firmly established tradition to look after his interests. His 'office' supplied, of course, no more than physical help towards the accomplishment of one of the most complex enterprises in the history of Italian architecture.[101] Bernini alone was responsible for this work which has always been universally admired, he alone had the genius and resourcefulness to find a way through a tangle of topographical and liturgical problems, and only his supreme authority in artistic matters backed by the unfailing support of Pope Alexander VII could overcome intrigues and envious opposition[102] and bring this task to a successful conclusion [I:1; II: 46, 47; III: 4]. Among a vast number of issues to be considered, particular importance was attached to two ritual ones right from the start. At Easter and on a few other occasions the pope blesses the people of Rome from the Benediction Loggia above the central entrance to the church. It is a blessing symbolically extended to the whole world: it is given *urbi et orbi*. The piazza, therefore, had not only to hold the maximum number of people, while the Loggia had to be visible to as many as possible, but the form of the square itself had to suggest the all-embracing character of the function. Another ceremony to be taken into account was the papal blessing given to pilgrims from a window of the private papal apartment situated in Domenico Fontana's palace on the north side of the piazza. Other hardly less vital considerations pertained to the papal palace. Its old entrance in the north-west corner of the piazza could not be shifted and yet it had to be integrated into the architecture of the whole.[103] The basilica itself required an approach on the grandest scale in keeping with its prominence among the churches of the Catholic world. In addition, covered ways of some kind were needed for processions and in particular for the solemn ceremonies of Corpus Domini; they were also necessary as protection against sun and rain, for pedestrians as well as for coaches.

Bernini began in the summer of 1656 with the design of a trapezoid piazza enclosed by the traditional type of palace fronts over roundheaded arcades. This scheme was soon

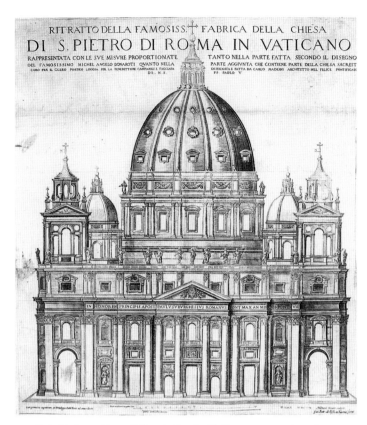

43. Carlo Maderno: Rome, St Peter's. Façade. M. Greuter's engraving, 1613

abandoned for a variety of reasons, not the least because it was of paramount importance to achieve greatest monumentality with as little height as possible. A palazzo front with arcades would have been higher than the present colonnades without attaining equal grandeur. So by March 1657 the first project was superseded by one with arcades of freestanding columns forming a large oval piazza; soon after, in the summer of the same year, Bernini replaced the arcades by colonnades of free-standing columns with a straight entablature above the columns. Only such a colonnade was devoid of any associations with palace fronts and therefore complied with the ceremonial character of the square more fully than an arcaded scheme with its reminiscences of domestic architecture. On ritualistic as well as artistic grounds the enclosure of the piazza had to be kept as low as possible. A high enclosure would have interfered with the visibility of the papal blessing given from the palace window. Moreover, a comparatively low one was also needed in order to 'correct' the unsatisfactory impression made by the proportions of the façade of St Peter's.

This requires a word of explanation. The substructures of Maderno's towers, standing without the intended superstructures,[104] look now as if they were parts of the façade, and this accounts for its excessive length [cf. I: 1; II: 43]. A number of attempts were made in the post-Maderno period to remedy this fault,[105] before Urban VIII took the fateful decision in 1636 of accepting Bernini's grand design of high towers of three tiers.[106] Of these only the southern one was built, but owing to technical difficulties and personal intrigues construction was interrupted in 1641, and finally

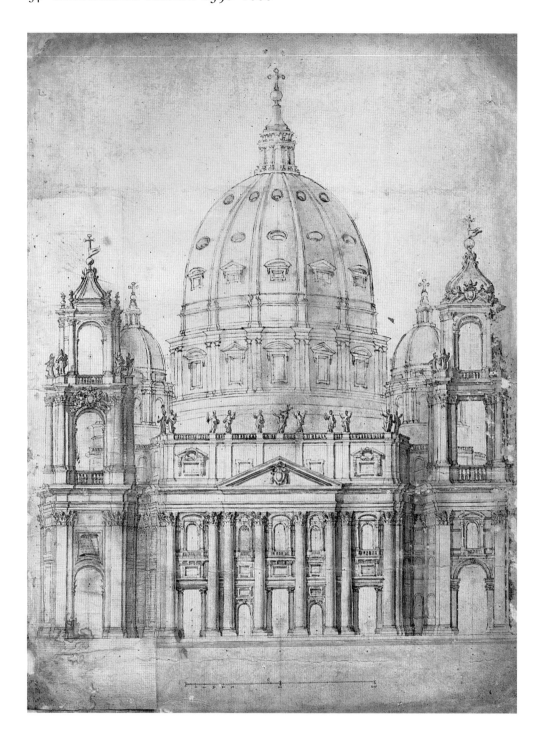

44. Gianlorenzo Bernini: Rome, St Peter's. Façade with semi-detached towers. Drawing, 1645–6. Rome, Vatican Library

in 1646 the tower was altogether dismantled. Since the idea of erecting towers ever again over the present substructures had to be abandoned, Bernini submitted during Innocent X's pontificate new schemes for a radical solution of the old problem.[107] By entirely separating the towers from the façade [44], he made them structurally safe, at the same time created a rich and varied grouping, and gave the façade itself carefully balanced proportions. His proposals would have involved considerable structural changes and had therefore little chance of success. When engaged on the designs for the piazza, Bernini was once again faced with the intractable problem of the façade. Although he also made an unsuccessful attempt at reviving Michelangelo's tetrastyle portico,[108] which would have broken up the uniform 'wall' of the façade, he now had to use optical devices rather than structural changes as a means to rectify the appearance of the building. He evoked the impression of greater height in the façade by joining to it his long and relatively low corridors which continue the order and skyline of the colonnades.[109] The heavy and massive Doric columns of the colonnades and the high and by comparison slender Corinthian columns of the façade form a deliberate contrast. And Bernini chose the unorthodox combination of Doric columns with Ionic entablature[110] not only in order to unify the piazza horizontally but also to accentuate the vertical tendencies in the façade.

For topographical and other reasons Bernini was forced to design the so-called *piazza retta* in front of the church.

45. Gianlorenzo Bernini: Rome,
Vatican Palace, Scala Regia,
1663–6

The length and slant of the northern corridor, and implicitly the form of the *piazza retta*, were determined by the position of the old and venerable entrance to the palace. Continuing the corridor, the new ceremonial staircase, the Scala Regia [45], begins at the level of the portico of the church. Here the problems seemed overwhelming. For his new staircase he had to make use of the existing north wall and the old upper landing and return flight.[111] By placing a columnar order within the 'tunnel' of the main flight and by ingeniously manipulating it, he counteracted the convergence of the walls towards the upper landing and created the impression of an ample and festive staircase.

There was no alternative to the *piazza retta*, and only beyond it was it possible to widen the square. The choice of

the oval for the main piazza suggested itself by a variety of considerations. Above all the majestic repose of the widely embracing arms of the colonnades was for Bernini expressive of the dignity and grandeur here required [46, 47]. Moreover, this form contained a specific *concetto*. Bernini himself compared the colonnades to the motherly arms of the Church 'which embrace Catholics to reinforce their belief, heretics to re-unite them with the Church, and agnostics to enlighten them with the true faith'.

Until the beginning of 1667 Bernini intended to close the piazza at the far end opposite the basilica by a short arm continuing exactly the architecture of the long arms. This proves conclusively that for him the square was a kind of forecourt to the church, comparable to an immensely

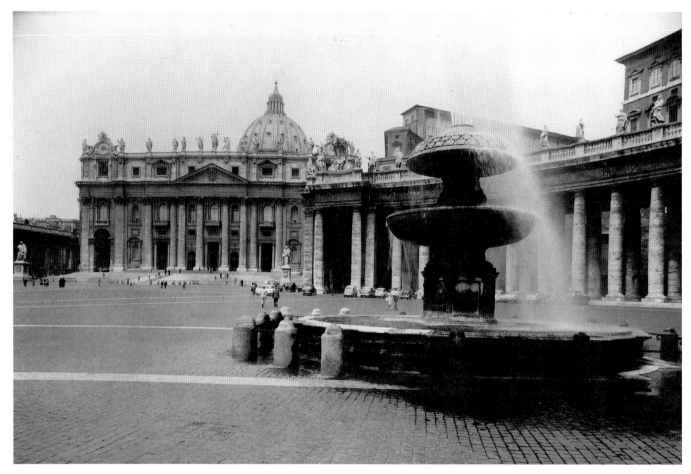

46. Gianlorenzo Bernini: Rome, The Piazza of St Peter's. Detail

extended atrium. The 'third arm' which was never built would have stressed a problem that cannot escape visitors to the piazza. From a near viewpoint the drum of Michelangelo's dome, designed for a centralized building, disappears behind Maderno's long nave and even the visibility of the dome is affected. Like Maderno before him,[112] Bernini was well aware of the fact that no remedy to this problem could possibly be found. In developing his scheme for the piazza, he therefore chose to disregard this matter altogether rather than to attempt an unsatisfactory compromise solution. Early in 1667 construction of the piazza was far enough advanced to begin the 'third arm'. It was then that Bernini decided to move the 'third arm' from the perimeter of the oval back into the Piazza Rusticucci,[113] the square at one time existing at the west end of the Borghi (that is, the two streets leading from the Tiber towards the church). He was led to this last-minute change of plan certainly less by any consideration for the visibility of the dome than by the idea of creating a modest ante-piazza to the oval. By thus forming a kind of counterpart to the *piazza retta*, the whole design would have approached symmetry. In addition, the visitor who entered the piazza under the 'third arm' would have been able to embrace the entire perimeter of the oval. It may be recalled that in centralized buildings Bernini demanded a deep entrance because experience shows – so he told the Sieur de Chantelou – that people, on

entering a room, take a few steps forward and unless he made allowance for this they would not be able to embrace the shape in its entirety. In S. Andrea al Quirinale he had given a practical exposition of this idea and he now intended to apply it once again to the design of the Piazza of St Peter's. In both cases the beholder was to be enabled to let his glance sweep round the full oval of the enclosure, in the church to come to rest at the aedicule before the altar and in the piazza at the façade of St Peter's. Small or large, interior or exterior, a comprehensive and unimpaired view of the whole structure belongs to Bernini's dynamic conception of architecture, which is equally far removed from the static approach of the Renaissance as from the scenic pursuits of northern Italy and the Late Baroque.

The 'third arm', this important link between the two long colonnades, remained on paper for ever, owing to the death of Alexander VII in 1667. The recent pulling down of the *spina* (the houses between the Borgo Nuovo and Borgo Vecchio), already contemplated by Bernini's pupil Carlo Fontana and, in his wake, by other eighteenth- and nineteenth-century architects,[114] has created a wide roadway from the river to the piazza. This has solved one prob-

47. Gianlorenzo Bernini: Rome, The Piazza of St Peter's, begun 1656. Aerial view

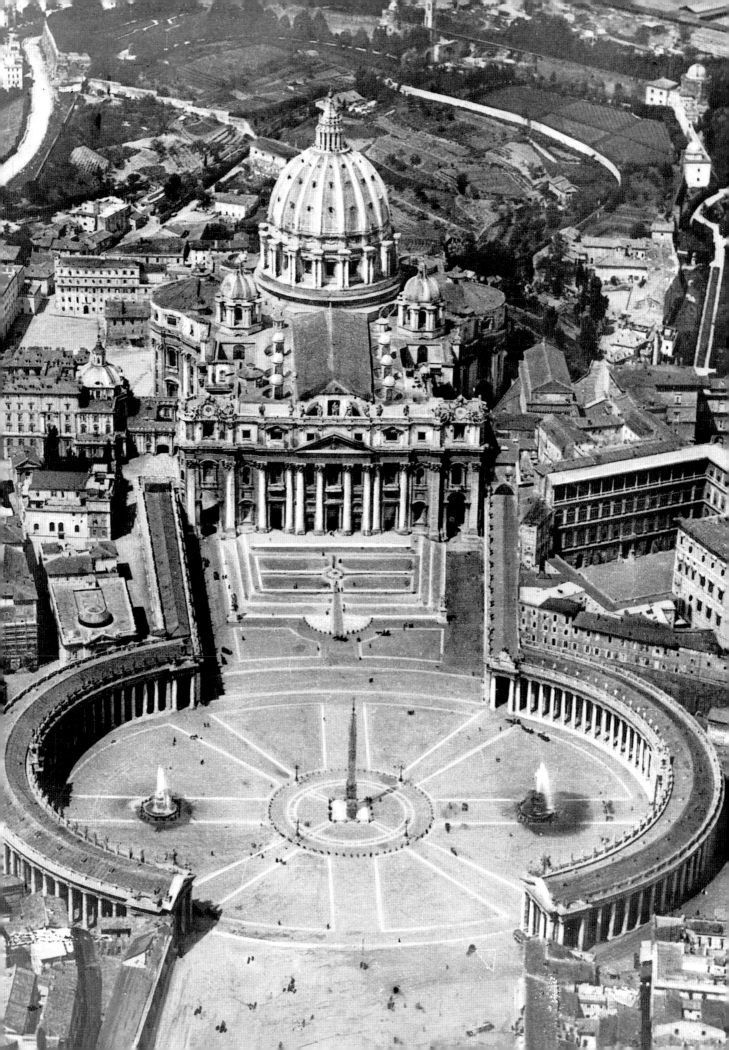

lem, and only one, namely that of a full view of the drum and dome from the distance; may it be recalled that they were always visible in all their glory from the Ponte S. Angelo, in olden days the only access to the precincts of St Peter's. To this fictitious gain has been sacrificed Bernini's idea of the enclosed piazza and, with no hope of redress, the scale between the access to the square and the square itself has been reversed. Formerly the narrow Borgo streets opened into the wide expanse of the piazza, a dramatic contrast which intensified the beholder's surprise and feeling of elation.

The most ingenious, most revolutionary, and at the same time most influential feature of Bernini's piazza is the self-contained, freestanding colonnade.[115] Arcades with orders of the type familiar from the Colosseum, used on innumerable occasions from the fifteenth century onwards, always contain a suggestion of a pierced wall and consequently of flatness. Bernini's isolated columns with straight entablature, by contrast, are immensely sculptural elements. When crossing the piazza, our everchanging view of the columns standing four deep[116] seems to reveal a forest of individual units; and the unison of all these clearly defined statuesque shapes produces a sensation of irresistible mass and power. One experiences almost physically that each column displaces or absorbs some of the infinitude of space, and this impression is strengthened by the glimpses of sky between the columns. No other Italian structure of the post-Renaissance period shows an equally deep affinity with Greece. It is our preconceived ideas about Bernini that dim our vision and prevent us from seeing that this Hellenic quality of the piazza could only be produced by the greatest Baroque artist, who was a sculptor at heart.

As happens with most new and vital ideas, after initial sharp attacks the colonnades became of immense consequence for the further history of architecture. Examples of their influence from Naples to Greenwich and Leningrad need not be enumerated. The aftermath can be followed up for more than two and a half centuries.

Francesco Borromini (1599–1667)

Among the great figures of the Roman High Baroque the name of Francesco Borromini stands in a category of its own. His architecture inaugurates a new departure. Whatever their innovations, Bernini, Cortona, Rainaldi, Longhi and the rest never challenged the essence of the Renaissance tradition. Not so Borromini, in spite of the many ways in which his work is linked to ancient and sixteenth-century architecture. It was clearly felt by his contemporaries that he introduced a new and disturbing approach to old problems. When Bernini talked in Paris about Borromini, all agreed, according to the Sieur de Chantelou, that his architecture was extravagant and in striking contrast to normal procedure; whereas the design of a building, it was argued, usually depended on the proportions of the human body, Borromini had broken with this tradition and erected fantastic ('chimerical') structures. In other words, these critics maintained that Borromini had thrown overboard the classical anthropomorphic conception of architecture which since Brunelleschi's days had been implicitly accepted.

This extraordinary man, who from all reports was mentally unbalanced and voluntarily ended his life in a fit of despair, came into his own remarkably late. The son of the architect Giovanni Domenico Castelli, he was born in 1599 at Bissone on the Lake of Lugano near the birthplace of his kinsman Maderno.[1] After a brief stay in Milan, he seems to have arrived in Rome in about 1620. Much as the artisans who for hundreds of years had travelled south from that part of Italy, he began as a stone-carver, and in this capacity spent more than a decade of his life working mainly in St Peter's on coats of arms, decorative putti, festoons, and balustrades. His name is also connected with some of the finest wrought-iron railings in the basilica.[2] Moreover, the aged Maderno, who recognized the talent of his young relation, used him as an architectural draughtsman for St Peter's, the Palazzo Barberini, and the church and dome of S. Andrea della Valle.[3] Borromini willingly submitted to the older man, and the lasting veneration in which he held him is revealed by the fact that in his will he expressed the wish to be buried in Maderno's tomb.

After Maderno's death in January 1629 a new situation arose. Bernini took over as Architect to St Peter's and the Palazzo Barberini, and Borromini had to work under him. Documents permit Borromini's position to be defined: between 1631 and 1633 he received substantial payments for full-scale drawings of the scrolls of the Baldacchino and for the supervision of their execution, and in 1631 he was also officially functioning as 'assistant to the architect' of the Palazzo Barberini. The Borrominesque character of the scrolls as well as certain details in the palazzo indicate that Bernini conceded a notable freedom of action to his subordinate, and it would therefore appear that Bernini rather than Maderno paved the way for Borromini's imminent emergence as an architect in his own right. But their rela-

tionship had the making of a long-lasting conflict. Fate brought two giants together whose characters were as different as were their approaches to architecture; Bernini – man of the world, expansive and brilliant – like his Renaissance peers regarded painting and sculpture as adequate preparation for architecture; Borromini – neurotic and recluse – came to achitecture as a trained specialist, a builder and first-rate technician. Almost exact contemporaries, the one was already immensely successful, the first artist in Rome, entrusted with most enviable commissions, while the other still lacked official recognition at the age of thirty. Bernini, of course, used Borromini's expert knowledge to the full. He had no reason for professional jealousy, from which, incidentally, he always remained free. For Borromini, however, these years must have been a degrading experience which always rankled with him, and when in 1645 the affair of Bernini's towers of St Peter's led to a crisis, it was he who came forward as Bernini's most dangerous critic and adversary. His guns were directed against technical inefficiency, the very point where – he knew – Bernini was most vulnerable.

At present it does not seem possible to separate with any degree of finality Borromini's active contribution to the Palazzo Barberini. His personal manner is evident, above all, in the top-floor window of the recessed bay adjoining the arcaded centre [48]. The derivation from Maderno's windows in the attic of the façade of St Peter's is obvious, but

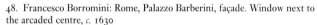

48. Francesco Borromini: Rome, Palazzo Barberini, façade. Window next to the arcaded centre, c. 1630

the undulating 'ears' with festoons fastened to them as well as the segmental capping with endings turned outward at an angle of 45 degrees are characteristic of Borromini's dynamic interpretation of detail. Here that Promethean force which imparts an unaccountable tension to every shape and form is already noticeable.

Original drawings for the doors of the great hall help to assess the relationship between Borromini and Bernini.[4] There was certainly a give and take on both sides, but on the whole it would appear that Borromini's new interpretation of the architectural detail made a strong impression on Bernini who, at this phase and for a short while later, tried to reconcile his own anthropomorphic with Borromini's 'bizarre' interpretation of architecture. Although the work on the Palazzo Barberini dragged on until 1638, the major part was finished in 1633. From then on the two men parted for good. It was then that Borromini set out on his own.

S. Carlo alle Quattro Fontane

His opportunity came in 1634, when the Procurator General of the Spanish Discalced Trinitarians commissioned him to build the monastery of S. Carlo alle Quattro Fontane, a couple of hundred yards from the Palazzo Barberini. Borromini first built the dormitory, the refectory (now sacristy), and the cloisters,[5] and the layout proved him a master in the rational exploitation of the scanty potentialities of the small and irregularly cut site [49]. In 1638 the foundation stone of the little church itself was laid. Except for the façade, it was finished in May 1641 and consecrated in 1646 [51]. Next to Cortona's SS. Martina e Luca, which went up during the very same years, it must be regarded as one of the 'incunabula' of the Roman High Baroque and deserves the closest attention.

The cloisters, a structure of admirable simplicity, contain features which anticipate the basic 'orchestration' in the church, such as the ring of rhythmically arranged, immensely effective columns forming an elongated octagon, the uniform cornice binding together the columns, and the

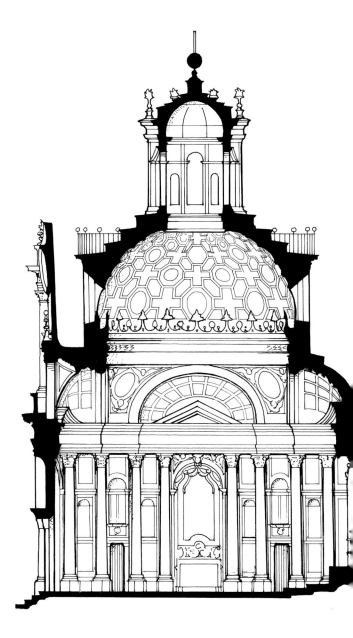

replacement of corners by convex curvatures which prevent caesuras in the continuity of movement.

A number of projects in the Albertina, Vienna, have always been – as we now know incorrectly – referred to the planning of the church ever since E. Hempel published them in 1924.[6] The geometric conception of the final project is a diamond pattern of two equilateral triangles with a common base along the transverse axis of the building; the undulating perimeter of the plan follows this rhomboid geometry with great precision.

It is of the greatest importance to realize that in S. Carlo and in later buildings Borromini founded his designs on geometric units. By abnegating the classical principle of planning in terms of modules, i.e. in terms of the multiplication and division of a basic arithmetical unit (usually the diameter of the column), Borromini renounced, indeed, a central position of anthropomorphic architecture. In order to make clearer the difference of procedure, one might state, perhaps too pointedly, that in the one case the overall plan and its divisions are evolved by adding module to module,

49. Francesco Borromini: Rome, S. Carlo alle Quattro Fontane, 1638–41. Plan

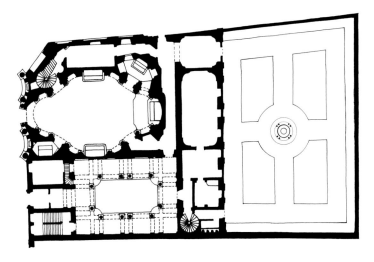

50 *(left)* and 51 *(right)*.
Francesco Borromini: Rome,
S. Carlo alle Quattro Fontane,
1638–41. Section and view
towards high altar

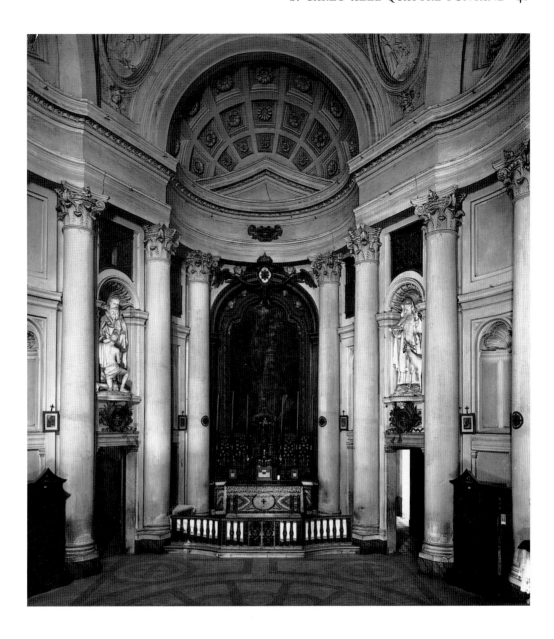

and in the other by dividing a coherent geometric configura-
tion into geometric sub-units. Borromini's geometric
approach to planning was essentially medieval, and one
wonders how much of the old mason's tradition had reached
him before he went to Rome. For hundreds of years
Lombardy had been the cradle of Italian masons, and it is
quite possible that in the masons' yards medieval building
practices were handed on from generation to generation.
Borromini's stubborn adherence to the rule of triangulation
seems to support the point.[7]

In Borromini's plan of S. Carlo extraordinary importance
is given to the sculptural element of the columns [50, 51].
They are grouped in fours with larger intervals on the lon-
gitudinal and transverse axes. While the triads of undulating
bays in the diagonals are unified by the wall treatment –
niches and continuous mouldings – the dark gilt-framed
pictures in the main axes seem to create effective caesuras.
Thus, starting from the entrance bay, a rhythm of the fol-
lowing order exists: A|bcb|A'|bcb|A| etc. But this is
clearly not the whole truth. A different rhythm is created by

the high arches and the segmental pediments above the pic-
tures. These elements seem to tie together each group of
three bays in the main axes. The reading, again from the
entrance bay, would therefore be: |bAb|c|bA'b|c|bAb|
etc. Where then are the real caesuras in this building? In the
overlapping triads of bays there is certainly a suggestion of
Mannerist complexity. However, instead of strengthening
the inherent situation of conflict, as the Mannerists would
have done, Borromini counteracted it by two devices: first,
the powerful entablature serves, in spite of its movement, as
a firm horizontal barrier which the eye follows easily and
uninterruptedly all round the perimeter of the church; and
secondly, the columns themselves, which by their very
nature have no direction, may be seen as a continuous accen-
tuation of the undulating walls. It is precisely the predomi-
nant bulk of the columns inside the small area of this church
that helps to unify its complex shape. The overlapping tri-
ads may be regarded as the 'background rhythm' which
makes for the never-tiring richness and fascination of the
disposition; or, to use a simile, they may be likened to the

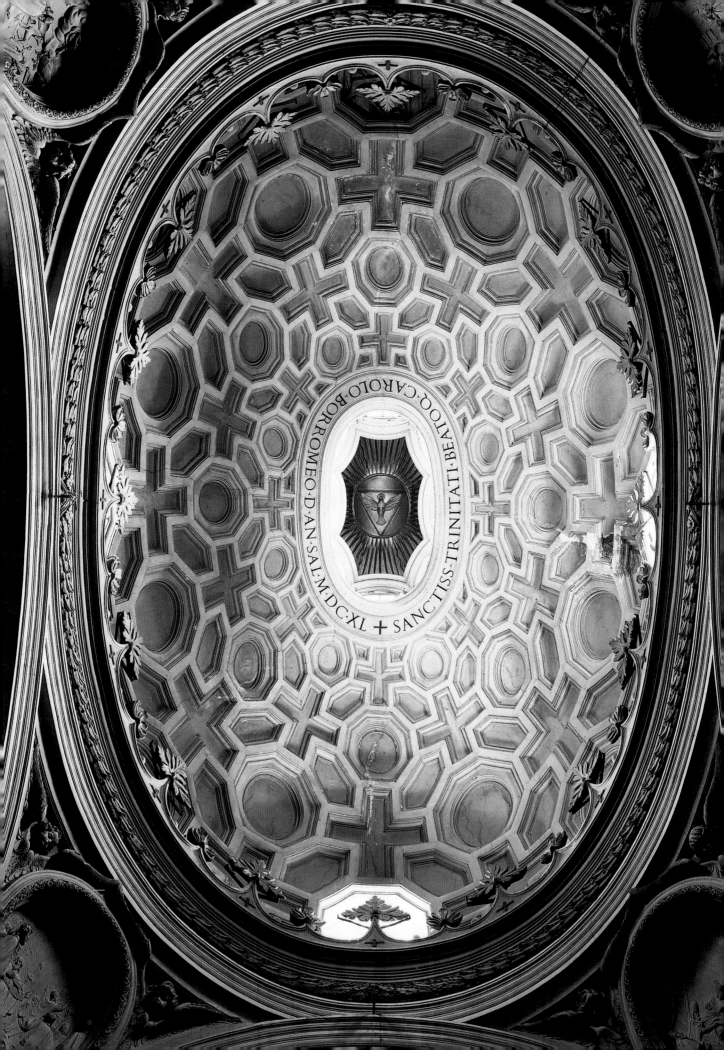

warp and woof of the wall texture. In musical terms the arrangement may be compared to the structure of a fugue.

What kind of dome could be erected over the undulating body of the church? To place the vault directly on to it in accordance with the method known from circular and oval plans (Pantheon type) would have been a possibility which Borromini, however, excluded at this stage of his development. Instead he inserted a transitional area with pendentives which allowed him to design an oval dome of unbroken curvilinear shape [52]. He used, in other words, the transitional device necessary in plans with square or rectangular crossings. The four bays under the pendentives ('c') fulfil, therefore, the function of piers in the crossings of Greek-cross plans. And, in actual fact, in the zone of the pendentives Borromini incorporated an interesting reference to the cross-arms. The shallow transverse niches as well as the deeper entrance and altar recesses are decorated with coffers which diminish rapidly in size, not only suggesting, theoretically, a depth greater than the actual one, but also containing an illusionist hint at the arms of the Greek cross. Yet this sophisticated device was meant to be conceptually rather than visually effective. Above the pendentives is the firm ring on which the oval dome rests. The dome itself is decorated with a maze of deeply incised coffers of octagonal, hexagonal, and cross shapes.[8] They produce an exciting honeycomb impression, and the crystalline sharpness of these simple geometric forms is as far removed from the classical type of coffers in Bernini's buildings [28] as from the smooth and curvilinear ones in those by Cortona [85]. The coffers decrease considerably in size towards the lantern, so that here again an illusionist device has been incorporated into the design. Light streams in not only from above through the lantern but also from below through windows in the fillings of the coffers, partly hidden from view behind the sharply chiselled ornamental ring of stylized leaves which crowns the cornice. The idea of these windows can be traced back to a similar, but typically Mannerist, arrangement in an oval church published by Serlio in his Fifth Book. Thus the dome in its shining whiteness and its even light without deep shadows seems to hover immaterially above the massive and compact forms of the space in which the beholder moves.

Borromini reconciled in this church three different structural types: the undulating lower zone, the pedigree of which points back to such late antique plans as the domed hall of the Piazza d'Oro in Hadrian's Villa near Tivoli; the intermediate zone of the pendentives deriving from the Greek-cross plan; and the oval dome which, according to tradition, should rise over a plan of the same shape. Nowadays it is difficult to appreciate fully the audacity and freedom in manipulating three generically different structures in such a way that they appear merged into an infinitely suggestive whole. With this bold step Borromini opened up entirely new vistas which were further explored later in the century in Piedmont and northern Europe rather than in Rome.

53. Francesco Borromini: Rome, S. Carlo alle Quattre Fontane, 1638–41. Façade drawing. Vienna, Albertina

The extraordinary character of Borromini's creation was immediately recognized. Upon the completion of the church the Procurator General wrote that 'in the opinion of everybody nothing similar with regard to artistic merit, caprice, excellence and singularity can be found anywhere in the world. This is testified by members of different nations who, on their arrival in Rome, try to procure plans of the church. We have been asked for them by Germans, Flemings, Frenchmen, Italians, Spaniards and even Indians . . .' The report also contains an adroit characterization of the buildings: 'Everything' – it says – 'is arranged in such manner that one part supplements the other and that the spectator is stimulated to let his eye wander about ceaselessly.'

The façade [53–5] was not erected during the early building period. It was Borromini's last work, begun in 1665 and completed in 1667, though the sculptural decoration was not finished until 1682. Although Borromini's whole career as an architect lies between the building of the church and of the façade, the discussion of the latter cannot be separated from that of the former. The system of articulation, combining a small and a giant order, derives from Michelangelo's Capitoline Palaces and the façade of St Peter's where Borromini had started work as a *scarpellino* almost fifty years before. But he employed this Michelangelesque system in an entirely new way. By repeating it in two tiers of

52. Francesco Borromini: Rome, S. Carlo alle Quattre Fontane, 1638–41. Dome

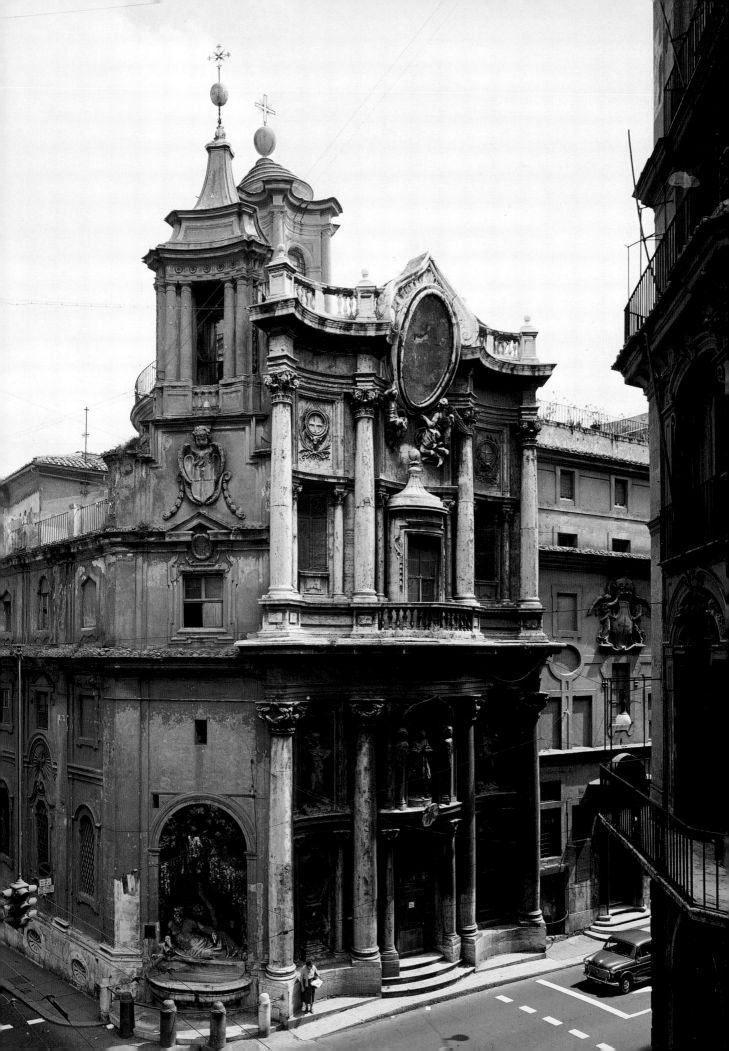

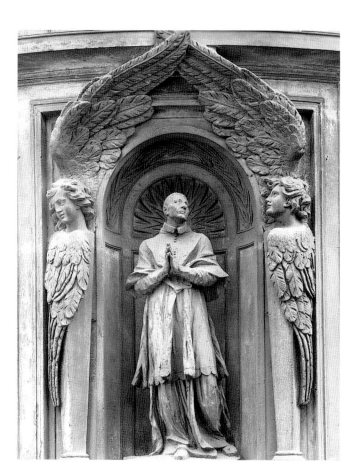

55. Detail of illustration 54, with Antonio Raggi's statue of St Charles Borromeo

56. Francesco Borromini: Rome, S. Ivo della Sapienza, 1642–50. Plan

almost equal importance, he acted against the spirit in which the system had been invented, namely to unify a front throughout its whole height. Moreover, this determined repetition was devised to serve a specific, highly original concept; in spite of the coherent articulation, the upper tier embodies an almost complete reversal of the lower one. The façade consists of three bays; below, the two concave outside bays and the convex centre bay are tied together by the strong, unbroken, undulating entablature; above, the three bays are concave and the entablature is deployed in three separate segments. In addition, the oval medallion carried by angels and capped by the onion-shaped crowning element nullifies the effect of the entablature as a horizontal barrier. Below, the small columns of the outside bays frame a wall with small oval windows and serve as support for niches with statues; above, the small columns frame niches and support enclosed wall panels – in other words, the open and closed parts have been reversed. The opening of the door in the central bay is answered above by the 'sculptural' and projecting element of the oval 'box' in which the convex movement of the façade is echoed. Finally, instead of the niche with the figure of St Charles, the upper tier has a

medallion loosely attached to the wall. The principle underlying the design is that of diversity and even polarity inside a unifying theme, and it will be noticed that the same principle ties the façade to the interior of the church. For the façade is clearly a different realization of the triad of bays which is used for the 'instrumentalization' of the interior.

The compactness of this façade, with its minimum of wall-space, closely set with columns, sculpture, and plastic decoration where the eye is nowhere allowed to rest for long, is typical of the High Baroque. Borromini also included a visionary element, characteristic of his late style. Above the entrance there are herms ending in very large, lively cherubs' heads, whose wings from a protecting arch for the figure of St Charles Borromeo in the niche [55]. In other parts of the façade, too, realistic sculptural detail supports functional architectural forms. This strange fusion of architecture and sculpture, the growth of which can be followed over a long period, is utterly opposed to the manner of Bernini, who could never divorce sculpture from narrative connotations and therefore never surrendered it to architecture.

S. Ivo della Sapienza

Almost immediately after the completion of S. Carlo alle Quattro Fontane Borromini was given a great opportunity further to develop his ideas on ecclesiastical architecture. He began the church of the Roman Archiginnasio (later the University), S. Ivo, in 1642; by 1650 most of the structure was finished. The decoration dragged on until 1660. As

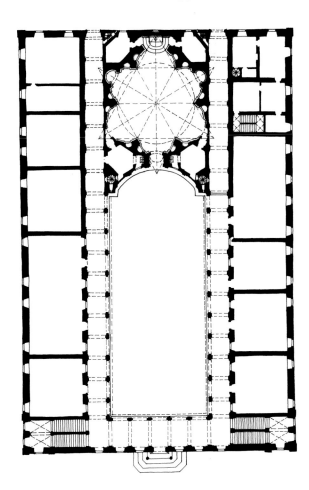

54 (opposite). Francesco Borromini: Rome, S. Carlo alle Quattro Fontane. Façade, 1665–7, completed by Bernardo Borromini, 1675–7

56. Francesco Borromini: Rome, S. Ivo della Sapienza. Plan, 1640–41. Rome, Archivio di Stato

57. Francesco Borromini: Rome, S. Ivo della Sapienza, 1642–60. Interior

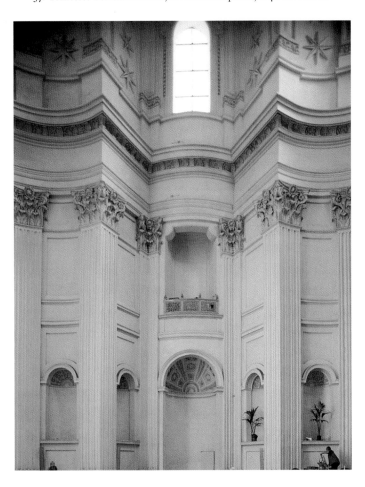

early as 1632 when work in the Palazzo Barberini was still in progress, Bernini had recommended Borromini as architect to the Sapienza.[9] He began by continuing the older south wing of the palace. The two great doors of the east wing on Piazza S. Eustachio, his most important exterior contribution, were executed much later, during Alexander VII's pontificate.

The church was to be erected at the east end of Giacomo della Porta's long, arcaded *cortile* [63]. For its plan Borromini returned once again to the basic geometry of the equilateral triangle [56, 58, 59]. But this time the triangles interpenetrate in such a way that they form a regular star-hexagon. The points of interpenetration lie on the perimeter of a circle, and by drawing straight lines from point to point a regular hexagon is formed. The semicircular recesses replacing the angles of one triangle are determined by circles with a radius of half a side of the hexagon, while the convex endings of the other triangle result from circles with the same radius and their centres in the points of the triangle.[10] Thus recesses of a concave shape and recesses with slanting walls and convex endings alternate and face each other across the space.

Before Borromini's S. Ivo, the star-hexagon was almost entirely excluded from Renaissance and post-Renaissance planning. It may have occurred in antiquity,[11] but apart from a sketch by Peruzzi in the Uffizi and Vittozzi's SS. Trinità at Turin (begun 1598) it would be difficult to name Italian precedents. Even the simple hexagon was hardly used. The reason is not difficult to guess. In contrast to the square, the octagon, and dodecagon, where equal sides confront each other in the two main axes, in the hexagon one axis goes through two sides, the other through two angles. It is therefore evident that in plans derived from the hexagon the parts can never conform, and herein lies an element of unrest or even conflict. But it must be said at once that the complexities inherent in hexagonal or star-hexagonal planning were skilfully avoided by Borromini. His method was no less than revolutionary. Instead of creating, in accordance with tradition, a hexagonal main space with lower satellite spaces placed in the angles of the triangles, he encompassed the perimeter with an uninterrupted sequence of giant pilasters impelling the spectator to register the unity and homogeneity of the entire area of the church [57]. This sensation is powerfully supported by the sharply defined crowning entablature which reveals the star form of the ground-plan in all its clarity [59]. The basic approach is, therefore, close to that in S. Carlo alle Quattro Fontane; and once again a sophisticated 'background-rhythm' constantly stimulates the beholder's curiosity. Each recess is articulated by three bays, two identical small ones framing a large one ('ACA' and 'A'BA'') [58]. But these alternating triads – equal in value though entirely different in spatial deployment – are not treated as separate or separable entities, for the two small bays across each corner (A A' or A' A) are so much alike that they counteract any tendency to perceiving real caesuras. Moreover, two other overlapping rhythms are also implied. The continuous string courses at half-height are interrupted by the central bay of the semicircular altar recess (C),[12] while the continuous string course under the capitals is not carried on across the convex bays (B). Thus two alternative groups

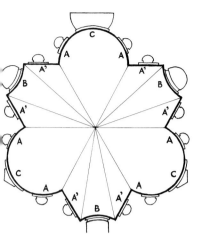

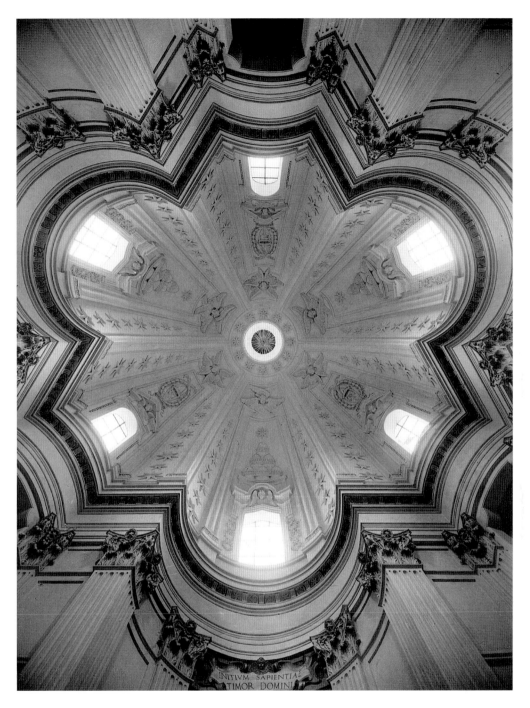

58. Francesco Borromini: Rome, S. Ivo della Sapienza, 1642–60. Plan

59. Francesco Borromini: Rome, S. Ivo della Sapienza, 1642–60. Dome

of five bays may be seen as 'super-units', either A A′ B A′ A or A′ A C A A′. It may therefore be said that the articulation contains three interlocking themes with the intervals placed at any of the three possible points: the large round-headed bays 'C', the convex bays 'B', or at the angles between the small bays 'A A′′'.

In contrast to S. Carlo alle Quattro Fontane, the dome caps the body of the church without a transitional structural feature. It continues, in fact, the star shape of the plan, each segment opening at its base into a large window. Moreover, the vertical lines of the pilasters are carried on in the gilded mouldings of the dome which repeat and accentuate the tripartite division into bays below [59]. In spite of the strong horizontal barrier of the entablature, the vertical tendencies have a terrific momentum. As the variously shaped sectors of the dome ascend, contrasts are gradually reduced until the movement comes to rest under the lantern in the pure form of the circle, which is decorated with twelve large stars. In this reduction of multiplicity to unity, of differentiation and variety to the simplicity of the circle, consists a good deal of the fascination of this church. Geometrical succinctness and inexhaustible imagination, technical skill and religious symbolism have rarely found such a reconciliation. One can trace the movement downward from the chastity of forms in the heavenly zone to the increasing complexity of the earthly zone. The decorative elements of the dome – the vertical rows of stars, the papal coat of arms above alternating windows, the cherubs under

61. Francesco Borromini: Rome, S. Ivo della Sapienza. Façade on Piazza S. Eustachio, reversed view by L. Cruyl, 1664. Amsterdam, Rijksmuseum

62. Francesco Borromini: Rome, S. Ivo della Sapienza, 1642–60. View from the courtyard

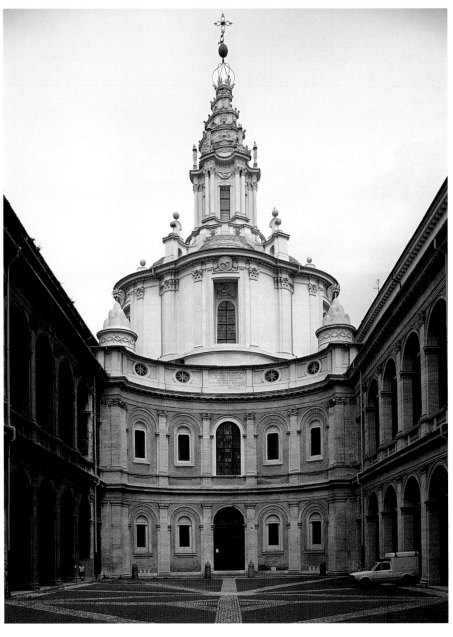

the lantern – have a fantastic, unreal, and exciting quality and speak at the same time a clear emblematical language.[13]

In continuing the shape of the ground-plan into the vaulting Borromini accepted the principle normally applied to circular and oval churches. Yet neither for the particular form of the dome nor for the decoration was there a contemporary precedent. In one way or another the customary type of the Baroque dome followed the example set by Michelangelo's dome of St Peter's. In none of the great Roman domes was the vaulted surface broken up into differently shaped units. But Borromini had classical antiquity on his side; he had surely studied such buildings as the Serapeum of Hadrian's Villa near Tivoli.[14] The dome of S. Ivo found no sequel in Rome. Again it was in Piedmont that Borromini's ideas fell on fertile ground.

The exterior of S. Ivo presented an unusual task, since the main entrance had to be placed at the far end of Giacomo della Porta's courtyard. Borromini used Porta's hemicycle with closed arcades in two tiers for the façade of the church; above it towers one of the strangest domes ever invented [61, 62]. In principle Borromini followed the North Italian tradition of encasing the dome rather than exhibiting its rising curve as had been customary in central Italy since Brunelleschi's dome of Florence Cathedral. He handled this tradition, however, in a new and entirely personal manner. His domed structure consists of four different parts: first, a high, hexagonal drum of immense weight which counters by its convex projection the concave recession of the church façade on the *cortile*. The division of each of the six equal convex sectors into two small bays and a large one prepares for the triads in the recesses of the interior. At the points where two convex sectors meet the order is strengthened; this enhances the impression of vitality and tension. Secondly, above the drum is a stepped pyramid, divided by buttress-like ribs which transfer the thrust on to the reinforced meeting-point of two sectors of the drum; thirdly, the pyramid is crowned by a lantern with double columns and concave recessions between them. The similarity to the little temple at Baalbek cannot be overlooked and has, indeed, often been stressed.[15] Above these three zones – which in spite of their entirely different character are welded together by the strong structural 'conductors' – rises a fourth element, the spiral, monolithic and sculptural, not corresponding to any interior feature or continuing directly the external movement. Yet it seems to bind together the several fields of energy which, united, soar up in a spatial movement along the spiral and are released into the lofty iron cusp. It is futile to speculate on the exact prototypes for the spiral feature. Borromini may have developed impressions of imperial Roman columns or may have had some unexpected knowledge of a ziggurat, the Babylonian-Assyrian temple towers of which a late derivation survives in the great mosque at Samarra.[16] In any case, it can hardly be doubted that this element has an emblematic meaning, the precise nature of which has not yet been rediscovered.

S. Ivo must be regarded as Borromini's masterpiece, where his style reached its zenith and where he played all the registers at his command. By comparison, his earlier and later buildings, ecclesiastical as well as domestic, often suffer through the fact that they are either unfinished or that he

was inhibited by complexities of site and the necessity to comply with existing structures.

In contrast to Bernini, who conceived architecture as the stage for a dramatic event expressed through sculpture, the drama in S. Ivo is inherent in the dynamic architectural conception itself: in the way that the motifs unfold, expand, and contract; in the way that movement surges upwards and comes to rest. Ever since Baldinucci's days it has been maintained that there is an affinity to Gothic structures in Borromini's work. There is certainly truth in the observation. His interest in the cathedral at Milan is well known, and the system of buttresses in S. Ivo proves that he found inspiration in the northern medieval rather than the contemporary Roman tradition. Remarkably medieval features may be noticed in his detail, such as the angular intersection of mouldings over the doors inside S. Ivo or the pedestal of the holy water stoup in the Oratory of S. Filippo Neri. Even more interesting is his partiality for the squinch, so common in the Romanesque and Gothic architecture of northern Italy before the Byzantine pendentive replaced it in the age of the Renaissance. But he used the squinch as a transitional element between the wall and the vault only in minor structures, such as the old sacristy of S. Carlo alle Quattro Fontane, or in certain rooms of the Palazzo Falconieri and of the Collegio di Propaganda Fide. His resuscitation of the squinch was again to find a sequel in Piedmont rather than Rome.

S. Giovanni in Laterano, S. Agnese, S. Andrea delle Fratte, and Minor Ecclesiastical Works

While S. Ivo was in course of construction three large works were entrusted to Borromini: the reconstruction of S. Giovanni in Laterano, the continuation of Rainaldi's S. Agnese in Piazza Navona, and the exterior of S. Andrea delle Fratte. A thorough restoration of S. Giovanni had become necessary since the Early Christian basilica was in danger of collapse. Borromini's work was begun in May 1646 and finished by October 1649, in time for the Holy Year.[17] His task was extremely difficult because Innocent X insisted on preserving the venerable basilica. How could one produce a modern Baroque building under these circumstances?[18] Borromini solved his problem by encasing two consecutive columns of the old church inside one broad pillar, by framing each pillar with a colossal order of pilasters throughout the whole height of the nave, and by placing a tabernacle niche of coloured marble for statuary into the face of each pillar where originally an opening between two columns had been [63]. The alternation of pillars and open arches created a basic rhythm well known since Bramante's and even Alberti's days. Borromini, however, not only carried it across the corners of the entrance wall, thereby transforming the nave into an enclosed space, but introduced another rhythm which reverses the primary one. The spectator perceives simultaneously the continuous sequence of the high bays of the pillars and the low arches (A b A b A . . .) as well as that of the low tabernacles and the high arches (a B a B a . . .). Moreover, this second rhythm has an important chromatic and spatial quality, for the cream-coloured arches – 'openings' of the wall – are contrasted by the dark-coloured

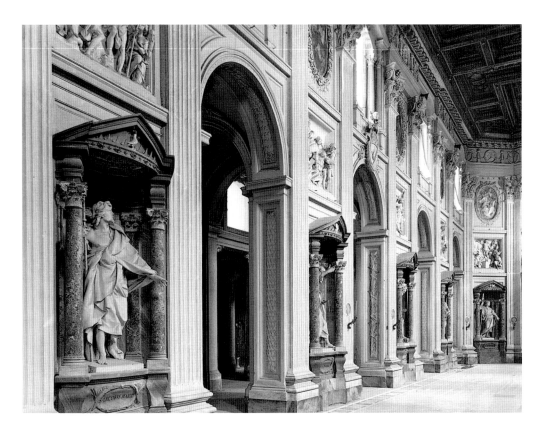

63. Francesco Borromini: Rome, S. Giovanni in Laterano. Nave, 1646–9

64. Francesco Borromini: Rome, S. Agnese in Piazza Navona, begun by Girolamo and Carlo Rainaldi in 1652. Section

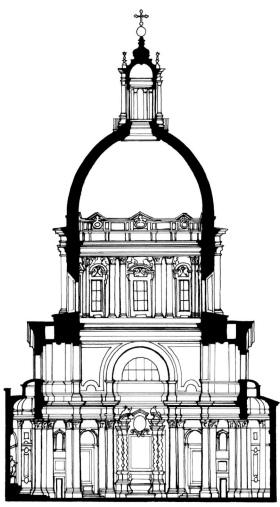

tabernacles, which break through the plane of the wall and project into the nave.

It has recently been ascertained[19] that Borromini intended to vault the nave. The present arrangement, which preserved Daniele da Volterra's heavy wooden ceiling (1564–72), must be regarded as provisional, but after the Holy Year there was no hope of continuing this costly enterprise. The articulation of the nave would have found its logical continuation in the vault, which always formed an integral part of Borromini's structures. If the execution of his scheme thus remained a fragment, he was yet given ample scope for displaying his skill as a decorator. The naturalistic palm branches in the sunken panels of the pilasters of the aisles, the lively floral ornament of the oval frames in the clerestory, the putti and cherubim forming part of the architectural design as in Late Gothic churches, and, above all, the re-arrangement in the new aisles during Alexander VII's pontificate of the old tombs and monuments of popes, cardinals, and bishops – all this shows an inexhaustible wealth of original ideas and an uninhibited imagination. Although contemporaries regarded the settings of these monuments as a veritable storehouse of capriccios,[20] they are far from unsuitable for the purpose for which they were designed – on the contrary, each of the venerable relics of the past is placed into its own kind of treasure-chest, beautifully adapted to its peculiar character. It is typical of Borromini's manner that in these decorations realistic features and floral and vegetable motifs of dewy freshness merge with the sharp and crystalline architectural forms.[21]

If in S. Giovanni in Laterano Borromini had to renounce completion of his design, the handicap in S. Agnese in

65. Francesco Borromini: Rome, S. Agnese in Piazza Navona, begun by Girolamo and Carlo Rainaldi in 1652. Plan and interior

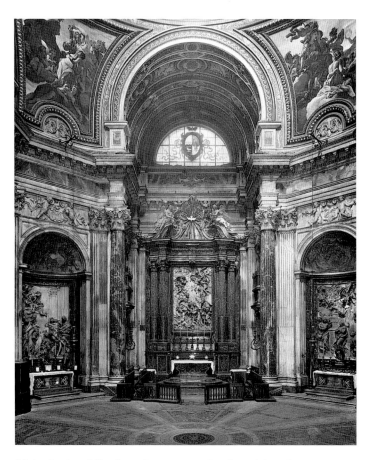

Piazza Navona was of a different nature. Pope Innocent X wanted to turn the square on which his family palace was situated into the grandest in Rome; it was to be dominated by the new church of S. Agnese to replace an older one close to the palace. Carlo Rainaldi, in collaboration with his father Girolamo, had been commissioned to build the new structure, the foundation stone of which was laid on 15 August 1652.[22] The Rainaldis designed a Greek-cross plan with short arms and pillars at the crossing with broad bevels which were opened into large niches framed by recessed columns. While the idea of the pillars with niches derived from St Peter's, the model for the recessed columns was Cortona's SS. Martina e Luca. The building went up in accordance with this design, but soon criticism was voiced, particularly as regards the planned staircase, which extended too far into the piazza. A crisis became unavoidable, the Rainaldis were dismissed, and on 7 August 1653 Borromini was appointed in their place.

To all intents and purposes he had to continue building in accordance with the Rainaldi plan, for the pillars of the crossing were standing to the height of the niches. Yet by seemingly minor alterations he changed the character of the design. Above all, he abolished the recesses prepared for the columns and bevelled the pillars so that the columns look as if they were detached from the wall [64].[23] By this device the beholder is made to believe that the pillars and the cross arms have almost equal width. The crossing, therefore, appears to the eye as a regular octagon; this is accentuated by the sculptural element of the all but free-standing columns [65]. Colour contrasts sustain this impression, for the body of the church is white (with the exception of the

high altar), while the columns are of red marble. Moreover, an intense verticalism is suggested by virtue of the projecting entablature above the columns, unifying the arch with the supporting columns; and the high attic above the entablature, which appears under the crossing like a pedestal to the arch,[24] increases the vertical movement. It will now be seen that the octagonal space – also echoed in the design of the floor – is encompassed by the coherent rhythm of the alternating low bays of the pillars framed by pilasters and the high 'bays' of the cross-arms framed by the columns. By giving the cross-arms a length much greater than that intended by Rainaldi, Borromini created a piquant tension between them and the central area. Thus a characteristically Borrominesque structure was erected over Rainaldi's traditional plan. Nor did the latter envisage a building of exceptionally high and slender design. Borromini further amplified the vertical tendencies by incorporating into his design an extraordinarily high drum and an elevated curve for the dome – which obviously adds to the importance of the area under the crossing [64]. Rainaldi, by contrast, had planned to blend a low drum with a broad, rather unwieldy dome.

In spite of the difficulties which Borromini had to face in the interior, he accomplished an almost incredible transformation of Rainaldi's project. In the handling of the exterior [66] he was less handicapped. The little that was standing of Rainaldi's façade was pulled down. By abandoning the vestibule planned by the latter, he could set the façade further back from the square and design it over a concave plan. In Rainaldi's project the insipid crowning features at both ends of the façade were entirely overshadowed by the weight

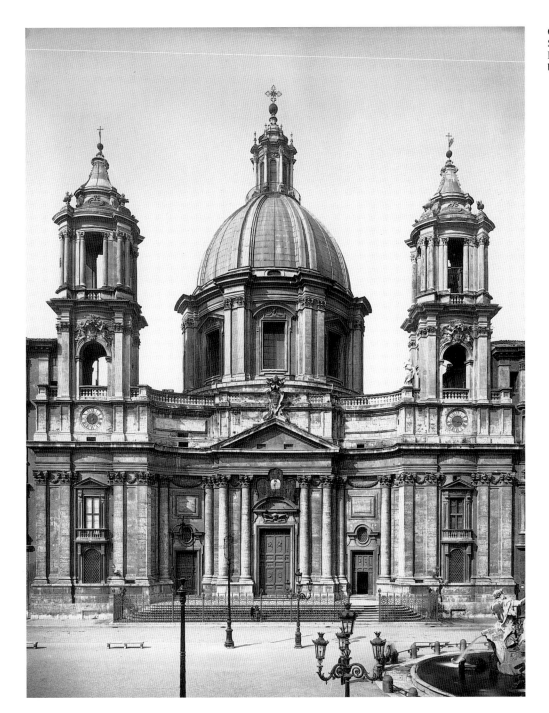

66. Francesco Borromini: Rome, S. Agnese in Piazza Navona. Façade, 1653–5, completed 1666 by other hands

of the dome. Borromini extended the width of the façade into the area of the adjoining palaces, thus creating space for freely rising towers of impressive height. But he was prevented from completing the execution of his design. After Innocent X's death on 7 January 1655, building activity stopped. Soon difficulties arose between Borromini and Prince Camillo Pamphili, and two years later Carlo Rainaldi in turn replaced Borromini. Assisted by Giovanni Maria Baratta and Antonio del Grande, Carlo proceeded to alter those parts which had not been finished: the interior decoration, the lantern of the dome, the towers, and the façade above the entablature. The high attic over the façade, the triangular pediment in the centre, and certain simplifications in the design of the towers are contrary to Borromini's

intentions.[25] But, strangely enough, the exterior looks more Borrominesque than the interior. For in the interior the rich gilt stuccoes, the large marble reliefs – a veritable school of Roman High Baroque sculpture – Gaulli's and Ciro Ferri's frescoes in the pendentives and dome: all this tends to conceal the Borrominesque quality of the structure.[26] Completion dragged on for many years. The towers went up in 1666; interior stuccoes were still being paid for in 1670, and the frescoes of the dome were not finished until the end of the century.

In defiance of the limitations imposed upon Borromini, S. Agnese occupies a unique position in the history of Baroque architecture. The church must be regarded as the High Baroque revision of the centralized plan for St Peter's. The

67. Francesco Borromini: Rome, S. Andrea delle Fratte. Dome, plan, 1652. Vienna, Albertina

68. Francesco Borromini: Rome, S. Andrea delle Fratte. Dome and campanile, 1653–65

dome of S. Agnese has a distinct place in a long line of domes dependent on Michelangelo's creation (III: p. 45). From the late sixteenth century onwards may be observed a progressive reduction of mass and weight, a heightening of the drum at the expense of the vault, and a growing elegance of the sky-line. All this reached a kind of finality in the dome of S. Agnese. Moreover, from a viewpoint opposite the entrance the dome seems to form part of the façade, dominates it, and is firmly connected with it, since the double columns at both sides of the entrance are continued in the pilasters of the drum and the ribs of the vault. Circumstances prevented the dome of St Peter's from appearing between two framing towers. The idea found fulfilment in S. Agnese; here dome and towers form a grand unit, perfectly balanced in scale. Never before had it been possible for a beholder to view at a glance such a rich and varied group of towers and dome while at the same time experiencing the spell of the intense spatial suggestions: he feels himself drawn into the cavity of the façade, above which looms the concave mass of the drum. Nobody can overlook the fact that Borromini, although he employed the traditional grammar of motifs, repeated here the spatial reversal of the façade of S. Ivo.

Probably in the same year, 1653, in which he took over S. Agnese from Rainaldi, Borromini was commissioned by the Marchese Paolo Bufalo to finish the church of S. Andrea delle Fratte which Gaspare Guerra had begun in 1605. Although Borromini was engaged on this work until 1665, he had to abandon it in a fragmentary state. The transept, dome, and choir which he added to the conventional interior reveal little of his personal style. Much more important is his contribution to the unfinished exterior [68]. It is his extraordinary dome and tower, designed to be seen as one descends from Via Capo le Case, that give the otherwise insignificant church a unique distinction. Similar to S. Ivo, the curve of the dome is encompassed by a drumlike casing. But here four widely projecting buttresses just out diagonally from the actual body of the 'drum'. In this way four equal faces are created, each consisting of a large convex bay of the 'drum' and narrower concave bays of the buttresses [67]. The plan of each face is therefore similar to the lower tier of the façade of S. Carlo alle Quattro Fontane. Once again Borromini worked with spatial evolutions of rhythmic triads, and once again a monumental order of composite

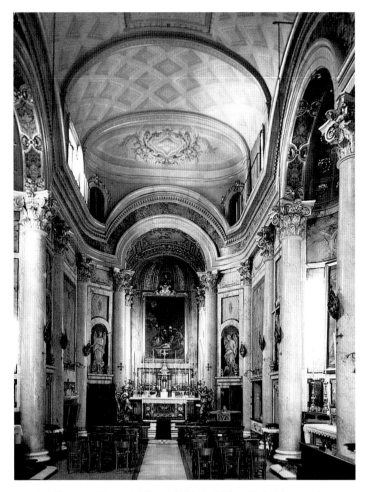

69. Francesco Borromini: Rome, S. Maria dei Sette Dolori, begun 1642–3. Interior

70 and 71. Francesco Borromini: Rome, Collegio di Propaganda Fide, 1662–4. Interior and vaulting of the Re Magi Chapel

columns placed at the salient points ensures the unbroken coherence of the design. This extraordinary structure was to be crowned by a lantern – which unfortunately remained on paper – with concave recesses above the convex walls underneath. Without this lantern the spatial intentions embodied in Borromini's design cannot be fully gauged.[27]

The tower, rising in the north-east corner next to the choir, was conceived as a deliberate contrast to the dome. Its three tiers form completely separate units. While the lowest is solid and square with diagonally-projecting columned corners, the second is open and circular and follows the model of ancient monopteral temples. By topping this feature with a disproportionately heavy balustrade the circular movement is given an emphatic, compelling quality. In the third tier the circular form is broken up into double herms with deep concave recesses between them – a new and more intensely modelled version of the lantern of S. Ivo. While full-blooded cherubs function as caryatids, their wings enfold the stems of the herms. At this late stage of his development Borromini liked to soften the precise lines of architecture by the swelling forms of sculpture, and the cherub-herm, an invention of his far removed from any classical models, fascinated him in this context.[28] The uppermost element of the tower consists of four inverted scrolls of beautiful elasticity; on them a crown with sharply pointed spikes balances precariously: the whole a triumph of complex spatial relationships and a bizarre *concetto* by which the top of the tower is wedded to the sky and the air. Thus the

flexible but homogeneous massive bulk of the dome is a foil for the small scale of the tower with its emphasis on minute detail (capitals of the monopteros!) and its radical division into contrasting shapes.[29]

Among Borromini's lesser ecclesiastical works two churches may be singled out for special consideration: S. Maria dei Sette Dolori and the Church of the Collegio di Propaganda Fide. In both cases the church lies at right angles to the façade, and both churches are erected over simple rectangular plans with bevelled or rounded corners. S. Maria dei Sette Dolori was begun in 1642–3 and left unfinished in 1646.[30] The exterior is an impressive mass of raw bricks and only the rather weak portal was executed in stone, but not from Borromini's design. The interior is articulated by an imposing sequence of columns arranged in triads between the larger intervals of the two main axes, which are bridged by arches rising from the uninterrupted cornice [69].[31] In spite of the difference in plan, S. Maria dei Sette Dolori is in a sense a simplified version of S. Carlo alle Quattro Fontane.[32] But above the cornice the comparison does not hold. Here there is a low clerestory and a coved vault divided by ribs, linking a pair of columns across the room.[33] This arrangement contained potentialities which were later further developed in the church of the Propaganda Fide.

In 1646 Borromini was appointed architect to the Collegio di Propaganda Fide. But it was not until 1662 that the church behind the west front of the palace was in course

of construction. Two years later it was finished, with the exception of the decoration.[34] At first Borromini planned to preserve the oval church built by Bernini in 1634. When it was decided to enlarge it, he significantly preferred the simple hall type in analogy to S. Maria dei Sette Dolori and the even earlier Oratory of St Philip Neri. But the changes in design are equally illuminating. The clerestory of S. Maria dei Sette Dolori was similar to that of the Oratory. By contrast, the church of the Propaganda Fide embodies a radical revision of those earlier structures [70]. The articulation consists here of a large and small order, derived from the Capitoline palaces. The large pilasters accentuate the division of the perimeter of the church into alternating wide and narrow bays, while the cornice of the large order and the entablature of the small order on which the windows rest function as elements unifying the entire space horizontally. Different from S. Maria dei Sette Dolori, the verticalism of the large order is continued through the isolated pieces of the entablature into the coved vaulting and is taken up by the ribs, which link the centres of the long walls with the four corners diagonally across the ceiling [71]. Thus an unbroken system closely ties together all parts of the building in all directions. The coherent 'skeleton'-structure has become all-important – hardly any walls remain between the

tall pilasters! – and to it even the dome has been sacrificed. The oval project, which would have required a dome, could not have embodied a similar system. No post-Renaissance building in Italy had come so close to Gothic structural principles. For thirty years Borromini had been groping in this direction. The church of the Propaganda Fide was, indeed, a new and exciting solution, and its compelling simplicity and logic fittingly conclude Borromini's activity in the field of ecclesiastical architecture.[35]

The Oratory of St Philip Neri

The brethren of the Congregation of St Philip Neri had for a considerable time planned to build an oratory next to their church of S. Maria in Vallicella. In conjunction with this idea, plans ripened to include in the building programme a refectory, a sacristy, living quarters for the members of the Congregation, and a large library. This considerable programme was, in fact, not very different from that of a large monastery. The Congregation finally opened a competition which Borromini won in May 1637 against, among others, Paolo Maruscelli, the architect of the Congregation. Borromini replaced him forthwith and held the office for the next thirteen years. Building activity was rapid: in 1640 the

72 and 73. Francesco Borromini: Rome, Oratory of St Philip Neri. Façade, 1637–40, and plan

oratory was in use; in 1641 the refectory was finished, between 1642 and 1643 the library above the oratory was built and between 1644 and 1650 the north-west front with the clock-tower overlooking the Piazza dell'Orologio.[36] Thus the building of the oratory coincided with that of S. Carlo alle Quattro Fontane. But although the work for the Oratorians was infinitely more important than that of the little church, as regards compactness and vitality the former cannot compete with the latter. This verdict does not, of course, refer to the brilliant façade of the oratory [72], nor do we overlook the fact that many new and ingenious ideas were brought to fruition in the buildings of the monastery.

Maruscelli, before Borromini, had already solved an intricate problem: he had designed a coherent layout for the whole area with long axes and a clear and logical disposition of the sacristy and the courtyards. Borromini accepted the essentials of this plan, which also included the placing of the oratory itself in the western (left) half of the main wing. Many refinements were introduced there by Borromini, but it must suffice to mention that, contrary to Maruscelli's intentions, he created for the eye, rather than in actual fact, a central axis to the entire front between S. Maria in Vallicella and the Via de' Filippini [73]. The organization of this front is entirely independent of the dispo-

that has been noticed, one will also find it compellingly logical that the important centre and the accompanying bays are not capped by a uniform pediment. The latter, in addition to suggesting a differentiated triple rhythm, also pulls together the three inner bays, which are segregated from the outer bays by a slight projection and an additional half-pilaster. Without breaking up the unity of the five bays, a triad of bays is yet singled out, and the pediment reinforces the indications contained in the façade itself. The treatment of detail further enriches the complexities of the general arrangement. Attention may be drawn to the niches below, which cast deep shadows and give the wall depth and volume; to the windows above them, which with their pediments press energetically against the frieze of the entablature; and to the windows of the second tier, which have ample space over and under them.[38]

The interior of the oratory, carefully adapted to the needs of the Congregation, is articulated by half-columns on the altar wall and a complicated rhythm of pilasters along the other three walls [74].[39] Michelangelo's Capitoline palaces evidently gave rise to the use of the giant order of pilasters in the two courtyards. It is worth recalling that Palladio had

74. Francesco Borromini: Rome, Oratory of St Philip Neri, 1637–40. Section by an anonymous draftsman. Rome, Archivio de S. Maria in Vallicella

sitions behind it. The central entrance does not lead straight into the oratory which lies at right angles to it and extends beyond the elaborate part of the façade, nor is the plan of the whole area symmetrical in depth, as a glance at the façade might suggest.[37]

Although the façade is reminiscent of that of a church, its rows of domestic windows seem to contradict this impression. This somewhat hybrid character indicates that Borromini deliberately designed it as an 'overture' for the oratory as much as for the whole monastery. By request of the Congregation the façade was not faced in stone so that it would not compete with the adjoining church of S. Maria in Vallicella. Borromini, therefore, developed a new and extremely subtle brick technique of classical ancestry, a technique which allowed for finest gradations and absolute precision of detail. The main portion of the façade consists of five bays, closely set with pilasters, arranged over a concave plan. But the central bay of the lower tier is curved outward, while that of the upper tier opens into a niche of considerable depth. Crowning the façade rises the mighty pediment which, for the first time, combines curvilinear and angular movement. The segmental part answers the rising line of the cornice above the bays, which are attached like wings to the main body of the façade, and the change of movement, comparable to an interrupted S-curve, echoes, as it were, the contrasting spatial movement of the central bays in the elevation. The form of the pediment is further conditioned by the vertical tendencies in the façade. Once

75. Francesco Borromini: Rome, Palazzo Falconieri, ceiling, 1649

introduced a giant order in the *cortile* of the Palazzo Porto-Colleoni at Vicenza (1552); but, although Borromini's simple and great forms seem superficially close to Palladio's classicism, the ultimate intentions of the two masters are utterly different. Palladio is always concerned with intrinsically plastic architectural members in their own right, while Borromini stresses the integral character of a coherent dynamic system. Thus in Borromini's courtyards the large pilasters would appear to screen an uninterrupted sequence of buttresses. This interpretation is supported by the treatment of the corners.

Renaissance architects had more often than not evaded facing squarely a problem which was inherent in the use of the classical grammar of forms. The half-pilasters, quarter-pilasters, and other expedients, which abruptly break the continuity of articulation in the corners of Renaissance buildings, must be regarded as naive compromise solutions. Mannerist architects who fully understood the problem not infrequently carried on the wall decoration across the corners, thereby neutralizing the latter and at the same time producing a deliberate ambiguity between the uninterrupted decoration and the change in the direction of the walls. Borromini abolished the cause for compromise or ambiguity by eliminating the corners themselves. By rounding them off, he made the unity of the space-enclosing structural elements, and implicitly of the space itself, apparent. In the two courtyards of the Filippini he applied to an external space the same principle that Palladio had used in a

comparatively embryonic manner in the interior of the Redentore.[40] This new solution soon became the property of the whole of Europe.

In contrast to the elaborate south façade, Borromini used very simple motifs for the long western and northern fronts of the convent: bank-like string courses divide the storeys and large horizontal and vertical grooves replace the cornices and corners.[41] From then on this type of design became generally accepted for utilitarian purposes in cases where no elaborate decoration was required.

Domestic Buildings

Between about 1635 and the end of his career Borromini had a hand in a great number of domestic buildings of importance, though it must be said that no palace was entirely carried out by him. At the beginning stands his work in the Palazzo Spada, where he was responsible for the erection of the garden wall, for various decorative parts inside the palace and, above all, for the well-known illusionist colonnade which appears to be very long, but is, in fact, extremely short. The idea seems to be derived from the stage (Teatro Olimpico). But one should not forget that it also had a respectable Renaissance pedigree. Bramante applied the same illusionist principle to his choir of S. Maria presso S. Satiro at Milan, which must have belonged to Borromini's earliest impressions. The concept of the Spada colonnade is, therefore, neither characteristically Baroque nor is it of more than marginal interest in Borromini's work. To over-emphasize its significance, as is often done by those who regard the Baroque mainly as a style concerned with optical illusion, leads entirely astray.[42]

Between 1646 and 1649 followed the work for the Palazzo Falconieri, where Borromini extended a mid-sixteenth-century front from seven to eleven bays.[42a] He framed the façade with huge herms ending in falcons' heads, an emblematic conceit which had no precedent. He added new wings on the rear facing the river and provided decoration for porch and vestibule. But his most signal contribution is the twelve ceilings with their elaborate floral ornament [75],[43] and, overlooking the courtyard, the Palladian loggia, equally remarkable for its derivation and for its deviation from Palladio's Basilica at Vicenza.[44] The U-shaped river front, dominated by the loggia, gives proof of the versatility of Borromini's extraordinary genius [76]. His problem consisted in welding old and new parts together into a new unit of a specifically Borrominesque character. He solved it by progressively increasing the height of the four storeys in defiance of long established rules and by reversing the traditional gradation of the orders. The ground floor is subdivided by simple broad bands; in the next storey the same motif is given stronger relief; the third storey has Ionic pilasters; and above these are the recessed columns of the loggia. Thus instead of diminishing from the ground floor upwards, the wall divisions grow in importance and plasticity. Only in the context of the whole façade is the unconventional and anti-classical quality of the loggia motif fully revealed.

Between 1646 and 1647 Borromini helped in an advisory capacity the aged Girolamo Rainaldi, whom Innocent X had

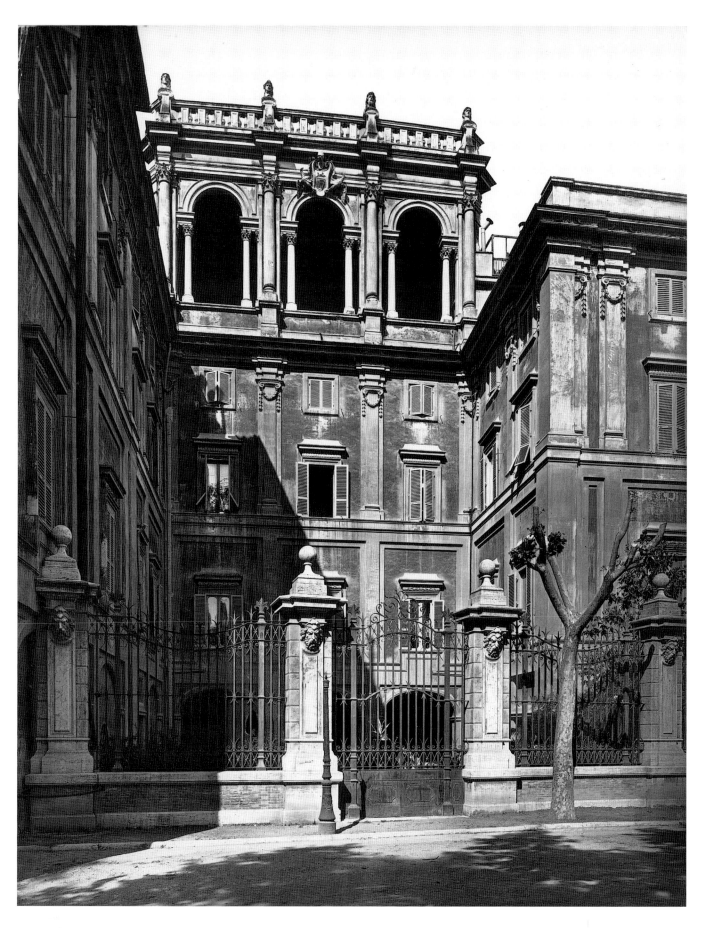

76. Francesco Borromini: Rome, Palazzo Falconieri, 1646–9. River front

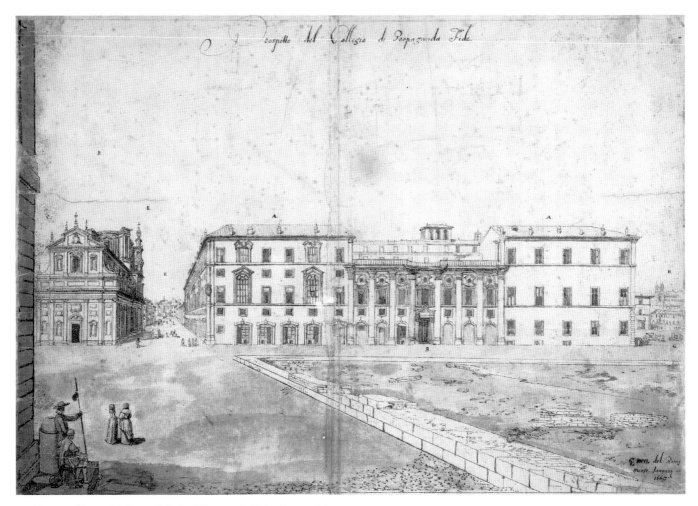

77. Francesco Borromini: Rome, Collegio di Propaganda Fide 1662–5 and S. Andrea delle Fratte, 1653–65. Reversed view by L. Cruyl, 1665. Cleveland Museum of Art

commissioned to build the extensive Palazzo Pamphili in Piazza Navona. Borromini had a tangible influence on the design, although his own plan was not accepted for execution.[45] He alone was, however, responsible for the decoration of the large salone and the building of the gallery to the right of S. Agnese, on a site which originally formed part of the Palazzo Mellini. Inside the gallery, to which Pietro da Cortona contributed the frescoes from the *Aeneid*, are to be found some of the most characteristic and brilliant door surrounds of Borromini's later style. Of his designs for the palace of Count Ambrogio Carpegna near the Fontana Trevi very little was executed,[46] but a series of daring plans survive which anticipate the eighteenth-century development of the Italian palazzo. Borromini took up all the major problems where they were left in the Palazzo Barberini and carried them much further, such as the axial alignment of the various parts of the building, the connexion of a grand vestibule with the staircase hall, and the merging of vestibule and oval courtyard. The latest drawing of the series shows two flights of stairs ascending along the perimeter of the oval courtyard and meeting on a common landing – a bold idea, heretofore unknown in Italy which was taken up and executed by Guarini in the Palazzo Carignano at Turin.[47]

Between 1659 and 1661 Borromini was concerned with the systematization of two libraries, the Bibioteca Angelica adjoining Piazza S. Agostino and the Biblioteca Alessandrina in the north wing of the Sapienza. Of the plans for the former hardly anything was carried out, but the latter survives as Borromini had designed it. The great hall of the library is three storeys high, and the book-cases form a constituent part of the architecture. This was a new and important idea, which he had not yet conceived when he built the library above the Oratory of St Philip Neri about twenty years earlier. It was precisely this new conception which made the Biblioteca Alessandrina the prototype of the great eighteenth-century libraries.

The Collegio di Propaganda Fide

Borromini's last great palace, surpassing anything he did in that class with the exception of the convent of the Oratorians, was the Collegio di Propaganda Fide. His activity for the Jesuits spread over the long period of twenty-one years, from his appointment as architect in 1646 to his death in 1667. At that time the Jesuits were at the zenith of their power, and a centre in keeping with the world-wide importance of the Order was an urgent requirement. They owned the vast site between Via Capo le Case, Via Due Macelli, and

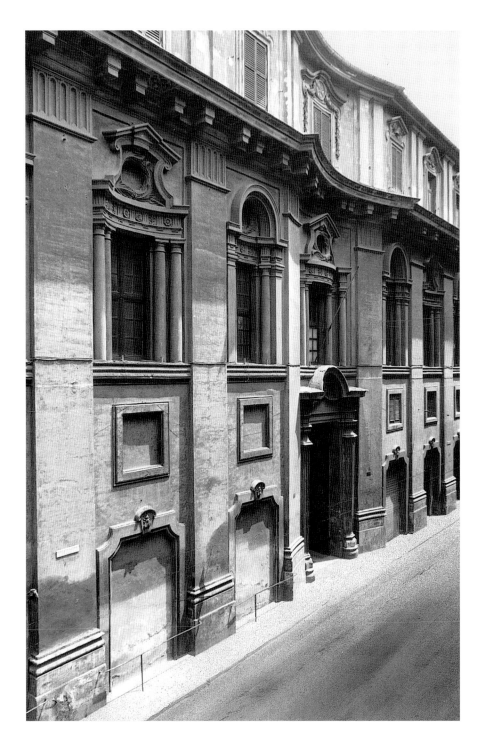

78. Francesco Borromini: Rome, Collegio di
Propaganda Fide. Façade, 1662

Piazza di Spagna, which, though large enough for all their
needs, was so badly cut that no regular architectural devel-
opment was possible. Moreover, some fairly recent buildings
were already standing, among them Bernini's moderniza-
tion of the old façade facing Piazza di Spagna and his oval
church which was, however, as we have seen, replaced by
Borromini. As early as 7 May 1647 Borromini submitted a
development plan for the whole site; but little happened in
the course of the next thirteen years. It is known that
Borromini gave the main façade in front of the church its
final shape in 1662, and the other much simpler façades also
show characteristics of his latest manner. The execution of
the major part of the palace would therefore seem to have

taken place in the last years of his life. Part of the palace was
reserved for administrative purposes, another large part
contained the cells for the alumni. But very little of
Borromini's interior arrangement and decoration survives;
in fact, apart from the church, only one original room seems
to have been preserved.

All the more important are the façades [77]. The most
elaborate portion rises in the narrow Via di Propaganda
where its oppressive weight produces an almost nightmarish
effect [78, 79]. Borromini's problem was here similar to that
of the oratory, for the façade was to serve the dual purpose
of church and palace. Once again the long axis of the church
lies parallel with the street and extends beyond the highly

79. Francesco Borromini: Rome, Collegio di Propaganda Fide. Centre bay, 1662

decorated part of the façade, but in contrast to the oratory this front has a definite, though entirely unusual, palace character. Its seven bays are articulated by a giant order of pilasters which rise from the ground to the sharply-projecting cornice.[48] Everything here is unorthodox: the capitals are reduced to a few parallel grooves, the cornice is without a frieze, and the projecting pair of brackets over the capitals seem to belong to the latter rather than to the cornice. The central bay recedes over a segmental plan [79], and the contrast between the straight lines of the façade and the inward curve is surprising and alarming. No less startling is the juxtaposition of the austere lower tier and the *piano nobile* with its extremely rich window decoration. The windows rise without transition from the energetically drawn string course and seem to be compressed into the narrow space between the giant pilasters.

It is here that the active life in the wall itself is revealed. All the window frames curve inwards with the exception of the central one which, being convex, reverses the concave shape of the whole bay. The movement of the window frames is not dictated simply by a desire for picturesque variety but consists like a fugue of theme, answer, and vari-

ations. The theme is given in the door and window pediments of the central bay; the identical windows of the first, third, fifth, and seventh bays are variations of the door motif while the identical second and sixth windows answer the central window, also spatially. In the windows of the attic above the cornice[49] the theme of the *piano nobile* is repeated in another key: the first, third, fifth, and seventh windows are simpler variations of the second and sixth below, and the windows in the even bays of the attic vary those in the uneven ones underneath. Finally, in the undulating pediment of the fourth attic window the two movements are reconciled. By such means Borromini created a palazzo front which has neither precursors nor successors.

In the south-western and southern façades only the ground-floor arrangement and the division of the storeys was continued, which assured the unity of the entire design. Otherwise Borromini contrasted these fronts with the intensely articulated main façade. There is no division into bays by orders, nor are the windows decorated. But their sequence is interrupted at regular intervals by strong vertical accentuations. At these points Borromini united the main and mezzanine windows of the *piano nobile* under one large frame, creating a window which goes through the entire height of the tier. The boldly projecting angular pediment seems to cut into the string course of the next storey, where the framework of the window with its gently curved pediment and concave recession shows a characteristic reversal of mood.

A comparison of the façades of the Oratory and the Collegio illustrates the deep change between Borromini's early and late style. Gone is a mass of detail, gone the subtle gradations of wall surface and mouldings and the almost joyful display of a great variety of motifs. However, the impression of mass and weight has grown immensely; the windows now seem to dig themselves into the depth of the wall. And yet the basic approach hardly differed.

To summarize Borromini's life-long endeavour, it may be said that he never tired in his attempt to mould space and mass by means of the evolution and transformation of key motifs. He subordinated each structure down to the minutest detail to a dominating geometrical concept, which led him away from the Renaissance method of planning in terms of mass and modules towards an emphasis on the functionally, dynamically, and rhythmically decisive 'skeleton'. This brought him close to the structural principles of the Gothic style and enabled him, at the same time, to incorporate into his work what suited his purpose: Mannerist features of the immediate past, many ideas from Michelangelo's architecture and that of Hellenism, both equally admired by him, and even severely classical elements which he found in Palladio. Being an Italian, Borromini could not deny altogether the anthropomorphic basis of architecture. This becomes increasingly apparent during his advancing years from the stress he laid on the blending of architecture and sculpture. Nevertheless, the antagonism between him and Bernini remained unbridgeable. It was in Bernini's circle that he was reproached for having destroyed the accepted conventions of good architecture.

Pietro da Cortona (1596–1669)

INTRODUCTION

The genius of Pietro Berrettini, usually called Pietro da Cortona, was second only to that of Bernini. Like him he was architect, painter, decorator, and designer of tombs and sculpture although not a sculptor himself. His achievements in all these fields must be ranked among the most outstanding of the seventeenth century. Bernini and Borromini have been given back the position of eminence which is their due. Not so Cortona. When this book first appeared in 1958 no critical modern biography had been devoted to him; G. Briganti's work[1] has now at least partially satisfied this need. To be sure, Cortona's is the third name of the great trio of Roman High Baroque artists, and his work represents a new and entirely personal aspect of the style.

An almost exact contemporary of Bernini and Borromini, he was born at Cortona on 1 November 1956 of a family of artisans. He probably studied under his father, a stonemason, before being apprenticed to the undistinguished Florentine painter Andrea Commodi,[2] with whom he went to Rome in 1612 or 1613. He stayed on after Commodi's return to Florence in 1614 and changed over to the studio of the equally unimportant Florentine painter Baccio Ciarpi.[3] According to his biographer Passeri he studied Raphael and the antique with great devotion during these years; while this is, of course, true of every seventeenth-century artist, in Cortona's case such training has more than usual relevance since he could not profit very much from his teachers. His copy of Raphael's *Galatea*[4] impressed Marcello Sacchetti so much that he took to the young artist who, from 1623 onwards, belonged to the Sacchetti household. It was in the service of the Sacchetti family that Cortona gave early proof of his genius as painter and architect. In the Palazzo Sacchetti he also met the Cavaliere Marino, fresh from Paris,[5] and Cardinal Francesco Barberini, Urban VIII's nephew, who became his lifelong patron; through him he obtained his early important commission as a fresco painter in S. Bibiana. At the same time he was taken on by Cassiano del Pozzo, the learned secretary to Cardinal Francesco Barberini, who employed in these years a number of young and promising artists for his collection of copies of all the remains of antiquity.[6] Thus Cortona was over twenty-six years old when his contact with the 'right' circle carried him quickly to success and prominence. As to his early development, relatively little has so far come to light.[7] More discoveries will be made in the future, but it will remain a fact of some significance that, whereas we can follow the unfolding of Bernini's talent year by year from his precocious beginnings, in Cortona we are almost suddenly faced with a distinctly individual manner in painting and, even more astonishingly, in architecture, though his training in this field can have been only rather superficial.[8]

From about the mid twenties his career can be fully gauged. From then until his death he had large architectural and pictorial commissions simultaneously in hand – he being the only seventeenth-century artist capable of such a *tour de force*. During the 1630s, with SS. Martina e Luca rising [87] and the Barberini ceiling in progress [96], he reached the zenith of his artistic power and fame, and his colleagues acknowledged his distinction by electing him *principe* of the Accademia di San Luca for four years (1634–8). Between 1641 and 1647 he stayed in Florence painting and decorating four rooms of the Palazzo Pitti, but the architectural projects of this period remained on paper. Back in Rome, his most extensive fresco commission, the decoration of the Chiesa Nuova [100], occupied him intermittently for almost twenty years. During one of the intervals he painted the gallery of the Palazzo Pamphili in Piazza Navona (1651–4); the erection of the façade of S. Maria della Pace is contemporaneous with the frescoes in the apse of the Chiesa Nuova, that of the façade of S. Maria in Via Lata with the frescoes of the pendentives, that of the dome of S. Carlo al Corso follows three years after the frescoes of the nave. Even if it were correct, as has more than once been maintained, that the quality of his late frescoes shows a marked decline,[9] the same is certainly not true of his late architectural works. In any case, his architectural and pictorial conceptions show a parallel development, away from the exuberant style of the 1630s towards a sober, relatively classicizing idiom to which he aspired more and more from the 1650s onwards.

ARCHITECTURE

The Early Works

Before he began the church of SS. Martina e Luca, Cortona executed the so-called Villa del Pigneto near Rome for the Sacchetti and possibly also the villa at Castel Fusano, now Chigi property. The latter was built and decorated between 1626 and 1630.[10] It is a simple three-storeyed structure measuring 70 by 52 feet, rather rustic in appearance, crowned with a tower and protected by four fortress-like corner projections. The type of the building follows a long-established tradition, but the interest here lies in the pictorial decoration rather than in the architecture. The Villa del Pigneto on the other hand commands particular attention because of its architecture [80, 81]. Unfortunately little survives to bear witness to its original splendour.[11] Nor is anything certain known about its date and building history. The patron was either Cardinal Giulio or Marchese Marcello Sacchetti;[12] the former received the purple in 1626, the latter died in 1636 (not 1629). There is, therefore, room for the commission during the decade 1626–36. For stylistic reasons a date not earlier than the late twenties seems indicated.[13]

The ground floor of the building [81] with its symmetrical arrangement of rooms reveals a thorough study of Palladio's plans, but the idea of the monumental niche in the central structure, which is raised high above the low wings, derives from the Belvedere in the Vatican. It is even possible

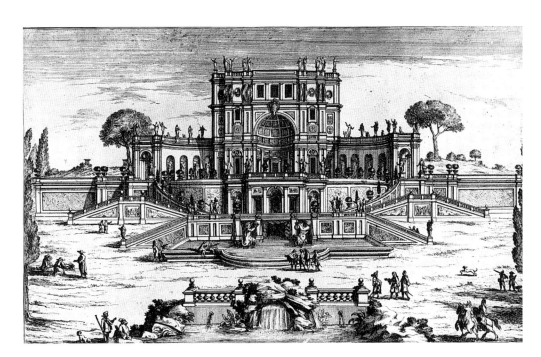

80 and 81. Pietro da Cortona:
Rome (vicinity), Villa del Pigneto,
before 1630. Destroyed. Engraving,
and plan drawn by P. L. Ghezzi.
London, Courtauld Gallery

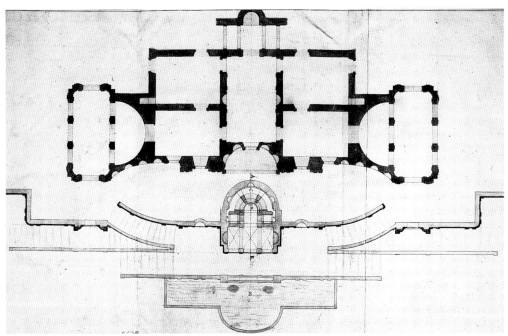

that Cortona was impressed at that early date by the ruins of the classical temple at Praeneste (Palestrina) near Rome, of which he undertook a reconstruction in 1636.[14] In any case, the large screened niches of the side fronts – a motif which has no pedigree in post-Renaissance architecture – can hardly have been conceived without the study of plans of Roman baths. While the arrangement of terraces with fountains and grottoes is reminiscent of earlier villas such as the Villa Aldobrandini at Frascati, the complicated system of staircases with sham flights recalls Buontalenti's Florentine Mannerism. If one can draw conclusions from the ground-plan, essentially Mannerist must also have been the contrast between the austere entrance front and the over-decorated garden front, a contrast well known from buildings like the Villa Medici on the Pincio. Although small in size and

derived from a variety of sources, the building was a landmark in the development of the Baroque villa. The magnificent silhouette, the grand staircases built up in tiers so as to emphasize the dominating central feature, and above all the advancing and receding curves which tie together staircase, terrace, and building – all this was taken up and further developed by succeeding generations of architects.

It is an indication of Cortona's growing reputation that on Maderno's death in 1629 he took part in the planning of the Palazzo Barberini. His project seems to have found the pope's approval, but the high cost prevented its acceptance.[15] Although Bernini was appointed architect of the palace, Cortona was not altogether excluded. The theatre adjoining the north-west corner of the palace was built to his design [82].[16] It would be a matter of absorbing interest to

82. Pietro da Cortona: Rome, Palazzo Barberini. Entrance to the theatre, *c.* 1638

know something about Cortona's project for the palace. In earlier editions of this book I illustrated the plan of a palace which I had come across on the London art market in the 1930s and which I immediately diagnosed as by Cortona's hand. In 1969 I discussed this plan at considerable length before a group of specialists, and the critical tenor of my colleagues induced me to remove the illustration from this edition. But since I still believe in the correctness of my original conclusions, some remarks about that plan are in place. It represents only the ground floor containing a web of octagonal rooms (apparently meant to be used as store-rooms), the walls of which were to serve as substructures to the rooms above.[17] In spite of the obvious difficulties of location, the colossal dimensions of the plan make it almost certain that it refers to the Palazzo Barberini. Cortona wanted to return to the traditional Roman block-shape; his design is a square of 285 by 285 feet as against the 262 feet of the present façade.[18] Even the scanty evidence of this plan reveals four rather exciting features: the palace would have had bevelled corners framed by columns; the main axes open into large rectangular vestibules articulated by columns; two vestibules give direct access to the adjoining staircase halls; finally, the double columns of the courtyard would have been carried on across the corners in an unbroken sequence. The idea of integrating vestibule and staircase hall, hardly possible without a knowledge of French designs, was new for Italy. Also the principal staircase with two opposite flights ascending from the main landing has no parallel in Rome at this time. Moreover, the arrangement of the courtyard anticipates Borromini's in the nearby monastery of S. Carlo alle Quattro Fontane, while the plan of the vestibules was taken up by Borromini in S. Maria dei Sette Dolori and the

church of the Propaganda Fide. The most astonishing element, however, is the kind of structural grid system that controls every dimension of the plan.

In 1633 Cortona won his first recognition as a designer of festival decoration: for the Quarantore of that year he transformed the interior of the church of S. Lorenzo in Damaso into a rich colonnaded setting with niches and gilded statues of saints.[19] Cortona was a born 'decorator', and it is therefore all the more to be regretted that none of his occasional works seems to have come down to us in drawings or engravings. It was not until his thirty-eighth year, the year of his election as *Principe* of the Academy of St Luke, that he received his first big architectural commission. He had hardly begun painting the great Salone of the Barberini Palace when the reconstruction of the church of SS. Martina e Luca at the foot of the Capitol fell to him. This work requires an analysis.

SS. Martina e Luca

In July 1634 Cortona was granted permission to rebuild, at his own cost and according to his plans, the crypt of the church of the Academy of St Luke, in order to provide a tomb for himself.[20] During the excavations, in October of that year, the body of S. Martina was discovered. This brought an entirely new situation. Cardinal Francesco Barberini took charge of the undertaking and in January 1635 ordered the rebuilding of the entire church.[21] By about 1644 the new church was vaulted, and its completion in 1650 is recorded in an inscription in the interior.[22]

Cortona chose a Greek-cross design with apsidal endings [83–7]. The longitudinal axis is slightly longer than the

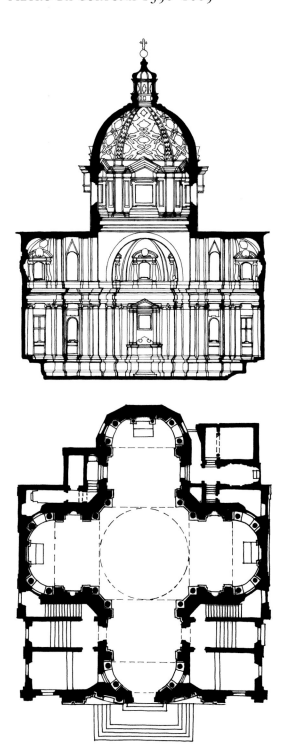

83. Pietro da Cortona: Rome, SS. Martina e Luca, 1635–50. Section and plan

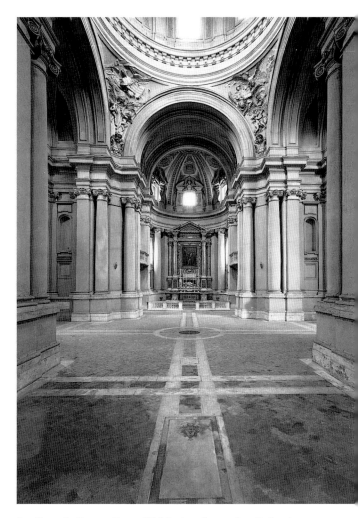

84. Pietro da Cortona: Rome, SS. Martina e Luca, 1635–66. Interior

transverse axis.[23] This difference in the length of the arms, significant though it seems in the plan, is hardly perceptible to the visitor who enters the church. His first sensation is that of the complete breaking up of the unified wall surface, and his attention is entirely absorbed by it. But this is not simply a painterly arrangement, designed to seduce and dazzle the eye, as many would have it who want to interpret the Baroque as nothing more than a theatrical and picturesque style. The wall so often no more than an inert division

between inside and outside has here tremendous plasticity, while the interplay of wall and orders is carried through with a rigorous logic. The wall itself has been 'sliced up' into three alternating planes. The innermost plane, that nearest to the beholder, recurs in the segmental ends of the four arms, that is, at those important points where altars are placed and the eye requires a clear and solid boundary. The plane furthest away appears in the adjoining bays behind screening columns. The intermediate plane is established in the bays next to the crossing. Similarly varied is the arrangement of the order: the pilasters occupy a plane before the columns, and the columns under the dome and in the apses are differently related to the wall. But all round the church pilasters and columns are homogeneous members of the same Ionic order. The overwhelming impression of unity in spite of the 'in' and 'out' movement of the wall and the variety in the placing of the order makes a uniform 'reading' of the centralized plan not only logically possible but visually imperative. Thus Cortona solved the problem of axial direction inherent in centralized planning by means entirely different from those employed by Bernini. It is also characteristic that at this period Cortona, unlike Bernini, rejected the use of colour. The church is entirely white, a neutrality which seems essential for the full impact of this

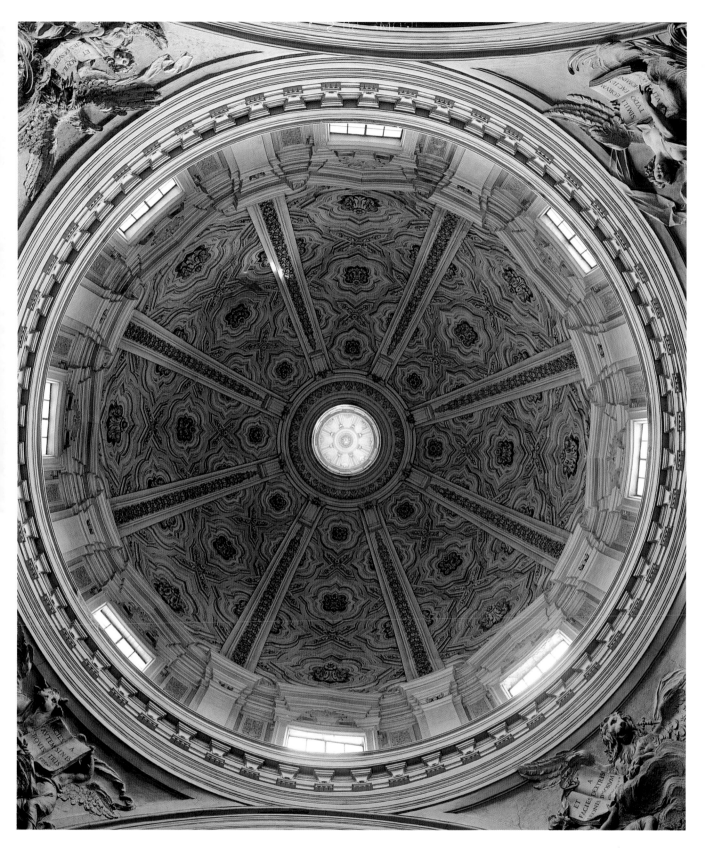

85. Pietro da Cortona: Rome, SS. Martina e Luca, 1635–66. Dome, interior, stucco design by Cirro Ferri

richly laden, immensely plastic disposition of wall and order.

By contrast to the severe forms of the architecture below, the vaultings of the apses above the entablature are copiously decorated. The entire surface is plastically moulded and hardly an inch of the confining wall is allowed to appear.

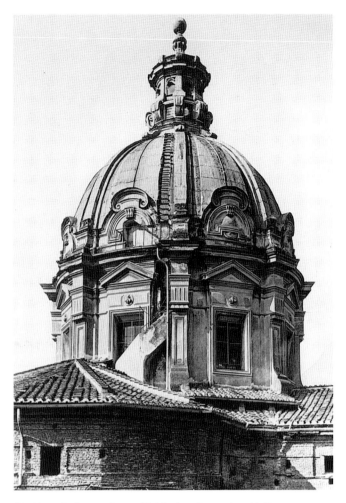

86. Pietro da Cortona: Rome, SS. Martina e Luca, 1635–66. Dome

Similar solutions recur in some of his other structures, most prominently on the drum of the dome of S. Carlo al Corso [93], one of his latest works (1668), where the screening columns correspond closely to those inside SS. Martina e Luca.

An analysis of the decoration of SS. Martina e Luca supplies most striking evidence of Cortona's Florentine roots. In spite of the wealth of decoration in the upper parts of the church, figure sculpture is almost entirely excluded and indeed never plays a conspicuous part in Cortona's architecture. His decoration combines two different trends of Florentine Mannerism: the hard and angular forms of the Ammanati–Dosio idiom with the smooth, soft, and almost voluptuous elements derived from Buontalenti. It is the merging of these two traditions that gives the detail of Cortona's work its specific flavour. Florentine Mannerism, however, does not provide the whole answer to the problem of Cortona's style as a decorator, for the vigorous plasticity and the compact crowding of a great variety of different motifs – such as in the panels of the vaultings of the apses – denote not only a Roman and Baroque, but above all a highly personal transformation of his source material. This style of decoration was first evolved by Cortona not in his architecture but in his painting. He translated into three-dimensional form the lush density of pictorial decoration to be found in the Salone of the Palazzo Barberini [96]. The similarity between painted and plastic decoration is extremely close, even in details. For instance, the combination of heads in shells and rich octagonal coffers above the windows of the apses, so striking a feature of the decoration of SS. Martina e Luca, also appears at nodal points of the painted system of the Barberini ceiling. But, having pointed out the close connexion between his architectural and painted decoration, one must emphasize once again that in his built architecture Cortona eliminates the figure elements which form so integral a part of his painted architecture. No stronger contrast to Bernini's conception of architecture could be imagined. For Bernini the very meaning of his classically conceived architecture was epitomized in realistic sculpture. Such sculpture would have obscured the wealth and complexity of Cortona's work. His decorative effervescence reaches its culmination in SS. Martina e Luca with the entirely unprecedented, wildly undulating forms of the dome coffering [85]. The very personal design of these coffers found no imitators, and it was only after Bernini had restored Cortona's coffers to their classical shape that their use in combination with a ribbed vault was generally accepted.

The undulation of Cortona's coffers is countered by the severe angularity of the pediments of the windows in the drum which intrude into the zone of the dome. On the exterior of the dome a similar phenomenon can be observed [86]. Here the austere window frames of the drum are topped by a sequence of soft, curved decorative forms at the base of the vaulting, and these forms are taken up in the lantern by scrolls of distinctly Mannerist derivation. The exterior of the dome is also highly original in that the drum and the foot of the vaulting are emphasized at the expense of the curved silhouette of the dome itself. With this Cortona anticipates a development which, though differently

And yet the idea of working with varying wall planes is transposed into the concept of using overlapping decorative elements. The windows between the ribs are framed by stilted arches; over these arches a second frame of disproportionately large consoles is laid which support broken segmental pediments. Similarly, the system of ribs in the dome is superimposed upon the coffers. It is now apparent that the use here of what would previously have been considered two mutually exclusive methods of dome articulation is characteristic of Cortona's style in this church. We have seen (p. 25) that this idea was soon taken up by seventeenth- and eighteenth-century architects.

Despite the new plastic-dynamic interpretation of the old Greek-cross plan, Cortona's style is deeply rooted in the Tuscan tradition. Even such a motif as the free-standing columns which screen the recessed walls in the arms of the cross is typically Florentine. Its origin, of course, is Roman, but in antiquity the columns screen off deep chapels from the main space (Pantheon). When this motif was applied in the Baptistery of Florence, the walls were brought up close behind the columns, whereby the latter lost their specifically space-defining quality. It is this Florentine version with its obvious ambiguity that attracted Mannerist Florentine architects (Michelangelo,[24] Ammanati, etc.), and it is this version of the classical motif that was revived by Cortona.

87. Pietro da Cortona: Rome, SS.
Martina e Luca, 1635–66. Façade

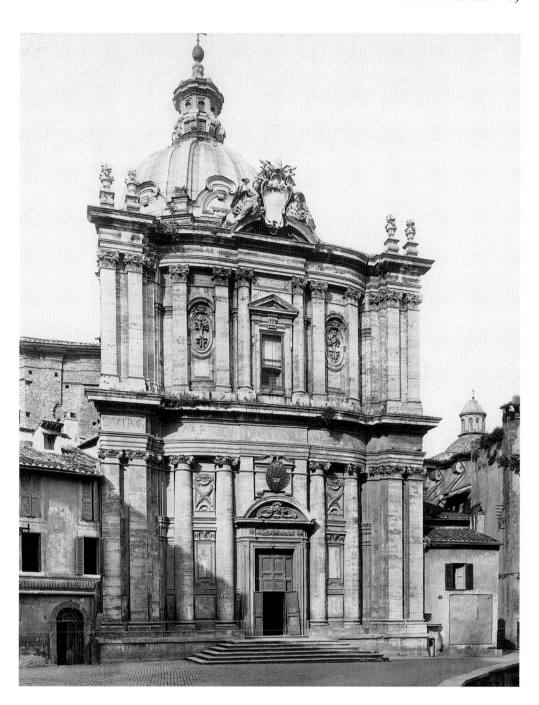

expressed, was to come into its own in the second half of the century.

The façade of SS. Martina e Luca represents another break with tradition [87]. The two-storeyed main body of the façade is gently curved, following the precedent of the Villa Sacchetti (though the curve is here inwards). Strongly projecting piers faced with double pilasters seem to have compressed the wall between them, so that the curvature appears to be the result of a permanently active squeeze. At precisely this period Borromini designed his concave façade for the Oratory of St Philip Neri. In view of their differences of approach, however, the two architects may have arrived independently at designing these curved fronts. The peculiarity of the façade of SS. Martina e Luca lies not only in its curvature but also in that the orders have no framing function and do not divide the curved wall into clearly defined bays. In the lower tier, the columns seem to have been pressed into the soft and almost doughy mass of the wall, while in the upper tier sharply cut pilasters stand before the wall in clear relief. This principle of contrasting soft and hard features, which occurred in other parts of the building, is reversed in the projecting central bays: in the upper tier framing columns are sunk into the wall, whereas in the lower tier rigid pilaster-like formations top the door. It would be easy to describe at much greater length the almost incredibly rich variations on the same theme, but it must suffice to note that specifically Florentine Mannerist traits are very strong in the subtle reversal of architectural motifs and in the overlapping and interpenetration of elements as well as in the use of decorative features. This is true despite the carefully framed realistic palm and flower panels. Moreover, the type of the façade with two equally developed storeys

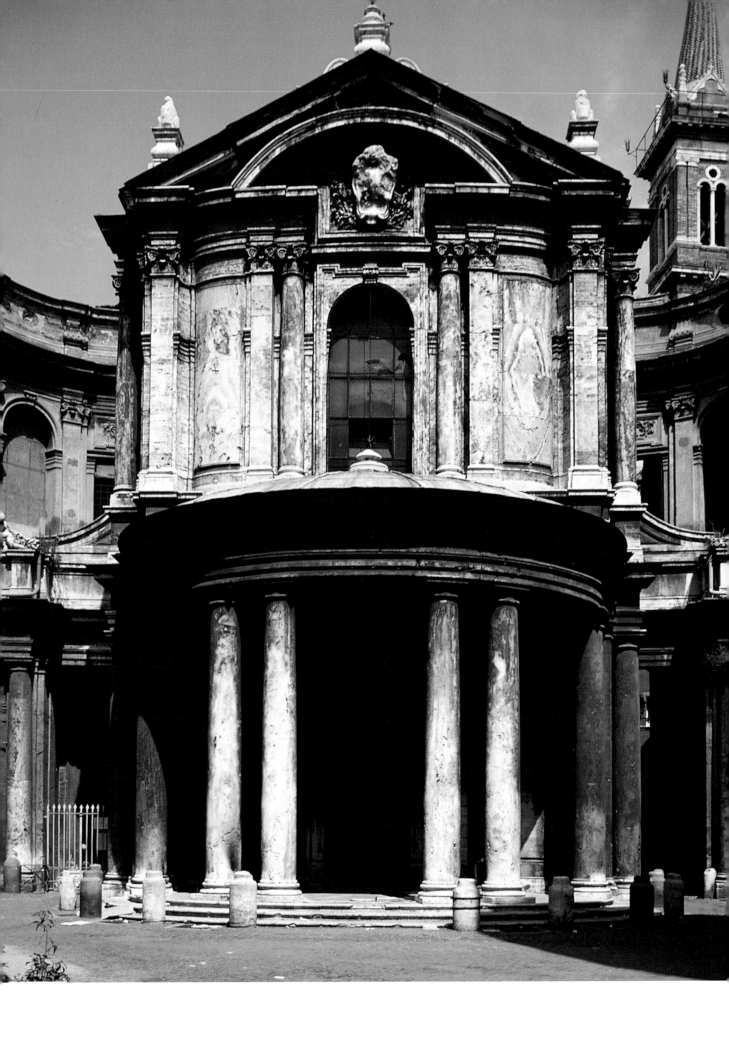

and strongly emphasized framing features has its roots in the Florentine rather than in the Roman tradition.[25]

Quite unlike any earlier church façade, this prepares the beholder for an understanding of the internal structure, for the wall treatment and articulation of the interior are here unfolded in a different key.[26] Cortona thinks in terms of the pliability of the plastic mass of walls: it is through this that he achieves the dynamic coordination of exterior and interior. To him belongs the honour of having erected the first of the great, highly personal and entirely homogeneous churches of the High Baroque.[27]

S. Maria della Pace, S. Maria in Via Lata, Projects, and Minor Works

Cortona's further development at an architect shows the progressive exclusion of Mannerist elements and a turning towards Roman simplicity, grandeur, and massiveness even though the basic tendencies of his approach to architecture remain unchanged. This is apparent in his modernization of S. Maria della Pace, carried out between 1656 and 1657 [88, 89].[28] The new façade, placed in front of the Quattrocento church, together with the systematization of the small piazza is of much greater importance than the changes in the interior.[29] Although regularly laid-out piazzas had a long tradition in Italy, Cortona's design inaugurates a new departure, for he applied the experience of the theatre to town-planning: the church appears like the stage, the piazza like the auditorium, and the flanking houses like the boxes. It is the logical corollary of such a conception that the

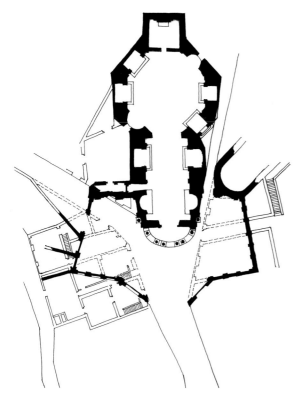

89. Pietro da Cortona: Rome, S. Maria della Pace, 1656–7. Plan of church and piazza

88. Pietro da Cortona: Rome, S. Maria della Pace, 1656–7. Façade

approaches from the side of the church are through a kind of stage doors, which hide the roads for the view from the piazza.[30]

The convex upper tier of the façade, firmly framed by projecting piers, repeats the motif of the façade of SS. Martina e Luca. But in the scheme of S. Maria della Pace this tier represents only a middle field between the boldly projecting semicircular portico and the large concave wings which grip like arms round the front, in a zone much farther removed from the spectator.[31] The interplay of convex and concave forms in the same building, foreshadowed in a modest way in Cortona's Villa Sacchetti, is a typically Roman High Baroque theme which also fascinated Borromini and Bernini.

S. Maria della Pace contains many influential ideas. The portico is one of Cortona's most fertile inventions. By projecting far into the small piazza and absorbing much space there, a powerful plastic and at the same time chromatically effective motif is created that mediates between outside and inside.[32] Bernini incorporated it into the façade of S. Andrea al Quirinale, and it recurs constantly in subsequent European architecture. The detail of the portico, too, had immediate repercussions. As early as 1657 Bernini made an intermediary project with double columns for the colonnades of St Peter's;[33] and his final choice of a Doric order with Ionic entablature was here anticipated by Cortona.[34] The crowning feature of the façade of S. Maria della Pace is a large triangular pediment encasing a segmental one. Such devices had been used for more than a hundred years from Michelangelo's Biblioteca Laurenziana onwards. With the exception, however, of Martino Longhi's façade of SS. Vincenzo ed Anastasio (p. 106), the motif does not occur in Rome at this particular time. Encased pediments are a regular feature of the North Italian type of the aedicule façade [1: 86], and to a certain extent Cortona must have been influenced by it. But he goes essentially his own way by working with a pliable wall and by employing once again architectural orders as an invigorating rather than a space- (or bay-)defining motif. Moreover, the 'screwhead' shape of the segmental pediment which breaks through the entablature so as to create room for Alexander VII's coat of arms adds to the unorthodox and even eccentric quality of the façade.[35]

In his next work, the façade of S. Maria in Via Lata, built between 1658 and 1662,[36] Cortona carried simplification and monumentality a decisive step further [90–92]. The classicizing tendencies already apparent in the sober Doric of S. Maria della Pace are strengthened, while the complexity of SS. Martina e Luca seems to have been reduced to the crystalline clarity of a few great motifs. It is obvious that the alignment of the street did not warrant a curved façade. Nevertheless, there are connexions between Cortona's early and late work; for, like SS. Martina e Luca, the façade of S. Maria in Via Lata consists of two full storeys, but, reversing the earlier system, the central portion is wide open and is flanked by receding bays instead of projecting piers. The main part, which opens below into a portico and above into a loggia, is unified by a large triangular pediment into which, as at S. Maria della Pace, a segmental feature has been inserted. Here, however, it is not a second smaller pediment,

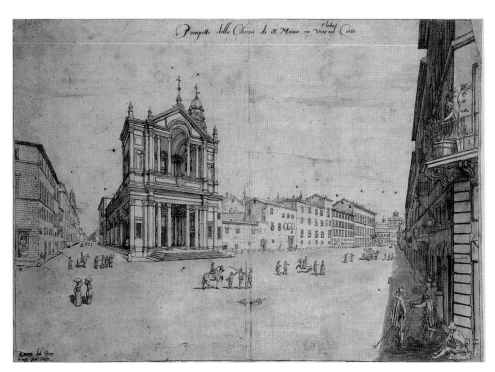

90. Pietro da Cortona: Rome, S. Maria in Via Lata, 1658–62. Reversed view by L. Cruyl, 1665. Cleveland Museum of Art

91. Pietro da Cortona: Rome, S. Maria in Via Lata. Interior of portico

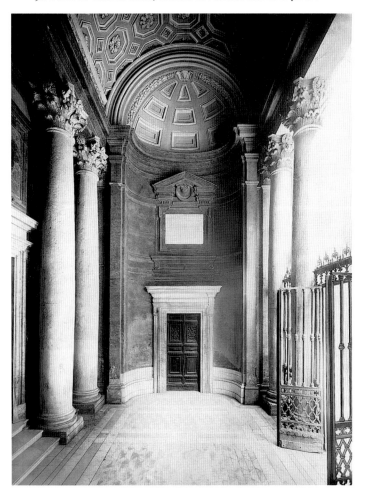

but an arch connecting the two halves of the broken straight entablature. The motif is well known from Hellenistic and Roman Imperial architecture (Termessus, Baalbek, Spalato, S. Lorenzo in Milan) and, although it was used in a somewhat different form in medieval as well as Renaissance buildings (e.g. Alberti's S. Sebastiano at Mantua), it is here so close to the late classical prototypes that it must have been derived from them rather than from later sources.[37] While thus the classical pedigree of the motif must be acknowledged, neither Cortona's Tuscan origin nor the continuity of his style is obscured. The design of the interior of the portico is proof of this [91]. With its coffered barrel vault carried by two rows of columns, one of which screens the wall of the church, it clearly reveals its derivation from the vestibule of the sacristy in S. Spirito at Florence (Giuliano da Sangallo and Cronaca, begun 1489). But in contrast to the Quattrocento model, the wall screened by the columns seems to run on behind the apsidal endings, and so does the barrel vault. Cortona thus produces the illusion that the apses have been placed in a larger room, the extent of which is hidden from the beholder. Only the cornice provides a structural link between the columns and the niches of the apses. The comparison of Cortona's solution with that of S. Spirito is extraordinarily illuminating, for the 'naive' Renaissance architect ignored the fact that a screen of columns placed in front of an inside wall must produce an awkward problem at the corners. Cortona, by contrast, being heir to the analytical awareness gained in the Mannerist period, was able to segregate, as it were, the constituent elements of the Renaissance structure and reassemble them in a new synthesis. Unlike Mannerist architects, who insisted on exposing the ambiguity inherent in many Renaissance buildings, he set out to resolve any prevarication by a radical procedure: each of the three component parts – the screen of columns, the apses, and the barrel vault – has its own fully defined structural *raison d'être*. There is hardly a more revealing example in the history of architec-

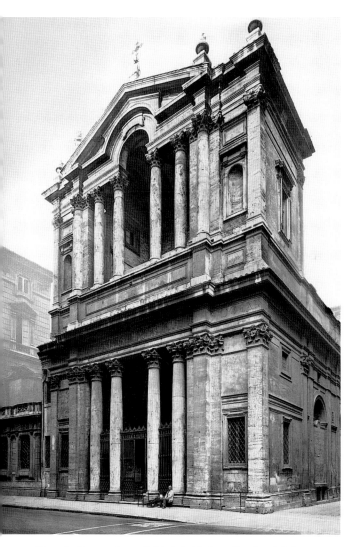

92. Pietro da Cortona: Rome, S. Maria in Via Lata. Façade, 1658–62

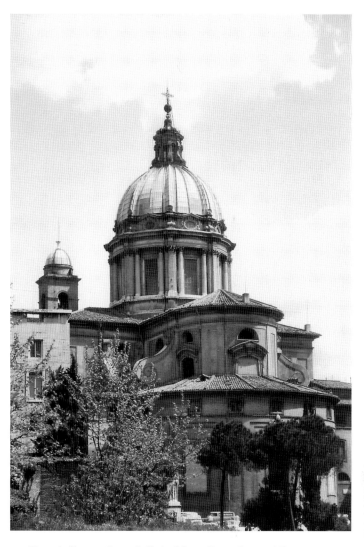

93. Pietro da Cortona: Rome, S. Carlo al Corso. Dome, begun 1668

ture of the different approaches to a closely related task by a Renaissance and a Baroque architect. But only a master of Cortona's perspicacity and calibre could produce this result; it is rooted in his old love for superimpositions (to wit, the vaults of the apses upon the barrel vault), and even he himself would not have been capable of such penetrating analysis at the period of SS. Martina e Luca, a time when he had not entirely freed himself from Mannerism.

Cortona's major late architectural work is the dome of S. Carlo al Corso, which has been mentioned [93].[38] Its drum shows a brilliant, and in this place unique, version of the motif of screening columns. Structurally, the buttresses faced with pilasters and the adjoining columns form a unit (i.e.: bab|bab|bab|. . .), but aesthetically the rhythm of the buttresses predominates and seems accompanied by that of the open, screened bays (i.e.: a|b–b|a|b b|a|. . .). A comparison of this dome with that of SS. Martina e Luca makes amply clear the long road Cortona had travelled in the course of a generation, from complexity tinged by Mannerism to serene classical magnificence. Similar qualities may be found in two minor works of the latest period,

the Cappella Gavotti in S. Nicolò da Tolentino, begun in 1668, and the altar of St Francis Xavier in the Gesù, executed after the master's death.[39]

What would have been one of Cortona's most important ecclesiastical works, the Chiesa Nuova (S. Firenze) at Florence, remained a project. At the end of 1645 his model was finished. But as early as January 1646 there seem to have been dissensions, for Cortona writes to his friend and patron Cassiano del Pozzo that he was never lucky in matters concerning architecture.[40] The affair dragged on until late in 1666, when his plans were finally shelved. A number of drawings, now in the Uffizi, permit us to get at least a fair idea of Cortona's intentions.[41] Equally, all his major projects for secular buildings remained unexecuted, while the Villa del Pigneto and the house which he built for himself late in life in the Via della Pedacchia no longer exist.[42]

Three of his grand projects should be mentioned, namely the plans for the alterations and additions to the Palazzo Pitti at Florence, the designs for a Palazzo Chigi in the Piazza Colonna, Rome, and the plans for the Louvre. As regards the Louvre, he competed with Bernini, who again

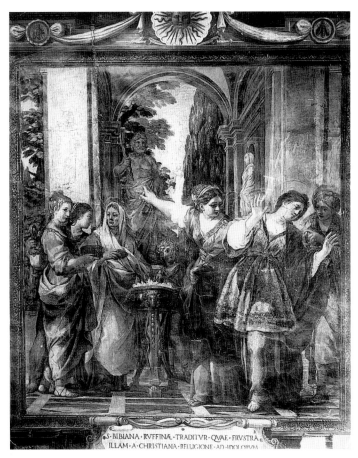

94. Pietro da Cortona: *St Bibiana refuses to sacrifice to Idols*, 1624–6. Fresco. Rome, S. Bibiana

superseded him as he had thirty-five years before in the work at the Palazzo Barberini. Cortona's Louvre project has recently been traced.[43] It always was in the Cabinet des Dessins of the Louvre, but remained unrecognized because it makes important concessions to French taste and is the least 'Cortonesque' of his architectural designs. The biased Ciro Ferri was certainly not correct when he maintained that Bernini had plagiarized his competitor's plan.[44] The modernization of the façade of the Palazzo Pitti was planned between 1641 and 1647, when Cortona painted his ceilings inside the palace.[45] His most notable contribution, however, would have been a theatre in the garden, for which several sketches are preserved. It was to rise high above curves and colonnaded terraces on the axis of the palace and would have formed a monumental unit with the courtyard. It is in these designs that Cortona's preoccupation with the ruins of Praeneste makes itself more clearly felt than in any of his other projects. He incorporated into his designs free-standing colonnades and a lofty 'belvedere', corresponding by and large to his reconstruction of the classical ruins made in 1636 for Cardinal Francesco Barberini and first published in Suarez's work on the ruins of Palestrina in 1655.[46] The prints probably influenced Bernini in his choice of colonnades for the Square of St Peter's. Moreover, the free-standing belvedere as a focusing point on high ground was frequently used in northern

Europe, particularly for gardens. If in such cases architects were no longer aware of the debt owed to Cortona's reconstruction of Praeneste, on occasion its direct influence can yet be traced. An impressive example is the eighteenth-century Castello at Villadeati in Piedmont with its sequence of terraces and its crowning colonnaded belvedere.[47] Cortona himself drew on his reconstruction for the designs of the Palazzo Chigi, which Alexander VII wanted to have erected when he planned to transform the Piazza Colonna, on which the older family palace was situated, into the first square in Rome. The most brilliant of the projects, preserved in the Vatican Library,[48] shows, for the first time, a powerful giant order of columns screening a concave wall above a rusticated ground floor from which the waters of the Fontana Trevi were to emerge. The repercussions of this design can still be felt in Bouchardon's Fontaine de Grenelle in Paris (1739–45).

Cortona once wrote despondently that he regarded architecture only as a pastime.[49] Can we believe him? It seems impossible to say whether he was primarily painter or architect. As a painter his real gift lay in the effective manipulation of large-scale ensembles which are inseparable from their settings. One cannot, therefore, think of the painter without the architect in the same person. The study of Cortona as a painter should not be divorced from the study of Cortona as a decorator of interiors.

PAINTING AND DECORATION

The Early Works

Until recently it has been thought that Cortona's first frescoes were those in S. Bibiana.[50] The discovery of frescoes by his hand in the Villa Muti at Frascati and in the Palazzo Mattei makes a revision necessary. The Frascati frescoes, powerful though crude and weakly designed, reveal the hand of the beginner,[51] while in the frescoes of the gallery of the Palazzo Mattei, executed between May 1622 and December 1623, Cortona's style appears fully developed.[52] He painted here four scenes from the story of Solomon. They show his sense for drama, his characteristic manner of composition, his love for archaeological detail, and his solidity and clarity in the conception of the main protagonists. Single figures as well as whole scenes seem to herald his later work, and the panel with the *Death of Joab* looks like an anticipation of the *Iron Age* painted in the Palazzo Pitti in 1637. And yet although the style is formed, or rather in the process of being formed, it lacks vigour and assurance, and the full-bloodedness of his mature manner. Interesting though these frescoes are as the first major performance of a great master, by contrast to Bernini's work at the age of twenty-five they do not reveal the hot breath of genius: it was only in the frescoes in S. Bibiana, executed between 1624 and 1626, that Cortona created a new historical style in painting.

The responsibility for the pictorial decoration was in the hands of the old-fashioned Mannerist Agostino Ciampelli, and Cortona's contribution consisted mainly of the three frescoes with scenes from the life of the saint above the left-hand arches of the nave. One of these scenes, *St Bibiana*

95. Pietro da Cortona: *The Rape of the Sabine Women*, *c.* 1629. Rome,
Capitoline Museum

refuses to sacrifice to Idols [94], may be chosen to assess the change which has taken place during the intervening decade since Domenichino's St Cecilia frescoes [I: 40]. The figures have grown in volume and their immensely strong tactile values make them appear real and tangible. Thus breathing life seems to replace the studied classicism of Domenichino's work. There is also a broadening of touch and a freer play of light and shade which, incidentally, is in keeping with the general development of the 1620s. Contrary to Domenichino's loose, frieze-like composition, in which every figure appears in statuesque isolation and is given almost equal significance, Cortona creates a diagonal surge into depth, a gradation in the importance of figures, and a highly dramatic focus. One diagonal is made up of the *dramatis personae*, St Bibiana and St Rufina, who press forward against the picture plane; the other is formed by the group of priestesses, unruffled bystanders recalling the chorus in the classical drama. The result of all this is a virile, bold, and poignant style which is closer in spirit to Annibale's Farnese ceiling than to Domenichino's manner and possesses qualities similar to Bernini's sculpture of these years.

Yet Cortona's point of departure was not in fact very different from that of Domenichino. The figures, as well as the accessories like the sacrificial tripod and the statue of Jupiter in the background, meticulously follow ancient models.

Cortona's antiquarian taste was nurtured and determined by his early intense study after the antique[53] and the scientific copying of classical works for Cassiano del Pozzo, whom he began to serve at about this time. It is often not realized that throughout his whole career and even during his most Baroque phase, Cortona shared the erudite seventeenth-century approach to antiquity. Thus, although there is a world of difference between Domenichino's rigid classicism of 1615 and Cortona's 'Baroque' classicism of 1625, the latter's work is essentially closer to the Carracci–Domenichino current than it is to the bold illusionism of Lanfranco, which asserted itself on the largest scale precisely at this moment.

In these early years Cortona was employed primarily by the Sacchetti family.[54] The major work in the service of Marchese Marcello was the decoration of the Villa at Castel Fusano (1626–9), and this time the direction was in Cortona's hands. It is known that a number of artists worked under him, among them Domenichino's pupil Andrea Camassei (1602–49)[55] and, above all, Andrea Sacchi[56] – a fact of particular interest, since their opinions on art as well as their practice soon differed so radically. The Castel Fusano frescoes are in a poor state and largely repainted, but the chapel with Cortona's *Adoration of the Shepherds* over the altar is well preserved. Here all around the walls are brilliantly painted landscapes with small figures depicting the

life of Christ; evidently derived from Domenichino, their painterly freedom is an unexpected revelation, and in a more accessible locality they would long have been given a place of honour in the development of Italian landscape painting. The principal decoration was reserved for the gallery on the second floor, and Marchese Marcello himself worked out the programme for the cycle of mythological-historical-allegorical frescoes. On entering the gallery, one is immediately aware that Cortona depends to a large extent on the Farnese ceiling, a clear indication that in these years he was still tied to the Bolognese tradition.[57]

During the same period he painted for the Sacchetti a series of large pictures (now in the Capitoline Museum) illustrating mythology and ancient history. The latest of these, *The Rape of the Sabine Women* of *c.* 1629 [95], a pendant to the earlier *Sacrifice of Polyxena*,[58] shows him amplifying the tendencies of the S. Bibiana frescoes. Once again an elaborately contrived antique setting is used as a stage for the drama, and details such as armour and dress are studied with a close regard for 'historical truth'. The scene is none the less permeated by a sense of Venetian romanticism, and indeed in its colour the painting owes much to Venice.[59] Three carefully considered groups close to the observer are the main components of the composition. The one on the right is clearly dependent on Bernini's *Rape of Proserpina*, while that in the centre seems to be indebted to poses known from the stage. Despite the loose handling of the brush, these powerful groups produce almost the sensation of sculpture in the round. They are skilfully balanced on a central axis and yet they suggest a strong surge from right to left; this movement, stabilized by the three architectural motifs, is simultaneously counteracted in the middle distance by the sequence of gestures starting from the figure of Neptune and passing through Romulus to the centurion, who seems to be about to intervene on behalf of old age and virginity in their contest with brute force. Furthermore, these figures adroitly fill the gaps between the main groups in the foreground. It will be noticed how subtly the earlier frieze composition of the Domenichino type of classicism has been transformed. A dynamic flow of movement and counter-movement is integrated with a stable and organized distribution of groups and figures. The *Rape of the Sabine Women* impressed following generations almost more than any other of Cortona's canvases, and its effect can be seen, for instance, in works by Giacinto Gimignani and Luca Giordano. Nevertheless the richness of its compositional devices, typical of the Baroque trend in the years around 1630, still owes a debt to Annibale's Farnese ceiling and in particular to his *Triumph of Bacchus* [I: 27].

The *Rape of the Sabine Women* shows both Cortona's strength as a painter and his weakness. Among his Roman contemporaries, Sacchi's characters are far more convincing, Poussin lends a moral weight to his canvases of which Cortona was incapable, Guercino is superior as a colourist. But none of them matches his fiery temperament, his wealth of ideas in organizing a canvas on the largest scale, his verve in rendering incidents, and his great gift as a narrator. These virtues predestined him to become the first fresco painter in Rome and lead this branch of painting to a sudden and unparalleled climax.

The Gran Salone of the Palazzo Barberini

The years 1633–9 mark the turning point in Cortona's career, and in retrospect they must be regarded as one of the most important caesuras in the history of Baroque painting. During these years he carried out the ceiling of the Gran Salone in the Palazzo Barberini, a work of vast dimensions and a staggering performance by any standards [96].[60] There was an interruption in 1637 when he paid a visit to Florence and Venice. The Venetian painter Marco Boschini reports that, after his return, Cortona removed part of what he had done in order to apply the lessons learnt in Titian's and Veronese's city. Whether this is correct or not, the Venetian note is certainly very prominent. But we have reached the cross-roads of Baroque ceiling painting, and one source of inspiration, decisive as it may be, cannot account for the conception of this work.

Following the tradition of *quadratura* painting (p. 35), Cortona created an illusionistic architectural framework which he partly concealed beneath a wealth of garland-bearers, shells, masks, and dolphins – all painted in simulated stucco. At this juncture two points should be noted: that, in contrast to the orthodox *quadratura*, the architectural framework here is not meant to expand the actual shape of the vault; and that the feigned stuccoes take up and transform a local Roman tradition. But it was *real* stucco decoration that was fashionable in Rome from Raphael's Logge onwards and became increasingly abundant in the course of the sixteenth century.

The framework divides the whole ceiling into five separate areas, each showing a painted scene in its own right. Although something of the character of the *quadro riportato* can thus in fact still be sensed,[61] Cortona has created at the same time a coherent 'open' space. The illusion is a dual one: the same sky unites the various scenes behind the painted stucco framework, while on the other hand figures and clouds superimposed on it seem to hover within the vault just above the beholder. In other words, it is the existence of the framework that makes it possible to perceive both the illusionist widening and the illusionist contraction of objective space.

It is worth recalling that Mannerist ceiling and wall decoration in Central Italy was concerned primarily with figures illusionistically intruding into, but not extending, the space of the beholder.[62] By contrast the architectural constructions of the *quadratura* painters aim first and foremost at a precisely defined extension of space. A diametrically opposed method, namely the suggestion of an unlimited space continuum, was applied by Correggio to the decoration of domes. Finally, the double illusion, where figures may appear in painted space behind and in front of a feigned architecture, has also a long history, mainly in Northern Italy, from Mantegna's Camera degli Sposi onwards.

Cortona, it will now be seen, followed basically the North Italian tradition descending from Mantegna through

96. Pietro da Cortona: *Glorification of Urban VIII's Reign*, 1633–9. Fresco. Rome, Palazzo Barberini, Gran Salone

97. Pietro da Cortona: Florence, Palazzo Pitti, Sala di Marte, 1646. Ceiling. Fresco

98. Pietro da Cortona: Florence, Palazzo Pitti, Sala di Giove, 1643-5. Stuccoes

99. Pietro da Cortona: Florence, Palazzo Pitti, Sala di Apollo, 1647. Stuccoes

Veronese, but he changed and amplified it by making use of the local stucco tradition, by applying to the framework *quadratura* foreshortening, and by employing and transforming Mannerist conventions of figure projection in front of the architecture. At the same time, he showed an awareness of the Correggiesque space continuum. Moreover, he devised the middle field in the typically Venetian mode of *sotto in su*, in analogy to Veronese's *Triumph of Venice* in the Palazzo Ducale, and for colour too he relied to a large extent on Veronese.

All these diverse elements are united in a breathtaking and dynamic composition which overwhelms the beholder. At first sight throngs of figures seem to swirl above his head and to threaten him with their bulk. But soon the elaborate arrangement makes itself felt, and attention is guided

through the chiaroscuro and the complex formal relationships to the cynosure of the composition, the luminous aureole surrounding the figure of Divine Providence, which is also the centre of meaning. It was to Francesco Bracciolini (1566-1645), court poet from Pistoia, a minor star of the sophisticated literary circle gathered round the pope, that the programme of the ceiling was due. Although his text has not yet been discovered, it is clear that he had devised an intricate story in terms of allegory, mythology, and emblematic conceits.[63] Divine Providence, elevated high on clouds above Time and Space (Chronos and the Fates), requests Immortality with commanding gesture to add the stellar crown to the Barberini bees. These magnificent insects (themselves emblems of Divine Providence) are flying in the formation of the Barberini coat of arms. They are sur-

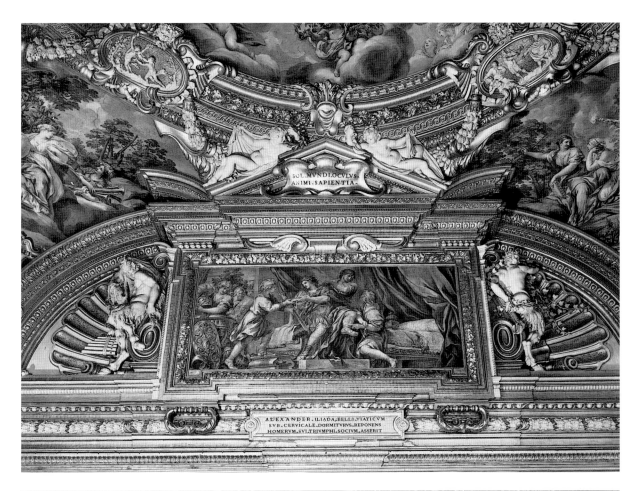

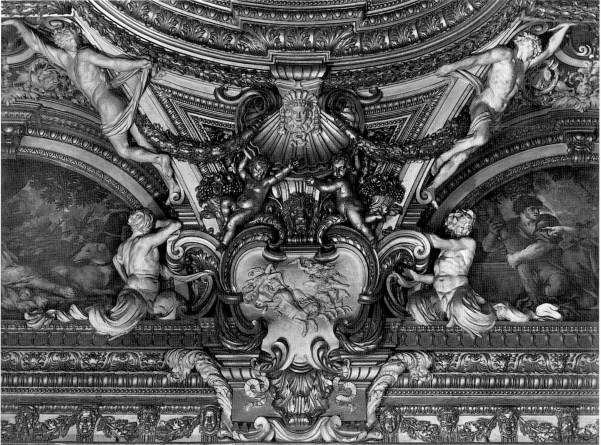

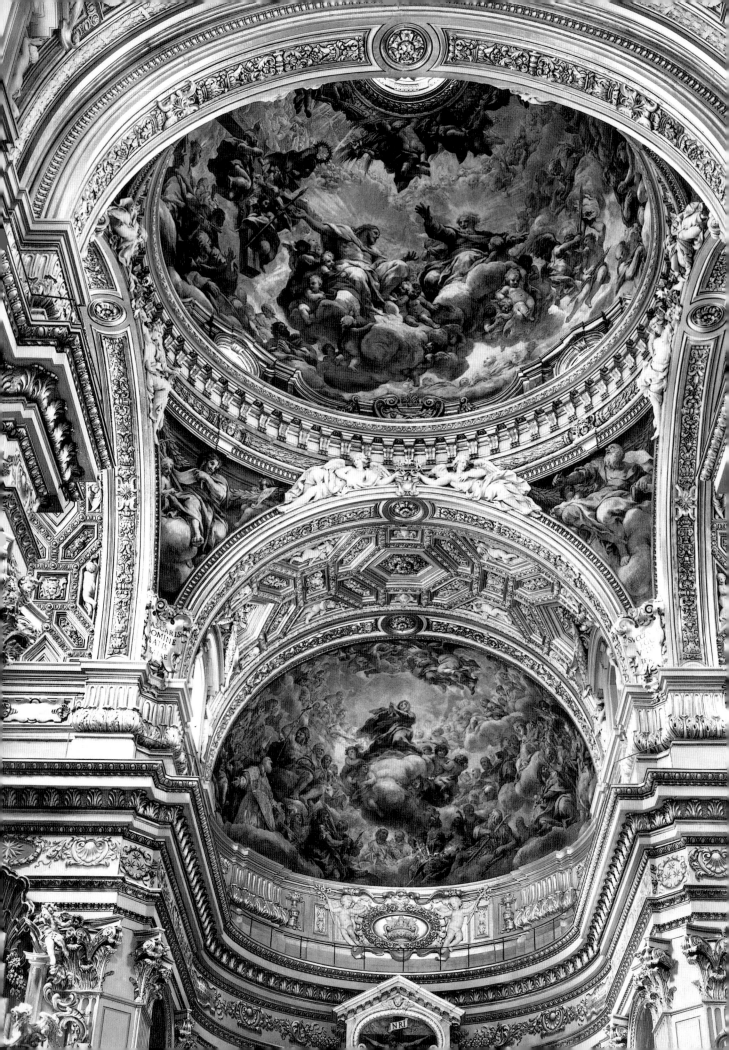

rounded by a laurel wreath held by the three theological Virtues so as to form a cartouche. The laurel is another Barberini emblem and also another symbol of Immortality. A putto in the top left corner extends the poet's crown – an allusion to Urban's literary gifts. When decoded, the visually persuasive conceit tells us that Urban, the poet-pope, chosen by Divine Providence and himself the voice of Divine Providence, is worthy of immortality. The four scenes along the cove, accessory to the central one, are like a running commentary on the temporal work of the pope. They illustrate in the traditional allegorical-mythological style his courageous fight against heresy (Pallas destroying Insolence and Pride in the shape of the Giants), his piety which overcomes lust and intemperance (Silenus and satyrs), his justice (Hercules driving out the Harpies), and his prudence which guarantees the blessings of peace (Temple of Janus). This summary barely indicates the richness of incidents compressed into these scenes. Never again did Cortona achieve, or aspire to, an equal density and poignancy of motifs animated by an equally tempestuous passion.[64]

The Frescoes of the Palazzo Pitti and the Late Work

When passing through Florence in 1637, Cortona had been persuaded by the Grand Duke Ferdinand II to stay for a while and paint for him a small room (Camera della Stufa) with representations of the Four Ages.[65] A characteristic sign of the time: there was no painter in Florence who could have vied with Pietro da Cortona. In 1641 he returned for fully six years, first to finish the 'Ages' and then to execute the large ceilings of the grand-ducal apartment in rooms named after the planets Venus, Jupiter, Mars, Apollo, and Saturn.[66] The programme, written by Francesco Rondinelli, may be regarded as a kind of astromythological calendar to the life and accomplishments of Cosimo I [97].[67] Events take place, therefore, in the sky rather than on earth, giving Cortona a chance to exploit in the ceiling frescoes the painterly potentialities of the airy realm. But it is the return to real stucco decorations[68] and their particular handling that guarantee these rooms a special place in the annals of the Baroque.

The wealth of these decorations baffles accurate description. One meets the entire repertory: figures and caryatids, white stuccoes on gilt ground or gilded ones on white ground; wreaths, trophies, cornucopias, shells, and hangings; duplication, triplication, and superimpositions of architectural and decorative elements; cartouches with sprawling borders incongruously linked with lions' heads, and with palmettes, cornucopias, and inverted shells [98] – a seemingly illogical joining, interlocking, associating of motif with motif. Unrivalled is the agglomeration of plastic forms and their ebullient energy. The quintessence of the Baroque, it would appear – and in a sense this may be agreed to. There is, however, another side to these decorations. Cortona care-fully observed the inviolability of the frames of the ceiling frescoes; the character of the decorations implies renunciation of illusionism; upon analysis it becomes evident that the decoration is placed before the architecture and not fused with it, that each element of the design is so clearly defined and self-contained that the figures could be taken out of their settings without leaving 'holes'; that, finally, the colour scheme of pure white and pure gold aims at stark and decisive contrasts. Thus the classicizing note is undoubtedly strong in the gamut of these High Baroque decorations. The details, too, open interesting perspectives: reminiscences of Michelangelo (corner figures, Sala di Marte [97]) appear next to Rubenesque tritons (Sala di Giove [98]) and chaste classical female caryatids (Sala di Giove); Buontalenti-like superimpositions (Sala di Apollo [99], and Sala di Venere) next to panels with trophies derived straight from antiquity (Sala di Marte). In a word, the basis for Cortona's decorative repertory is extremely broad, and yet the strange balance between effervescence and classical discipline remains unchanged.

To a certain extent these decorations epitomize Cortona's work in SS. Martina e Luca and the Palazzo Barberini, with which they are linked in many ways. But his earlier work as a decorator cannot account for the new relationship between the plastic decorations and the illusionist paintings [97] contained in heavy frames. The explanation is provided by Cortona's experience of Venice. Cinquecento ceilings such as that of the Sala delle Quattro Porte in the Palace of the Doges show essentially the same combination of stucco and painting. Here were the models which he translated into his personal luscious Seicento manner. It is the union of dignity and stateliness, of the festive, swagger, and grand, that predestined Cortona's manner to be internationally accepted as the official decorative style of aristocratic and princely dwellings. The 'style Louis XIV' owes more to the decorations of the Palazzo Pitti than to any other single source.[69]

Returning to Rome in 1647 without having finished the work in the Palazzo Pitti, Cortona immediately engaged upon his most extensive ecclesiastical undertaking, the frescoes in S. Maria in Vallicella. After the execution of the frescoes of the dome (1647–51) there was an interruption until 1655, and in the intervening years he painted for Pope Innocent X the ceiling of the long gallery in the Palazzo Pamphili in Piazza Navona (1651–4),[70] only recently (1646) built by Borromini. Here Cortona designed a rich monochrome system creating an undulating framework for the main scenes with the life and apotheosis of Aeneas. A work of infinite charm, the problem of changing viewpoints has here been approached and solved with unequalled mastery. His palette has become even more transparent and luminous than in the last ceilings of the Palazzo Pitti. Delicate blues, pale pinks, violet, and yellow prevail, foreshadowing the tone values used by Luca Giordano and during the eighteenth century. While this work easily reveals the study of antiquity, Raphael, and Veronese, the frescoes of S. Maria in Vallicella look back to Lanfranco and Correggio [100]; whereas the sophistication, elegance, delicacy, and decorative profuseness of the Pamphili ceiling appeal to the refined taste of the few, the work in the church speaks to the masses by its broad sweep, its dazzling multitude of figures and

100. Pietro da Cortona: *The Trinity in Glory* (dome), 1647–51, and *The Assumption of the Virgin* (apse), 1655–60. Frescoes. Rome, S. Maria in Vallicella

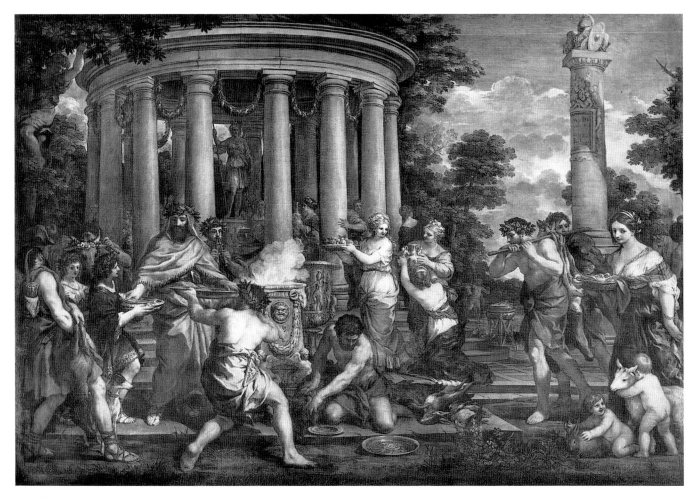

101. Pietro da Cortona: *Xenophon's Sacrifice to Diana*. Rome, Palazzo
Barberini (formerly)

powerful accentuation. Once again, these frescoes form an
ensemble of mesmerizing splendour with their setting, the
criss-cross of heavy, gilded coffers, the richly ornamented
frames (in the nave), and the white stucco figures – all
designed by Cortona. But he did not attempt to transplant
into the church his secular type of decoration; nor did he
employ the illusionistic wizardry used in the Bernini-Gaulli
circle and by the *quadraturisti*. Faithful to his old convic-
tions, he insisted on a clear division between the painted and
the decorative areas.

Compared with his great fresco cycles, his easel pictures
are of secondary importance. But if they alone had survived,
he would still rank as one of the leading figures of the High
Baroque. Pictures like the *Virgin and Saints* in S. Agostino,
Cortona (1626–8), and in the Brera (*c.* 1631), *Ananias heal-
ing St Paul* (S. Maria della Concezione, Rome, *c.* 1631),
Jacob and Laban (1630s) and *Romulus and Remus* (*c.* 1643),
both in the Louvre, and the *Martyrdom of St Lawrence* (S.
Lorenzo in Miranda, Rome, 1646), with their brilliant
painterly qualities, their careful Renaissance-like grouping,
their powerfully conceived main protagonists, and their
concentration on the dramatic focus, belong to the highest
class of 'history painting' in which the most coveted tradi-
tions of Raphael, Correggio, and Annibale Carracci find
their legitimate continuation. The *Sacrifice to Diana* (after

1653,* formerly Barberini Gallery, present whereabouts
unknown) [102] may serve to illustrate Cortona's late man-
ner. True to the allegorical-mythological mode of thinking,
Xenophon's sacrifice after his happy return from the East
(*Anabasis* V, iii) was meant to celebrate the homecoming of
the Barberini after their exile. Compared with the early *Rape
of the Sabine Women* [95] the classical and archaeological
paraphernalia have grown in importance at the expense of
the figures. The meticulous observance of classical decorum
shows Cortona in step with the late Poussin [102]. But
unlike the latter, who aimed at extreme simplicity and con-
centration, Cortona tended to become diffuse, epic, and pas-
toral, and to this extent such pictures prepare the new
stylistic position of the Late Baroque. At the same time, he
toned down the *fortissimo* of his early manner, and with the
insistence on predominant verticals, the firm framing of the
composition, and the arrangement of figures in parallel lay-
ers, he confirmed that the period of the exuberant High
Baroque was a thing of the past.

* The *Sacrifice to Diana* is now related to a payment for a frame in 1631, and
accepted as an early work (I. Lavin, 1970, doc. 2). In adding an illustration of a
late work [102], we are well aware that this confutes Wittkower's description of
Cortona's late style.

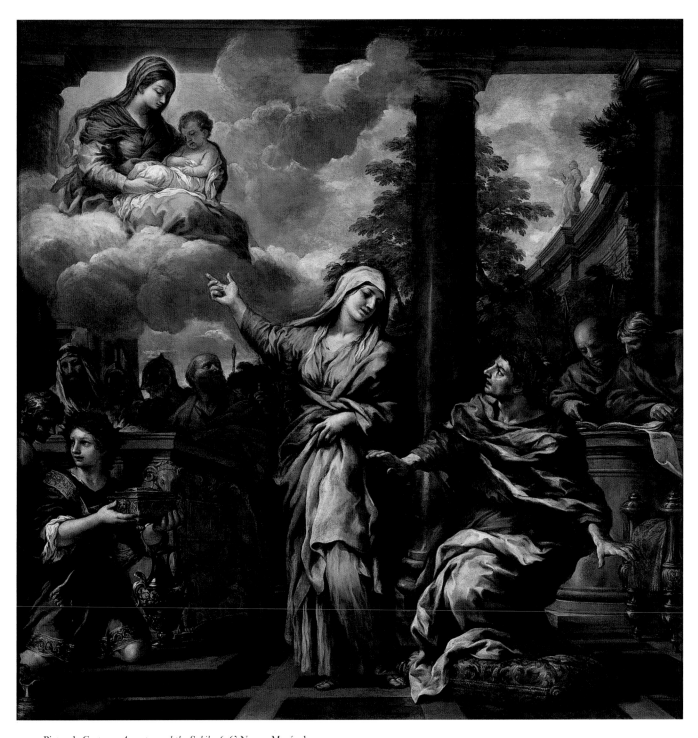

102. Pietro da Cortona: *Augustus and the Sybil*, 1656? Nancy, Musée des
Beaux-Arts

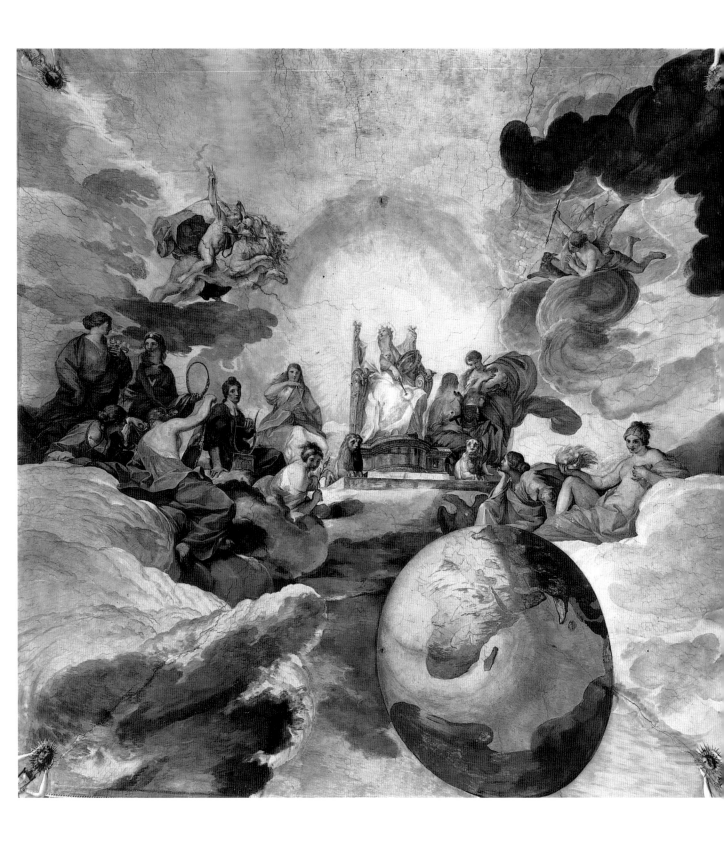

103. Andrea Sacchi: *La Divina Sapienza*, 1629–33. Fresco. Rome, Palazzo
Barberini

'High Baroque Classicism': Sacchi, Algardi, and Duquesnoy

The foregoing chapters have been devoted to the three great masters of the High Baroque. Older artists, mainly Guercino and Lanfranco, had decisively contributed in the 1620s to the Baroque surge, to which the Bolognese classicism of the second decade had to yield. Although the authority of all these masters was tremendous, it remained by no means unchallenged; the voices of moderation, rationalism, and partisanship with the classical cause were not drowned for long. In the 1630s new men formed a powerful phalanx. They knew how to fight and even win their battles. The most distinguished artists of this group are the Frenchman Poussin, the Roman painter Andrea Sacchi, and two sculptors, the Bolognese Alessandro Algardi and the Fleming Francesco Duquesnoy. What they stand for is not a straight continuation of Bolognese classicism, but a revised version, tinged by the influence of the great masters and, in painting, by a new impact of Venetian colourism which was shared by the leading 'Baroque' artists, Lanfranco, Cortona, and Bernini. Compared with the Early Baroque classicism, the new classicism was at first rather boisterous and painterly; it has a physiognomy of its own, and it is this style that by rights may be termed 'High Baroque classicism'.

ANDREA SACCHI (1599–1661)

For Poussin's development and the principles he believed in, the reader must be referred to Anthony Blunt's masterly presentation.[1] The Italian leader of the movement was Sacchi.[2] Reared in Rome, he was trained by Albani, first in his native city, later at Bologna; but from about 1621 he was back in Rome for good. In contrast to the dynamic Baroque artists a slow producer, critical of himself, bent on theorizing, he was by temperament and training predisposed to embrace the classical gospel. Yet his earliest large altarpiece, the *Virgin and Child appearing to St Isidore* (after 1622, S. Isidoro), is still much indebted to Lodovico Carracci. Probably less than three years later he painted the *St Gregory and the Miracle of the Corporal* (1625–7, Vatican Pinacoteca) [104], which reveals a mature and great master. With its rich and warm colours painted in a light key and its splendid loose handling, this work may be regarded as the first masterpiece of the new manner. The story, taken from Paulus Diaconus, illustrates how the cloth with which the chalice had been cleaned is pierced with a dagger by the pope and begins to bleed. The stranger who had doubted its magic quality sinks on to his knee, amazed and convinced. His two companions echo his wonderment, but the pope and his deacons are unperturbed. Sacchi had learned his lesson from Raphael's *Mass of Bolsena* and rendered the story in similar psychological terms: the calmness of those firm in their faith is contrasted to the excitement of the uninitiated. A minimum of figures, six in all, invites detailed scrutiny

and enhances the effect of the silent drama. The organization of the canvas with its prominent triangle of three figures is essentially classical. But there is no central axis, and the cross of spatial diagonals allies the design to advanced compositional tendencies. Moreover the tight grouping of massive figures and the emphatic pull exercised by those turned into the picture belong to the Baroque repertory. The *St Gregory* is exactly contemporary with Cortona's Bibiana frescoes [94], and it is evident that at this moment the antagonism between the two artists, though latent, has not yet come into the open – on the contrary, both works reveal similar intense qualities and clearly form a 'common front' if compared with works of the older Bolognese or the Caravaggisti.

104. Andrea Sacchi: *St Gregory and the Miracle of the Corporal*, 1625–7. Rome, Vatican Pinacoteca

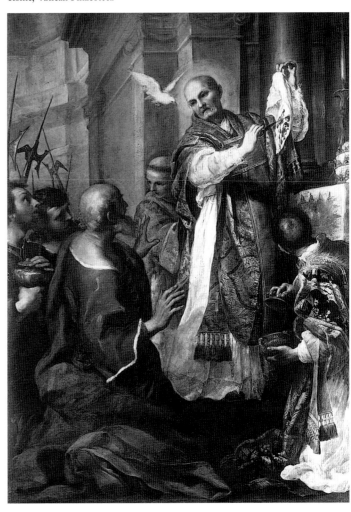

105. Andrea Sacchi: *The Vision of St Romuald*, 1631. Rome, Vatican Pinacoteca

We have seen that shortly after the *St Gregory* Sacchi worked with and under Cortona at Castel Fusano (1627–9). At that time their ideological and artistic differences must have begun to clash. A few years later Sacchi had moved far from the position of the *St Gregory*, as is proved by his best-known work, the *Vision of St Romuald*[3] (Vatican Pinacoteca) [105]. Here under the shadow of a magnificent tree, the saint is telling the brethren his dream about the ladder leading to heaven on which the deceased members of the Order ascend to Paradise. The choice and rendering of the subject are characteristic for Sacchi: instead of employing the Baroque language of rhetoric, he creates real drama in terms of intense introspection in the faces and attitudes, and the soft Venetian gold tone permeating this symphony in white is in

perfect harmony with the pensive and deeply serious frame of mind of the listening monks. Within Sacchi's range, the *St Gregory* is by comparison 'loud' and trenchant colouristically, compositionally, and psychologically. The Baroque massiveness of the figures has now been considerably reduced; in addition they are moved away from the picture plane and face the beholder. All his later work is painted in a similar low key and with a similar attention to psychological penetration and concentration on bare essentials. In the 1640s he went a step further beyond the *St Romuald*. The principal work of this period, the eight canvases illustrating the *Life of the Baptist* painted for the lantern of S. Giovanni in Fonte (1641–9),[4] shows that he wanted to strip his style of even the slightest embroidery. Trained on Raphael, he reached a degree of classical simplicity that is the precise Italian counterpart to Poussin's development of these years.[5]

Sacchi's and Cortona's ways parted seriously during their work in the Palazzo Barberini. As Cardinal Antonio Barberini's protégé, Sacchi was given the task of painting on the ceiling of one room *Divine Wisdom* (1629–33)[6] [103], illustrating the apocryphal text from the *Wisdom of Solomon* (6:22); 'If therefore ye delight in thrones and sceptres, ye princes of peoples, honour wisdom, that ye may reign for ever.' Possibly finished in the year in which Cortona began his *Divine Providence*, the two works, with their implicit allegorical references to the Barberini Pope, supplement each other as far as the theme is concerned. But how different from Cortona's is Sacchi's approach to his task! Divine Wisdom enthroned over the world is surrounded by eleven female personifications symbolizing her qualities in accordance with the text. Sacchi represented the scene with the minimum number of figures in tranquil poses; they convey their sublime role by their being rather than by their acting. Raphael's *Parnassus* was the model that he tried to emulate. He renounced illusionism and painted the scene as if it were a *quadro riportato* – an easel-painting. But he did not return to the position of Bolognese classicism, for the fresco is not framed and the entire ceiling has become its stage. Although the affinities with Domenichino cannot be overlooked, the light and loose handling is much closer to Lanfranco.

The Controversy between Sacchi and Cortona

Cortona's and Sacchi's vastly different interpretations of great allegorical frescoes reflect, of course, differences of pinciples and convictions, which were voiced in the discussions of the Accademia di S. Luca during these years.[7] The controversy centred round the old problem, whether few or many figures should be used in illustrating a historical theme. The partisans of classical art theory had good reasons to advocate compositions with few figures. According to this theory, the story in a picture should be rendered in terms of expression, gesture, and movement. These are the means at the painter's disposal to express the 'ideas in man's mind' – which Leonardo regarded as the principal concern of the good painter. It is only in compositions with few figures (Alberti admits nine or ten) that each figure can be assigned a distinct part by virtue of its expression, gesture, and movement, and can thus contribute a characteristic feature to the whole. In a crowded composition, single figures

are evidently deprived of individuality and particularized meaning.

Another aspect supported these conclusions. Since painters had always borrowed their terms of reference from poetry (stimulated by Horace's 'ut pictura poesis'),[8] they maintained that a picture must be 'read' like a poem or tragedy, where not only does each person have his clearly circumscribed function, but where the Aristotelian unities also pertain.

Pietro da Cortona fully accepted the traditional assumption that the familiar concepts of poetical theory apply to painting. But he pleaded for paintings with many figures, thus departing from classical theory. He compared the structure of painted plots to that of the epic. Like an epic, a painting must have a main theme and many episodes. These are vital, he maintained, in order to give the painting magnificence, to link up groups, and to facilitate the division into compelling areas of light and shade. The episodes in painting may be compared to the chorus in ancient tragedy, and, like the chorus, they must be subordinate to the principal theme. Sacchi, by contrast, insisted unequivocally that painting must vie with tragedy: the fewer figures the better; simplicity and unity are of the essence.[9] It is now clear that both masters made the theoretical position which they defended explicit in their work.

If we can here follow the formation or rather consolidation of two opposing camps, it is also evident that Cortona never dreamed of throwing overboard the whole intellectual framework of classical art theory. Like Bernini, he subscribed to its basic tenets but modified them in a particular direction. On the other hand, the circle round Poussin, Sacchi, Algardi, and Duquesnoy was a strong party which would never waive its convictions. His French rationalism and discipline carried Poussin even further than Sacchi; as early as the end of the 1620s he endeavoured to emulate ancient tragedy by reducing the *Massacre of the Innocents* (Chantilly) to a single dramatic group. The stiffening of the theoretical position may be assessed by comparing Poussin's *Massacre* with Reni's, of 1611.

Sacchi himself further clarified his theoretical standpoint in the studio talk given at about this time to his pupil Francesco Lauri (1610–35),[10] and later in a letter written on 28 October 1651 to his teacher, Francesco Albani.[11] In the former document he reiterated the basic repertory of the classical theory by concentrating on decorum and the rendering of the *affetti*,[12] gestures and expression. He advocated natural movement and turned against the obscurantism produced by rhetorical embroidery and every kind of excess, such as the overdoing of draperies. In the letter to Albani, concerned with similar problems, he laments with extremely sharp words the neglect of propriety and decorum which has caused the decay of the art of painting. Albani, in his answer, strikes a new note by deriding the choice of tavern scenes and similar low subjects, for which he makes the northern artists responsible. Against their degrading of high principles, he upholds the ideals of Raphael, Michelangelo, and Annibale Carracci.[13]

Albani's targets were, of course, the Bamboccianti. Sacchi's controversy with Cortona, by contrast, was on the level of 'high art'. Equal is speaking to equal, and the differences are fought out in the lofty atmosphere of the Academy. The theoretical rift, though, and its practical consequences are clear enough. It did not, however, prevent Cortona from frequenting the circle of artists who were opposed to his views. We are not astonished to find that Cortona, in the *Treatise*[14] which he published together with the Jesuit Ottonelli in 1652, upheld the traditional ideals of propriety and decorum and also insisted on the moral function of art. But side by side with this appears the concept of Art as pure form without an extraneous *raison d'être*. Thus the Baroque antithesis *docere-delectare*[15] makes its entry into the theory of art, and the hedonistic principle of delight as the purpose of painting comes into its own. In keeping with this, Cortona's art has an outspoken sensual quality, while Sacchi, classicist and moralist like Poussin, refrains more and more from appealing to the senses.

There is no doubt that Sacchi and his circle won the day. Not only did he and his confrères pursue relentlessly the aim of cleansing their art of Baroque reminiscences, but they extended their influence to Cortona's pupils, such as Francesco Romanelli and Giacinto Gimignani (1606–81), and made possible in the 1640s the ascendancy in Rome of archaizing painters like Sassoferrato (1609–85) and Giovan Domenico Cerrini (1609–81). Even the great Baroque masters were touched by their ideas, and Bernini himself, after his abortive classicizing phase of the 1630s, found a new approach to this problem in his old age. The classical wave surged far beyond the confines of the artistic capital and threatened to quell a free development in such vigorous art centres as Bologna. Moreover the classical point of view received literary support, not dogmatically perhaps, from the painter and biographer of artists Giovanni Battista Passeri, the friend of Algardi and Sacchi, and most determinedly from Giovanni Bellori (1615–96), the learned antiquarian, the intimate of Poussin and Duquesnoy, and the mouthpiece and universally acclaimed promoter of the classical cause.

Even if it is correct that Monsignor Agucchi (I: p. 14) anticipated Bellori's ideas, the old battles were fought on new fronts. While Agucchi had turned against Caravaggio's 'naturalism' and the *maniera* painters, Sacchi, Bellori and the rest sustained the classic-idealistic theory against the Baroque masters and the Bamboccianti, the painters of the lower genre. In the light of this fact, we may once again confirm that 'Baroque classicism' dates from the beginning of the 1630s. Before that time no serious collision took place. It was only from the seventeenth century on that there existed real dissenters, and, therefore, classicism had to dig in. While at the beginning of the century there was a large degree of theoretical flexibility, the attitude of the defenders of classicism had to become, and became, less tractable after 1630; and as the century advanced the breach between the opposing camps widened – until in the wake of Poussin the French Academy turned the classical creed into a pedantic doctrine. The Italians proved more supple. Sacchi's position was taken up by his pupil Carlo Maratti, who handed on the classical gospel to the eighteenth century and ultimately to Mengs and to Winckelmann, the real father of Neoclassicism and passionate enemy of all things Baroque. Pietro da Cortona, on the other hand, must be regarded as

the ancestor of the hedonistic trend which led via Luca Giordano to the masters of the French and Italian Rococo.[16]

ALESSANDRO ALGARDI (1598-1654)[17]

No sculptor of the seventeenth century bears comparison with Bernini. Indeed, in the second quarter of the century there existed in Rome, apart from his studio, only two independent studios of some importance: those of Algardi and Duquesnoy. The latter was a solitary character; with the exception of the statue of St Andrew in St Peter's, he never had a large commission, he never had a devoted pupil, and his considerable influence was exercised through the objective qualities of his work rather than through the fascination

106. Alessandro Algardi: *St Mary Magdalen*, *c*. 1628. Stucco. Rome, S. Silvestro al Quirinale

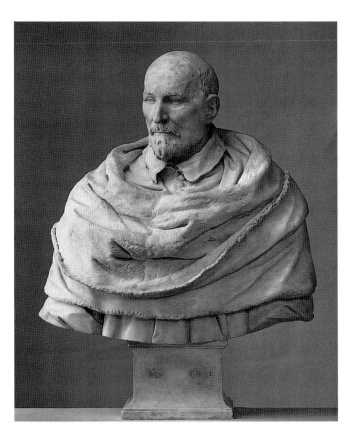

107. Alessandro Algardi: Bust of Cardinal Laudivio Zacchia, 1626(?). Berlin, Staatliche Museen

of his personality.[18] The case of Algardi is different. For a short time his studio had some similarity to that of Bernini. During the last fifteen years of his life he had to cope with numerous and extensive commissions; and, after Bernini's, his reputation as a sculptor had no equal between about 1635 and his death in 1654. At the beginning of Innocent X's reign (from 1644), at a time when the greater man was temporarily out of favour, he even stepped into Bernini's place.

Algardi, coming from Bologna where he had frequented the Academy of the aged Lodovico Carracci and studied sculpture with the mediocre Giulio Cesare Conventi (1577–1640), reached Rome in 1624 after a stay of some years at Mantua. He came with a recommendation from the Duke of Mantua to Cardinal Lodovico Ludovisi, himself a Bolognese and the owner of a celebrated collection of ancient sculpture,[19] and established contact with his Bolognese compatriots, above all with Domenichino. Cardinal Ludovisi entrusted him with the restoration of antique statues,[20] while Domenichino negotiated for him his first Roman commission of some importance: the statues of *Mary Magdalen* [106] and *St John the Evangelist* for the Cappella Bandini in S. Silvestro al Quirinale (*c*. 1628). These data indicate the components of his style, which derived from the classically tempered realism of the Carracci Academy, the close study of, and constant work with, ancient statuary, and his association with men like Domenichino, the staunch upholder of the classical *disegno*. As one would expect, for the rest of his life Algardi belonged to the younger circle of artists with classical inclinations;

108. Alessandro Algardi: Bust of Cardinal Giovanni Garzia Millini, after 1629. Rome, S. Maria del Popolo

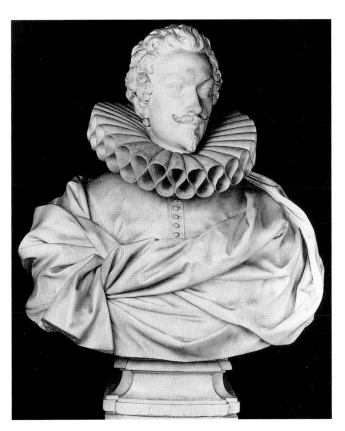

109. Alessandro Algardi: Bust of a member of the Pamphili family, after 1644. Rome, Palazzo Doria

and Poussin, Duquesnoy, and Sacchi were among his friends.

Yet in spite of the difference of talent and temperament, education and artistic principles, Algardi was immediately fascinated by Bernini: witness his figure of Mary Magdalen [106], the style of which is half-way between the subjectivism of Bernini's *Bibiana* and the classicism of Duquesnoy's *Susanna* [114]. In fact Algardi remained to a certain extent dependent on his great rival. This is also apparent in his early portrait busts; that of Cardinal Giovanni Garzia Millini (d. 1629)* [108] in S. Maria del Popolo is unthinkable without Bernini's *Bellarmine*, while that of Monsignor Odoardo Santarelli in S. Maria Maggiore, probably belonging to Algardi's earliest productions in this field, follows closely Bernini's *Montoya*.

Nevertheless, Bernini's and Algardi's approach to portraiture differed considerably. A comparison between Bernini's *Scipione Borghese* of 1632 [7] and Algardi's perhaps earlier *Cardinal Laudivio Zacchia* in the Staatliche Museen, Berlin [107],[21]** makes this abundantly clear. In contrast to the transitory moment chosen by Bernini, Algardi represents his sitter, with his mouth closed, in a state of permanence and tranquil existence. Scipione Borghese seems to converse with us, while Algardi's cardinal remains static, immobile for ever. Even the most meticulous attention to detail, down to wrin-

kles and warts, and the most able treatment of skin, hair, and fur does not help to give such portraits Bernini's dynamic vitality. Compared with Bernini, who never loses sight of the whole to which every part is subordinated, Algardi's busts look like aggregates of an infinite number of careful observations made before the sitter. All forms and shapes are trenchant and precise and retain their individuality: this is a decisive aspect of Algardi's 'realist classicism'. But for solidity and seriousness his portraits are unequalled; the mere bulk of any of his early busts brings the sitter physiologically close to us, and in this weightiness consists the High Baroque community of spirit not only with Bernini but also with Cortona and the early Sacchi.[22]

Algardi's genius for the sober representation of character has always been admired. The number of portrait busts by his hand is considerable, and it seems that many of them were done during his first years in Rome. In any case, it would appear that already in the course of the 1630s Algardi had begun to move away from his intense realism. Abandoning the warm and vivid treatment of the surface and the subtle differentiation of texture, he replaced the freshness of the early works by a noble aloofness in his later busts. One of the finest of that period, the stylish a member of the Pamphili family (after 1644, Rome, Palazzo Doria) [109], exhibits this classicism to perfection.[23] Thus, not unlike Sacchi, Algardi steers towards a more determined classicality.

In 1629 Algardi's reputation was not yet sufficiently established for him to be considered for one of the four

* This tomb was commissioned in 1637 (J. Montagu, 1985).
** D. Dombrowski (1997) has demonstrated that this bust does not represent Cardinal Laudovico Zacchia; his attribution of it to Giuliano Finelli is more debatable.

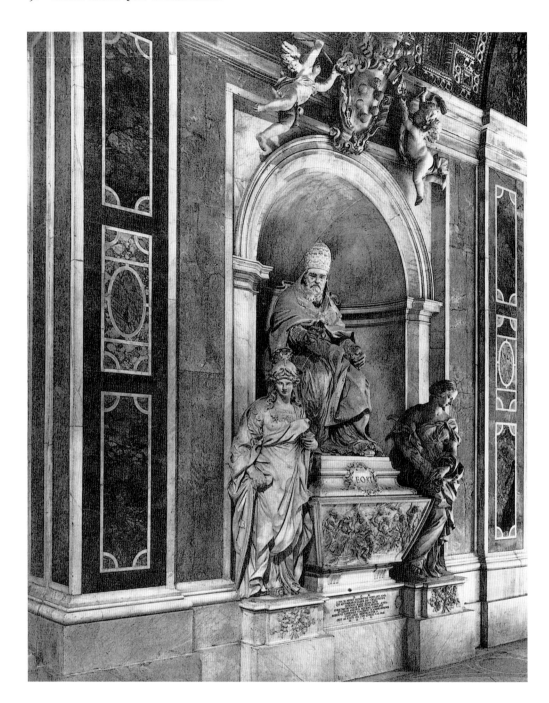

monumental statues under the dome of St Peter's. He was in his fortieth year when the first great commission, the tomb of Leo XI, fell to him; and it was not until 1640 that he was offered another monumental task: the over-life-size statue of St Philip Neri in S. Maria in Vallicella, in which he followed closely the example set by Guido Reni in the same church. Then, under Innocent X, the commissions came in quick succession.[24] Between 1649 and 1650 he executed the memorial statue of Innocent X in bronze as a counterpart to Bernini's earlier statue of Urban VIII (Palazzo dei Conservatori). Once again Algardi was impressed by Bernini; but instead of suppressing detailed characterization as Bernini had done, his pope has been rendered with minutest care and is, indeed, a great masterpiece of portraiture. Yet for all its intimate qualities the statue lacks the visionary power of its counterpart. Algardi did not accept

the hieratic frontality of Bernini's *Urban*; he turned his statue in a more benevolent attitude towards the left; he considerably toned down the great diagonal of the papal cope, and transformed an energetic and commanding gesture into one of restraint and halting movement. He weakened the power of the blessing arm by the linear and decorative folds of the mantle, while Bernini enhanced the poignancy of benediction by pushing the arm forcefully forward into the beholder's space.

The execution of Leo XI's tomb [110, 111], extending over many years,[25] ran parallel with that of Bernini's tomb of Urban VIII. But Algardi, beginning six years after Bernini, must have been familiar with Bernini's design. Leo's tomb is, in fact, the first papal tomb dependent on that of Urban VIII. All the salient features recur: the pyramidal arrangement of three figures, the blessing pope above the sarcophagus, and

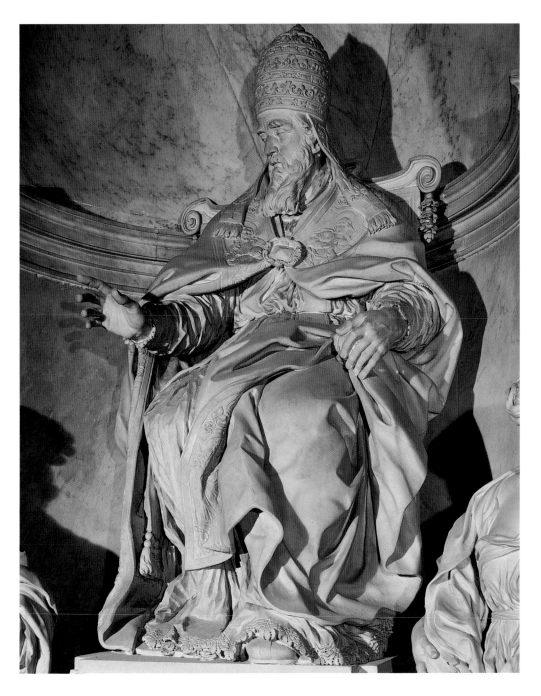

the allegories standing next to it in a zone before the papal figure. Algardi had to plan for an unsatisfactory position in one of the narrow passages of the left aisle of St Peter's. Bound by spatial restrictions, he reduced the structural parts to a minimum. At the same time, the absolute preponderance of the figures suited his classicizing stylistic tendencies. Algardi also supplied a narrative relief,[26] for which there was no room in the dynamic design of the Urban tomb. But during his classical phase Bernini did introduce a relief on the sarcophagus of the Countess Matilda monument in St Peter's (begun 1633), and slightly later on the tombs of the Raimondi Chapel in S. Pietro in Montorio.[27] Algardi made use of this device, and his debt to the Matilda monument is borne out by the fact that he fitted his narrative biographical relief into a similar trapezoid shape.

If the compositional elements of Leo XI's tomb were thus derived from Bernini, Algardi departed from him most decisively in other respects. The tomb consists entirely of white Carrara marble. Algardi avoided the use of colour as emphatically as Bernini accepted it. Instead of a warm rendering of the skin and a luminous sparkle of the surface such as are found in Bernini's Urban tomb, Algardi's evenly-worked marbles have a cool, neutralized surface which is particularly evident in the head of the allegory of Courage. Instead of the transitory moment represented in Bernini's allegories, we find a permanent condition in those of Algardi. In fact, Algardi asserts his classical convictions in all and every respect, but I am far from suggesting that the result is a truly classical work. It is as far or even farther removed from Canova's classicism as Sacchi's paintings are from those of Mengs. Under the shadow of Bernini's overpowering genius, Algardi never even attempted to follow

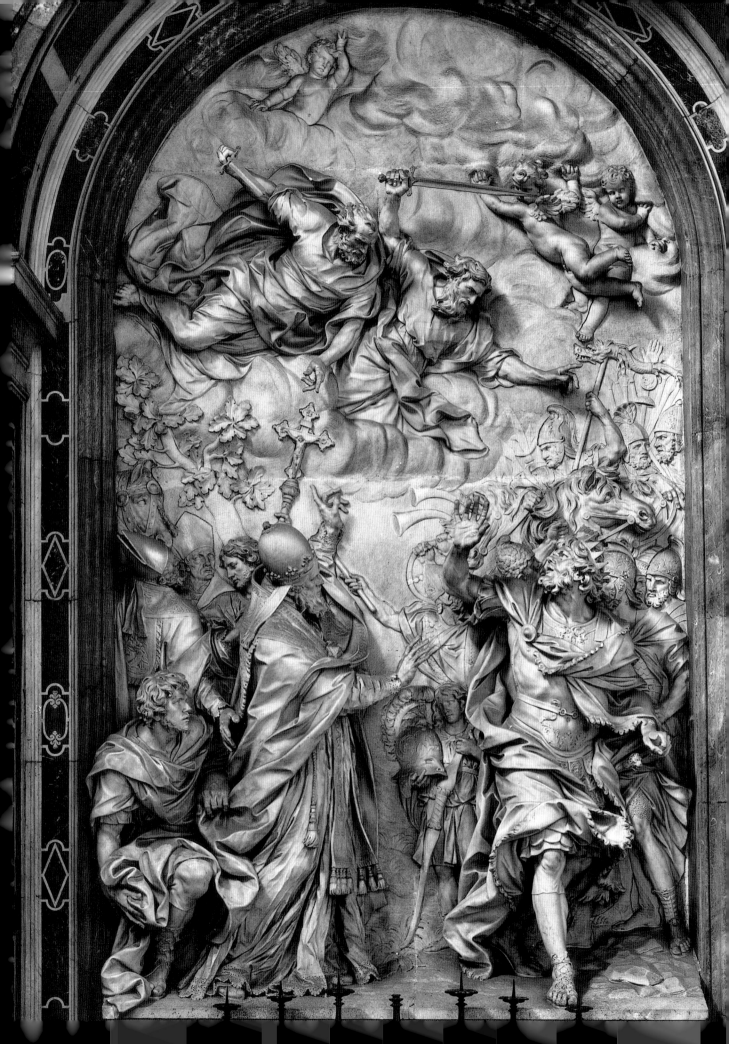

Sacchi the whole way. His tomb of Leo XI is a true monument of High Baroque classicism.

In contrast to this papal tomb, Algardi created a new Baroque species in his largest work, the relief representing the *Meeting of Leo and Attila* (1646–53, St Peter's) [112].[28] The historical event of the year A.D. 452 was always regarded as a symbol of the miraculous salvation of the Church from overwhelming danger, and it was only appropriate to give this scene pride of place in St Peter's. Much indebted to Raphael's example, Algardi's interpretation of the event is simple and convincing. As in Raphael's fresco, only pope and king perceive the miraculous apparition of the Apostles; the followers on both sides are still unaware of it. The rigidly maintained triple division of the left half, right half, and the upper zone results from the story, the protagonists of which dominate the scene. Once the traditional reserve towards this relief has been overcome, one cannot but admire its compositional logic and psychological clarity. Its unusual size of nearly 25 feet height has often led to the fallacious belief that its style, too, has no forerunners; but in fact the history of the illusionistic relief dates back to the early days of the Renaissance, to Donatello and Ghiberti. In contrast, however, to the *rilievo scacciato* of the Renaissance, Algardi desisted from creating a coherent optical space and used mainly gradations in the projection of figures to produce the illusion of depth. The flatter the relief grows, the more the figures seem to recede into the distance, while the more they stand out, the nearer they are to us. Those in the most forward layer of the relief are completely three-dimensional and furnish transitions between artistic and real space; the problem of spatial organization is thus turned into one of psychological import and emotional participation.

After Algardi had created this prototype, such reliefs were preferred to paintings whenever circumstances permitted it. This was probably due to the fact that a relief is a species half-way, as it were, between pictorial illusion and reality, for the bodies have real volume, there is real depth, and there is a gradual transition between the beholder's space and that of the relief. More effectively than illusionist painting, the painterly relief satisfied the Baroque desire to efface the boundaries between life and art, spectator and figure. Only periods which demand self-sufficiency of the work of art will protest against such figures as the Attila, who seems to hurry out of the relief into our space; for people of the Baroque era it was precisely this motif that allowed them fully to participate in Attila's excitement in the presence of the miracle. But now it is important to realize why it was Algardi rather than Bernini who brought into being the pictorial relief of the Baroque.

In Bernini's work, reliefs are of relatively little consequence; it seems that they did not satisfy his desire for spatial interpenetration of sculpture and life. A relief is, after all, framed like a picture, and consequently the illusion it creates cannot be complete. If we recall Bernini's handling of plastic masses which invade real space without limiting

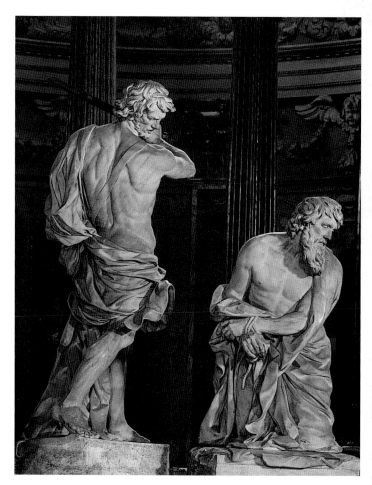

113. Alessandro Algardi: *The Decapitation of St Paul*, 1638–43. Bologna, S. Paolo

frames (p. 14), Algardi's *Attila* appears by comparison temperate, controlled, and relegated to the sphere of art. It would not be difficult to show that this difference between Bernini's and Algardi's approach cannot be explained by the hazards or demands inherent in different commissions. While Bernini seeks to eliminate the very difference between painting, relief, and free-standing sculpture, Algardi meticulously preserves the essential character of each species.

His interpretation of a free-standing group can best be studied in his *Decapitation of St Paul* (1638–43, Bologna, S. Paolo) [113].[29] The two figures of the executioner and the saint are placed within a framing semicircle of columns behind the main altar. Entirely isolated, each figure shows an uninterrupted silhouette and preserves its block-like quality. It would have been contrary to Algardi's principles to detract from the clarity of these figures by placing them against a sculptured or 'picturesque' background. This is particularly revealing in view of the fact that he was stimulated by pictorial impressions: it was Sacchi's *Martyrdom of St Longinus* at Castelgandolfo that had a formative influence on his conception.[30]

The Attila relief was Algardi's most important legacy to posterity.[31] While a work like the *Decapitation of St Paul* with its Sacchesque gravity, simplicity, and psychological

112. Alessandro Algardi: *The Meeting of Pope Leo I and Attila*, 1646–53. Rome, St Peter's

penetration illustrates excellently his partisanship with the classical cause, the more 'official' relief shows that, confronted with a truly monumental task, Algardi was prepared to compromise and to attempt a reconciliation between the leading trend of Bernini's grand manner and the sobriety of classicism – between the impetuous art of a genius and his own more limited talents.

FRANCESCO DUQUESNOY (1597–1643)

Duquesnoy was probably a greater artist than Algardi; in any case, he was less prepared to compromise.[32] Born in Brussels in 1597, the son of the sculptor Jerôme Duquesnoy, he came to Rome in 1618 and stayed there until shortly before his premature death in 1643.[33] He was so thoroughly acclimatized that even the discerning eye will hardly discover anything northern in his art. Soon Duquesnoy was a leading figure in the circle of the classicists; after Poussin's arrival in Rome he shared a house with him, and he was on intimate terms with Sacchi. He also soon belonged to the group of artists who worked for Cassiano del Pozzo's *corpus* of classical antiquity (p. 63). But ten years went by before he became a well-known figure in the artistic life of Rome. Between 1627 and 1628 Bernini employed him on the sculptural decoration of the Baldacchino.[34] His reputation established, he was chosen to execute the *St Andrew*, one of the four giant statues under the dome of St Peter's. And in 1629 he received the commission for his most famous work, the statue of St Susanna in the choir of S. Maria di Loreto [114].[35]

For a study of Duquesnoy, one should first turn to this celebrated figure. Susanna originally held the martyr's palm in her right hand; with the left she is making a timid gesture towards the altar, while her face is turned in the direction of the congregation.[36] Bellori, a devoted admirer of Duquesnoy's art, maintained that it was impossible to achieve a more perfect synthesis of the study of nature and the idea of antiquity. Duquesnoy, he relates, worked for years from the model, while the ancient statue of Urania on the Capitol was always before his mind's eye. The stance and the fall of the drapery are, indeed, close to the Urania and other similar ancient figures. The contour of the statue is clear and uninterrupted and the studied *contrapposto* is utterly convincing: the leg on which the weight of the body rests, the free-standing leg, the sloping line of the shoulders, the gentle turn of the head – all this is beautifully balanced and supported by the fall of dress and mantle. The folds are gathered together on the slightly protruding right hip, and it was precisely the classically poised treatment of the drapery that evoked the greatest enthusiasm at the time. Bellori regarded the *Susanna* as the canon of the modern draped figure of a saint. This judgement was perfectly justified, since there is hardly any other work in the history of sculpture, not excluding Bernini's most important statues, that had an effect as lasting as Duquesnoy's *Susanna*.

114. Francesco Duquesnoy: *St Susanna*, 1629–33. Rome, S. Maria di Loreto

115. Francesco Duquesnoy: *St Andrew*, 1629–40. Rome, St Peter's

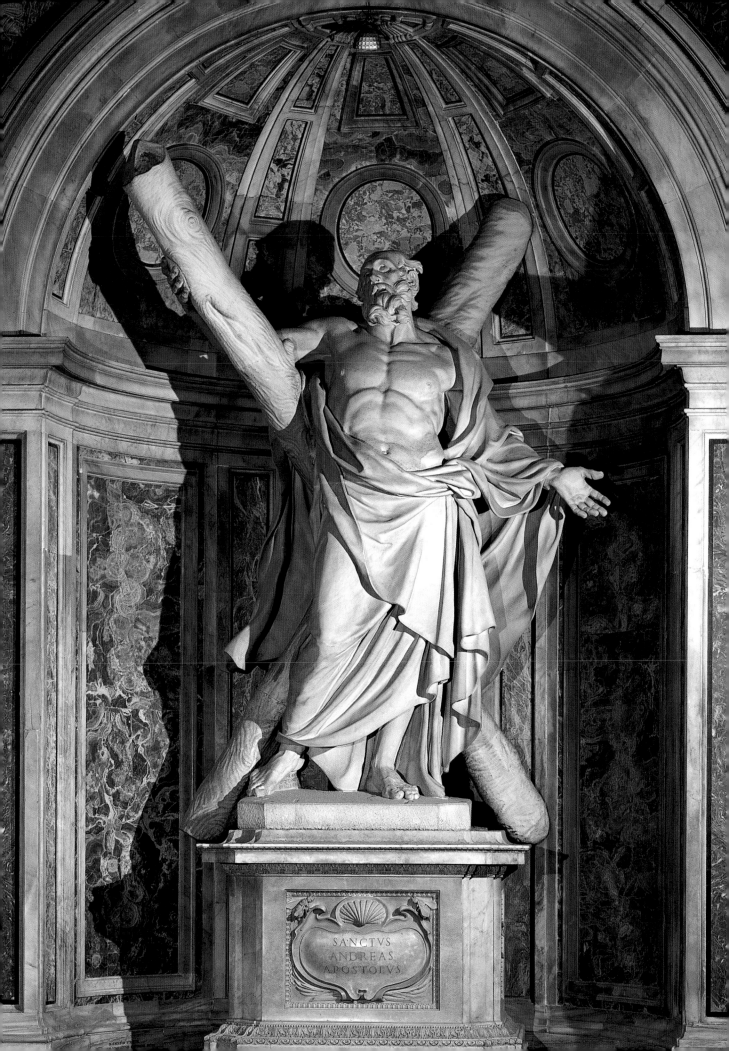

116. Francesco Duquesnoy: Tomb of Ferdinand van den Eynde, 1633–40. Rome, S. Maria dell' Anima

117 (*right*). Francesco Duquesnoy: A Putto from the Andrien Vryburch Tomb, 1629. Rome, S. Maria dell' Anima

118 (*far right*). Francesco Duquesnoy: A Putto, after 1630. Terracotta.

A comparison between the *Susanna* and Bernini's *Bibiana* of five years earlier [4] makes the limpid and temperate simplicity of the *Susanna* all the more obvious, particularly if one considers that the *Bibiana* was well known to Duquesnoy, and that even he could not entirely dismiss her existence from his thoughts. Coming from the *Susanna*, one finds the stance of Bernini's figure ill-defined and the mantle obscuring rather than underlining the structure of the body. In contrast to the wilfully arranged fall of the folds in the *Bibiana*, the mantle of the *Susanna* strictly follows the laws of gravity; in contrast to the individual characterization of Bibiana's dress, Susanna is shown in the timeless attire of classical antiquity. Duquesnoy abstained from any indication of time and space; a simple slab, instead of a rock with vegetation, forms the base of the statue. It was not the individual fate of a saint, but the objective state of sainthood which he desired to portray. Consequently, he represented his saint in a state of mental and physical repose instead of selecting a transitory moment as Bernini had done. He gave shape to an ideal norm with the same compelling logic with which Bernini had characterized a fleeting instant and a fluctuating movement. No light is playing on the surface, the forms are firm, clear, and unchangeable, and any departure from such objectivity is carefully avoided.[37] The face of

Susanna is shown with her mouth closed and her eyes gazing into space with the blank eyeballs of Roman statues; whereas Bernini made it a point to incise the iris and pupil, which gives the look direction and individual expression. Behind these two contrasting interpretations of saints lie the two different approaches: the Baroque and the classical, a subjective as opposed to an objective conception, dynamic intensity as opposed to rational discipline. The similarity of Sacchi's and Duquesnoy's developments is more than mere coincidence; both turn over a new leaf in 1629, the one with the *Divine Wisdom*, after having worked under Cortona at Castel Fusano, the other with the *Susanna*, after having worked under Bernini in St Peter's.

So far I have treated the *Susanna* and *Bibiana* as basically antagonistic, but this is not the whole story. Nobody with any knowledge of the history of sculpture would fail to date the *Susanna* in the seventeenth century. Sacchi's and Algardi's works have shown that this 'Baroque classicism' reveals symptoms characteristic of the period. The head of the *Susanna* displays a lyrical and delicate sweetness (Bellori called it 'un aria dolce di grazia purissima') such as is found neither in classical antiquity nor in the adored models of Raphael and his circle; but we do find the same sort of expression in paintings of the period, such as the almost

exactly contemporary frescoes by Domenichino in the choir of S. Andrea della Valle; and conversely, echoes of the head of the *Susanna* are frequent in Sacchi's pictures. This essentially seventeenth-century sensibility and the stronger sensations of ecstasy and vision do not differ intrinsically, but only in degree. The blending of classical purity of form with the expression of seventeenth-century susceptibility had an immense appeal for contemporaries, a fact which is borne out by the many replicas of the head of Susanna.[38] Moreover, a direct line leads from here to the often sentimental prettiness of the 'classicist Rococo'[39] of which Filippo della Valle's *Temperance* [III: 69] may serve as an example. Not only has the head of the Susanna a distinctly seventeenth-century flavour: the porous and soft treatment of the surface, of skin, hair, and dress, which seems to impart warm life to the statue – a life that is completely lacking in most of the ancient models known to the seventeenth century – is typical of the spirit of the Baroque. Finally, with the subtle relations between the statue, the altar, and the congregation, Duquesnoy enlarged the spiritual relevance of his figure beyond its material boundaries. Thus he advanced some steps along the path which Bernini followed to the end.

The case of the *Susanna* is closely paralleled by Duquesnoy's *St Andrew* (1629–40) [115].[40] The stance of the figure and the fall of the drapery are of almost academic classicality, adapted from ancient statues of Jupiter. A comparison with Bernini's *Longinus* [5] illustrates emphatically the deep chasm that divides the two artists. But even this figure is not self-sufficient, for St Andrew turns with pleading gesture and devotional expression towards the heavenly light streaming in from the dome, while the ample cloak endows him with Baroque mass and weight. Duquesnoy's eminence, however, lay in the handling of works of smaller dimensions, and this monumental statue lacks the convincing oneness which in those very years he was able to give to his *St Susanna*. The statuesque body of the figure contrasts with the emotional expression of the head; and the transference of the heroic Jupiter type to the Christian saint is as unsatisfactory as the Baroque diagonal going through shoulders and arms is petty and feeble.

During his first Roman years Duquesnoy had earned his living mainly by small sculpture in bronze and ivory, by wooden reliquaries, and by restoring ancient marbles. Nor are many of his later works in marble of large size; neither the tomb of Andrien Vryburch of 1629 [117] nor that of Ferdinand van den Eynde of 1633–40 [116], both in S. Maria dell'Anima, nor the earlier tomb of Bernardo Guilelmi (S. Lorenzo fuori le Mura),[41] in which he fol-

119. Francesco Duquesnoy: *Putto Frieze*, 1640–2. Wax model for
SS. Apostoli (Naples). Berlin, Staatliche Museen

lowed fairly closely Bernini's Montoya bust. An endless
number of small reliefs and statuettes in bronze, ivory, wax,
and terracotta representing mythological, bacchic, and reli-
gious subjects continued to come from his studio to the end
of his life; and it was on these little works of highest per-
fection that his reputation was mainly based. Artists and
collectors valued them very highly and regarded them as
equal to antiquity itself; and original models and casts after
such works belonged to the ordinary equipment of artists'
studios.[42]

Duquesnoy's special interest was focused on representa-
tions of the putto [117, 118]. He really gave something of the
soul of children and modelled their bodies so round, soft,
and delicate that they seem to be alive and to breathe; the
subtle transitions between one form and another and the
tenderness of the surface can be as little reproduced as the
quivering *sfumato* of Correggio's palette. It was Duques-
noy's conception of the *bambino* that became a general
European property and, consciously or unconsciously, most
later representations of small children are indebted to him.
But Duquesnoy's rendering of the putto was not static, and
this is reflected in the differences of opinion about the
Vryburch and van den Eynde tombs. Some critics regarded
only the one, some only the other as original. The truth
seems to be that the putti of both monuments are entirely by
the hand of the master; but while the Vryburch monument,
the earlier of the two, shows a type close to Titian, those of

the van den Eynde monument are evidently indebted to
Rubens.[43]

Even if Bellori and Passeri had not related it, it would be
impossible to overlook how carefully Duquesnoy had stud-
ied Titian. We know from the sources that he was fascinat-
ed by Titian's *Children's Bacchanal*, now in the Prado, at that
time in the collection of Cardinal Ludovisi – a fascination
which he shared with Poussin. The putti of the Vryburch
monument comply closely with Italian standards of beauty
and show a comparatively firm treatment of the skin, while
those of the van den Eynde tomb have the fat bellies and soft
flexibility of children by Rubens. There are other works
which testify to Duquesnoy's intimate study of Titian, and
I would date these, analogous to Poussin's Venetian period,
in the early years, before or about 1630.[44] On the other hand
Flemish characteristics become more prominent towards
the end of Duquesnoy's career, the most important example
being the relief with singing putti on Borromini's altar of the
Cappella Filomarino in SS. Apostoli, Naples [119].[45]

It appears that Duquesnoy returned to his native Flemish
realism, which had lain dormant under the impact of the
Italian experience, and that he imparted it above all to his
putti – in other words when he was not concerned with work
on a large scale, and therefore felt free from the ideological
limitations of the classical doctrine. He thus inaugurated
a specific Baroque type, the influence of which not even
Bernini and his circle could escape.[46]

Architectural Currents of the High Baroque

Each of the three great masters of the High Baroque, Bernini, Borromini, and Pietro da Cortona, created an idiom in his own right. Since many or even most of their buildings were erected after 1650, their influence, on the whole, did not make itself felt until the later seventeenth century and extended far into the eighteenth century. The decisive factor of the new situation due to their activity lies in that, for the time being, Rome became the centre of every advanced movement. And as so often in similar circumstances, minor stars with a distinctly personal manner arose in the wake of the great masters. It is with their work in Rome that we must first be concerned. The following survey is necessarily rather cursory, and only buildings which in the author's view have more than ephemeral significance can be mentioned.

ROME

Carlo Rainaldi

By far the most important architect in Rome after the great trio was the slightly younger Carlo Rainaldi (1611–91). He commands particular interest not only because his name is connected with some of the most notable architectural tasks of the century, but also because he achieved a unique symbiosis of Mannerist and High Baroque stylistic features. Some of his buildings are, moreover, more North Italian in character than those of any other architect working in Rome at that time. This was certainly the result of his long collaboration with his father, Girolamo, who, born in Rome in 1570 and a pupil of Domenico Fontana, had imbibed North Italian architectural conceptions during his long stays at Bologna, Parma, Piacenza, and Modena.[1] In Rome we find him as the 'Architect to the City' (1602) working on a large number of commissions,[2] and even when Innocent X appointed him 'papal architect' at the advanced age of seventy-four (1644) and entrusted him with the design of the Palazzo Pamphili in Piazza Navona,[3] he appeared unburdened by his years – and almost untouched by modern stylistic developments. Together with his son, Carlo, he later shouldered the great task of the planning of S. Agnese. But by then – he was eighty-two – the initiative seems to have slipped into Carlo's hands. The large design of the exterior of S. Agnese in the Albertina, Vienna, showing a heavy and clumsy dome and an unsatisfactory façade derived from Maderno's St Peter's, must be attributed to the son rather than to the father.[4] It illustrates, however, the extent to which Carlo accepted an outmoded fashion.

His time came after his father's death in 1655. Soon he was moving into the limelight and developed a typically Roman grand manner, though without ever ridding himself of the paternal heritage. It is mainly three works, executed during the 1660s and 1670s – S. Maria in Campitelli, the façade of S. Andrea della Valle, and the churches in the Piazza del Popolo – that warrant a more thorough discussion.

In 1660 Pope Alexander VII decided to replace the old church in the Piazza Campizucchi by a new, magnificent structure of large dimensions.[5] Two years later medals showing Rainaldi's design were buried in the foundations. This design, a grand revision of the project for S. Agnese, had little in common with the present building: a dominating dome was to rise above a concave façade framed by powerful projecting piers. The derivation from Cortona's façade of SS. Martina e Luca is evident. Since this scheme was much too ambitious, Carlo next designed a two-storeyed façade behind which the dome, considerably reduced in size, was to disappear. While he retained from SS. Martina e Luca the concept of the convex façade between piers, he drew on another of Cortona's buildings, namely S. Maria in Via Lata, for the portico in two storeys [120].[6] At this stage the plan consisted of a large oval for the congregation and an architecturally isolated, circular domed sanctuary for the

120. Carlo Rainaldi: Rome, S. Maria in Campitelli. Project for the façade. 1658. Rome, Archivio di S. Maria in Campitelli

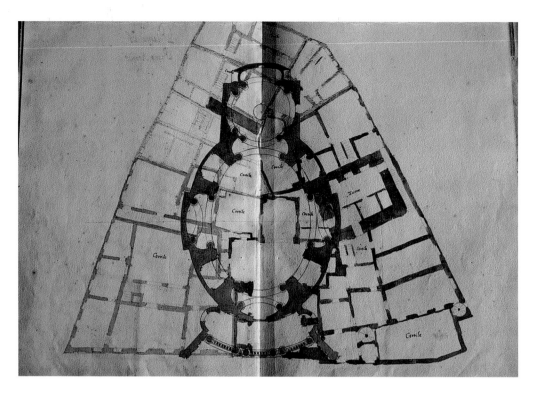

121. Carlo Rainaldi: Rome,
S. Maria in Campitelli. Plan, 1658.
Rome, Archivio di S. Maria in
Campitelli

122. Giovanni Magenta: Bologna,
S. Salvatore, 1605–23. Interior

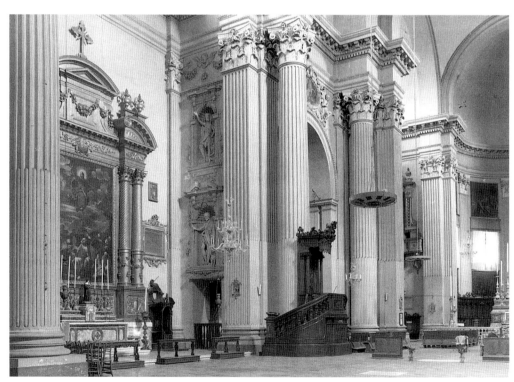

miraculous picture of the Virgin in honour of which the new building was to be erected [123]. The elevation of the oval room followed closely, but not entirely, Bernini's S. Andrea al Quirinale, for the strong emphasis on the transverse axis – a Mannerist motif – was derived from Francesco da Volterra's S. Giacomo degli Incurabili, and so was the shape of the dome, closed at the apex and with lunettes cutting deep into the vaulting. I have singled out this plan for a close scrutiny because the combining of the most recent High Baroque achievements of Cortona and Bernini modified by a deliberate return to a Mannerist structure is typical of Rainaldi. In the final design, which was still further reduced, Rainaldi exchanged the oval room with its low dome for a nave, and this required a straight façade. The building was begun early in 1663 and finished by the middle of 1667.

The final plan contains a number of exciting features which are adumbrated in the oval scheme [126]. The longitudinal nave, to which the domed sanctuary is again

123. Carlo Rainaldi: Rome, S. Maria in Campitelli. Project for the interior. 1658. Rome, Archivio di S. Maria in Campitelli

124. Carlo Rainaldi: Rome, S. Maria in Campitelli, 1658–74. Interior

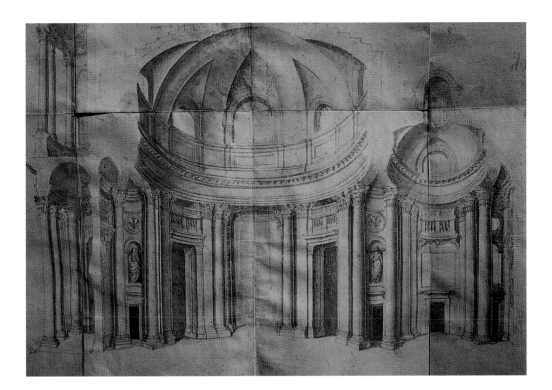

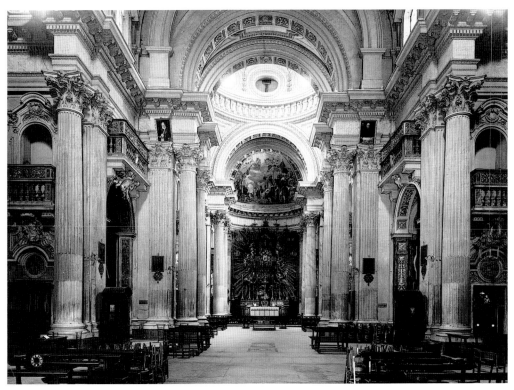

attached, opens in the center into large chapels placed between smaller chapels. It will be recalled that this type of plan has a distinctly North Italian pedigree. Notable among such churches is Magenta's S. Salvatore at Bologna (1605–23) [122], which was rising when Girolamo Rainaldi began to erect S. Lucia in the same city. In S. Salvatore too the transverse axis is strongly emphasized by means of chapels which open to the full height of the nave. In S. Maria in Campitelli these chapels have been given still more

prominence by virtue of their decoration with free-standing columns and by the gilded decorations of the arches. By contrast, the nave is uniformly white and has only pilasters; but an arrangement of columns identical to that of the chapels, an identical accentuation of bays, and the same type of gilded decoration recur at the near and far ends of the sanctuary. Thus there are most telling visual relations between the large chapels and the sanctuary, and the eye can easily wander from the impressive barriers of the transverse

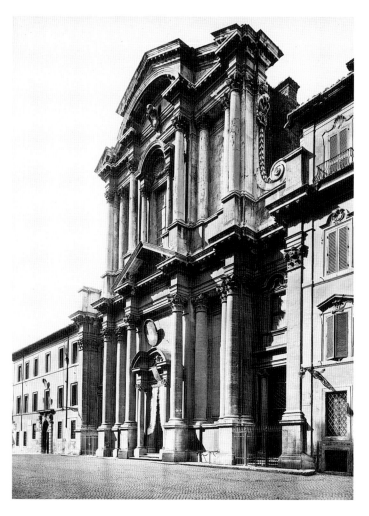

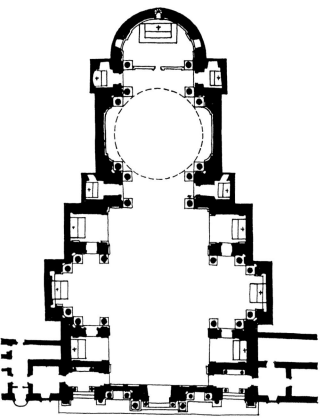

axis along the main direction to the sanctuary [124]. Moreover the bright light streaming into the sanctuary from the dome immediately attracts attention. It appears that in this church the Mannerist conflict of axial directions has been resolved and subordinated to the unifying High Baroque tendencies of direction determined by mass (columns) and light. Details, such as door and balcony surrounds and the curved pilasters standing in the corners of the domed part, owe not a little to Borromini. But it would be a mistake to believe that there is anything Borrominesque in the basic conception of the structure.

What singles out this building and gives it a unique place among the High Baroque churches of Rome is its scenic quality, produced by the manner in which the eye is conducted from the 'cross-arm' to the sanctuary and into depth from column to column. This approach was at home in northern Italy (i: p. 85), but in Rome the scenic character of the architecture of S. Maria in Campitelli anticipates the development of the Late Baroque. Thus we find in this extraordinary building North Italian planning coupled with Roman gravity and Mannerist retrogressions turned into progressive tendencies. The plan of S. Maria in Campitelli had no sequel in Rome. On the other hand, one need not search long to come across similar structures in the North. In the year in which Rainaldi's church was finished Lanfranchi began to build S. Rocco in Turin, where freestanding columns arranged like those of S. Maria in Campitelli were given a similar scenic function. Moreover, the 'false' Greek cross with an added domed chapel remained common in the North throughout the eighteenth century.[7]

An interesting combination of North Italian and Roman tendencies will also be found in the façade of S. Maria in Campitelli [125]. The main characteristics of this front are the two aedicules, one set into the other and both going through the two storeys. This type, which I have called before 'aedicule façade' (i: p. 83), had no tradition in Rome; it was, however, common in the North of Italy and only needed the thorough Romanization brought about by Rainaldi to become generally acceptable. Preceded by his father's attempt in the design of S. Lucia at Bologna, Carlo knew how to blend the aedicule façade with the typically Roman increase in the volume of the orders from pilasters to half-columns and free-standing columns. The Roman High Baroque quality is clearly expressed in the powerful projections of the pediments, the heavy and great forms, and the ample use of columns. Characteristically Roman, too, are the farthest bays, which derive from the Capitoline palaces;[8] and the motif of the two recessed columns in the bays between the outer and inner aedicule stems from Cortona's SS. Martina e Luca. Rainaldi's transplantation of the North Italian aedicule façade to Rome led to its most mature and most effective realization. None of the highly individual

125 (*top left*). Carlo Rainaldi: Rome, S. Maria in Campitelli, 1658–74. Façade

126 (*left*). Carlo Rainaldi: Rome, S. Maria in Campitelli, 1658–74. Plan

127 (*right*). Carlo Maderno and Carlo Rainaldi: Rome, S. Andrea della Valle, 1624–9. Façade, 1661–5

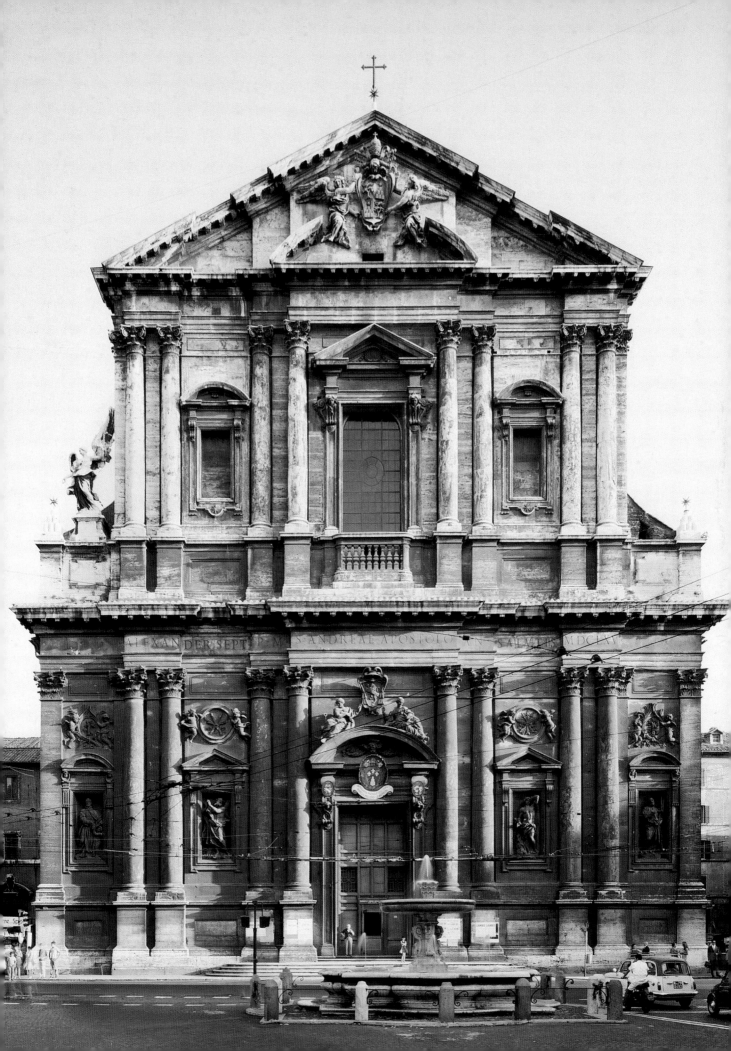

church façades by Cortona, Bernini, and Borromini lent itself freely to imitation. But Rainaldi's aedicule conception in Roman High Baroque dress was easily applicable to the longitudinal type of churches and was, therefore, constantly repeated and re-adapted to specific conditions.[9]

Almost exactly contemporary with S. Maria in Campitelli runs Rainaldi's execution of one of the great church façades in Rome, that of S. Andrea della Valle [127]. Here, however, he had not a free hand. The façade was begun in 1624 from a design of Carlo Maderno. When the latter died, it remained unfinished with only the pedestals of the order standing. Rainaldi not only turned Maderno's design into an aedicule façade but also managed by a stress on mass, weight, and verticalism to bring to bear upon the older project the stylistic tendencies of the mid seventeenth century. The façade which we see today does not, however, entirely correspond to Rainaldi's intentions.[10] As compared with his design, the present façade shows a greater severity in the treatment of detail, a simplification of niche and door surrounds, an isolation of decoration and sculpture from the structural parts, and a change in the proportions of the upper tier. All these alterations go in one and the same direction: they classicize Rainaldi's design, and since there is proof that Carlo Fontana was Rainaldi's assistant during 1661 and 1662,[11] it must have been he who was responsible for all these modifications. The present façade of S. Andrea della Valle, therefore, is a High Baroque alteration of a Maderno design by Carlo Rainaldi, whose design in its turn was 'purified' and stripped of its ambiguities by Carlo Fontana.

Concurrently with S. Maria in Campitelli and the façade of S. Andrea della Valle ran the work of S. Maria di Monte Santo and S. Maria de' Miracoli in the Piazza del Popolo [128, 129]. Here the architect had to show his skill as a town-planner. His task consisted of creating an impressive piazza which would greet the traveller on entering Rome by the Porta del Popolo. From the Piazza del Popolo three main streets radiate between the Pincio and the Tiber, each of them leading into the heart of the city. The decisive points were the two front elevations, facing the piazza between these streets. At these points Rainaldi planned two symmetrical churches with large and impressive domes as focusing-features from the Porta del Popolo. But since the sites were unequal in size, the symmetry which was here essential was not easily attained. By choosing an oval dome for the narrower site of S. Maria di Monte Santo and a circular dome for the larger one of S. Maria de' Miracoli, Rainaldi produced the impression from the square of identity of size and shape.[12] On 15 July 1662 the foundation stone of the left-hand church, S. Maria di Monte Santo, was laid. After an interruption in 1673 building activity was continued from a project by Bernini, and Carlo Fontana, as acting architect, completed the church by the Holy Year 1675. Rainaldi himself remained in charge of S. Maria de' Miracoli, which was executed between 1675 and 1679, again with Fontana's assistance.[13] The interior of S. Maria di Monte Santo shows, of course, none of Rainaldi's idiosyncrasies. At S. Maria de' Miracoli on the other hand Rainaldi worked once again with a strong accentuation of the transverse axis but counteracted it by emphasizing at the same time the homogeneity of the

128. Rome, Piazza del Popolo, from G. B. Nolli's plan, 1748

129 (opposite). Carlo Rainaldi and Gianlorenzo Bernini: Rome, Piazza del Popolo. S. Maria di Monte Santo and S. Maria de' Miracoli, 1662–79

circular space. He wedded Mannerist ambiguity to the High Baroque desire for spatial unification.

Much more important than the interiors are the exteriors of the churches. The façades with their classically poised porticoes, which already appear in the foundation medal of 1662, seem to contradict in many respects the peculiarities of Rainaldi's style. In fact, no reasonable doubt is possible that he was influenced by his youthful assistant, Carlo Fontana, through whom he became familiar with Bernini's approach to architecture.[14] When working for Bernini on the plans of the Square of St Peter's, Fontana must also have been involved in Bernini's project of 1659 (which remained on paper) to erect a four-columned portico in front of Maderno's façade of the basilica. This idea of the classical temple was realized in the churches in the Piazza del Popolo.[15] But the Berninesque appearance of these porticoes has an even more tangible reason, for it was precisely here that Bernini altered Rainaldi's design in 1673. Rainaldi wanted to place the pediments of the porticoes against a high attic. For him a pediment was always an element of linear emphasis. Bernini abolished Rainaldi's attic, so that, in accordance with his own style, the free-standing pediment regained its full classical plasticity. Moreover, Bernini probably had a formative influence on the solution of Rainaldi's

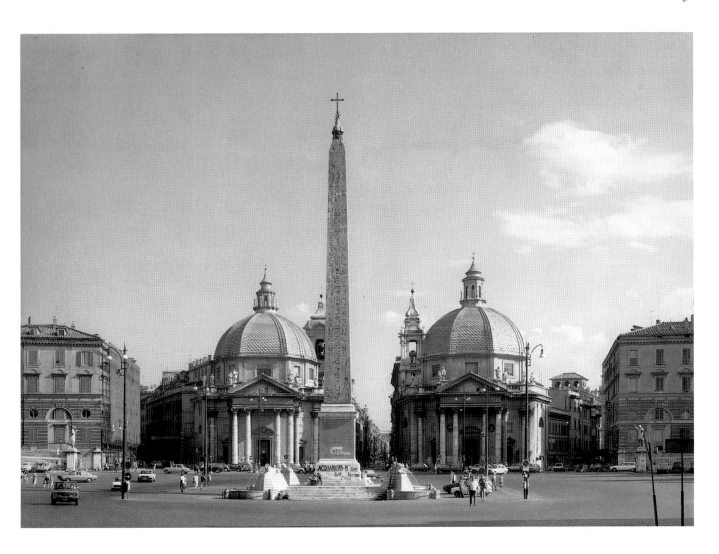

most pressing problem. Bernini always had the beholder foremost in mind and the optical impression a structure would make on him from a given viewpoint. One wonders, therefore, whether Rainaldi would ever have devised the pseudo-symmetrical arrangement of these churches without the impact of Bernini's approach to architecture. In any case, it is worth noting that Rainaldi began planning the two churches as corresponding 'false' Greek crosses. This would have made absolutely symmetrical structures possible, but at the expense of the size of the domes. However, the final design marks a new and important departure from the enclosed piazza, for the churches not only create a monumental front on the piazza but also crown the wedge-shaped sites, unifying and emphasizing the ends of long street fronts. The breaking-in of the streets into the piazza, or rather the weaving into one of street and square, was a new town-planning device – foreign to the High Baroque, and heralding a new age.

With the exception of the exterior of the apse of S. Maria Maggiore no work fell to Rainaldi in any way comparable with those that have been discussed. In S. Maria Maggiore he united the older chapels of Sixtus V and Paul V and the medieval apse between them into a grand design (1673), forming an impressive viewpoint from a great distance. It is informative to compare Bernini's project of 1669 with Rainaldi's executed front. Bernini wanted to screen the apse with an open portico; his design embodied a structural organization of the utmost sculptural expressiveness, while in Rainaldi's somewhat straggling front the apse stands out from the thin and unconvincing wall of the high attic.

In the early 1670s Rainaldi was also responsible for the façade and the interior decoration of Gesù e Maria (pp. 128–9). In addition, during the 1670s and 1680s he had a hand in a great many smaller enterprises, such as chapels in S. Lorenzo in Lucina, S. Maria in Araceli, S. Carlo ai Catinari, the design of tombs and altars, and the completion of older churches.[16] But his star was waning. Although Rainaldi's principal works belong to the 1660s, he represents a slightly later phase of the Roman High Baroque than the three great masters. In fact Cortona's and Borromini's careers came to an end in that decade, while Rainaldi worked on for almost another generation. His life-long attachment to Mannerist principles, his transplantation to Rome of North Italian conceptions of planning, his scenic use of the free-standing column, his borrowings from Bernini, Cortona, and Borromini – all this is blended in a distinctly individual manner which, however, never carries the conviction of any of the cogent High Baroque architectural systems.

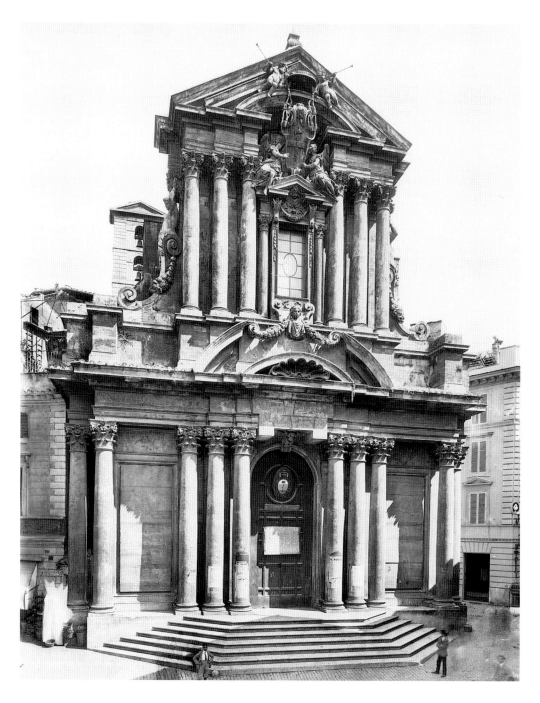

130. Martino Longhi the Younger:
Rome, SS. Vincenzo ed Anastasio.
Façade, 1646–50

131 (*right*). D. Barriere: Rome,
SS. Vincenzo ed Anastasio.
Façade. London, British Library

Martino Longhi the Younger, Vincenzo della Greca,
Antonio del Grande, and Giovan Antonio de' Rossi

Next to Rainaldi there were four approximately contempo-
rary architects of some distinction working in Rome, whose
names are given in the title to this section. Apart from
Giovan Antonio de' Rossi, none of them has many buildings
to his credit. Martino Longhi (1602–60), the son of Onorio
and grandson of the elder Martino, belonged to an old fam-
ily of architects who had come to Rome from Viggiù. His
reputation is mainly based on one work of outstanding
merit, the façade of SS. Vincenzo ed Anastasio in the Piazza
di Trevi, built for Cardinal Mazarin between 1646 and 1650
[130, 131].[17] This front, thickly set with columns, is
superficially similar to that of S. Maria in Campitelli, but the
similarity consists in High Baroque massiveness rather than

in any actual interdependence. To be sure, SS. Vincenzo ed
Anastasio is in a class of its own and is as little derived from
earlier models as the façades of SS. Martina e Luca or S.
Carlo alle Quattro Fontane. The principal feature of the
façade is three free-standing columns at each side of the cen-
tral bay, forming a closely connected triad which is repeated
in both tiers. This repetition, together with the slight step-
ping forward of the columns towards the centre, gives the
motif its brio and power.[18] The freedom which the columns
have here attained is evidenced by the fact that their move-
ment is not dependent on, or caused by, a gradation of the
wall, and their impression of energetic strength is reinforced
by the accumulation of massive pediments. It is further rein-
forced by the large caesuras between the triads and the outer
columns in the lower tier.[19] But the logical arrangement of

132. Rome, S. Adriano. Modernized by Martino Longhi the Younger, 1656

the articulation was obscured in more than one place. The farthest columns and the third columns of the lower triad frame empty wall space, and that two such columns should be regarded as complementary is emphasized by the unbroken entablature that unites them. Moreover in the lower tier, in contrast to the upper one, no structural link exists between the third columns of the triads.[20] Such a link, however, is provided for the second columns by the broken pediment, the two segments of which are connected by decorative sculpture. More problematical is the central segmental pediment from which a compressed shell juts out energetically: instead of capping the inner pair of columns, it crowns the angularly broken tablet (with the inscription) which is superimposed on the entablature above the door. It will be noticed that the projections at the level of the entablature correspond in number, but not in structure either to the projections of the upper tier or to those of the triad of columns. But Longhi created the optical impression that the two lower pediments top the outer and inner pairs of columns.[21]

This rather cumbersome analysis has shown that the relationship between the pediments and the columns is as inconsistent as that between the lower and upper triad, and in this inconsistency may very well lie part of the peculiar attraction of the façade. Seen genetically, Longhi employed Mannerist devices but subordinated them to an overwhelmingly High Baroque effect of grandeur and mass. The character of the decoration reveals similar tendencies, for Longhi combined Berninesque free-moving, realistic sculpture with the rigid, hard, and tactually indifferent motifs of Mannerism. It appears, therefore, that Longhi, like Carlo

Rainaldi, did not entirely eliminate Mannerist ambiguities, and this view is strengthened by a study of his modernization of S. Adriano (1656) [132], where in the crossing two free-standing columns matched two pilasters as supports of the oval dome.[22] The construction of S. Carlo al Corso, one of the largest churches in Rome, begun by his father Onorio, occupied Martino for several decades. It is fair to assume that the plan with an ambulatory, quite unique for Rome, depends on northern models. But the history of S. Carlo is extremely involved, and since Cortona rather than Martino was responsible for the decoration, hardly any trace of the latter's personal style can now be discovered.[23]

Vincenzo della Greca,[24] who came to Rome from Palermo, deserves a brief note for his work in SS. Domenico e Sisto. The flat, reactionary façade, always attributed to him but in reality designed by Nicola Turriani in 1628,[25] would not be worth mentioning were it not for its superb position on high ground, of which Vincenzo della Greca made the most by devising an imaginative staircase (1654) which ascends in two elegant, curved flights to the height of the entrance. The idea was probably derived from Cortona's Villa del Pigneto,

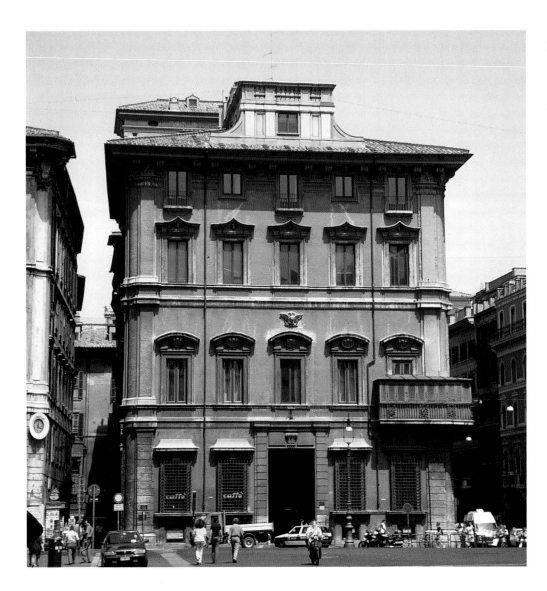

133. Giovan Antonio de' Rossi: Rome, Palazzo D'Aste-Bonaparte, 1658–c. 1665

134 (*right*). Bartolomeo Avanzini and others: Modena, Palazzo Ducale, begun 1651

but it was here that a Roman architect built for the first time a Baroque staircase in an urban setting – a prelude to Specchi's Port of the Ripetta and to the grand spectacle of De Sanctis's Spanish Stairs.

Although more eminent than Vincenzo della Greca, Antonio del Grande,[26] a Roman by birth whose activity is documented between 1647 and 1671, also has nothing to show that could compare with Longhi's SS. Vincenzo ed Anastasio. Most of his work is domestic, done in the service of the Colonna and Pamphili families. His monumental Carceri Nuovi (1652–8) in Via Giulia owe not a little of their effect to Borromini's influence, as the deeply grooved cornice proves. In his great gallery of the Palazzo Colonna, of impressive dimensions and the largest in Rome, begun in 1654, and vaulted in 1665, he took up the theme of Borromini's gallery of the Palazzo Pamphili in the Piazza Navona. At both ends of the gallery he screened off adjoining rooms by free-standing columns, an idea that may have come to him from Bernini's S. Andrea al Quirinale, then rising.[27] His most important work is that part of the Palazzo Doria-Pamphili which faces the Piazza del Collegio Romano (1659–61).[28] But the large façade contains no new or impor-

tant ideas. It follows Girolamo Rainaldi's design for the Palazzo Pamphili in the Piazza Navona in that the central bays are articulated by orders in two tiers resulting in an additive system which lacks the High Baroque emphasis on the *piano nobile*. The rest of the façade, outside the central bays, is in the tradition of Roman palazzo fronts; but with the unequal rhythm of the windows the architect even returned to the Late Mannerist arrangement of Giacomo della Porta's Palazzo Chigi in the Piazza Colonna, and also truly Mannerist is the portal with its frame of pilasters superimposed on quoins. More progressive are the details of the window-frames of the second storey and some door-surrounds inside the palace, where Borromini's dynamic life of forms has been toned down to a peculiar staccato movement. The most interesting feature is perhaps the vestibule, impressively spacious and ample and with a treatment of detail of almost puritanical sobriety.[29]

Giovan Antonio de' Rossi (1616–95), a contemporary of Carlo Rainaldi, produced some works that might be described as transitional between the High and the Late Baroque. This is less obvious in his ecclesiastical than his secular buildings. Some of his ecclesiastical work belongs to

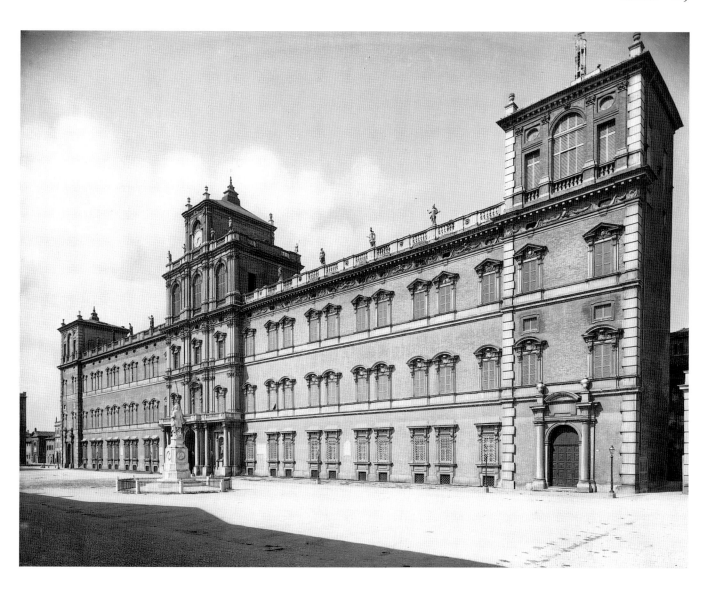

the finest flower of a slightly softened High Baroque in which the influence of each of the three great masters can easily be detected. We may single out the interesting Cappella Lancellotti in S. Giovanni in Laterano,[30] built on an oval plan with projecting columns – the whole clearly a Baroque reinterpretation of Michelangelo's design of the Cappella Sforza in S. Maria Maggiore. The masterpiece of his mature style is S. Maria in Campo Marzo (1682–5),[31] an impressive Greek cross with oval dome but without drum. The way the bulk of the apse closes the view from the Via della Maddalena is devised in the best tradition of the Roman High Baroque. Still later he built the oval chapel in the Palazzo Monte di Pietà, a little jewel resplendent with coloured marble incrustation and amply decorated with reliefs, statues, and stuccoes.[32] But of the High Baroque density of space- and wall-treatment little remains.

Among Rossi's palaces, two require special mention: the Palazzo Altieri in the Piazza del Gesù and the Palazzo D'Aste-Bonaparte overlooking the Piazza Venezia. The first is his most extensive if not his most accomplished work. Begun by Cardinal Giovan Battista Altieri in 1650, the palace was probably finished at the time of the latter's death

in 1654. After the accession to the papal throne of the Altieri Pope Clement X an enlargement became necessary, which Rossi carried out between 1670 and 1676.[33] The new parts towards the Piazza Venezia continue the earlier scheme but remain architecturally unobtrusive, so that the older palace stands out unimpaired as the principal building. Although the interior rather than the traditional façade deserves attention, Rossi's skill in solving his difficult task shows that we are dealing with a resourceful architect. The Palazzo D'Aste-Bonaparte [133] is perhaps the most accomplished example of his mature manner.[34] Designed as a free-standing block, the palace is essentially a revision of the traditional Roman type. Only the Borrominesque rounded-off corners and the chaste, unorthodox order in three tiers, retaining the four façades, are mildly progressive; all the motifs, including the elegant curved pediments of the windows, are rather unpretentious. Reserve and an immaculate sense of proportion are the virtues of this style. Rossi's intelligent blending of Cortonesque and Borrominesque decorative detail and its transformation into a comparatively light and pleasant personal idiom – such as we see it in the pediments of the Palazzo D'Aste and on many occasions – pre-

destined him to play an important part in the development of eighteenth-century architecture. It is not by chance that Alessandro Specchi's palazzo de Carolis (now Banco di Roma)[35] and Tommaso de Marchis's Palazzo Millini-Cagiati,[36] both on the Corso, vary Rossi's Palazzo D'Aste but little. A further study would show that the style of his many smaller palaces – some of which have been pulled down in recent years – determined the character of innumerable houses of the aristocracy and wealthy bourgeoisie of eighteenth-century Rome.[37]

ARCHITECTURE OUTSIDE ROME

During the roughly fifty years between 1630 and 1680 the architectural panorama in the rest of Italy is on the whole less interesting than one might be prepared to expect. Venice, it is true, had a great architect. But Lombardy, after the full and varied Borromeo era, had little to offer; Genoa was exhausted by the plague of 1657; Turin, under her progressive rulers, was only beginning to develop into an important architectural centre. To be sure, Ricchino carried on at Milan and Bianco at Genoa till after 1650, but the climax of their activity lay earlier in the century. When all is said and done, there remain only three High Baroque architects of more than average rank outside Rome: Longhena in Venice, Gherardo Silvani in Florence, and Cosimo Fanzago in Naples. Of these, Longhena seems to me by far the greatest. In addition, there is Guarino Guarini, who must be regarded in many respects as a master of the High Baroque although he belongs to a slightly later generation. There is, however, good reason not to separate his work from the survey of later Piedmontese architecture (III: p. 29).

During this period churches, palaces, and villas of intrinsic merit rose in great numbers all over the country, but historically speaking many of these buildings are 'provincial', since they not only rely on Roman precedent or assistance but are also often retardataire by Roman standards. The Palazzo Ducale at Modena [134], one of the largest palaces in Italy, may serve as an example. Attributed to the mediocre Bartolomeo Avanzini (c. 1608–58),[38] it is certain that at the beginning, between 1631 and 1634, Girolamo Rainaldi had a leading hand in the planning; the present palace shows, in fact, a distinct affinity with Rainaldi's Palazzo Pamphili in the Piazza Navona. In 1651 Avanzini's design, based on that of Rainaldi, was submitted to the criticism of Bernini, Cortona, and Borromini, and Bernini, stopping at Modena in 1665 on his return from Paris, made further suggestions. Later (1681) Guarini directed the execution. Ideas of all these masters, and particularly of Bernini, were certainly incorporated, but it is doubtful whether the history of the building can ever be fully disentangled.

Bologna, always an important centre of the arts and always a melting-pot of Central and North Italian conceptions, provides another aspect of the situation. Between 1638 and 1658 Bartolomeo Provaglia (d. 1672), the architect of the magnificent Porta Galliera (1661), built the Palazzo Davia-Bargellini with an austere and monumental façade, rather unusual for Bologna, but close to Roman palazzo types. Only the two free-moving, massive atlantes that carry

135. Giovan Battista Bergonzoni: Bologna, S. Maria della Vita, begun 1686. Plan

the balcony above the entrance show that we are not on Roman soil. These figures, seemingly bending under a heavy load, are the Baroque descendants of Leone Leoni's Mannerist atlantes on the façade of the Palazzo degli Omenoni at Milan and must be regarded as an important link with the use of the same motif in the Austrian and German Baroque. A similar mixture of Roman and North Italian ideas is to be found in Giovan Battista Bergonzoni's (1629–92) S. Maria della Vita, which belongs to the end of the period under discussion. The main body of the church was built between 1686 and 1688, while the oval dome was not erected until a century later.[39] The derivation from S. Agnese in Piazza Navona is evident in the elevation rather than in the plan [135]. While the latter is actually a rectangle with bevelled corners and shallow transverse chapels, the elevation is treated like a Greek cross, with the arches under the dome resting on projecting columns.[40] A square choir with dome is joined to the oval main room, and it is this that tallies with the North Italian type of plan which Ricchino had fully developed in S. Giuseppe at Milan. Yet in contrast to this church, built half a century earlier, the congregational room and the choir are here firmly interlocked, for the arch as well as the supporting columns belong to both spaces: they have exactly corresponding counterparts at the far end of the choir. Gaetano Gandolfi and Serafino Barozzi, by painting between 1776 and 1779 a domed room which extends, so it seems, behind the choir, stressed only the scenic quality contained in the architecture itself.

It was the long established interest of Bolognese *quadratura* painters in ever more daring illusions that found a response in the architects at the end of the century. The staircase hall of the Palazzo Cloetta-Fantuzzi (1680) by Paolo Canali (1618–80) is a case in point. Two broad flights open above into arcades and are lit from both sides under the painted ceiling – a scenographic spectacle which owed nothing to Rome. A new era was dawning, and later Bolognese architects found here a model that they followed and developed in the grand staircase designs of the eighteenth century (III: p. 20). The staircase in the Palazzo Cloetta illustrates a volte-face from Rome to Venice. It is a tribute to the genius of Longhena, who was to have a profound influence on North Italian architecture.

Baldassare Longhena (1598–1682)

Longhena's span of life corresponds almost exactly to that of Bernini, and unquestionably he is the only Venetian architect of the seventeenth century who comes close in stature to the great Romans.[41] He left one capital work, S. Maria della Salute [136–40], which occupied him in the midst of his vast activity for most of his working life.[42] During the plague of 1630 the Republic deliberated the erection of a church as an *ex voto*. Longhena won a competition against Antonio Fracao and Zambattista Rubertini, who had suggested a Latin-cross plan, and, as a memorandum by his hand shows, he was well aware and immensely proud of the novelty of his design. Construction began on 6 September 1631, and after more than twenty years the bulk of the structure was standing though the consecration did not take place until 1687, five years after the architect's death. Venice is nowadays unthinkable without the picturesque silhouette of this church, which dominates the entrance to the Canal Grande; but it would be wrong to insist too much on the picturesqueness of the building, as is usually done, while forgetting that this is in every respect one of the most interesting and subtle structures of the entire seventeenth century. No further credentials are, therefore, needed for a detailed analysis.

The salient feature of the plan is a regular octagon surrounded by an ambulatory [136]. This seems to be unique in Renaissance and post-Renaissance architecture, but the type is of Late Antique ancestry (S. Costanza, Rome) and is common in medieval, particularly Byzantine, buildings (S. Vitale, Ravenna). Longhena reverted to these early sources only for the plan and not for the elevation. The latter is a free adaptation of a well-known North Italian type derived from Bramante,[43] S. Maria della Salute differing from the Renaissance models mainly in the decorative interpretation of the columns. Instead of continuing the columns of the octagon into the architecture of the drum, we find a large figure topping the projecting entablature of each column. It is these iconographically important figures of prophets that turn each column into an isolated unit and at the same time emphasize the enclosed centralized character of the main room. The idea may have come to Longhena from the famous woodcut in Colonna's *Hypnerotomachia Polifili*, which shows precisely this motif in a section through a centralized domed building with ambulatory. But the

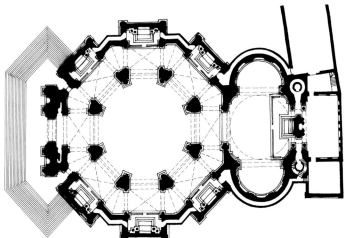

136. Baldassare Longhena: Venice, S. Maria della Salute, begun 1631. Section and plan

Hypnerotomachia, well known to every Venetian, can of course have determined only the conceptual direction, not the actual architectural planning. For it Longhena used, as we have seen, Late Antique, medieval and Bramantesque ideas and wedded them, moreover, to the Palladian tradition with which he was linked in a hundred direct and indirect ways.

From Palladio derives the colouristic treatment: grey stone for the structural parts and whitewash for the walls and fillings. But it should be remembered that this was not Palladio's speciality; it had, in fact, a medieval pedigree, was taken up and systematized by Brunelleschi, and after him used by most architects who were connected with the classical Florentine tradition. The architects of the Roman Baroque never employed this method of differentiation, the isolating effect of which would have interfered with the dynamic rhythms of their buildings. In contrast, however, to Florentine procedure, where colour invariably sustains a

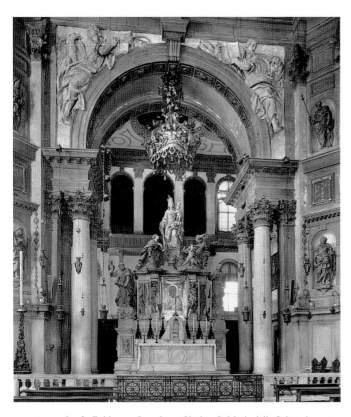

137 and 138. Baldassare Longhena: Venice, S. Maria della Salute, begun 1631. View towards the chapels (*above*) and view towards the high altar (*below*)

coherent metrical system, Longhena's colour scheme is not logical; colour for him was an optical device which enabled him to support or suppress elements of the composition, thereby directing the beholder's vision.

Many details of the Salute are also Palladian, such as the orders, the columns placed on high pedestals (see S. Giorgio Maggiore), and the segmental windows with mullions in the chapels [137], a type derived from Roman thermae and introduced by Palladio into ecclesiastical architecture (S. Giorgio, Il Redentore). All these elements combine to give the Salute the severe and chaste appearance of a Palladian structure. But it can be shown that Palladio's influence was even more vital.

One of Longhena's chief problems consisted in preserving the octagonal form outside without sacrificing clarity and lucidity inside. By the seemingly simple device of making the sides of two consecutive pillars parallel to each other, he succeeded in giving the optically important units of the ambulatory and the chapels regular geometrical shapes,[44] entirely in the spirit of the Renaissance. The full meaning of this organization is revealed only when one stands in the ideal and real centre of the octagon [138]. Looking from this point in any direction, the spectator will find that entirely homogeneous 'pictures' always appear in the field of vision.[45] Longhena's passionate interest in determining the beholder's field of vision is surely one of the factors which made him choose the problematical octagon with ambulatory rather than one of the traditional Renaissance designs over a centralized plan. It cannot be emphasized too strongly that no other type of plan allows only carefully integrated views to be seen; here the eye is not given a chance to wander off and make conquests of its own.

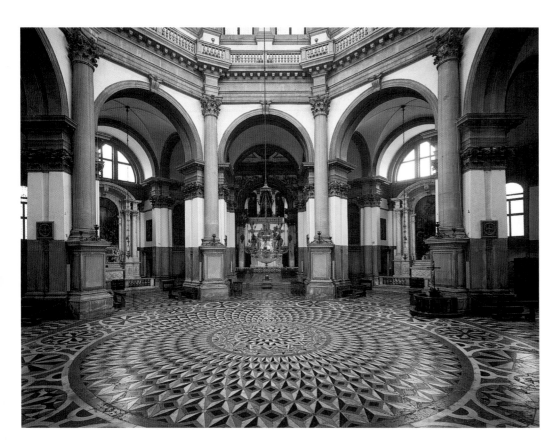

139 (*opposite*). Baldassare Longhena: Venice, S. Maria della Salute, begun 1631

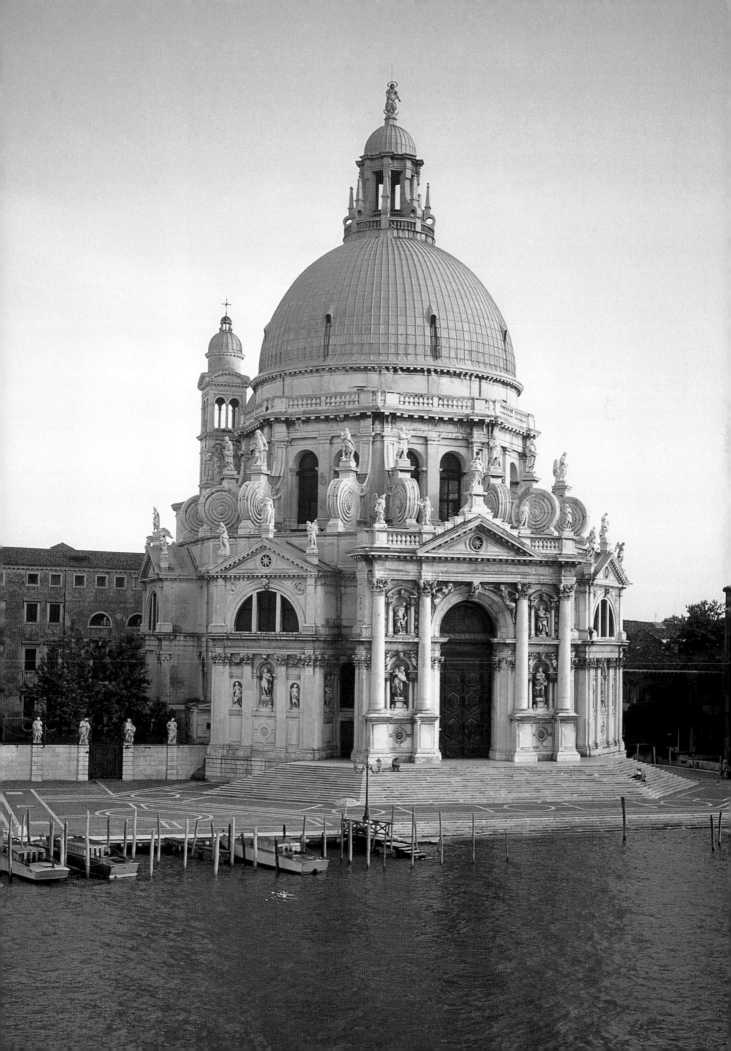

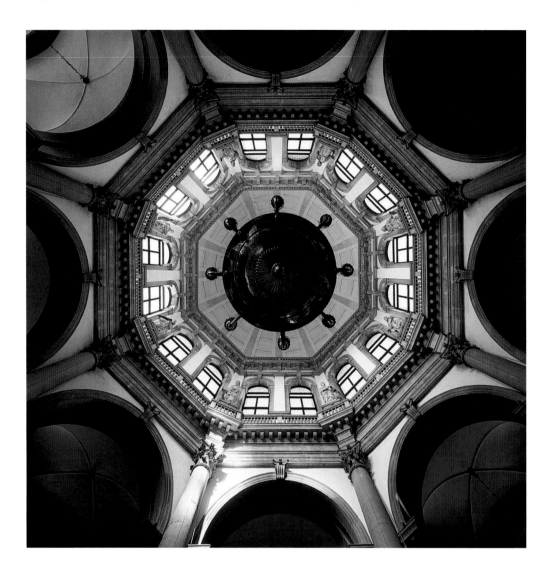

140. Baldassare Longhena: Venice,
S. Maria della Salute, begun 1631.
View into the dome

141. Baldassare Longhena: Venice,
Palazzo Bon, façade, 1649–62,
completed as Palazzo Rezzonico,
1750–58 by Giorgio Massari

It would seem that the centralization of the octagon could not have been carried any further. Moreover, the sanctuary, which is reached over a few steps, appears only loosely connected with the octagon. Following the North Italian Renaissance tradition of centralized plans (Bramante's S. Maria di Canepanova), main room and sanctuary form almost independent units. For the two large apses of the domed sanctuary Longhena employed a system entirely different from that of the octagon: he used giant pilasters instead of columns and replaced the mullioned windows of the chapels by normal windows in two tiers.[46] Shape and detail of the sanctuary depend on the Redentore, where Palladio had performed a similar change of system between the nave and the centralized portion.

A third room, the rectangular choir, is separated from the sanctuary by an arch resting on pairs of free-standing columns, between which rises the huge, picturesque high altar [137]. Inside the choir the architectural system changes again: two small orders of pilasters are placed one above the other. At the far end of the choir three small arches appear in the field of vision.[47] Longhena, one is tempted to conclude, simply grouped together isolated spatial units in a Renaissance-like manner. But this would mean opening the door to a serious misinterpretation, for in actual fact he found a way of unifying these entities by creating scenic connexions between them.

From the entrance of the church the columns and arch framing the high altar lie in the field of vision – it is important that only this motif and no more is visible – and the beholder is directed to the spiritual centre of the church through a sequence of arches, one behind the other: from the octagon to the ambulatory and the altar and, concluding the vista, to the arched wall of the choir. Thus, in spite of the Renaissance-like isolation of spatial entities and in spite of the carefully calculated centralization of the octagon, there is a scenic progression along the longitudinal axis. It is often said that Baroque architecture owes a great deal to the contemporary stage. As regards Roman High Baroque architecture, it is correct only with considerable qualifications, for an architecture aiming at dynamic spatial effects is intrinsically non-scenic. Quite different Longhena: in his case a specific relation to the stage does exist. In S. Maria della Salute clearly defined prospects appear one behind the other like wings on a stage. Instead of inviting the eye – as the Roman Baroque architects did – to glide along the walls and savour a spatial continuum, Longhena constantly determines the vistas across the spaces.

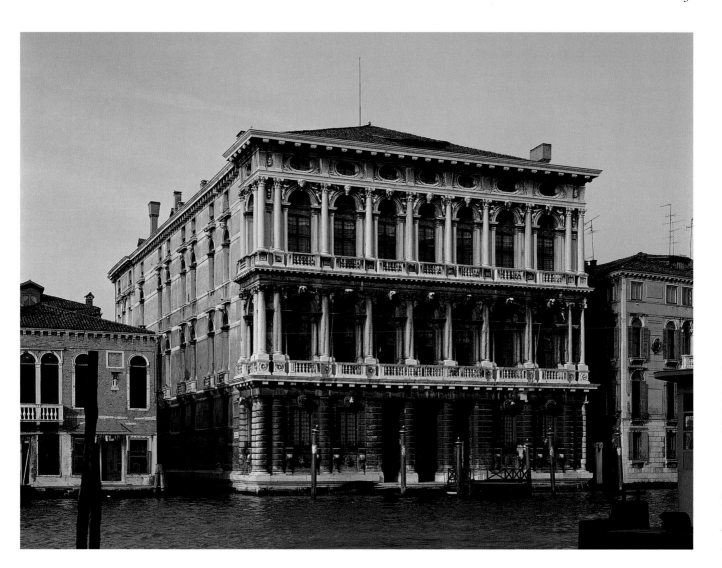

It is apparent that the judicious grouping of self-contained units rather than the Roman concept of dynamic spatial unification was the precondition for a strictly scenographic architecture. This also explains why the Late Baroque in spite, or just because, of its classicizing tendencies was essentially a scenographic style, even in Rome.[48]

In unifying separate spaces by optical devices, Longhena once again followed Palladio's lead. The hall-like nave and the centralized domed part of the Redentore – entirely separate entities – are knit together optically for the view from the entrance,[49] and it was this principle of scenic integration that Longhena developed much further. Thus, based on Palladio, Longhena had worked out an alternative to the Roman Baroque. His Venetian Baroque was, in fact, the only high-class alternative Italy had to offer. It is not sufficiently realized that in their search for new values many architects of the late seventeenth century turned from Rome to Venice and embraced Longhena's scenographic concepts.

Like the interior, the picturesque exterior of S. Maria della Salute was the result of sober deliberations [139]. The thrust of the large dome is diverted on to pairs of buttresses (the scrolls) which rest on the arches of the ambulatory. The side walls of the chapels (aligned with these arches) are therefore abutments to the dome. It is often maintained that

Longhena's Salute follows closely a design engraved by Labacco in 1558. This opinion, however, cannot be accepted without reservation.[50] Even if Longhena was attracted by the large scrolls in Labacco's engraving, he entirely transformed them and invented the imaginative decorative spirals which introduce a luxuriant note into his otherwise austere design.

The large dome of the Salute has an inner [140] and outer vault, the outer one consisting of lead over wood, in keeping with Venetian custom (including Palladio). While the principal dome ultimately derives from that of St Peter's,[51] the subsidiary dome with its stilted form over a simple circular brick drum and framed by two campanili follows the Byzantine–Venetian tradition. The grouping together of a main and a subsidiary dome fits well into the Venetian *ambiente* – the domes of S. Marco are quite near – but never before had the silhouette been so boldly enriched by the use of entirely different types of domes and drums in one and the same building. No less important than the aspect of the domes from a distance is the near view of the lower zone from the Canal Grande. From here the chapels right and left of the main entrance are conspicuous. They are therefore elaborately treated like little church façades in their own right; in fact they are clever adaptations of the small front of

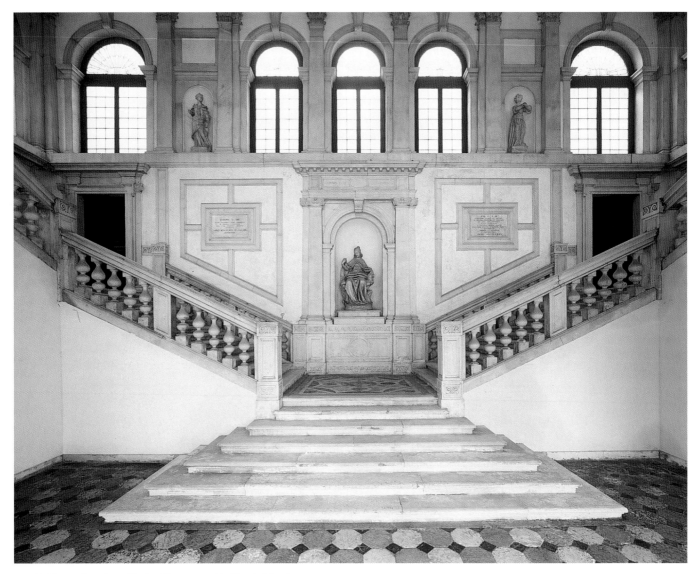

142. Baldassare Longhena: Venice, Monastery of S. Giorgio Maggiore.
Staircase, 1643–5

Palladio's Chiesa delle Zitelle. Their small order is taken up
in the gigantic triumphal arch motif of the main entrance. It
is this motif that sets the seal on the entire composition.

The central arch with the framing columns corresponds
exactly to the interior arches of the octagon, so that the
theme is given before one enters the church. In addition, the
small order also repeats the one inside, and the niches for
statues in two tiers conform to the windows in the sanctu-
ary. And more than this: the façade is, in fact, devised like a
scenae frons, and with the central door thrown wide open, as
shown in a contemporary engraving, the consecutive
sequence of arches inside the church, contained by the tri-
umphal arch, conjures up a proper stage setting. It can
hardly be doubted that the *scenae frons* of Palladio's Teatro
Olimpico had a decisive formative influence on Longhena's
thought. In a sense entirely different from Cortona's,
Borromini's, and Bernini's churches in Rome, Longhena
has created in the Salute an organic whole of outside and
inside, a fact which an impressionist approach to this kind of
building tends to obscure.[52]

Centralized buildings with ambulatories remain exceed-
ingly rare in Italy, even after Longhena's great masterpiece
was there for anybody to see and study. The only other
important church of this type, Carlo Fontana's Jesuit
Sanctuary at Loyola in Spain, could not, however, have been
designed without the model of S. Maria della Salute.[53] Thus
a Late Antique plan, common in Byzantine architecture,
revised in seventeenth-century Venice, was taken up by a
Roman architect and transplanted to Spain.

Longhena's other works in Venice and on the *terra ferma*
can hardly vie with his *magnum opus*. This is true of his
two other large churches, the early cathedral at Chioggia
(1624–47)[54] and S. Maria degli Scalzi in Venice (begun
1656);[55] the latter, a simple hall structure with large central
chapels, stimulated a considerable number of later church
plans. As characteristic for one facet of his late style we may
mention the immensely rich façade of the little Chiesa
dell'Ospedaletto near SS. Giovanni e Paolo (1670–8),[56]
where the structure seems submerged under glittering
sculptural decoration. In his many palaces we find him

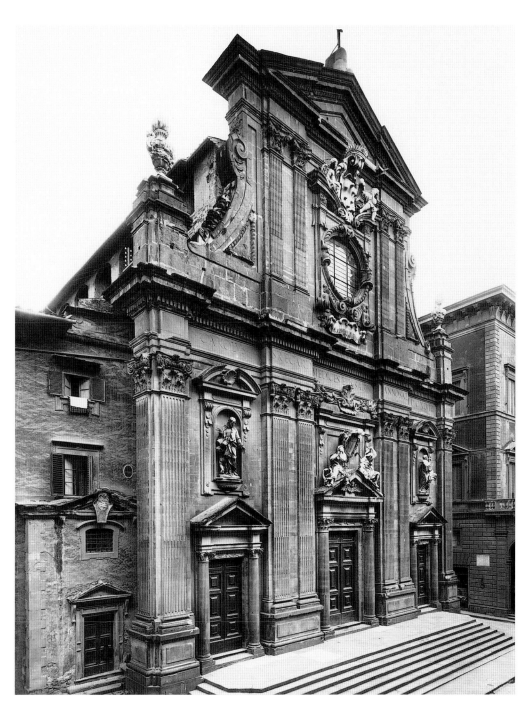

143. Gherardo Silvani: Florence, S. Gaetano. Façade, 1645

slowly turning away from the dry classicism of his teacher Scamozzi[57] and evolving a typically Venetian High Baroque manner by a premeditated regression to Sansovino's High Renaissance palaces. The formula of rusticated ground floor, ample use of columns in the upper storeys, and a far-reaching dissolution of wall surface suited him perfectly. His final triumph of sculptural accentuation, Baroque monumentality, and luminous richness will be found in the celebrated Palazzi Rezzonico [141] and Pesaro,[58] which fully expose his debt to Sansovino's palazzo Corner and, to a lesser extent, Sanmicheli's Palazzo Grimani. Thus, measured by Roman standards of the 1660s, these splendid palaces must be regarded as retrogressive. On the other hand, in the staircase hall of the monastery of S. Giorgio Maggiore (1643–5)

[142], where two parallel flights ascend along the walls to a common landing, Longhena once again proved his consummate skill as a master of scenic architecture. This staircase hall is far in advance of its time; it made a deep impression on architects, particularly in northern Italy, and was taken up and developed north of the Alps.

Florence and Naples: Silvani and Fanzago

It is characteristic of the situation in Florence after the first quarter of the seventeenth century that in 1633 Grand Duke Ferdinand II planned to execute Dosio's model of 1587 for the façade of the cathedral. The members of the Accademia del Disegno opposed this idea – not because they regarded

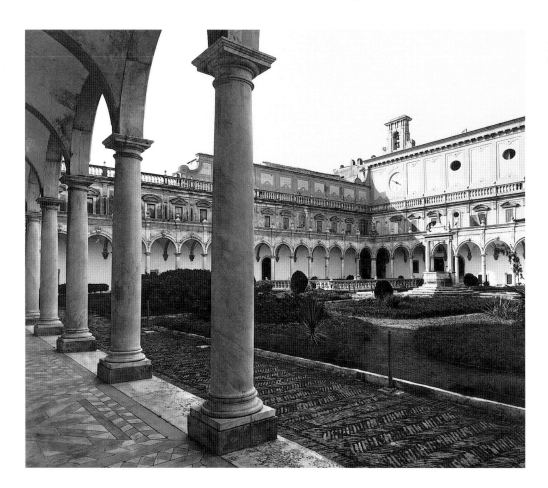

144 and 145. Cosimo Fanzago:
Naples, S. Martino. Cloisters,
c. 1630. Detail (*opposite*)

Dosio's project as too tame, but because, in their view, he had not sufficiently taken into account the older parts of the cathedral. They produced a counter-project which, in contrast to the classical dignity of Dosio's model, suffers from a breaking down of their design into many petty motifs. At the same moment, in 1635, Gherardo Silvani, who had grand-ducal support, made a model of his own (Museo dell'Opera, Florence) with was in fact an improvement on the Academy project. In his design Silvani combined mildly Baroque decorative features with neo-Gothic elements borrowed from Giotto's Campanile. Yet the weaker and more conformist Academy model was chosen. Execution, however, never went beyond the initial stages.[59]

It is clear that in the antiquarian climate of Florence there was no room for a free Baroque development. The enlargement of the Palazzo Pitti is another case in point. In two campaigns, the first starting in 1620 and the second in 1631, Giulio Parigi enlarged the palace from its original six bays to its present width of twenty-five bays. His simple device of repeating the Quattrocento parts was preferred to Pietro da Cortona's vigorous designs for the remodelling of the entire palace front.[60]

In spite of such conservative and antiquarian tendencies, Gherardo Silvani (1579–1673)[61] gave Florence and other Tuscan cities (Volterra, Prato, Pisa, etc.) buildings of considerable distinction. For over fifty years he was in full command of the situation; he had an extraordinary capacity for work, and the list of his creations is very long. His best known ecclesiastical work is S. Gaetano, in the construction

of which Nigetti is traditionally given too great a share.[62] The impressive façade [143] comes closer to a High Baroque design than any other building in Florence. But one should not be misled by the use of a massive pediment, by the bold projections, and the accumulation of sculpturally conceived architectural forms in comparatively narrow spaces: the structure itself, based on a simple rhythm of pilasters (the double pilasters framing the central bay are repeated in the upper tier), takes up the theme of Giovanni de' Medici's cathedral model of 1587, and while the three doors under their aedicule frames are derived from Dosio, other features point to an influence of Buontalenti's cathedral model. A good deal of the decoration, in fact, consists of an ebullient reworking of Buontalenti motifs. But much of the decoration belongs to the late seventeenth century, and it is this that gives the façade its flickering Late Baroque quality. The interior shows the noble reserve typical of the best Florentine Seicento buildings.[63] The wide nave with three chapels to each side separated by pillars with niches for statues above them owes its effect to the sophisticated colour scheme: the white reliefs on the pillars and the white statues above them,[64] silhouetted against the blue-grey *pietra serena* architecture, combine to give an impression of aristocratic restraint. Nothing could be further removed from contemporary Roman buildings such as Borromini's S. Carlino.

Silvani's palaces, with their unadorned plaster fronts, simple string courses, and overhanging wooden roofs are Tuscan counterparts to the severe Roman palace type such as Maderno's Palazzo Mattei (e.g. Palazzi Covoni, 1623, and

largely determined by these artists. But Fanzago's position can be compared only with that of Bernini, for like the greater man he too was a master of all-round performance, being architect, sculptor, decorator, and even painter. Unlike Bernini, however, who had to struggle all his life against the competition of first-rate artists, Fanzago's supremacy at Naples seems to have been almost unchallenged. He was born in October 1591 at Clusone near Bergamo, and settled as early as 1608 in Naples, where he lived with an uncle. Trained as a sculptor – in 1612 he calls himself 'maestro di scultura di marmo' – he makes his debut as an architect probably in 1617 with the design of S. Giuseppe dei Vecchi a S. Potito (finished 1669). It is here that he first planned a Greek-cross church, a scheme to which he returned in one form or another in most of his later churches.[69] But since he stressed the main axis, the centralization of these plans is usually not complete. Although he thus carried over into the High Baroque an essentially Mannerist conflict (I: p. 83), his high domes produce a new and decisive concentration. Only S. Maria Egiziaca (1651–1717) [146] is a true Greek cross and

146. Cosimo Fanzago: Naples, S. Maria Egiziaca, 1651–1717. Section and plan

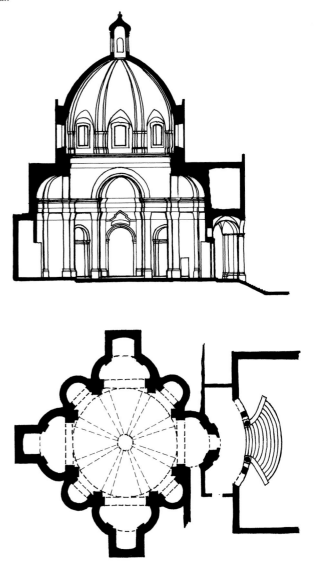

Fenzi, 1634). Only the central axis is given emphasis by a projecting balcony with a richly designed balustrade and, in the case of the Palazzo Fenzi, by the superb portal with Raffaele Curradi's Harpies.[65]

Seicento architecture at Naples would seem at the farthest remove from that of Florence, for Naples under her Spanish rulers with their native love for the plateresque witnessed the rise of a decorative style of dazzling richness and most intense polychromy produced by inlaid coloured marbles.[66] But to see the Tuscan and the Neapolitan Seicento in terms of absolute contrasts is somewhat misleading; structurally, the architecture of Naples is much closer to that of Florence than to that of Rome: this is revealed by such an important work as Cosimo Fanzago's large *chiostro* of the Certosa of S. Martino (1623–31)[67] with its elegant arcades which would not be out of place in fifteenth-century Florence [144]. Fanzago's range is, however, very wide. One need only step inside from the courtyard to come face to face with his exuberant decorative Baroque [145], showing his characteristic Neapolitan style fully developed.

In Fanzago (1591–1678)[68] Naples had a Baroque master who must be ranked very high, if not always for the quality, at least for the versatility of his talent. Longevity, an incredible stamina, facility of production, and inexhaustible reserves of energy – these are some of the characteristics of this tough generation. Bernini died aged eighty-two, Longhena eighty-four, Fanzago eighty-seven, and Silvani ninety-six. In Rome, Venice, Florence, and Naples artistic events till the last quarter of the seventeenth century were

departs altogether from the more traditional plans of his other churches. The plan of this, Fanzago's finest church, is so close to that of S. Agnese in Rome that a connexion must be assumed. In addition, the design of the dome seems to be derived from Bernini's S. Andrea al Quirinale and the convex portico from other Roman models. But if the date 1651 is correct, Fanzago would have anticipated later Roman conceptions. Since building proceeded very slowly, one would prefer to believe that he adjusted his design after having become acquainted with the most recent Roman events. However, the extreme economy in detail and the emphasis laid on structural parts by painting them slightly off-white (polychromy is reserved for the high altar) help to produce an imposing effect of simplicity, which is entirely un-Roman.

The phenomenon that Fanzago was capable of such a design is revealing, for it shows that ornament was for him, in Alberti's phrase, 'something added and fastened on, rather than proper and innate'. It is precisely this that makes one aware of the deep gulf between Fanzago's and Borromini's architecture although certain of Fanzago's decorative features [145] are reminiscent of the great Roman master. None of Fanzago's designs betray dynamic concepts of planning[70] – on the contrary, he is tied to certain academic patterns, and a search for a continuous development from project to project will therefore be disappointing. This is, however, not true so far as his façades for churches and palaces are concerned; for they provided large scope for a display of imaginative combinations. Here it is easy to follow the change from the severe classicism of the portico of the Chiesa dell'Ascensione (1622), still dependent on Domenico Fontana, to the rich façade of S. Maria della Sapienza (1638–41),[71] which in spite of complexities remains classically academic, and further to the façade of S. Giuseppe degli Scalzi with its decorative profusion and accumulation of incongruous elements – an early example of a Late Baroque composition, if the traditional date 1660 is correct. Taking also into account such strange compound creations as the Guglia di S. Gennaro (1631–60) with its surprising mixture of Mannerist and Baroque features, or the vast Palazzo Donn' Anna (1642–4),[72] bristling with personal though perhaps provincial re-interpretations of traditional motifs (never finished, and left a ruin after the earthquake of 1688), or the decorative abundance of the powerful portal of the Palazzo Maddaloni – one will find that Fanzago mastered in the long course of his immensely active life the whole gamut of Seicento possibilities from Early Baroque classicism to the pictorial effervescence of the Late Baroque.[73]

*

While the prevailing inter-Italian classicism of the first quarter of the seventeenth century had an impersonal quality, the architectural trends of the next fifty years are as many as there are names of great architects. It will be granted that in spite of the numerous cross-currents, Rainaldi's, Longhena's, Silvani's, and Fanzago's buildings have as much or as little in common as those of a Bernini and a Borromini. Nevertheless, the generic term 'High Baroque' retains its value, if only to circumscribe the age of the great individualistic creators.

Trends in High Baroque Sculpture

ROME

The First Generation

High Baroque sculpture came into its own with the full expansion of Bernini's studio. This, however, did not happen until the mid 1640s, when Bernini had to face the gigantic task of decorating the pilasters and chapels of St Peter's.[1] The building up of the studio began, of course, at a much earlier date. It was the Baldacchino [17] that first required extensive help by other hands. In addition to the old Stefano Maderno, some promising sculptors of Bernini's own generation found employment here: his brother Luigi, Stefano Speranza, Duquesnoy, Giuliano Finelli, Andrea Bolgi, and the younger Giacomo Antonio Fancelli. Not much need be said about Luigi Bernini; he always remained a devoted amanuensis of his great brother, supported him in a number of enterprises (mainly in St Peter's), and never showed a personal style.[2] Nor shall I discuss Stefano Speranza. Bernini used him over a number of years and his only doubtful claim to fame is the weak and retrogressive relief on the sarcophagus of the Matilda monument. Finelli and Bolgi on the other hand were, after the great masters, the most distinguished sculptors of this generation.

Giuliano Finelli (1601–57) arrived in Rome in 1622 and was immediately taken on by Bernini as his first studio hand.[3] He did not come direct from his home town Carrara, but from Naples, where he had studied sculpture under Naccherino. Finelli's association with Bernini lasted only a few years; in 1626 another Carrarese, Andrea Bolgi (1605–56), who had worked in Florence with Pietro Tacca, settled in Rome together with his compatriot Francesco Baratta, and soon attracted Bernini's attention. When, in 1629, the commissions for the four giant statues in the pillars of St Peter's were placed, Bernini recommended him in preference to Finelli. This virtually spelt the end of Finelli's career in Rome; and although he was not without work[4] (mainly due to the good offices of Pietro da Cortona) he soon went back to Naples, where he built up a large practice[5] in spite of Cosimo Fanzago's attempts to get rid of the dangerous rival. While in Naples Finelli maintained contact with Rome; and it was from Naples that he sent to Rome the tomb of Cardinal Domenico Ginnasi, to which we shall return later. In his youth, Finelli had thoroughly absorbed Bernini's grand manner. In Naples he progressively lost his sense for

147. Giuliano Finelli: Monument to Giuseppe Bonanni, c.1650. Rome, S. Caterina da Siena a Monte Magnanapoli

148. Andrea Bolgi: St Helena, 1629–39. Rome, St Peter's

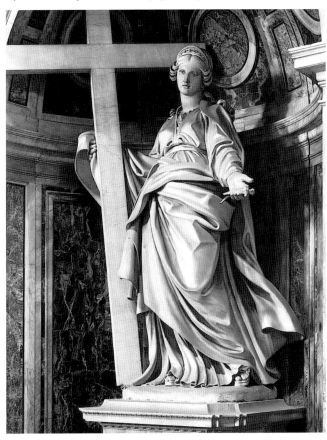

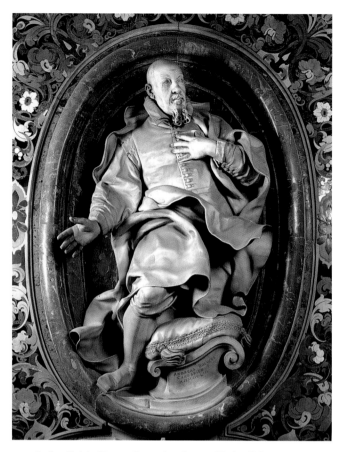

149. Andrea Bolgi: *Giuseppe Bonanni*, *c*.1649–53. Naples, S. Lorenzo Maggiore

the finesse and subtlety of texture; his style became hard and coarse. This cannot be regarded simply as a degeneration into provincialism of a talented artist removed from the spiritual centre, Rome; it is after all what happened *mutatis mutandis* to the work of a great many artists during the 1630s and 40s, but in most cases the 'petrifaction' lay in the direction of a strengthened classicism. After his return to Rome at the end of his life, Finelli went even further in the same direction [147]. Like Mochi in his last phase, he entirely lost interest in pleasing, warm, or sensuous surface qualities.[6]

While Finelli worked fast in Naples, executing considerable commissions, the sluggish Bolgi, the driest among Bernini's protégés, spent the better part of ten years on his statue of St Helena (1629–39) [148].[7] Its classicizing coolness, its boring precision and slow linear rhythm would seem to run counter to Bernini's dynamic conception of mass, of which an echo may be felt in the great sweep of the mantle. One might therefore rashly conclude that Bernini and Bolgi had parted company. On the contrary, however, Bolgi's style shows remarkable affinities to Bernini's work at this period. The *St Helena* is in fact so close to Bernini's *Countess Matilda* (1633–7) that the latter has often been ascribed to Bolgi. We have seen (p. 8) that during the 1630s Bernini himself made concessions to the classical ideals held by the Poussin–Sacchi circle. It is therefore understandable that at this period he regarded Bolgi as one of his most reliable assistants.[8] He still employed him in St Peter's throughout the 1640s; but by then a new generation had arisen

which responded enthusiastically to Bernini's new ideas. Before 1653 Bolgi went to Naples, and some of his work there shows a rather forced attempt to emulate Bernini's vigorous Baroque of the mid century [149].[9]

Among the remaining sculptors of this generation has been mentioned the unstable Francesco Baratta (*c*. 1590–1666), author of the relief above the altar in the Cappella Raimondi, S. Pietro in Montorio, and of one of the giant figures (Rio della Plata) on the Four Rivers Fountain in the Piazza Navona. Finally, Nicolò Menghini (*c*. 1610–65) should be recorded; he worked for Bernini in St Peter's during the 1640s and restored classical statues in the Palazzo Barberini. His name survives as the artist of the unsatisfactory figure of S. Martina (1635) under the high altar of SS. Martina e Luca, one of the many recumbent statues of martyrs dependent on Stefano Maderno's *St Cecilia*.[10]

This survey has shown that, apart from Bernini, Algardi, and Duquesnoy, in the second quarter of the seventeenth century the number of gifted sculptors in Rome was small. Of course, it must not be forgotten that the aged Mochi lived and worked throughout this period, and that Stefano Maderno died only in 1636. It is apparent that for the greatest task of the second quarter, the giant statues in the pillars under the dome of St Peter's, Bernini, Duquesnoy, and Mochi were the obvious choice; for the fourth figure the choice lay between Finelli and Bolgi, no better masters being at hand since Algardi's reputation had not yet been sufficiently established. This situation changed considerably about the middle of the century. The next generation was rich in talent, though there was none who approached in quality and importance the pathfinders of the High Baroque.

The Second Generation

Among the many young sculptors working in 1650, there are three or four who stand out either by the intrinsic merits of their work or as heads of large studios. Their names are Ercole Ferrata (1610–86), the oldest of this group, Antonio Raggi (1624–86), and Domenico Guidi (1625–1701). The fourth sculptor who should here be mentioned is Ferrata's pupil Melchiorre Caffà. Born in Malta as late as 1635, Caffà really belongs to a Late Baroque generation. But he was extremely precocious and died at the early age of thirty-two (in 1667)[11] – too young to carry the style over into its new phase. Without any doubt, he was the most gifted of the younger sculptors, and nobody came as close as he did to the exalted style of Bernini's later period. The principal works which he executed in the short span of less than ten years are quickly mentioned; they are the *Ecstasy of St Catherine* in the choir of S. Caterina da Siena a Monte Magnanapoli [150], *St Thomas of Villanova distributing Alms* (S. Agostino) [151], the relief of *St Eustace in the Lion's Den* (S. Agnese in Piazza Navona), and the recumbent figure of *St Rosa* in S. Domingo at Lima, Peru.[12] These works, all of considerable size, were executed concurrently over a number of years; but it seems that only the *St Catherine* was entirely finished by Caffà himself before his death.[13] The saint, in mystic exaltation, is carried heavenwards on clouds supported by angels. Higher up the sky opens (i.e., in the lantern), and a crowd of

150. Melchiorre Caffà: *The Ecstasy of St Catherine*, finished 1667. Rome, S. Caterina da Siena a Monte Magnanapoli

151. Melchiorre Caffà: *St Thomas of Villanova distributing Alms*, 1661. Terracotta model. La Valletta, Museum

angels and putti play in the heavenly light, out of which the Trinity floats down in a radiant glory to receive the saint. The thaumaturgic character of the mystery has been emphasized by contrasting the white marble of the saint and her angelic companions with the multicoloured marble background.

It seems certain that the whole choir was to form a grand unit comprising reliefs along the side walls, which death prevented him from executing.[14] Caffà utilized fully the ideas of Bernini's Cornaro Chapel and, indeed, no other work is so close in spirit to the *St Teresa*. There is, however, a significant difference between master and disciple: an almost morbid sensibility emanates from the relief of St Catherine, and this can never be said of any of Bernini's works. This difference seems to be one of generation rather than of personal temperament, for the younger artist was able to use freely those formulas of expression which the older one had to create.

The *Ecstasy of St Catherine* belongs to the new Berninesque category of a pictorial group attached to the wall. In his *St Thomas of Villanova* Caffà produced a free-standing group which is closely integrated with the entire scheme of the chapel. The work forms the centre of a large sculptured 'altarpiece', the wings of which consist of reliefs by Andrea Bergondi (c. 1760) showing scenes from the life of the saint. Unlike Algardi's *Beheading of St Paul* [113], where two isolated figures are deployed in the same plane, Caffà's composition not only ties together very closely the saint and the woman receiving alms, but by placing the latter outside the central niche and turning her towards the saint, he has made her function as a link between real life and the fictitious world of art. Instead of adoring a cult image, the poor who pray here are stimulated to identify themselves with the recipient of the alms and to participate in the charitable work of the Church 'in action'. But the female figure is not an anonymous woman of the people – by an act of poetical identification of the donor with the recipient, she appears herself in the traditional role of Charity. For the composition of his group Caffà followed a pictorial model, namely Romanelli's painting of the same scene in the Convent of S. Agostino. The figures, by contrast, take their cue from Bernini, as the very attractive terracotta model [151] shows: the saint is indebted to the church fathers of the Cathedra, and the 'Charity' to the corresponding group on the tomb of Urban VIII.[15] But once again these figures display a hypersensitive spirituality, in comparison with which Bernini's works appear solid, firm and virile.

Apart from technical skill, Caffà could have learned little from his infinitely less subtle teacher, Ercole Ferrata, who was born at Pelsotto, near Como, and worked at Naples[16] and

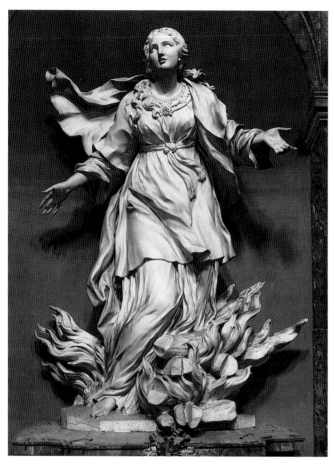

152. Ercole Ferrata: *St Agnes on the Pyre*, 1660. Rome, S. Agnese in Piazza Navona

[152] recalls in certain respects Duquesnoy's *St Susanna*, for here too the dress is relatively unruffled and supports the structure of the body, while the head derives as much from Duquesnoy as from classical Niobids. But no artist working in 1660 in Bernini's orbit could return to Duquesnoy's classical purity of 1630. Following the example of Bernini's statues of saints, Ferrata represented a transitory moment; we witness a dramatic climax: the power of her prayer makes the saint immune against the leaping flames. The gesture of the extended arms, the painterly treatment of the fire, the wind-swept gown – all these create a formal and emotional unrest, strongly contrasting with the purist tendencies of the 1630s. Along the left side of the figure will be noticed an autonomous piece of drapery, which Ferrata borrowed from Bernini's *Longinus*. The motif is only a weak echo of the original; it remains alien to the form and spirit of the statue and is a revealing pointer to the derivative quality of Ferrata's art.

The study of a relief, the large *Stoning of S. Emerenziana* in the same church (begun 1660) [153], leads to similar conclusions. In accordance with current classical theory (p. 86) Ferrata composed his work with a minimum number of figures, each clearly differentiated by action, gesture, and

153. Ercole Ferrata: *The Stoning of S. Emerenziana*, begun 1660 (finished by Leonardo Retti, 1689–1709). Rome, S. Agnese in Piazza Navona

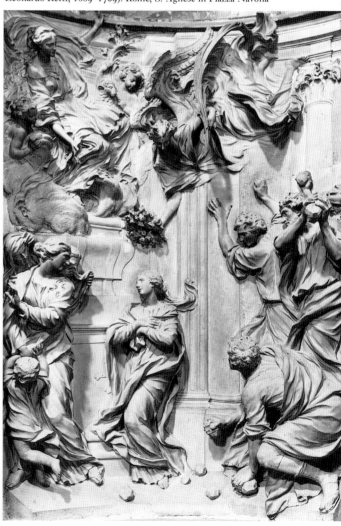

Aquila before settling in Rome. What has survived of his early work is provincial and of little interest. He was already middle-aged when we find him in Rome, working under Bernini on the marble decoration of the pillars of St Peter's (1647). Contrary to a persistent tradition, he cannot have executed one of the allegories for Algardi's tomb of Leo XI, nor is it certain that he collaborated on the Attila relief. By 1653 his reputation was such that Bernini entrusted him with the most important figure on the tomb of Cardinal Pimentel in S. Maria sopra Minerva – that of the Cardinal himself. Ferrata was given preference here over the younger Antonio Raggi and the less distinguished Giovan Antonio Mari, each of whom executed one of the allegories in full relief.[17] A year or two later he had the main share in continuing, after Algardi's death, the latter's work for S. Nicolò da Tolentino, to which Guidi and Francesco Baratta also contributed. During the following fifteen years Bernini showed his appreciation of Ferrata's skill by employing him on a number of great undertakings;[18] in spite of such close contacts, however, Ferrata never fully absorbed Bernini's dynamic style but tended towards a classicism of Algardian derivation.

Characteristic works by Ferrata are in S. Agnese in Piazza Navona, where one can study the different manners of the four masters with whom we are at present concerned. Ferrata's free-standing statue of *St Agnes on the Pyre* (1660)

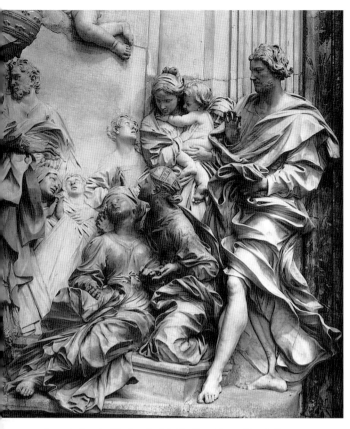

154. Antonio Raggi: *The Death of St Cecilia*, 1660–7. Detail. Rome, S. Agnese in Piazza Navona

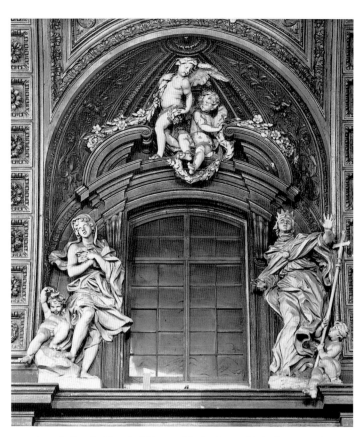

155. Antonio Raggi: *Allegorical Figures*, 1669–83. Rome, Gesù, clerestory of nave

expression. The clean and simple tripartite arrangement with the attackers on the right, the frightened people on the left, and the saint isolated in the centre seems to result from a dogmatic application of Algardi's principles. While the type of the saint again shows a close study of Duquesnoy's Susanna, and while certain figures are evidently inspired by the Attila relief, Ferrata reverts for the figures of the attackers to the most classical of Baroque painters, Domenichino, whose *Stoning of St Stephen* (now at Chantilly) must have been known to him.[19] The reader may have noticed that the sculptural principles displayed in the upper half of the relief contrast with those of the lower half. The figures – particularly that of the huge shapeless angel – not only have different proportions, small heads and elongated bodies, but masses of picturesque drapery conceal the structure of the bodies, and the diffuse silhouettes entirely lack Ferrata's clarity and precision. It is evident that Ferrata was not responsible for this part of the relief; after his death it was handed over to Leonardo Retti,[20] who finished it between 1689 and 1709, and only in this year were the two parts of the relief joined. Retti, Ferrata's pupil, worked many years under Raggi; thus the stylistic difference in the two halves of the Emerenziana relief is characteristic of the two different tendencies represented by Ferrata and Raggi and even more of the chronological change from the High Baroque to the picturesque and discursive manner of the Late Baroque.

In certain respects, Antonio Raggi represents the opposite pole to Ferrata. If Ferrata is the Algardi, Raggi is the Bernini of the second generation. Fourteen years younger

than Ferrata, he also was born in the region of Como, at Vico Morcote; in contrast to Ferrata, he went to Rome in early youth and joined Algardi's studio. Little is known of his activity under Algardi[21] and, like Ferrata, we meet him first in 1647 engaged under Bernini on the decoration of the pilasters of St Peter's. Subsequently he became Bernini's most intimate and most prolific pupil, and with the exception of Caffà there was nobody who so fully absorbed the master's grand manner. In addition to his extensive activity under Bernini over a period of thirty years,[22] Raggi carried on independent work of great importance, among which the following deserve special mention: the relief with the *Death of St Cecilia* in S. Agnese (1660–7) [154], the large *Baptism of Christ* on the high altar of S. Giovanni dei Fiorentini (*c.* 1665), the vast cycle of stucco decorations in the clerestory of the nave and transept of the Gesù (1669–83) [155], the relief and statues of the Cappella Ginetti in S. Andrea della Valle (1671–5), and finally, at the beginning of the 1680s, the Gastaldi monument and the decoration of the high altar in S. Maria de' Miracoli.

It is difficult to give an adequate idea of the high quality of Raggi's sculpture without illustrating many details.[23] His genius was particularly suited to work in stucco, and the marble relief in S. Agnese is perhaps not his most engaging performance. But it commands special interest for a number of reasons. Originally, Giuseppe Peroni (*c.* 1626–63), one of the closest collaborators of Algardi, was commissioned with the relief (1660). Peroni died when the fullscale model was finished. Raggi, who was asked to take over, appears not to

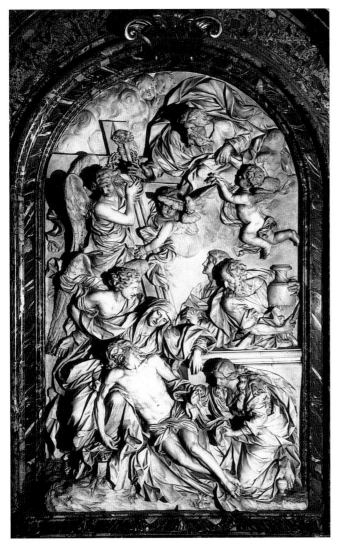

156. Domenico Guidi: *Lamentation over the Body of Christ*, 1667–76. Rome, Cappella Monte di Pietà

classical dogma of clarity expressed through a minimum number of figures. On the other hand, the beautiful angel with the martyr's palm, thoroughly Berninesque and obviously derived from the contemporary glory of angels on the Cathedra, shows the sweetness and tenderness of feeling characteristic of Raggi's art. These qualities, perhaps less obvious in other parts of the relief, can be observed in a great number of his works and often seem like anticipations of the lighter charms of the eighteenth century. The story of Raggi's St Cecilia relief illustrates the futility of attempting a rigid separation of the Berninesque from the Algardesque current; at the time such contrasts were not of sufficient consequence to prevent a commission's being transferred from the follower of one master to that of the other.

In his later work, especially in his stuccoes, Raggi yielded wholly to the mystical late style of Bernini, and this phase in his development is best studied in the Gesù [155]. According to contemporary sources, Gaulli, the painter of the frescoes, was also responsible for the design of the stuccoes. Whether this is entirely or only partly true, Raggi's stuccoes are a perfect sculptural parallel to Gaulli's intense response to Bernini's fervent, spiritualized late manner. The tempestuous movement and rapture of Raggi's jubilant putti on clouds, set into panels above the cornice of the nave and transept, must be understood as reactions to the main subject of the ceiling – the fresco of the *Adoration of the Name of Jesus*. As types, these putti owe not a little to Duquesnoy, but no greater contrast to the soothing composure of the latter's creations could be imagined. Higher up, flanking the windows, are allegories[25] of monumental size, wildly gesticulating or in attitudes of deep devotion and contemplation, clad in draperies that seem to follow their own laws, wind-blown, rearing, twisting, and zigzagging across the figures. Although many of them disclose a real understanding of the late Bernini, it will be found that others must be regarded as an anticlimax, since virtuosity replaces spirituality. In other words, in this cycle of figures the decorative quality of the Late Baroque appears side by side with the purposeful tension of the High Baroque.

With the exception of the sculptural decoration of St Peter's, which was carried out by many hands over a period of 150 years, there is no other Baroque sculptural cycle in Rome that bears comparison with Raggi's, executed in the short span of little more than a decade. In order to accomplish this *tour de force*, Raggi had to use assistants on an extensive scale, and this may account for the differences in quality. The allegories on the right-hand side of the nave are on the whole weaker than the ones on the left; they seem to be by Leonardo Retti, whose large share in the decoration of the Gesù is well attested. Other collaborators were Michele Maglia (right transept) and the worthy Paolo Naldini, who was thoroughly trained in Bernini's studio and was mentioned by Bernini himself as the best sculptor in Rome after Antonio Raggi.[26]

Ferrata and Raggi stand for rival trends without being antagonists. The case of Domenico Guidi is different. It is characteristic of him that he never went through Bernini's school; and he was probably the only important artist of his generation whose services were rarely sought by Bernini. In addition, he did not often participate in common under-

have entirely discarded Peroni's preparatory work; the left half of the relief in particular, with the standing figure of Pope Urban (who was present when the martyr saint died surrounded by Christians) and his kneeling attendant, corresponds closely to Algardi's Attila relief. Here, too, we find the division in the centre, and the differentiation between the calm faith of the pope and the emotional crowd on the right. This is as far as Algardi's influence goes. Raggi's individual manner is apparent in the extremely elongated proportions of the figures, their slender build and elegant movements,[24] as well as in the fall of the draperies, which betray a nervous and restless temperament. This restlessness is also noticeable in the grouping of the figures. Unlike Ferrata, Raggi rejected the lesson to be learned from Domenichino, whose classically poised fresco of the same subject in S. Luigi dei Francesi is not much farther than a stone's throw from S. Agnese. Compared with the lucid disposition of Ferrata's Emerenziana relief, the figures in Raggi's work appear crowded together in complicated, almost confused groups which reveal his disregard for the

takings with Ferrata and Raggi but concentrated on building up a large clientele of his own. Born in Carrara, he followed his uncle Giuliano Finelli to Naples; his career really began when, at the age of twenty-two, he fled to Rome at the time of Masaniello's revolt and joined the studio of Algardi. There he remained as a favourite pupil until the latter's death in 1654, after which he established an independent studio and evolved a rule-of-thumb method for quick success. He surrounded himself with a staff of mere craftsmen, and with their help he was able to work more quickly and more cheaply than the *professori* whom he despised. By such methods. Guidi managed to pour out a stream of works, not only for Rome and the rest of Italy,[27] but also for Germany, France, Spain, and Malta.

His early works, such as the monument to Natale Rondinini in S. Maria del Popolo (1657), are dry versions of Algardi's prototypes. During the 1650s and 60s he still shows interest in solid and careful execution, but his productions during the last quarter of the century display, with few exceptions, an unpleasant crudeness and rigidity. His figures become stocky and are criss-crossed by angularly broken masses of drapery. It was he who was mainly responsible for the change from the Roman High Baroque to the new Late Baroque idiom – a change well illustrated in his large relief over the altar of the Cappella Monte di Pietà (1667–76) [156]. In this work, Algardi's painterly relief style has been submitted to an interesting transformation. Compared with other works by Guidi, the composition, rising in a great curve from the kneeling Magdalen at the right bottom corner to the figure of God the Father at the top, is not without merits; but there is no discrimination between the degrees of spiritual importance of the holy personages, nor are the single figures sufficiently articulated to enable the beholder to follow their movements with confidence and ease, or even to decide whether drapery belongs to one figure or to another. And no longer are the superhuman and the human sphere separated. The plane of the relief is covered by figures without much qualifying differentiation, resulting in a flickering farrago of plastic form. Algardi had worked back into depth starting from the principal figures, which stand out almost three-dimensionally and thus hold the interest of the spectator. Guidi, by contrast, gave most of the figures equal relief projections, leading to a neutralization of the dramatic focus. It is mainly this change from a painterly, illusionistic relief conception to a 'picturesque' one, reminiscent of Late Antique sarcophagi, that accounts for the unaccentuated distribution of sculptural form over the surface.

Looking back from the new position, Algardi's Attila relief seems to have a powerful, dynamic quality. And although there are always close ties between Guidi and Algardi as regards individual forms and types, the slackened tension of the former's work is characteristic of a new period in which the passion of the High Baroque has grown cold. The breaking-down of the High Baroque sense of unity and drama may be observed not only in other works by Guidi but also, of course, in contemporary productions in the other arts. Guidi himself played a leading part in effecting this transition, of which hardly an indication was to be found in the works of Ferrata and Raggi.

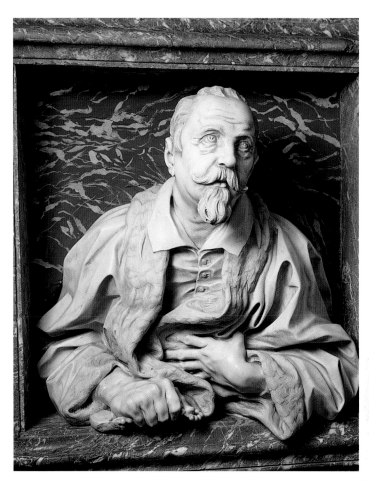

157. Gianlorenzo Bernini: *Gabriele Fonseca*, c. 1668–75. Rome, S. Lorenzo in Lucina

Tombs with the Effigy in Prayer

Before turning to the minor masters of this period, we may single out for special consideration the most common type of the High Baroque tomb showing the portrait of the deceased, who turns in devotional attitude towards the altar. The best-known tomb of this type is that of the physician Gabriele Fonseca, one of the most moving works of the late Bernini (c. 1668–75, S. Lorenzo in Lucina) [157]. Fonseca's fervent devotion and spiritual surrender are called forth by the mystery of the Annunciation, painted above the altar; thus an intangible bond between Fonseca and the altar bridges the space in which the beholder moves. This idea first occurs in tombs of the fifteenth century, and from then on may be found in Spain, France, Germany, and the Low Countries.[28] With the exception of Spanish Naples, however, the type was rare in Italy, and it was not until well into the sixteenth century that the bust with praying hands turned towards the altar began to appear in Rome. The series starts with the impressive Elena Savelli by Giacomo del Duca in S. Giovanni in Laterano (1570)[29] and leads on, before the end of the century, to such works as Valsoldo's simple and sturdy Cardinal Giovan Girolamo Albani in S. Maria del Popolo (1591).[30] Bernini first took up the type in his early bust of Cardinal Bellarmine (1622, Gesù), whose slight turn of the face in

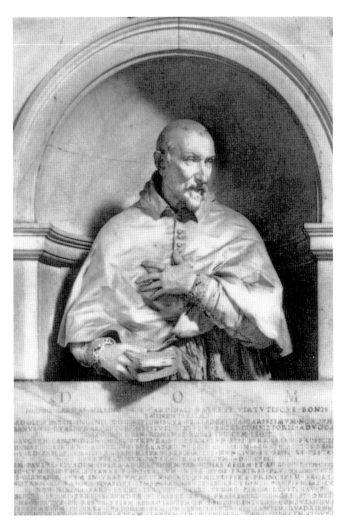

158. Alessandro Algardi: Tomb of Cardinal Giovanni Garzia Millini, 1637. Rome, S. Maria del Popolo

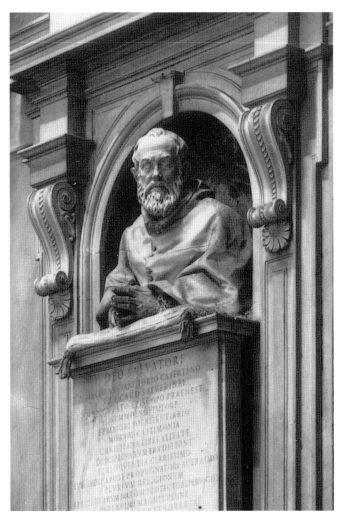

159. Giuliano Finelli: Tomb of Cardinal Giulio Antonio Santorio, after 1630. Rome, S. Giovanni in Laterano

the opposite direction from the praying hands suggests a link between the congregation and the altar.

The next step in the evolution of the High Baroque type is, unexpectedly perhaps, due to Algardi in the Millini tomb in S. Maria del Popolo (*c.* 1630)* the figure of the deceased cardinal is distinctly turned towards the altar, one hand clasping the prayer-book, the other pressed to his chest in the traditional gesture of devotion [158]. Moreover, the large rectangular tablet of the inscription serves as a parapet,[31] and, although no real illusion is here attempted or achieved, Bellori's description of the tomb shows that contemporaries were reminded of 'a kneeling figure which turns praying towards the altar'. Giuliano Finelli developed the idea further in the tomb of Cardinal Giulio Antonio Santorio [159], placed in Onorio Longhi's large oval chapel in S. Giovanni in Laterano, dating from the early 1630s, probably just before the artist went to Naples. It is here that the figure really seems to kneel behind a prie-dieu, resting his praying hands on the cushion. The Algardesque realism

of the surface treatment supports the illusion of real life. And with this goes a bolder movement of the figure towards the altar and an intensified expression of devotion. About ten years later, Finelli made the tomb of Cardinal Domenico Ginnasi for the little church of S. Lucia dei Ginnasi.[32] Although the handling is less refined, the work must be regarded as a further step towards the consolidation of the type. Finelli returned to the gestures of Algardi's Millini, but the figure is leaning out of the niche in deep agitation, the mouth half open as if murmuring a prayer. Thus while the stone image of the dead appears in the attitude of everlasting adoration, a transient moment in his relationship with the Divine has been caught. This was the end of the development, and in future the type could only be varied. Bernini's *Fonseca* complied with it, and numberless busts in Roman chapels testify to a trend of devout piety during the Catholic Restoration. Such works began to become rarer, however, with the slackening of religious fervour at the end of the seventeenth century.

Before this happened the theme was extended, and in Gesù e Maria an entire church instead of a chapel became the field of action for the deceased. Giorgio Bolognetti,

* This tomb was in fact commissioned in 1637 (J. Montagu, 1985).

160. Francesco Aprile: Model for the tombs of Pietro and Francesco Bolognetti, after 1675. London, Victoria and Albert Museum

Bishop of Rieti, commissioned the work. He financed the splendid decoration and had the whole church turned into a kind of mausoleum for members of his family. Carlo Rainaldi unified the entire space not only architecturally but also colouristically; its black, brown, and reddish marbles, interrupted by the flicker of the white figures, form perhaps the last sonorous High Baroque colour symphony.[33] Sculpture was assigned a place on the two pairs of broad pillars above the confessionals; the pillars near the entrance contain double tombs with lively gesticulating half-figures behind prie-dieus, while behind those nearer the altar kneel single full-size figures. All these portrayals of the Bolognetti turn their attention to the gorgeous altar with Giacinto Brandi's *Coronation of the Virgin*. The statues are placed before a small-scale, columned architecture suggesting the opening into imaginary spaces, and above them, like heavenly protectors, are large stucco figures of saints in simple niches. As in Bernini's Cappella Cornaro there are here no sarcophagi, and hardly anything is reminiscent of death: the illusion was to be as complete as possible. The six deceased are represented in finely differentiated stages of religious enthusiasm. Near the entrance the visitor meets those who look and listen, prepare themselves for prayer, or are absorbed in colloquy about the eucharistic miracle on the altar [160]; proceeding towards the altar, he finds himself face to face with Bishop Giorgio Bolognetti, the donor, kneeling in silent prayer, and with the Maltese knight Francesco Mario, who sinks upon his knee with gestures of profound devotion. But if one compares these figures by Michele Maglia, Francesco Aprile, and Francesco Cavallini

with Bernini's *Fonseca*, one cannot overlook that they carry considerably less conviction, and that the most excited of them, Francesco Mario, the one closest in style to the late Bernini, appears almost melodramatic in his reverential exuberance.[34] The spatial conceptions of the High Baroque found in this church a triumphant realization, but the religious feeling which had carried them began to flag.

The connexion across space between figures and the altar, as developed during the Roman High Baroque, weaves together art and life and effaces the most powerful boundary of all, the one that separates life from death. Nowhere else can one pinpoint so clearly the paradoxical situation of the Baroque age: it is the dead who invite the living to join in their prayers, and while the dead seem alive and the living emotionally prepared to accept the elimination of the borderline between fiction and reality, they yet remain always conscious that commemorative portraits greet them from the walls.

Minor Masters of the later Seventeenth Century

Two of the artists responsible for the Bolognetti monuments, Aprile and Maglia, were Ferrata's pupils. There were no sculptors of importance in Guidi's studio;[35] nor was Raggi the head of a school.[36] The opposite is true of Ferrata: as well as Caffà, Retti, and the artists just mentioned, Filippo Carcani, Giuseppe Mazzuoli, Lorenzo Ottoni, the Florentine Giovan Battista Foggini, the Milanese Giuseppe Rusnati, and even Camillo Rusconi were among his pupils.[37]

161. Michele Maglia: *St Peter of Alcantara*, 1682? Rome. S. Maria in Aracoeli

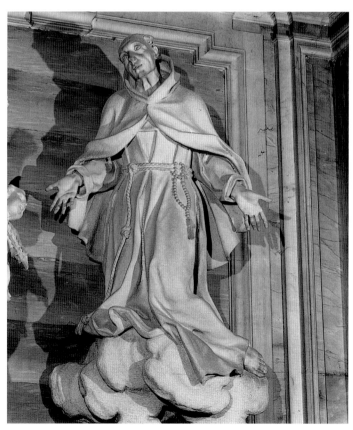

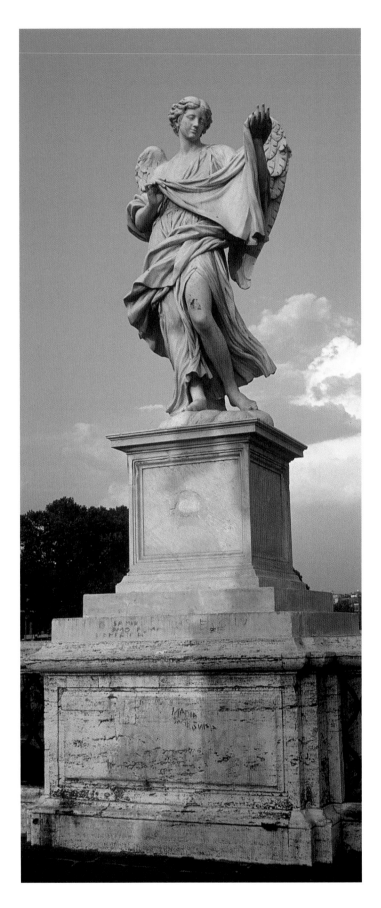

162. Cosimo Fancelli: *The Angel with the Sudary*, 1668–9. Rome, Ponte S. Angelo

But Ferrata was not a great enough artist to give his school a personal stamp; most of the work turned out by his studio consisted of variations of the Berninesque idiom. The majority of his pupils belong to a later generation, and a word about them will therefore be reserved for another chapter. Francesco Aprile died young, in 1685,[38] so that it fell to his teacher Ferrata to finish his masterpiece, the recumbent statue of St Anastasia under the high altar of the church of that name, a statue in which the type of Maderno's St Cecilia was translated into the forms of Bernini's late manner. Maglia, whose earliest known works date from about 1672, adhered more closely to the manner of his master. His principal work is the decoration of the beautiful chapel in S. Maria in Araceli dedicated to St Peter of Alcantara (1682–4) [161],[39] where above the altar the ecstatic saint hovers in the air before a vision of the Cross, while on the side walls life-size angels carry medallions with reliefs of St Stephen and St Ranieri. The convincing spirituality of these figures and the free transitions between sculpture and space make this work a legitimate descendant of Bernini's Cornaro Chapel.

Maglia often collaborated with Francesco Cavallini, an able decorator who was the third chief contributor to the sculptural decoration of Gesù e Maria. The over-life-size stucco statues of saints in S. Carlo al Corso (1678–82) were his largest commission; these are uneven in quality and on the whole show close affinities with Raggi's turbulent style. Cavallini, however, came neither from Ferrata nor Raggi: he was a pupil of Cosimo Fancelli (1618–88), the more important brother of Giacomo Antonio (1606–78) whom we saw employed, in spite of his youth, on the Baldacchino. After beginning his career under Bernini in St Peter's, Cosimo attached himself to Pietro da Cortona; and wherever we find the latter working as architect and decorator, Cosimo Fancelli is sure to be near at hand. Thus there is decorative sculpture by him in SS. Martina e Luca (1648–50), S. Maria della Pace (1656), S. Maria in Via Lata (c. 1660), S. Carlo al Corso (after 1665), in the Cappella Gavotti in S. Nicolò da Tolentino (1668), and on the vaulting of the Chiesa Nuova (1648–65). After Cortona's death he still took part in a variety of important tasks, and since he was one of the most distinguished sculptors in Rome Bernini transferred to him the execution of an angel for the Ponte S. Angelo. This angel (1668–9) [162] shows, in the somewhat voluptuous forms and the type of the head, how indebted Fancelli was to Cortona while at the same time he paid tribute to the current Berninesque manner. Uneven in his work, he often attempted to reconcile Cortona's and Bernini's manners with an emphatic simplicity of forms which he shared with Ferrata, his collaborator on more than one occasion. It is often difficult, therefore, to distinguish between their work.[40]

The angels on the Ponte S. Angelo enable the student to assess the position of Roman sculpture in the year 1670. Bernini naturally employed the sculptors with the highest reputation and those of whom he was particularly fond. As well as the angels for which he was himself responsible, we find – as we should expect – angels by Ferrata, Raggi, and Guidi; there are those by his closest circle, Lazzaro Morelli, Giulio Cartari, and Paolo Naldini; finally there is

the angel by Cosimo Fancelli, and there are others by Antonio Giorgetti and Girolamo Lucenti.[41] Gioseppe Giorgetti,[42] Antonio's brother, left one masterpiece of great beauty: the recumbent *St Sebastian* in S. Sebastiano fuori le Mura – yet another version of Maderno's St Cecilia type – a statue derived from Michelangelo's *Dying Slave* in the Louvre and imbued with an exquisite Hellenistic flavour. Girolamo Lucenti (1627–92) began as a pupil of Algardi, whose influence is still traceable in the relatively unemotional angel on the Ponte S. Angelo. His tomb of Cardinal Girolamo Gastaldi (1685–6) in the choir of S. Maria de' Miracoli shows him as a weak imitator of Raggi's manner; while the bronze statue of Philip IV of Spain, under the portico of S. Maria Maggiore, dating from the last years of Lucenti's life, is hardly a shadow of the one planned by Bernini in 1667.[43]*

Looking back for a moment from the statues on the Ponte S. Angelo to those placed forty years earlier under the dome of St Peter's, we realize that, in contrast to the earlier highly personal and subjective performance, we are faced with the work of epigones among whom Bernini appears like a solitary giant. His intense High Baroque did not only have an equalizing influence on most of these masters of the younger generation but also reduced their capacity for individual expression, and perhaps even their desire to attain it.

Bernini's Studio and the Position of Sculptors in Rome

The last remark indicates that for good or evil Bernini's influence on the sculptors in Rome during the second half of the seventeenth century cannot be overestimated. After Algardi's death in 1654 there was, in fact, nobody seriously to challenge his authority. I cannot attempt here to reconstruct the organization and working of the studio. Suffice it to say that it became the attraction for artists from all over Europe, and such sculptors as the Englishman Nicholas Stone the younger, the Frenchman Puget,[44] and the German Permoser laid there the foundation for their future work. Nearer home, year by year a stream of masons and sculptors, particularly from the North of Italy, went to Rome, stimulated less by the idea of acquiring there a great style than by the hope of getting a share in the gigantic commissions the Church had to offer. More often than not they were utterly disappointed, and sculptors were lucky if they found a corner for themselves in Bernini's vast organization or in one of the studios more or less dependent on him. Willy-nilly they had to submit to the established hierarchy.

The fate of the competent Lazzaro Morelli (1619–90) may be quoted as one example of many. He came to Rome from Ascoli, but in spite of excellent letters of introduction everything seemed to go wrong, and his biographer, Pascoli, makes him exclaim bitterly: 'How much better would it have been for me to stay at home, where I did not and could not earn very much, but where, eventually, I would have taken first place amongst my colleagues.' In the end, Morelli shared the fate of so many others in becoming almost entirely dependent on Bernini for work. In fact Bernini

must have regarded him as one of his most reliable studio hands, for he allotted to him tasks of great responsibility in the work on the Piazza of St Peter's,[45] the Cathedra, and the tomb of Alexander VII. Morelli maintained contact with his native town and became on his part the head of a school through which Bernini's manner spread in the Marches.[46] This is the typical constellation: it was by direct transmission rather than by the independent initiative of other masters that the style was disseminated throughout Italy and Europe. Since, as I mentioned at the beginning of this chapter, the great extension of the studio did not take place until the later 1640s, it will be apparent that Bernini's Baroque was taken up in the rest of Italy not until the second half and, as a rule, only during the last quarter of the century.

It was to a large extent due to Bernini's immense authority that the profession of a sculptor had become financially rewarding. To be sure, towards the middle of the seventeenth century there was an unparalleled boom for sculptors, and yet in spite of the years of prosperity the proletariat of artists remained large in Rome. In 1656 one hundred and eleven artists lived in the borough of Campo Marzio, and no less than fifty-three of them – i.e. almost 50 per cent – were registered as poor.[47] But quality was so highly valued that the top class of sculptors, and above all Bernini, were paid star salaries, even by modern standards. As early as 1633 an original statue by Bernini was estimated as being worth between four and five thousand scudi.[48] In 1651 Francis I of

163. Ferdinando Tacca: *Bacchino*, 1658–65. Prato, Museum

* Ostrow (1991) has shown that this is an autonomous work by Lucenti.

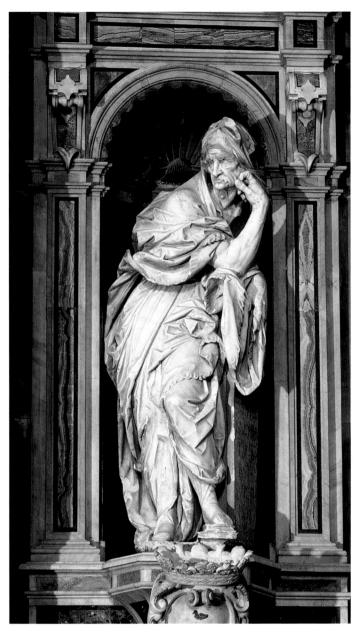

164. Cosimo Fanzago: *Jeremiah*, *c*.1646. Naples, Gesù Nuovo

SCULPTURE OUTSIDE ROME

It has already become apparent that not much need be said about the development of sculpture outside Rome. With Rome's supremacy incontestably established, Roman sculptors catered for the need of patrons all over Italy. Naples, vigorously active, had room even for Finelli and Bolgi. But as a rule figures and busts were sent from Rome. Bernini provided work for Spoleto, Siena, Modena, Venice, and Savona (school piece); Algardi for Genoa, Piacenza, Parma, Bologna, Perugia, and Valletta (Malta). Not Florentines or Sienese but Caffà, Ferrata, and Raggi gave Siena Cathedral monumental Seicento sculpture. Later, Giuseppe Mazzuoli, born near Siena, inundated Siena with Berninesque statuary. Ferrata also worked for Venice, Modena, and Naples; Raggi for Milan, Sassuolo, and Loreto; Naldini for Orvieto and Todi. There is no need to prolong this list.

It was not until late in the century that flourishing local schools sprang up in centres like Bologna, Genoa, and Venice. Apart from Milan with her conservative cathedral school of sculptors, a continuity was maintained only in Florence and Naples, due in each city mainly to the activity of one artist. Florentine sculpture did not enter a High Baroque phase even with Pietro Tacca's son, Ferdinando

165. Cosimo Fanzago: Naples, Certosa, inlaid marble floor

Este paid as much as 3,000 scudi for his portrait bust. This was, of course, exceptional, even for Bernini. In 1634 Algardi signed his contract for the tomb of Leo XI with a fee of 2,550 scudi, but at the time the tomb was finished, eighteen years later, when both the craving for sculpture and Algardi's reputation were at a climax, he was granted an additional 1,000 scudi. Such prices were not maintained from the late seventeenth century onwards. A good comparison is offered by the 7,000 scudi Bernini was paid in 1671 for his *Constantine* as against the 4,000 scudi Cornacchini received in 1725 for its counterpart, the equestrian statue of Charlemagne.[49]

(1619–86), who remained Tuscan through and through. His bronze relief of the *Martyrdom of St Stephen* in S. Stefano, Florence (1656), points back via Francavilla and Giovanni Bologna to the illusionism of Ghiberti's Porta del Paradiso, while his fountain of the Bacchino at Prato (1665, now Museum) [163], with the figure crowning the shaft and basin like a monument, is not developed far beyond Giovanni Bologna's prototypes in the Boboli Gardens. Compelling Baroque unification of parts remained foreign to Florentine artists. But the little bronze Bacchus on top of the fountain has High Baroque softness and roundness although one cannot overlook the faint family likeness to Verrocchio's putti. All too often the bronze relief of the Crucifixion in the Palazzo Pitti has been attributed to Pietro Tacca,[50] revealing an erroneous assessment of what was possible in Florence around 1640. As K. Lankheit has shown, the relief dates from 1675–7 and is by G. B. Foggini.[51] He at last exchanged the Florentine for the Roman relief style of the type of the reliefs at S. Agnese in Piazza Navona. The Roman High Baroque had made its entry into Florence.

Earlier than any other Italian city, Naples assimilated Roman High Baroque sculpture through the activity of Giuliano Finelli; and in the Lombard Cosimo Fanzago (p. 119) Naples had an autonomous Baroque sculptor. He began with works of late Mannerist classicism (1615–16, *St Ignatius* at Catanzaro; 1620, tomb of Michele Gentile, Cathedral, Barletta) and developed even before Finelli's arrival towards a High Baroque style [145], certainly not without contacts with events in Rome. Yet in contrast to the true High Baroque masters in Rome, the versatile Fanzago was capable of using side by side two idioms which would seem mutually exclusive: the Tuscan Renaissance comes to life in the chaste *Immacolata* of the Cappella Reale (1640–6) while the Roman Baroque informs a figure like the Jeremiah (1646, Cappella S. Ignazio, Gesù Nuovo) with its masses of brittle folds, its luminous surface and strong *contrapposto* movement [164].[52] Although by training a sculptor and mainly active as an architect, Fanzago's most lasting achievement was probably in the field of semi-decorative art, such as his fountains and pulpits, his splendid bronze gates in S. Martino and the Cappella del Tesoro, and his many polychrome altars, where he wedded flourishing sculptural ornament to inlaid marble work [165]. As early as the 1630s this manner was fully developed (1635, high altar, SS. Severino e Sosio, Naples), and there is reason to believe that it had considerable repercussions in the rest of Italy.[53] Even the decorative style of an architect like Juvarra seems to owe a great deal to Fanzago, and the question to what extent the roots of the Rococo ornament can be traced back to Fanzago, directly or indirectly, would need further careful investigation.

High Baroque Painting and Its Aftermath

ROME

Baroque Classicism; Archaizing Classicism;
Crypto-Romanticism

The preceding discussion of the Cortona–Sacchi contro-
versy supplies the background to the development of paint-
ing in Rome during most of the second and third quarters of
the seventeenth century. Painters had to side with one of the
two opposing camps: the general trend of their decision has
already been indicated.

At the beginning of this period Rome harboured two
immensely vigorous Baroque frescoes of singular impor-
tance, those by Lanfranco in the dome of S. Andrea della
Valle and by Cortona in the Gran Salone of the Palazzo
Barberini. One would have thought that these masterpieces
would immediately have led to a revolution in taste, even
among the artists of second rank, and there cannot be any
doubt about the impression they made. But Lanfranco soon
left Rome and settled for about twelve years in Naples
(1634–46), where he continued his dense and dramatic

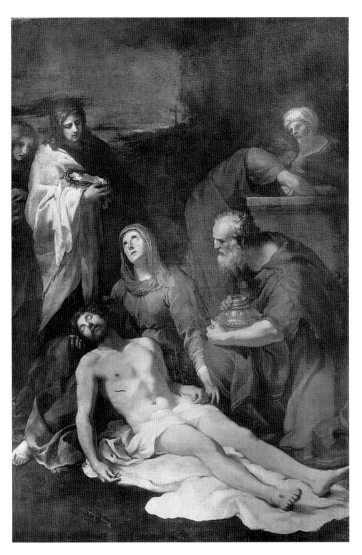

166. Andrea Camassei: *Pietà*, 1632–5. Rome, S. Maria della Concezione

Baroque manner in a number of large fresco cycles (p. 161).
When he returned to Rome (1646), shortly before his death,
the climate had considerably changed, mainly due to the
ascendancy of Andrea Sacchi. Between 1640 and 1647
Cortona too was absent from Rome, and this meant that
Sacchi remained in full command of the situation.

It is for this reason that among the rank and file of artists
born between 1600 and 1620 the pattern of development
varies but little. Andrea Camassei (1602–49), Francesco
Cozza (1605–82), Sassoferrato (1609–85), and Giovanni
Domenico Cerrini (1609–81) stem mainly from Dom-
enichino; G. F. Romanelli (1610–62), Giacinto Gimignani
(1606–81), and Paolo Gismondi (*c.* 1612–*c.* 1685), to name
only a few, from Pietro da Cortona.[1] But Sacchi lined up
all these painters behind him. It is characteristic that in
the 1640s Camassei and Gimignani worked for him in the
Baptistery of the Lateran, where also the young Maratti
painted from the master's cartoons. Camassei, who disap-
pointed the high hopes of his Barberini patrons, had a typi-
cal career; after his beginnings under Domenichino, he
painted under Cortona in Castel Fusano, only to be associ-
ated with Sacchi towards the end of his brief life. With few
exceptions his work is archaistic, like that of the whole
group. In fact, Sassoferrato's stereotyped pictures of the
Virgin and Child appeared so anachronistic that he was long
taken for a follower of Raphael. Cozza is the most interest-
ing and Romanelli the best-known of these practitioners
who had their great moment in the decade before the mid
century. While Cozza deserves being resuscitated from
semi-obscurity (see below),[2] little need be said about
Romanelli's career. Trained under Domenichino, he became
Cortona's assistant on the Barberini ceiling, was perma-
nently patronized by the Barberini, and was given commis-
sions of considerable size which he executed not without
decorative skill. It was he who introduced a watered-down
and classicized version of Cortona's manner into Paris,
where his mythological, allegorical, and historical frescoes in
the gallery of the Hôtel Mazarin (1646–7)[3] and in several
rooms of the Louvre (1655–7) reveal a facile routine, which
is equally apparent in his Roman work of these years (fre-
coes, Palazzo Lante, 1653).

At the beginning of the 1630s these artists were still too
young to contribute independently to important commis-
sions. Only the oldest of them, Camassei, was allowed a
share in the most interesting enterprise of this period, the
decoration with paintings of S. Maria della Concezione
(1631–8) [166], undertaken on the initiative of Cardinal
Antonio Barberini, the pope's brother. Here the older gen-
eration was given pride of place: Reni, Domenichino, and
Lanfranco (two pictures)[4] painted mature masterpieces; the

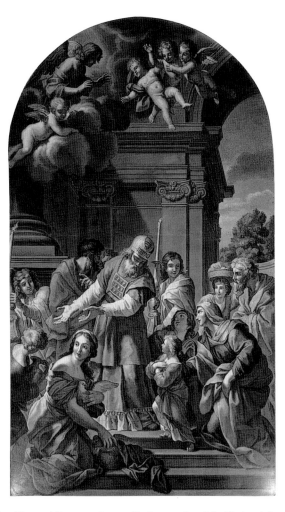

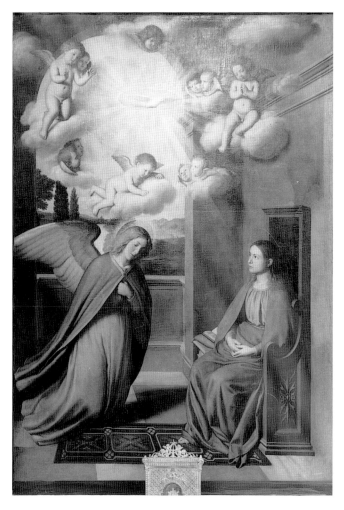

167. Giovanni Francesco Romanelli: *Presentation of the Virgin*, 1638–42. Rome, St Peter's

168. Giovanni Battista Salvi, il Sassoferrato: *The Virgin of the Annunciation*, *c.* 1640–50. Casperia (Rieti), S. Maria Nuova

Florentine Mannerist Baccio Ciarpi, Cortona's teacher, contributed a picture as well as Alessandro Turchi (1578–1648) from Verona, who had made Rome his home and, after an early Caravaggesque phase, had moved far towards Bolognese classicism. Of the younger masters, in addition to Camassei, only Sacchi (two) and Cortona were commissioned. All in all, the church offers an excellent cross-section of the various trends of monumental easel painting in the 1630s: the old Bolognese classicism next to Sacchi's Baroque classicism and Reni's elegant and sublime late manner next to Lanfranco's and Cortona's full-blooded versions of the Baroque. The keynote of the latter's *Ananias healing St Paul of Blindness* (*c.* 1631) consists, rather typically, in a saturation of Raphaelesque reminiscences with Venetian colourism.

The reversal of values during the next decade, the return to a dry and archaizing Bolognese manner, the emphasis on design, and the almost complete turning away from Venetian colour will be found in such works as Sassoferrato's *Madonna del Rosario* (1643, S. Sabina), Cerrini's *Holy Family with St Agnes and St Catherine* (1642, S. Carlo alle Quattro Fontane), Gimignani's frescoes in S.

Carlo ai Catinari (1641), and Romanelli's *Presentation of the Virgin* (1638–42, St Peter's) [167].[5] One of the most extraordinary paintings of these years [168] illustrates this trend in absolute purity. Nazarene or Pre-Raphaelite paintings come to mind: this archaism seems to have a radical and therefore revolutionary quality. Even a man of a different calibre, the young Mattia Preti (1613–99), in spite of his originality and vigour, paints the frescoes in the apse of S. Andrea della Valle in 1650–1 essentially in the manner of Domenichino.

It is true that all these painters reflect as well as ossify in their work a development towards which Poussin, Sacchi, Algardi, and even Cortona tended, a development that had wide repercussions and links up with international Late Baroque classicism. Seen in proper perspective as an offshoot of Roman High Baroque classicism, this group of painters is therefore neither as anachronistic nor as revolutionary as it might appear.

In the meantime, the lower genre, the so-called Bambocciate (I: p. 45), to which Pieter van Laer had given rise, found scores of partisans. These 'Bamboccianti' had become a powerful coterie even before the 1640s; apart from

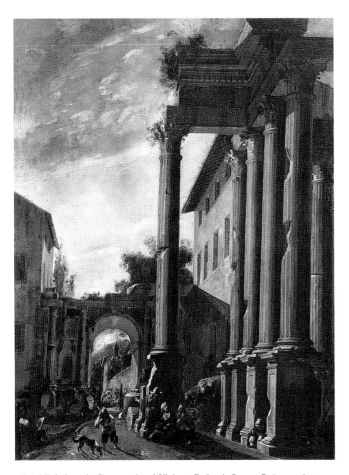

169. Michelangelo Cerquozzi and Viviano Codazzi: *Roman Ruins, c.* 1650.
Rome, Pallavicini Collection

Michelangelo Cerquozzi (1602–60), Viviano Codazzi (1611, not 1604,–72), and a few others,[6] they were however mainly northerners, among them Jan Miel, Jan Asselyn, Andries Both, Karel Dujardin, and Johannes Lingelbach. As early as 1623 the Dutch organized themselves in the Schildersbent,[7] a guild which guarded their interests but was at the same time a centre of Bohemian life in Rome. Just like their lives, their pictures, minute and intimate records of Roman street life, always in the cabinet format, seem unprincipled when compared with official painting in Rome. In their work these Bamboccianti would appear to represent the precise opposite to the conscious primitivism and classicism of the minor monumental painters. But the matter is not quite so simple. Codazzi's classically constructed *vedute*, which such painters as Miel, Micco Spadaro (p. 163), and, above all, Cerquozzi peopled with figures[8] [169], show that the rift concerned the choice of subject matter rather than composition and design. It was the degraded subjects of the Bamboccianti against which the attacks from the classical camp were directed (p. 87). The critics, however, were unable to realize that, unlike themselves, the Bamboccianti, with their exploration of a vast field of human and visual experience, were fighting the battles of the future.

Moreover, precisely in the years of the ascendancy of the Sacchi clique, another 'unprincipled' artist, Bernini, began his bold experiments in painting which helped to break out

of the cul-de-sac of classicist dogmatism. Two other, more intimate trends counterbalanced to a certain extent the rigidity of the archaizing group: a renewed interest in the representation of landscape and, not unconnected with this, the rise of a crypto- or quasi-romantic movement. These new departures are primarily connected with the names of Pier Francesco Mola (1612–66), Pietro Testa (1612?–50), and Salvator Rosa (1615–73); characteristically, none of these was in the first place a fresco painter. Mola began under the Cavaliere d'Arpino but received his direction for life from a prolonged stay at Venice. Not back in Rome until 1647,[10] he used in the following two decades a rich palette of warm brownish tones and created works in which once again the landscape element often forms the hub of the composition. He gave his best in small pictures which display a quite personal idyllic and even elegiac quality.[11] His masterpiece as a fresco painter, the *Joseph making himself known to his Brethren* in the Quirinal Palace (1657) [171],[12] reveals the specific problem of this group of artists. Even here the landscape plays a predominant part, but the organization of the painting with a figure composition as much indebted to Raphael as to Cortona exposes a tendency towards reconciliation with the prevailing classicism of the period.

In Testa's case the same conflict between an innate romanticism and the classical theories which he professed, takes on tragic proportions, for his brief career – he died at the age of about forty – probably ended by suicide.[13] Born at Lucca, he was in Rome before 1630, began studying with Domenichino, later worked with Cortona, and became one of the main collaborators of Cassiano del Pozzo (p. 63) in the 1630s and was thus drawn into Poussin's orbit. He was also closely associated with Mola. Passeri describes him as an extreme melancholic, bent on philosophical speculations, who found that work in black-and-white was more suitable than painting to express his fantastic mythological and symbolic conceptions. His etchings [170][14] have an abstruse emblematic quality and a poetical charm only matched by his Genoese contemporary, Giovanni Benedetto Castiglione

170. Pietro Testa: *Allegory of Reason*, 1640–50. Etching

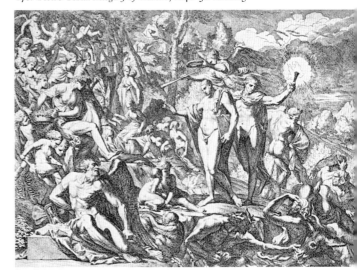

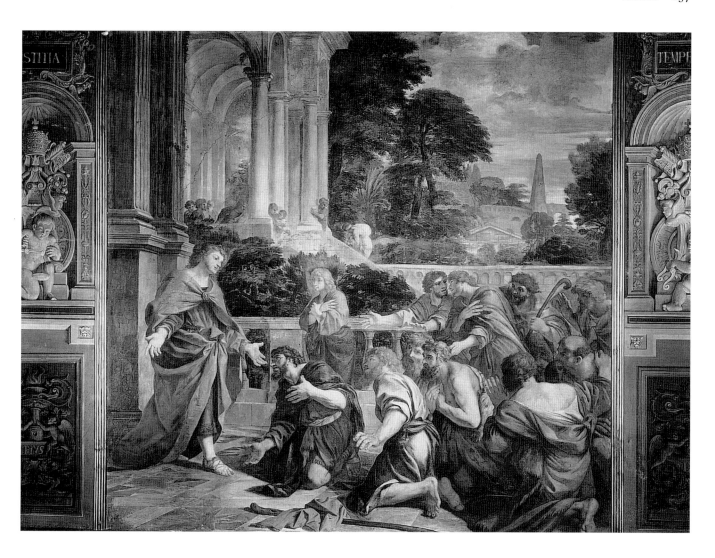

171. Pier Francesco Mola: *Joseph making himself known to his Brethren*, 1657. Fresco. Rome, Palazzo del Quirinale, Gallery

172. Pietro Testa: *The Massacre of the Innocents. c.*1639–42. Rome Galleria Spada

173. Salvator Rosa: *Landscape with the Finding of Moses, c.* 1650. Detroit, Institute of Art

[205]. It was Passeri's opinion that Testa outdistanced every painter by the variety and nobility of his ideas and the sublimity of his inventions.

The most unorthodox and extravagant of this group was certainly Salvator Rosa. Born in Naples, he began under his brother-in-law, Francesco Fracanzano, but soon exchanged him for Aniello Falcone. From the latter stems his interest in the battle-piece.[15] He was in Rome first in 1635, was back at Naples in 1637, and returned to Rome two years later. His Satire against Bernini during the Carnival of 1639 made the leading Roman artist a formidable enemy, and so, once again, Rosa left – this time for Florence, where he nursed his genius for over eight years, writing poems and satires, composing music, acting, and painting. His house became the centre of a sophisticated circle (Accademia dei Percossi). In 1649 he finally settled in Rome and now stayed till his death in 1673. A man of brilliant talent, but a rebel in perpetuity,[16] remorseless in his criticism of society, obsessed by a pre-romantic egotistic conception of genius, he took offence at being acclaimed as a painter of landscapes, marines, and battle-pieces. But it is on his achievement in this field rather than on his great historical compositions that his posthumous fame rests.[17] True to the Italian theoretical approach (I: p. 17), he regarded these 'minor' genres as a frivolous pastime. On the other hand, they gave him the chance of letting his hot temper run amok. Setting out from the Flemish

landscape tradition of Paul and Mattheus Brill, many of his landscapes have their skies dark and laden, storms twist and turn the trees, melancholy lies over the crags and cliffs, buildings crumble into ruins, and banditti linger waiting for their prey. Painted with a tempestuous brownish and grey palette, these wild scenes were soon regarded as the opposite to Claude's enchanted elysiums. The eighteenth century saw in Salvator's and Claude's landscapes the quintessential contrast between the sublime and the beautiful. In Sir Joshua Reynolds's words, Claude conducts us 'to the tranquillity of Arcadian scenes and fairy land', while Rosa's style possesses 'the power of inspiring sentiments of grandeur and sublimity'.

Yet it must be emphasized that the romantic quality of Rosa's landscapes is superimposed on a classical structure, a recipe of 'landscape making' which he shares with the classicists. The example of illustration 173[18] shows the repoussoir trunk and tree left and right in the foreground, the classical division into three distances, the careful balancing of light and dark areas. In addition, the arc of the group of figures, which represent the Finding of Moses, fits harmoniously into the undulating terrain, is 'protected' by the larger arc of the tree, and given prominence by the silvery storm-clouds of the background. Based on accepted formulas, such landscapes were carefully devised in the studio; they are, moreover, 'landscapes of thought', because more

174. Salvator Rosa: *The Temptation of St Anthony*, c. 1645–9. Florence, Palazzo Pitti

often than not the figures belong to mythology or the Bible and tie the genre, sometimes by a tender link, to the great tradition of Italian painting. The quasiromantic approach to landscape painting was shared to a lesser extent by Mola and Testa and, while the work of the minor classicists of this period was soon almost forgotten, Rosa's new landscape style opened horizons of vast consequences.[19]

It was during the very years of the rise of the 'romantic' landscape that Poussin and Claude developed their formulas of the heroic and ideal landscape and that landscapes *al fresco* were once again admitted to palace and church; and it is a memorable fact that in the late 1640s and early 1650s Poussin's brother-in-law, Gaspar Dughet (1615–75), whose early manner – not uninfluenced by Salvator – may be described as half-way between the classical and romantic conception of landscape, painted the cycle of monumental landscapes with scenes from the lives of Elijah, Elisha, and St Simon Stock in S. Martino ai Monti as well as landscape friezes in the Colonna, Costaguti, and Doria-Pamphili palaces – thus taking up a tradition for which Agostino Tassi had been famed in the second and third decades of the century.[20] At the same time, the Bolognese Gian Francesco Grimaldi (1606–80), an all-round talent, returned in his frescoes and cabinet pictures to the older tradition of Annibale Carracci's classical landscape style.[21]

On the whole, therefore, the lure of classical discipline far outweighed the attractions of the crypto-romantic movement during the fifth and sixth decades. The 'inferiority complex' from which the romantics suffered makes this doubly clear. How thoroughly they were steeped in the current classical theory is demonstrated by Testa's manuscript treatise on art[22] as well as by Rosa's rather dreary and emphatically rhetorical history paintings. Only on occasion did he allow the fantastic and visionary-romantic elements to gain the upper hand. A case in point is the extraordinary *Temptation of St Anthony* which conjures up the spirit of a Jerome Bosch [174].[23]

Not many years later – in the 1660s – the law was laid down *ex cathedra*. The prevalent taste of the 1640s and 50s had prepared the climate for Bellori's *Idea*, the supreme statement of the classic-idealist doctrine, read to the Academy of St Luke in 1664.[24] This tract, in turn, laid the theoretical foundation for the ascendancy of Maratti's Late Baroque Classicism. Soon Maratti was acclaimed the first painter in Italy. And yet Salvator and the other romantics, far from being out of touch with the spirit of their own time, struck chords which reverberated through the whole of Italy.

The Great Fresco Cycles

It is a memorable fact that none of the High Baroque churches built by Bernini, Cortona, Borromini, and Rainaldi had room for great Baroque ceiling decoration,[25] the only exception being the dome of S. Agnese, and here no indication is extant of what Borromini would have wished to do. All these churches were designed as architectural entities which would have been interfered with by an illusionistic break-through in the region of the dome. A moment's reflection will make it clear how absurd it would be to imagine the domes of S. Ivo, SS. Martina e Luca, S. Andrea al Quirinale, or the vault of S. Maria in Campitelli decorated with grandiloquent Baroque frescoes. Only Bernini admitted illusionist ceiling painting under certain conditions (e.g. Cornaro Chapel). High Baroque ecclesiastical architecture of the first order, in other words, had no use for contempoary fresco paintings, and this also applies by and large to the cities outside Rome.[26] It is doubtful whether other than artistic reasons may account for this situation, for a man like Cortona, who made it impossible for all time to have the dome of SS. Martina e Luca painted, began in the very same years of its construction the extensive fresco decoration of the Chiesa Nuova.

The paradoxical position then is this: High Baroque frescoes were only admitted on the vaults of older churches, where originally none or certainly not this kind of decoration was planned, while contemporary architecture offered no room for monumental painting. This revealing fact must be supplemented by an equally interesting one, namely that after Lanfranco's frescoes in the dome of S. Andrea della Valle, painted between 1625 and 1627, twenty years went by until another dome was similarly decorated: that by Cortona in the Chiesa Nuova (1647–51). At the same moment Lanfranco, back from Naples,[27] painted the frescoes in the apse of S. Carlo ai Catinari (1646–7), his not entirely successful parting gift to the world; and after February 1650

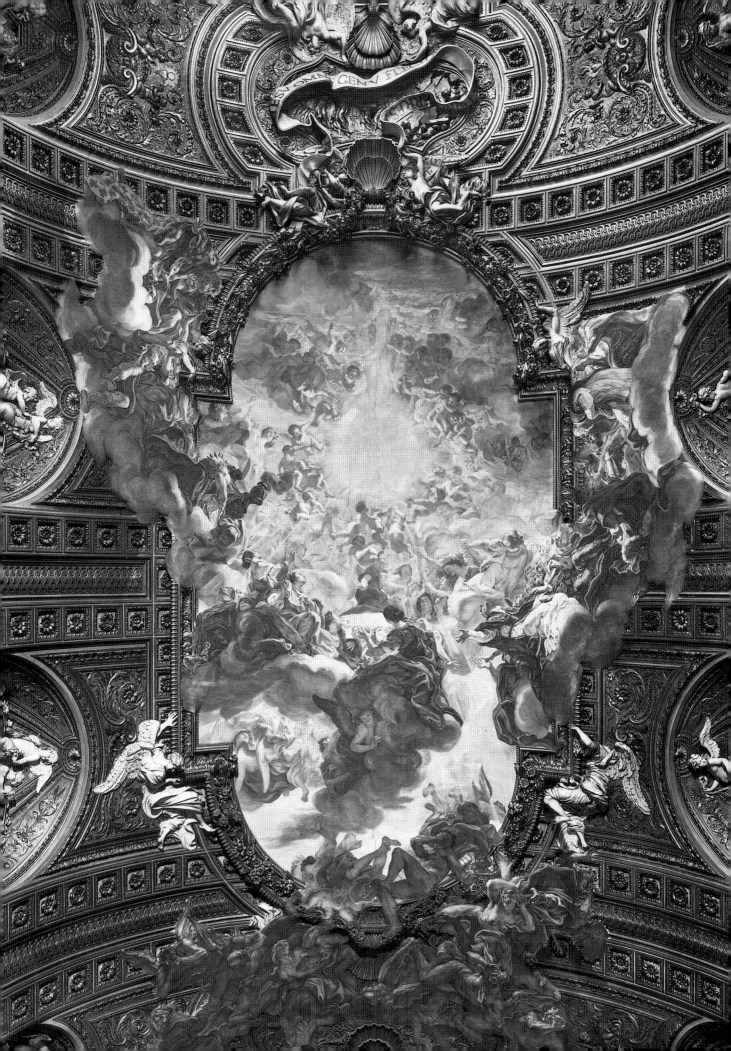

followed Mattia Preti's frescoes in the apse of S. Andrea della Valle. Excepting the continuation of Cortona's work in the Chiesa Nurova during the mid fifties and mid sixties, nothing of real importance happened until 1668, when Gaulli painted the pendentives of S. Agnese (finished 1671). From then on the pace quickened. In 1670 Ciro Ferri, Cortona's faithful pupil, began the dome of S. Agnese in the tradition deriving from Lanfranco's S. Andrea della Valle (finished in 1693, after Ferri's death).[28] Antonio Gherardi's (1644–1702) remarkable frescoes on eighteen fields of the ceiling of S. Maria in Trivio – the most Venetian work in Rome at this period – also date from 1670. In 1672 Gaulli began in the Gesù the most ambitious decoration of the Roman Baroque, which kept him occupied for over a decade [175].[29] Two years later Giacinto Brandi worked on the large vault of S. Carlo al Corso and Canuti on that of SS. Domenico e Sisto (1674–5) [178]. Between 1682 and 1686 follow Brandi's ceiling frescoes in S. Silvestro in Capite, and immediately after, those in Gesù e Maria (1686–7). Filippo Gherardi's *Triumph of the Name of Mary* in S. Pantaleo dates between 1687 and 1690. Padre Pozzo's immense frescoes in S. Ignazio [179] were painted between 1691 and 1694; after 1700 fall Garzi's frescoes in S. Caterina da Siena and Calandrucci's ceiling in S. Maria dell'Orto (1703) and, finally, from 1707 date Gaulli's late frescoes in SS. Apostoli.[30]

It appears, therefore, that most of the large frescoes in Roman churches belong to the last thirty years of the seventeenth and the beginning of the eighteenth century. Gaulli's work in the Gesù and Pozzo's in S. Ignazio, which are rightly regarded as the epitome of monumental Baroque painting, were done at a time when High Baroque architecture and sculpture had long passed their zenith. This situation is not entirely paralleled as regards the decoration of palaces. But in the thirty years between about 1640 and 1670 only three major enterprises are worth mentioning, namely the decoration of the Palazzo Pamphili in Piazza Navona where Camassei (1648), Giacinto Gimignani (1649),[31] Giacinto Brandi, Francesco Allegrini[32] (*c.* 1650), Cortona (1651–4), and Cozza (1667–73) created the most impressive aggregate of friezes and ceilings after the Palazzo Barberini; the great Gallery of the Quirinal Palace, the most extensive work of collaboration, dated 1656–7, where, under Cortona's general direction, G. F. Grimaldi (who seems to have had an important share in the enterprise), the Schor brothers,[33] Guglielmo and Giacomo Cortese (Courtois), Lazzaro Baldi, Ciro Ferri, Mola [171], Maratti, Gaspar Dughet, and some minor *Cortoneschi* appear side by side;[34] and the cycle of frescoes in the Pamphili palace at Valmontone near Rome,[35] painted between 1657 and 1661 by Mola, Giambatista Tassi ('il Cortonese'), Guglielmo Cortese, Gaspar Dughet, Cozza, and Mattia Preti.

Once again some of the most sumptuous decorations follow after 1670. Apart from Cozza's library ceiling in the Palazzo Pamphili [176], mention must be made of the frescoes in the Palazzo Altieri by Cozza, Canuti,[36] and Maratti

176. Francesco Cozza: *Apotheosis of Casa Pamphili*, 1667–73. Fresco. Rome, Palazzo Pamphili in Piazza Navona, Library

[181] and of Giovanni Coli's and Filippo Gherardi's immense Gallery in the Palazzo Colonna (1675–8) [180].[37] And once again, this chronological situation also prevails throughout Italy.

This survey makes it abundantly clear that monumental fresco decorations in Roman churches belong mainly to the Late Baroque. The stylistic change from the High to the Late Baroque can be traced in Preti's fresco of the Stanza dell'Aria in the Valmontone palace, dated 1661.[38] It was here for the first time that the High Baroque method of using time-honoured concepts of firm organization and clear, incisive structure as well as of stressing the individuality and massiveness of each single figure were abandoned and replaced by a flickering dotting of the entire ceiling with seemingly casually arranged figures so that the eye seeks a focusing or resting point in vain. Compared with Preti's Valmontone fresco, even such contrasting performances as

175. Giovan Battista Gaulli: *Adoration of the Name of Jesus*, 1674–9. Fresco. Rome, Gesù, ceiling of nave

177. Giovan Battista Gaulli: *Head of an Angel*, after 1679. Fresco. Detail. Rome, Gesù, apse

Cortona's and Sacchi's Barberini ceilings [96, 103] have basic features in common. Preti's work, on the other hand, shows stylistic idiosyncrasies which soon became current not only in painting but also in the sculpture of the Late Baroque.

Cozza was quick in accepting his friend Preti's new manner; and with the latter's Valmontone frescoes almost entirely gone, Cozza's library ceiling in the Palazzo Pamphili [176][39] takes on particular importance. Painted with an extremely light and luminous palette, the individual figures remain much indebted to Domenichino. Thus one is faced here with the attractive and almost unbelievable spectacle of a typically Late Baroque open sky peopled with masses of allegorical figures in a naive classicizing style.

In a varying degree elements of Preti's revolution will be found in the decoration of churches from about 1670 on. A generic description has to emphasize two decisive points. In the grand decorative frescoes of the High Baroque, each figure has an immense plastic vitality, seems close to the beholder, and plays a vital part in the whole composition [96]. By contrast, the figures of the later series of frescoes [175, 178, 179] have, as it were, only a collective existence; they are dependent on larger units and, what is more, get much smaller with the feigned distance from the spectator until they are lost in the immeasurable height of the empyrean. While Cortona's figures seem to act before the open sky, the figures now people the sky, they inhabit it as far as the eye can see. And secondly, dazzling light envelops them. The nearer they are to the source of divine illumination, the more ethereal they become. Aerial perspective supports the diminution of figures in creating the sensation of infinitude. The Correggio–Lanfranco tradition had, of course, a considerable share in bringing about the new illusionism.

178. Domenico Maria Canuti and Enrico Haffner: *Apotheosis of St Dominic*, 1674–5. Fresco. Rome, SS. Domenico e Sisto

Despite such common features, some of the monumental fresco decorations are poles apart. We saw in a previous chapter (p. 23) how Gaulli in the Gesù became the mouthpiece of Bernini's ideas. Before this Genoese artist (1639–1709)[40] arrived in Rome he had laid the foundation for his style in his native city under the impression of Van Dyck and Strozzi and, above all, of Correggio during a stay at Parma. A brilliant talent, also one of the first portrait painters of his time, he was capable of conveying drama in fresco as well as on canvas with a warm and endearing palette. The head of the Angel of illustration 177, a detail from his frescoes in the Gesù, gives a good idea of the loving care of execution, the bravura of handling, the free and easy touch, and the flickering light effects produced by the application of fresh impasto. Moreover, by painting the half-open mouth and the eyes as if seen through a haze – revealing his study of Correggio's *sfumato* – he managed to endow such a head with the languid spirituality of Bernini's latest

179. Andrea Pozzo: *Allegory of the Missionary Work of the Jesuits*, 1691–4. Fresco. Rome, S. Ignazio, ceiling of nave

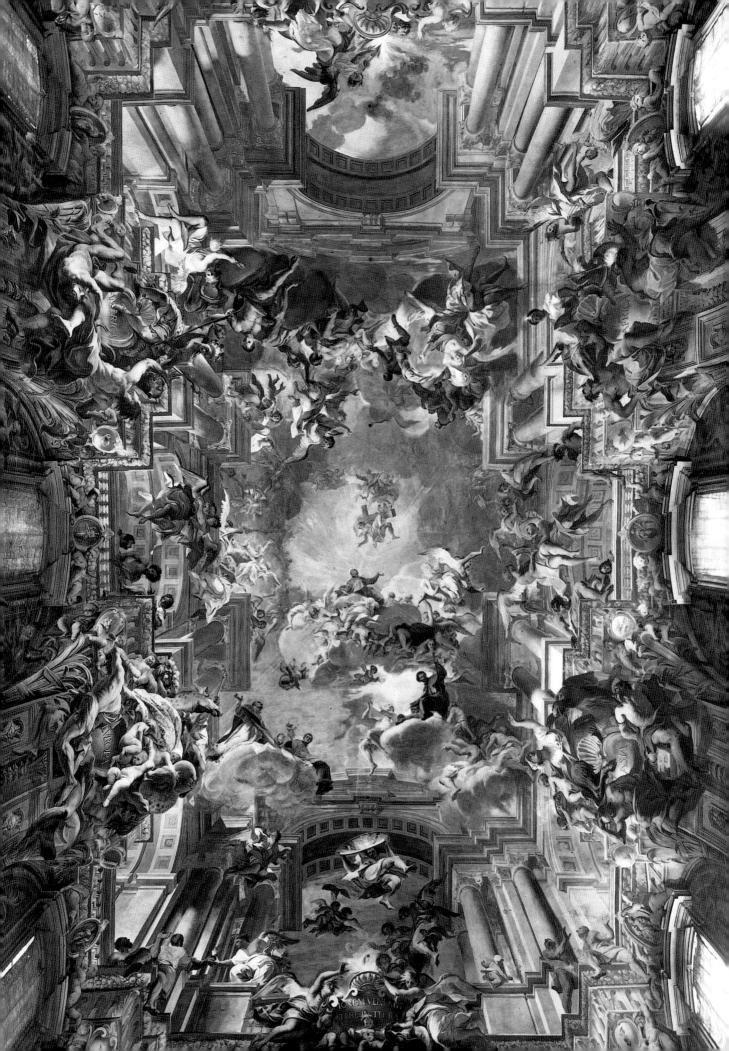

180. Giovanni Coli and Filippo Gherardi: *The Battle of Lepanto*, 1675–8.
Fresco. Rome, Palazzo Colonna, Gallery

manner (see illustrations 78 and 79). In his later work his palette got paler and the intensity of his style dwindled, no doubt under the influence of the prevailing taste of the *fin de siècle*.

The Bolognese Domenico Maria Canuti (1626–84), in his time a celebrated fresco painter, had been reared in the tradition of Reni's late manner, and came to Rome in 1672. What he saw there was not lost on him, for his dramatic *Apotheosis of St Dominic*[41] [178] in the open centre of the ceiling of SS. Domenico e Sisto discloses his familiarity with the grouping of figures and the aerial and light conquests of Gaulli's Gesù decoration, then *in statu nascendi*.[42] But Canuti also introduced a novelty. He framed the entire ceiling by a rich *quadratura* design (executed by Enrico Haffner) whereby Rome was given a type of scenographic fresco for which neither Bernini nor Cortona had any use, but which one may well expect to find in Genoa.

The greatest of all *quadratura* painters, Padre Andrea Pozzo[43] (1642–1709), also took his cue from the Bolognese masters. By contrast to the decorative profusion of Haffner's design, Pozzo's *quadratura* is always strictly architectural and in so far old-fashioned; it is only the virtuosity and hypertrophic size of his schemes – typical signs of a late phase – that give him his special stature. Within the *quadratura* framework in S. Ignazio [179], as elsewhere, he arranged his figures in loosely connected light and dark areas – proof that he too had learned his lesson from Gaulli.

Giovanni Coli (1636–81) and Filippo Gherardi (1643–1704), two artists from Lucca who always worked together, combined their Venetian training with the study of Cortona's style in the gallery of the Palazzo Colonna.[44] The Cortonesque framework, executed by G. P. Schor between 1665 and 1668, displays an enormous accretion of detail, while the strongly Venetian central panel [180] dazzles the eye by the almost unbelievable entanglement of figures, keels, and masts, all bathed in flickering light. How far this style is removed from Cortona's High Baroque needs no further comment. It is also evident that Gaulli's and Coli-Gherardi's styles have little in common, arising as they do from different sources: the one mainly from Bernini's spiritualized later manner, the other from the hedonistic Cortonesque-Venetian painterly tradition. On the other hand, compared with Maratti's Palazzo Altieri fresco [181], Gaulli and Coli-Gherardi seem to be on the same side of the fence.

Let the reader be reminded that these three contemporary works far outdistanced in importance any other fresco executed during the 1670s, and, furthermore, that Gaulli's cycle was infinitely more Roman and infinitely stronger than Coli-Gherardi's ceiling. The constellation that emerged at this historic moment was simply a struggle for primacy between Gaulli and Maratti. Forty years after the Cortona-Sacchi controversy the fronts were once again clearly defined. But neither the 'baroque' nor the 'classical' wing was the same. Gaulli's style had a distinctly metaphysical basis; often mystical and stirring in its appeal, it may have derived its strength from the forces lying behind Bernini's late manner: the current revival of pseudo-dionysiac mysticism[45] as well as the growing popularity of Molinos's quietism. A knowledge of the intervening history of painting makes it evident that the odds weighed heavily against Gaulli. Just as the close fol-

181. Carlo Maratti: *The Triumph of Clemency*, after 1673. Fresco. Rome, Palazzo Altieri, Great Hall

lowers of Bernini in sculpture had not a ghost of a chance in the face of Late Baroque rationalism which was backed by the strong French party, so also in painting: Gaulli's mystical Late Baroque soon burnt itself out in the cool breeze blowing from Maratti's classicist camp.[46]

Carlo Maratti (1625–1713)

A study of Maratti's Altieri ceiling [181] plainly shows that he wanted to restore the autonomous character of the painted area: once again the fresco is clearly and simply framed.[47] He also wished to reinstate the autonomy of the individual figure; he returned to the classical principle of

182. Carlo Maratti: *Virgin and Child with St Francis and St James*, 1687. Rome, S. Maria di Montesanto

generalizations with which his work abounds, admission of just the right does of festive splendour – all this predestined his grand manner to become the accepted court style in Louis XIV's Europe. Maratti was not an artist given to speculation and theory.[48] Somewhat paradoxically, it was his pragmatic approach by virtue of which he came up to the hybrid theoretical expectations of his friend Bellori who, like Agucchi before him, wanted the artist's *idea* to result from the empirical selection of beautiful parts rather than from an *a priori* concept of beauty.[49]

All this sounds perhaps scathing, yet it must be admitted that Maratti was an artist of extraordinary ability. Born at Cammerino (Marches) in 1625, he appeared as a boy of twelve in Andrea Sacchi's studio. As early as 1650 his reputation was firmly established with the Sacchesque *Adoration of the Shepherds* in S. Giuseppe dei Falegnami. From then on Maratti's career was a continuous triumph, and, indeed, one monumental masterpiece after another left his studio. Nor was he entirely partial to the manner of Sacchi and the other classicists. The paintings of the 1650s reveal the impact of Lanfranco's Baroque; he admitted influences from Cortona and Bernini and even had some sympathy with the mystic trend of the second half of the century. What impressed his contemporaries most was that he re-established a feeling for the dignity of the human figure seen in great, simple, plastic forms and rendered with a sincerity

183. Morazzone: *St Francis in Ecstasy*, c. 1615. Milan, Brera

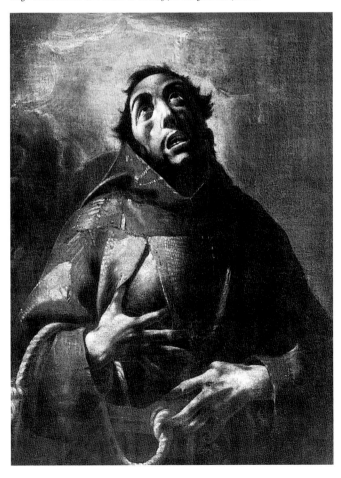

composing with few figures and to an even, light palette which invites attention to focus on the plastically conceived figure, its attitude and gestures; he almost relinquished the *sotto in sù* but, characteristically, did not revive the austere *quadro riportato* of the Early Baroque classicism. Moreover, the figures themselves are more Baroque and less Raphaelesque than he may have believed them to be, and the composition lacks poignancy and incisive accents. It undulates over the picture plane, and the first impression is one of a perplexing mass of sodden form. The closeness of this style to Domenico Guidi's in sculpture is striking.

It is also revealing that the Early Baroque classicism of Reni's *Aurora* [1: 48] and the High Baroque classicism of Sacchi's *Divina Sapienza* [103] are closer to each other than either is to Maratti's Late Baroque Classicism. By comparison, Maratti had gone some way towards a reconciliation of the two opposing trends, the Baroque and the classical. In every sense he steered an agreeable middle course. His paintings contain no riddles, nothing to puzzle the beholder, nothing to stir violent emotions. His glib handling of the current allegorical language, the impersonal

and moral conviction without parallel at that moment [182]. As early as the mid seventies neither Gaulli nor the Cortona succession was left with a serious chance, and by the end of the century Rome had to all intents and purposes surrendered to Maratti's manner. At his death in 1713 his pupils were in full command of the situation.[50]

PAINTING OUTSIDE ROME

During the period under review the contribution of Tuscany, Lombardy, and Piedmont was rather modest. Apart from Reni's late manner, even Bologna had little to offer that would compare with the great first quarter of the century. Venice slowly began to recover, while the schools of Genoa and Naples emerged as the most productive and interesting, next to Rome.

A bird's-eye view of the entire panorama reveals that neither the classical nor the crypto-romantic trend was peculiar to Rome. In fact, the Roman constellation is closely paralleled in other centres. With Reni in an unchallenged position at Bologna, his late manner became the inescapable law during the 1630s. His influence extended far beyond the confines of his native city, bringing about, wherever it was felt, a soft, feeble, sentimental, and rather structureless classicism. One can maintain that there was almost an inverse ratio between Reni's success on the one hand and Cortona's

184. Francesco del Cairo: *St Francis in Ecstasy, c.* 1630. Milan, Museo del Castello Sforzesco

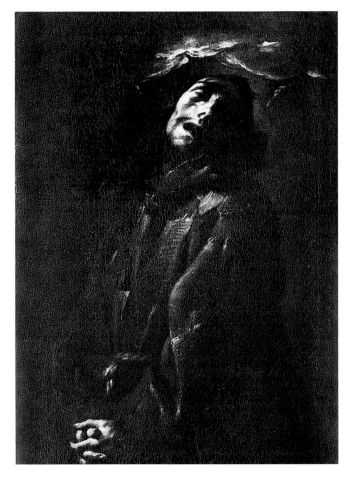

and Lanfranco's on the other. Soon Reni's Baroque classicism filtered through to the North and South of Italy. In Milan Francesco del Cairo (1607–65),[51] who began in Morazzone's manner [183, 184], formed his style in the later 1640s on Reni and Venice, and his work became languid, thin, and classical. His contemporary, Carlo Francesco Nuvolone, called 'il Panfilo' (1608–61?), had a similar development; dependent on Reni, which earned him the epithet 'Guido lombardo', he exchanged his early *tenebroso* manner for a light tonality. In Florence, too, Reni's influence is evident; in Furini's work, superimposed on the native tradition, it led to a highly sophisticated, over-refined style. On the other hand, probably impressed by Poussin's classicism, from the 1640s on an artist like Carpioni in Venice found a way out of the local academic eclecticism through elegant classicizing stylizations. The classical *détente* of the 1640s and 50s is particularly striking in Naples. During their late phase such artists as Battistello, Ribera, and Stanzioni turned towards Bolognese classicism, while Mattia Preti embraced the fashion in his early period, only to break away from it some time later. Sicily, finally, had an artist of distinction in Pietro Novelli, called 'il Monrealese' (1603–47), who abandoned his early Caravaggesque *tenebroso* in the early 1630s, not uninfluenced by Van Dyck's visit to Palermo (1624) and under the impact of a journey to Naples and Rome (1631–2).[52]

By and large, the classical reaction, which lies broadly speaking between 1630 and 1660, spells a falling off of quality. This does not, of course, apply to the two great leaders, Sacchi in Rome and Reni at Bologna, nor to the position in Venice and Florence, where Baroque classicism was to some extent a regenerative agent; yet it is certainly true of the first generation of Carracci pupils at Bologna (p. 59 ff.); it is true of Guercino's manner in the last thirty years of his life, when he was open to Reni's influence and produced works with a strong classical bias, many of which have no more than a limited interest; and it is, above all, true of Naples, where the *élan* of the early Ribera fizzles out during the fourth and fifth decades into a rather feeble academic manner.

On the other side of the fence were some artists of a slightly younger generation (most of them born between 1615 and 1625), who reacted vigorously against the prevalent Baroque classicism. The principal names to be mentioned are Maffei from Vicenza, the Florentine Mazzoni, and the Genoese Langetti, all working in Venice and the *terra ferma*; Valerio Castello in Genoa; Mattia Preti and the early Luca Giordano in Naples. In one way or another these and other artists revitalized Caravaggio's heritage; but theirs was a new, painterly High Baroque Caravaggism [194, 195, 203, 214], the Caravaggism that was handed on to Magnasco and Crespi and through them to Piazzetta and the young Tiepolo.

There is, however, an important area where these baroque individualists and the Baroque classicists meet. For the lightening of the palette, the most characteristic mark of those masters who turned Baroque classicists, was not simply a tactical reversal of their earlier *tenebroso* manner; it had a distinctly positive aim, namely the unification of the picture plane by means of an even distribution of colour and light. These painterly tendencies, mentioned in a previous

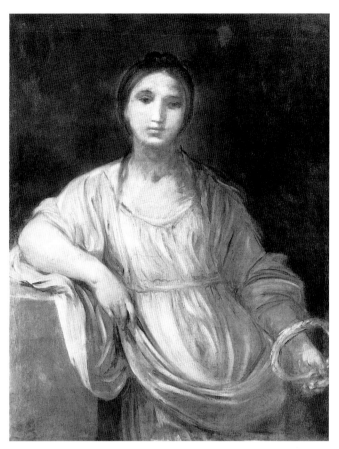

185. Guido Reni: *Girl with a Wreath, c.* 1635. Rome, Capitoline Museum

186. Simone Cantarini: *Portrait of Guido Reni, c.* 1640. Bologna, Pinacoteca

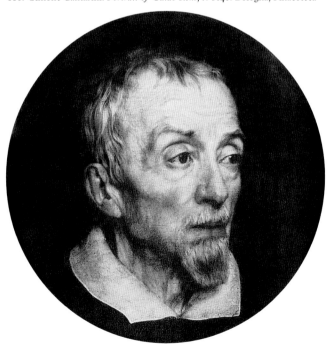

chapter (p. 85) and nowhere more evident than in Reni's late manner [185], distinguish High Baroque classicism from the classicism of the first quarter of the century. Although worlds apart, it is these painterly tendencies that form the common denominator between the Baroque classicists and the *neo-Caravaggisti*. In all other respects they differed most seriously.

To the comparatively light palette of the Baroque classicists the *neo-Caravaggisti* opposed a strong chiaroscuro; to the relatively smooth handling of paint, a *pittura di tocco* (stroke) and *di macchia* (spot) – work with the loaded brush and sketchy juxtapositions of small areas of colour; to the harmonious scale of tones, unexpected colour contrasts; to the classical types of beauty, subjective deviations; to the tedium of balanced compositions, unaccountable vagaries; to the facile rhetorical repertory, violent movement, drama, and even a new mysticism. Even though this generic list of contrasts may be too epigrammatic, it helps to clarify the entangled position of the second and third quarters of the century.

No doubt Salvator Rosa's crypto-romanticism had partisans up and down the peninsula. But allegiance to one trend or the other also changed; some artists were torn between them. Giovan Benedetto Castiglione seems the most remarkable example.

Bologna, Florence, Venice, and Lombardy

After this introduction, the Reni succession at Bologna need not detain us: Francesco Gessi (1588–1649), Giovan Giacomo Sementi (1580–1636), Giovanni Andrea Sirani (1610–70) and his daughter Elisabetta (1638–65), or Luca Ferrari from Reggio (1605–54) who transplanted his master's manner to Padua and Modena. These mediocre talents transformed the positive qualities of Reni's late 'classicism' [185]:[53] the unorthodox simplicity of his inventions into compositions of boring pedantry; his refined silvery tonality into a frigid scale of light tones; his vibrant tenderness into sentimentality; and his late 'sketchy' manner with its directness of appeal was neither understood nor followed. Among the Reni succession in Bologna only two artists stand out, namely Simone Cantarini (1612–48)[54] and Guido Cagnacci (1601–63);[55] the former for having left a number of carefully constructed, serene, and strong works, in which Carraccesque elements are combined with those from Cavedoni and the early Reni to form a distinctly personal style, well illustrated by the moving portrait of his aged teacher [186]; the latter, who sought his fortune in Vienna (*c.* 1657) and became court painter to Emperor Leopold I, for breaking away from the orthodox Baroque classicists and creating some works of great poignancy in strange violet and bluish tones. On the whole, the Bolognese remained faithful to their classical tradition, guarded, during the second half of the century, by the three *caposcuole*, Reni's pupil, Domenico Maria Canuti (p. 145); Cantarini's pupil, Lorenzo Pasinelli (1629–1700);[56] and Albani's pupil, Carlo Cignani, to whom I have to return in a later chapter.

At the same time, Bologna continued to be the acknowledged centre of *quadratura* painting. This tradition was handed on through Girolamo Curti, called il Dentone

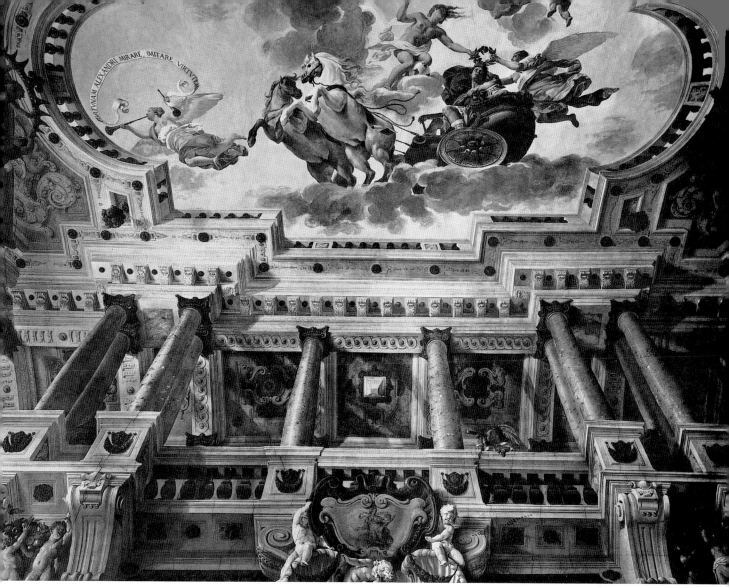

187. Angelo Michele Colonna and Agostino Mitelli: *Quadratura* frescoes, 1641. Florence, Palazzo Pitti, Museo degli Argenti

188. Francesco Furini: *Faith*, *c.* 1635. Florence, Palazzo Pitti

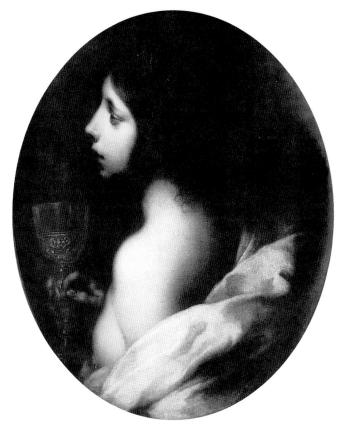

(1570–1632), to Angelo Michele Colonna (1600–87) and Agostino Mitelli (1609–60). These two artists joined forces and for a time almost monopolized *quadratura* painting, working together at Parma, Florence [187], Genoa, Rome, and even Madrid, where Mitelli died. Their rich scenographic views, foreshadowing the Late Baroque by virtue of the complexity of motifs, form a decorative court style in its own right rather than a mere framework for figure painters. They educated a large school, and since Mitelli claimed to have invented *quadratura* with more than one vanishing point,[57] it is he who must be credited with having laid the foundation for the rich eighteenth-century development of this speciality.

Very different from the Bolognese was the Florentine position.[58] Matteo Rosselli, who has been mentioned (1: p. 65), made sure that the typically Florentine qualities of elegant design and bright local colour remained for a time unchallenged. He educated the foremost artists of the next generation, among whom may be mentioned Giovanni

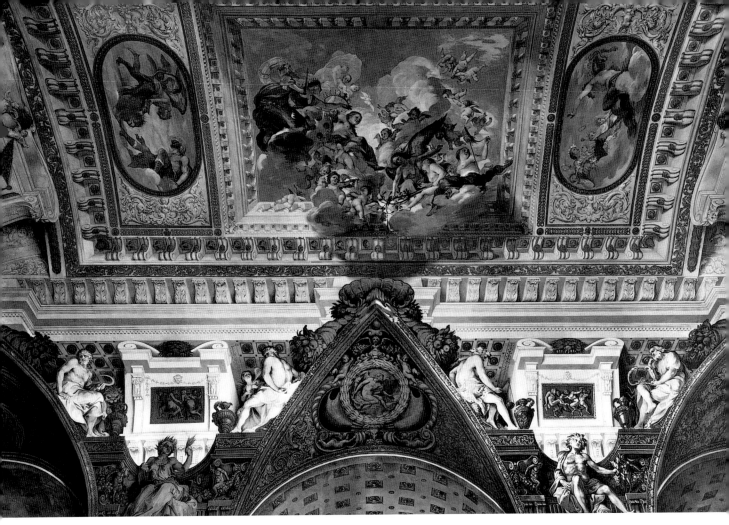

189. Giovanni da San Giovanni: *Allegory of the Union of the Houses of Medici and della Rovere*, 1635–6. Fresco. Florence, Palazzo Pitti, Salone degli Argenti

Mannozzi, called Giovanni da San Giovanni (1592–1636), Francesco Furini (*c.* 1600–46), Lorenzo Lippi (1606–65), Baldassare Franceschini, called Volterrano (1611–89), and Jacopo Vignali (1592–1664)[59] and his pupil Carlo Dolci (1616–86). These artists responded in various ways to the rarefied atmosphere of the Florentine court.

Furini, above all, influenced by Reni, produced paintings of a morbid sensuality [188]. The ultramarine flesh-tones together with his *sfumato* give his pictures a sweetish, sickly flavour, but nobody can deny that he had a special gift for rendering the melodious calligraphy of the female body, thus disclosing his attachment to the Mannerist tradition. Giovanni da San Giovanni had a more healthy temperament. An artist capable of handling very large fresco commissions, even the experience of Rome (fresco in the apse of SS. Quattro Coronati, 1623) did not rid him of Florentine idiosyncrasies. Although his light touch, translucent colours, and the ease and brilliance of his production make him one of the most attractive Florentine painters of the Seicento, the retardataire character of his art[60] is shown by the fresco cycle in the Sala degli Argenti of the Palazzo Pitti (1635), glorifying Lorenzo de' Medici's concern for art and philosophy, a work, incidentally, that was finished after Giovanni's death by Furini, Ottavio Vannini, and Francesco Montelatici, called Cecco Bravo (1607–61) [189].[61] The

comparison with Cortona's work in Rome and Florence reveals Giovanni's provincialism.[62]

Giovanni da San Giovanni had been dead for some years when Cortona settled in Florence, and Furini died before he left. But a number of other artists were thrown off their course by the study of Cortona's grand manner. Volterrano's case is characteristic [190]. He had begun as Giovanni da San Giovanni's assistant in the Palazzo Pitti (1635–6) and painted his frescoes in the Villa Petraia (1637–46)[63] in the same manner, but changed to a Cortonesque style in the Sala delle Allegorie of the Palazzo Pitti (*c.* 1652), a style which with modifications he maintained in his later work (e.g. the frescoes in the dome of the SS. Annunziata, 1676–80/3). A similar course was taken by Giovanni Martinelli (active between 1635 and 1668), while Furini's pupil Simone Pignoni (1611–98)[64] made few concessions to the new vogue. It was mainly Ciro Ferri (1634–89), Cortona's closest follower, who ensured the continuity of the Cortona succession in Florence. Ferri made it his home in 1659–65 in order, above all, to complete the Palazzo Pitti frescoes which his master had left unfinished when he returned to Rome in 1647.[65]

Carlo Dolci's art, the Florentine counterpart to that of Sassoferrato in Rome, deserves a special note because the languid devoutness expressed by his half-figures of Virgins

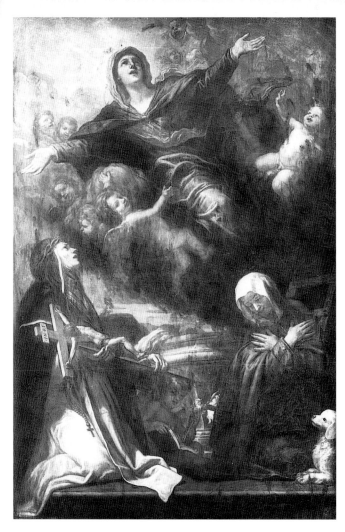

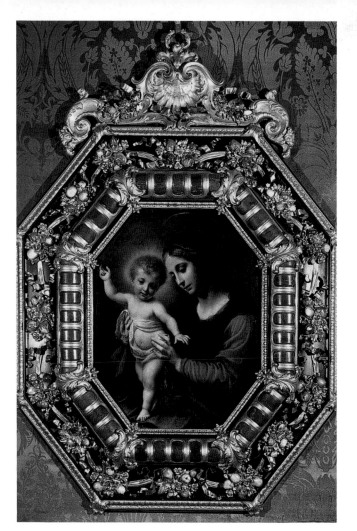

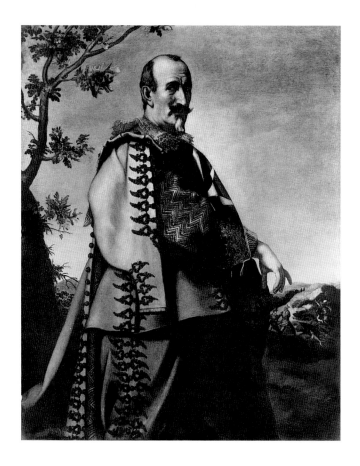

190. Volterrano: *Assumption of the Virgin*, 1669. Fresco. Florence, SS. Annunziata

191. Carlo Dolci, *Virgin and Child* (within a frame by G.B. Foggini), *c.* 1630–5. Florence, Palazzo Pitti

192. Carlo Dolci: *Portrait of Fra Ainolfo de' Bardi*, 1632. Florence, Palazzo Pitti

and Magdalens must be regarded as the fullest realization of one side of Late Baroque mentality [191]. These cabinet pictures, painted with the greatest care in a slick miniature technique, enjoyed a great reputation in his time, and contemporaries admired what appears to the modern spectator a false and even repulsive note of piety. A real prodigy, Dolci at the age of sixteen painted the excellent portrait of Ainolfo de' Bardi [192]. But it was not only his own vow to devote his life to religious imagery, in acceptance of Cardinal Paleotti's theoretical demand,[66] that prevented him from making headway as a portrait painter. He had no chance against the immensely successful Fleming Justus Sustermans (1597–1681), court painter in Florence from 1620 on and a master of the official international style of portraiture which developed in the wake of Van Dyck.

Finally, Stefano della Bella (1610–64)[67] must be mentioned, whose place is really outside the tissue of Florentine Seicento art. The teacher of his choice was Callot; magically attracted by the latter's etchings, della Bella preserved in his work something of their spirited elegance. His best and most

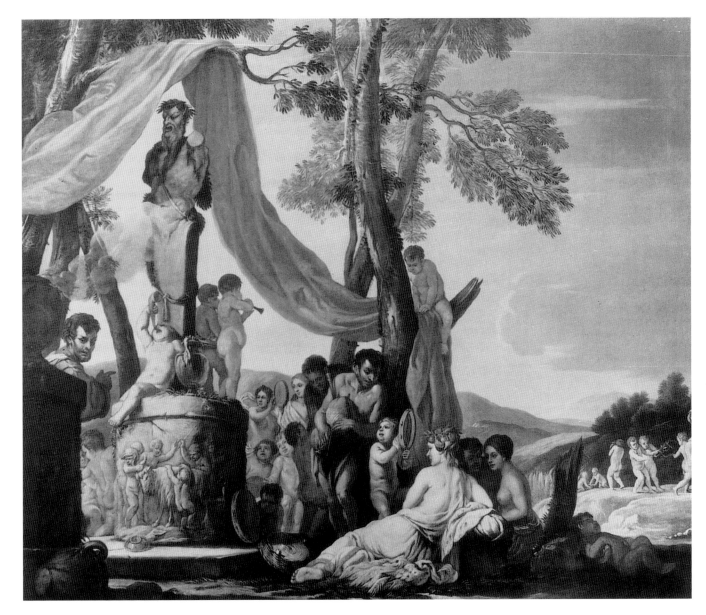

193. Giulio Carpioni: *Bacchanal*, before 1650. Columbia, South Carolina, Museum of Art

productive period was the ten years in Paris, 1639–49, in the course of which his style changed under the impact of Rembrandt and the Dutch landscapists. He must rank as one of the greatest Italian etchers, but he was a typical master of the *petite manière*, his more than a thousand etchings, often peopled with tiny figures, being concerned with all aspects of popular life. The influence of his work on the further course of Italian genre painting was probably greater than is at present realized.

The development in Venice[68] shows certain parallels to that in Florence, in spite of the exquisite work of the great triad Fetti, Lys, and Strozzi, who brought entirely new painterly values to bear on the Venetian scene between 1621 and 1644, the year of Strozzi's death. What Matteo Rosselli had been for Florence, Padovanino was for Venice. Most painters of the second and third quarter of the century stemmed from him; they carried over his academic eclecti-

cism into a refined and often languid Seicentesque idiom. Girolamo Forabosco from Padua (1604/5–79), distinguished as a portrait painter, Pietro Muttoni, called della Vecchia[69] (1605–78), Giulio Carpioni[70] (1613–79), who worked mainly at Vicenza, and the feeble Pietro Liberi (1614–87) represent different facets of this somewhat superficial manner. The Palma Vecchio character of Forabosco's portraits, Vecchia's neo-Giorgionesque paintings, and Carpioni's Poussinesque Bacchanals would seem to be nuances of the same classicizing vogue [193].[71]

Like Cortona's appearance in Florence, Luca Giordano's stay in Venice in 1653 had a revolutionizing effect on local artists. Riberesque in his early phase, Giordano brought to Venice a Neapolitan version of Caravaggio's 'naturalism' and *tenebroso*. This dramatic manner found immediate response in the work of the Genoese Giambattista Langetti[72] (1625– 76), who probably began under Assereto, then

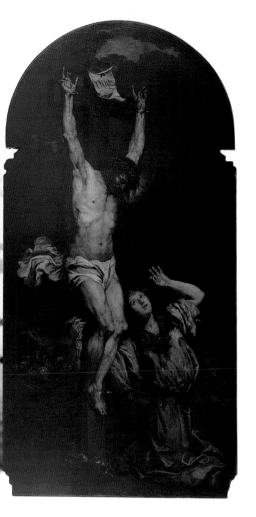

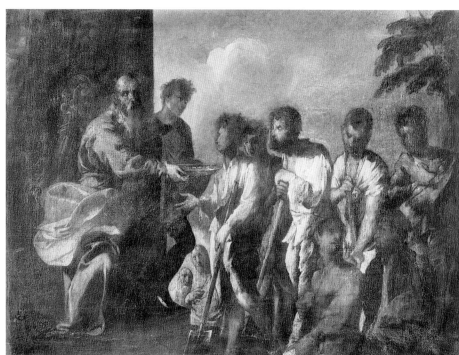

195 (*above*). Francesco Maffei: *Parable of the Workers in the Vineyard, c.* 1650. Verona, Museo di Castelvecchio

194 (*left*). Giambattista Langetti: *Magdalen under the Cross*, after 1650. Venice, Chiesa delle Terese

worked in Rome under Cortona,[73] and appeared in Venice towards the mid century. His work is distinguished by violent chiaroscuro applied with a loaded brush [194]. Langetti's manner was followed, above all, by the German Johan Karl Loth (1632–98), who had settled in Venice after 1655,[74] and by his competitor Antonio Zanchi from Este (1631–1722). Further, Pietro Negri, Zanchi's pupil, the Genoese Francesco Rosa, and Antonio Carneo (1637–92) from Friuli[75] should be mentioned in this context.

But long before Luca Giordano's first visit to Venice two 'foreigners', both artists of exceptional calibre, revolted against the facile academic practices: Francesco Maffei[76] from Vicenza (*c.* 1600–60) and the Florentine Sebastiano Mazzoni[77] (1611–78). Soon after 1620 Maffei liberated himself from the fetters of current Mannerism. The study of Jacopo Bassano, of Tintoretto and Veronese, and, above all, of such Mannerists as Parmigianino and Bellange led to his characteristic manner, which was fully developed in the *Glorification of Gaspare Zane* (1644, Vicenza, Museum). Painting with a nervous and rapid brush, he delighted in exhibiting sophisticated dissonances. Much of his work has an uncouth and almost macabre quality, a refreshingly unorthodox style which may best be studied in such late works as the *Glorification of the Inquisitor Alvise Foscarini* (1652, Vicenza, Museum) and those in the Oratories delle Zitelle and of S. Nicola da Tolentino (Vicenza). The ghostly *Parable of the Workers in the Vineyard* (Verona, Museo di Castelvecchio) [195] exemplifies his late manner, showing in

addition how he transformed his debt to Domenico Fetti. The younger Mazzoni, the only artist of this generation who took the teachings of Fetti and Strozzi to heart, was surely impressed by Maffei's work. His brilliant and free brushwork, to be found as early as 1649 in the paintings in S. Benedetto (Venice), and, slightly later, in the most remarkable *Annunciation* [196], makes him a real forerunner of the Venetian Settecento. Another Florentine, Mazzoni's contemporary Cecco Bravo, shows a similar unconventional handling of paint [197].

With Giovanni Coli and Filippo Gherardi echoes of the Roman grand manner reached Venice, but the strongest impact came once again from Luca Giordano, whose pictures in S. Maria della Salute and other churches, painted in the late 1660s and the 1670s, show the light palette of his mature style, derived mainly from impressions of Veronese. The stage was set for the artists born between about 1635 and 1660. They accepted Giordano's neo-Venetian manner to a greater or lesser extent and helped to prepare the way for the great luminous art of the eighteenth century. Andrea Celesti[78] (1673–*c.* 1711), whose masterpieces are in the parish church at Desenzano (Lake Garda); Federico Cervelli from Milan (active 1674–*c.* 1700), Sebastiano Ricci's teacher; Antonio Bellucci (1654–1727),[79] who spent his best years abroad, and many others[80] should here be named. But neither Maffei nor the *tenebrosi* were forgotten. Thus Celesti as well as Bellucci were indebted to Maffei, while Antonio Molinari[81] (1665–1727), working in Zanchi's manner and

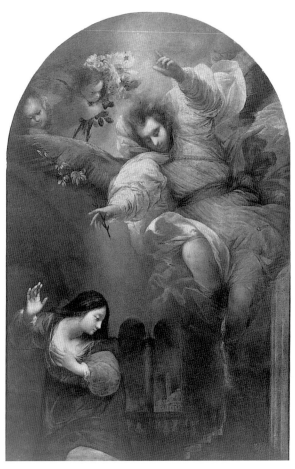

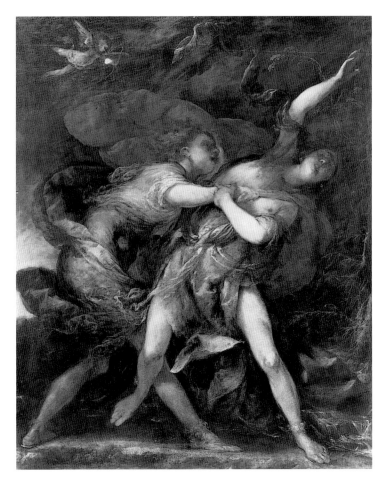

196. Sebastiano Mazzoni: *Annunciation*, c. 1650. Venice, Accademia

197. Cecco Bravo: *Apollo and Daphne*, c. 1650. Ravenna, Pinacoteca

revealing Giordano's influence, also opened the way to Piazzetta's *tenebroso* style [198].

In conclusion it must be said that, with the exception of Langetti, Mazzoni, and Maffei, few of these painters fully relinquished the facile decorative manner of a Forabosco and a Liberi, nor were they capable of a new and coherent vision – in spite of the fact that some of them lived far into the eighteenth century.

While Venice and the *terra ferma* were teeming with painters to whom magnificent opportunities were offered, Milan's decline after the Borromeo era was irrevocable. Apart from Francesco del Cairo, who has been mentioned, there were no painters of real rank. Carlo Francesco Nuvolone (1608–61), to whom reference has also been made, a minor master, a brother of the even weaker Giuseppe (1619–1703), had the most flourishing school.[82] Giovanni Ghisolfi (1623–83) contributed little to the art of his native city. At the age of seventeen he went to Rome, where he made his fortune as Italy's first painter of views with fanciful ruins (III: p. 101).

The Lombard tradition of the unadorned rendering of painstakingly observed facts was kept alive in Bergamo rather than Milan. Only recently have these qualities become apparent in Carlo Ceresa's (1609–79)[83] portraits, painted in an austere 'Spanish taste' [199]. Ceresa was a contemporary of Evaristo Baschenis (1617–77) and helps an

understanding of the ambience in which the latter's art flourished. Probably Italy's greatest still-life painter, Baschenis, as is well known, concentrated on one speciality, the pictorial rendering of musical instruments. What attracted him was the warm tonality of the polished wood as much as the complex stereometry of the shapes. By means of a dry, almost 'photographic' realism he thus produced abstract-cubist designs in which highly sophisticated space definitions are supported by the contrast and superimposition of flat, bulging, smooth, broken, or meandering forms [200]. These truly monumental creations, so foreign to northern still-life painters, have, of course, their intellectual focus in Caravaggio's 'realistic stylization' of the Italian still life (I: p. 17).

Genoa

The beginning of the seventeenth century opened up rich possibilities for Genoese painters. A vigorous native school developed which flourished unbroken into the eighteenth century in spite of the disastrous plague of 1657. It is a sign of the innate strength of the Genoese school that it also survived the loss of its greatest Seicento painters; Bernardo Strozzi went to Venice, Castiglione spent most of his working life outside Genoa, and Gaulli settled in Rome. While at the dawn of the century Genoa had been a melting pot of

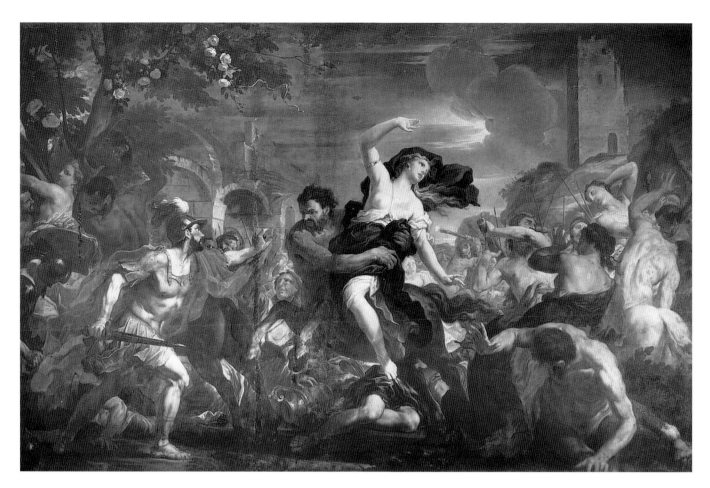

198. Antonio Molinari: *Fight of Centaurs and Lapiths, c.* 1698. Venice,
Palazzo Rezzonico

199. Carlo Ceresa: *Lady with a Handkerchief, c.* 1640. Milan, Brera

various foreign trends, after 1630 her artists influenced
artistic events in Venice and Rome.

To be sure, these masters belong to the broad stream of
the intra-Italian development and they received as much as
they gave. Strozzi is a case in point. After his early 'dark'
period with strong chiaroscuro effects [201], not indepen-
dent of the early seventeenth-century Lombard masters, his
palette lightened while he was still in Genoa; his colours
became rich, warm, glowing, and succulent, and the flesh
tones ruddy. The impression the great Venetian masters,
above all Veronese, made upon him after his removal to
Venice in 1630 should not be underestimated [203], but the
sketchy touch, the bravura of the brush-stroke, and the
luminosity of his paint he owed to Fetti and Lys. In contrast,
however, to the 'modernity' of these masters – Fetti's *petite
manière* with its emotional intricacies and Lys's romantic
extravagances – Strozzi remained essentially tied to the tra-
dition of the grand manner with its focus on rhetorical
figure compositions.[84] On the other hand, the painterly, fes-
tive, and dynamic qualities of his Genoese–Venetian manner
destined him to become the third in the triad of 'foreign'
artists who rekindled the spirit of great painting in Venice.

The influence exercised by Strozzi in Genoa can hardly
be overestimated. Only recently it has been shown how
strongly Giovanni Andrea de Ferrari (1598–1669) leant on
him.[85] This prolific artist was himself the head of a large

200. Evaristo Baschenis: *Still life*, after 1650. Brussels, Musée des Beaux Arts

201. Bernardo Strozzi: *St Augustine washing Christ's Feet*, c. 1620–5. Genoa, Accademia Ligustica

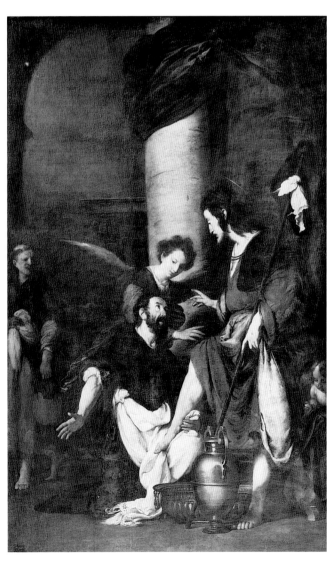

studio through which, among others, Giovanni Bernardo Carbone, Valerio Castello, and Castiglione passed. Ferrari's work – true to the special artistic climate at Genoa – reveals echoes of Tuscan Mannerism as well as of Caravaggism, of Rubens and Van Dyck as well as Velázquez who was in Genoa in 1629 and 1649. Unequal in quality, towards the end of his career he ridded himself of academic encumbrances and produced works of considerable depth of expression in a free and painterly style.[86]

Whether or not this happened under the influence of his pupil Valerio Castello (1624–59), son of Bernardo, is difficult to decide.[87] Valerio had also gone through Fiasella's school but soon set out on conquests of his own. Impressed by Correggio, Van Dyck, and Rubens, he produced a few masterpieces of extraordinary intensity during a career of hardly more than ten years. A real painter, he loved violent contrasts and fiery, scintillating hues; he is dramatic, sophisticated, and spontaneous at the same time. A work like the rapid oil sketch for the *Rape of the Sabines* [202], dating from his last years, clearly prepares the way for Magnasco. Under Castello was trained the gifted Bartolomeo Biscaino who died during the plague of 1657 at the age of twenty-five.[88]

As the century advanced three different trends can be clearly differentiated, all developing on the foundations of the past: first, in the wake of Van Dyck an 'aristocratic' Baroque much to the taste of the Genoese nobility, mainly kept alive in the portraits of Giovanni Bernardo Carbone (1614–83) and to a certain extent in those of Gaulli; secondly, also of Flemish derivation, the rustic genre which triumphed in Castiglione; and finally, the great decorative Baroque fresco, for which Luca Cambiaso had prepared the ground.

Giovanni Benedetto Castiglione, called il Grechetto (1609–64), ran through almost the whole gamut of stylistic

202. Valerio Castello: *Rape of the Sabines*, *c.* 1655.
Genoa, Coll. Duca Nicola de Ferrari

203. Bernardo Strozzi: *David*, *c.* 1635. Rotterdam,
Museum Boijmans Van Beuningen

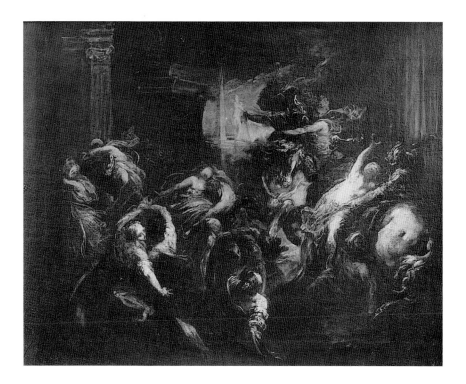

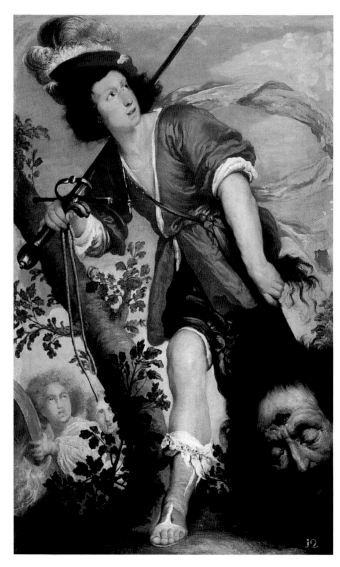

possibilities in the course of his astonishing career.[89]
Attracted early by the Flemish animal genre [204], he seems
to have studied with Sinibaldo Scorza (1589–1631), who in
turn depended on such Flemings as Jan Roos (1591–1638),
Snyders's pupil, active in Genoa from 1614 on. At the same
time a passionate student of Rubens and Van Dyck, he was
also the first Italian to discover Rembrandt's etchings – as
early as about 1630 – which means that Caravaggism
reached him in the northern transformation. Rembrandt
remained a permanent stimulus throughout his life. A stay
in Rome for more than a decade from 1634 on led him to
appreciate Poussin's as well as Bernini's art. In these years
he evolved his fluent technique of brush drawings in oil on
paper and invented the monotype technique. Back in Genoa
in 1645, he painted such monumental Baroque works as the
St Bernard adoring Christ on the Cross (S. Maria della Cella)
and *St James driving the Moors from Spain* (S. Giacomo della
Marina). Slightly later he treated philosophical subjects in a
picturesque mood [205] which shows him close to the
Testa–Rosa current in Rome. His appointment as court
painter at Mantua in 1648 brought him in contact with the
art of Fetti, whose freedom of touch was soon reflected in
his work. At the end of his career he produced ecstatic com-
positions of great intensity, reminiscent of Bernini's style of
these years [207]. Perhaps more clearly than any other artist
Castiglione exposes the particular problems which assailed
his generation, for throughout his life he was torn between
a philosophical scepticism and an ecstatic surrender.

Being equally at home in the rustic genre and the grand
manner – history, mythology, and religious imagery – a bril-
liant draughtsman and engraver, he influenced artists as dis-
tant in time and as different in style as Tiepolo and
Fragonard, Nearer home, his rustic and bucolic manner
found followers in his son Francesco (d. 1716), who suc-
ceeded him as court painter at Mantua; in Anton Maria

204. Giovanni Benedetto Castiglione: *The Animals Entering the Ark*, *c.* 1630? Florence, Uffizi

205. Giovanni Benedetto Castiglione: *The Genius of Castiglione*, 1648. Etching

206. Domenico Piola: Decorative Frescoes, 1684. Detail. Genoa, Palazzo Balbi-Groppallo, Sala delle Rovine

Vassallo[90] (active *c.* 1640–60); and in a number of specialists of the animal genre, while his grand manner had a formative influence on the younger generation of great decorative painters.

The protagonists of the older Genoese fresco style are the brothers Giovanni Andrea (1590–1630) and Giovanni Battista (1592–1677) Carlone,[91] who belong to that fertile Lombard family which had great decorators among its members for three centuries. The later fresco style is mainly represented by Domenico Piola[92] (1628–1703) and Gregorio de Ferrari[93] (1647–1726). It is they, above all, who brought about the glorious climax of this art at Genoa. In their mature works both artists influenced each other, but the younger man proved to be the stronger master. The essential character of their later style derives from a wedding of Pietro da Cortona's grand manner with Bolognese *quadratura*[94] and of Castiglione's verve with Correggio's *sfumato* – resulting in an immensely rich, festive, and luminous manner with a strong emphasis on the ebullient decorative element [206]. The early Piola leant heavily on Castiglione, Strozzi, and Valerio Castello. It has been suggested that he turned to his Cortonesque manner under the influence of Giovanni Maria Bottalla, Cortona's assistant on the Barberini ceiling, who died, however, in 1644, the year he returned to his native Genoa. The Correggiesque note of the style was due to Gregorio de Ferrari who had spent four years at Parma

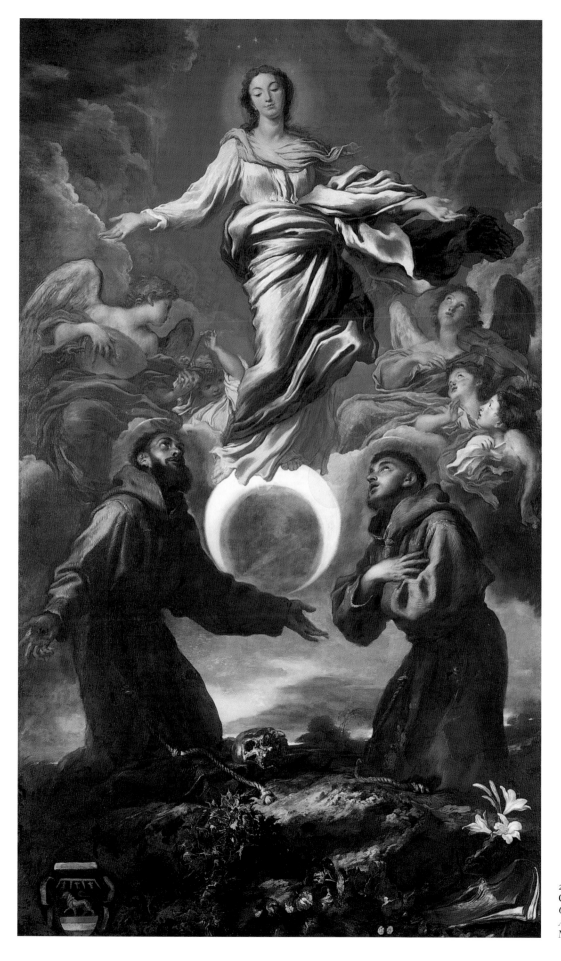

207. Giovanni Benedetto
Castiglione: *The Immaculate
Conception with Sts Francis and
Anthony of Padua*, 1649–50.
Minneapolis Institute of Arts

(1669–73), an experience that contributed to the formation of the proto-Rococo character of Gregorio's art. His *Death of St Scolastica* [208], one of his masterpieces on canvas, illustrates this style at its best. Still tied by a tender link to Bernini's late manner, the languor and sensibility of expression, the suppleness of the bodies, the great musical curve of the composition, the sweetness and elegant rhythms of the angels – all this presages the art of the Rococo. A manner similarly delicate and refined was practised by Bartolomeo Guidobono (1654–1709) who again had made Correggio his special study. He spent almost thirty years of his life at the court of Duke Vittorio Amedeo in Turin.

Naples

When Caravaggio came to work in Naples in 1606–7, the Mannerists were in full command of the situation, and he never swayed artists like Fabrizio Santafede (*c.* 1560–1634), Gian Bernardino Azzolino (*c.* 1572–1645), Gerolamo Imparato (1550–1621), and Belisario Corenzio (*c.* 1560–1643) from their course; they continued their outmoded conventions, largely indebted to the Cavaliere d'Arpino, through the first half of the seventeenth century. The only exception to the rule was Giovanni Battista Caracciolo, called Battistello (*c.* 1578–1635),[95] the solitary founder of the 'modern' Neapolitan school who, in opposition to the Mannerists, developed his new manner based on the deeply felt experience of Caravaggio. His *Liberation of St Peter* in the Chiesa del Monte della Misericordia [209], painted two or three years (1608–9) after Caravaggio's *Seven Works of Mercy* in the same church, is not only a monument of orthodox Caravaggism, but its specific qualities, the hard contrasts, the compositional austerity and mute intensity reveal a talent of the first rank. Yet the pattern of Baroque painting in Naples was determined neither by Caracciolo's early manner nor by him alone.

He had a younger rival in the Spaniard Jusepe de Ribera (1591–1652)[96] who, after journeys through Italy, settled in Naples in 1616 and soon painted Caravaggesque pictures utterly different from those by Caracciolo. While the latter hardened and stiffened the more flexible style of the master in an attempt at rendering internalized drama, the former loosened and externalized what he had learned from Caravaggio by an aggressive and vulgar realism and a painterly chiaroscuro with flickering light effects. Ribera found a powerful patron in the Duke of Osuna, the Viceroy of Naples, who appointed him court painter, and later viceroys and Neapolitan nobles were equally attracted by his art. It is an interesting phenomenon that Ribera's passionate and violent pictures satisfied the taste of the Neapolitan court society. What attracted them was probably the essentially Spanish sensual surface quality of

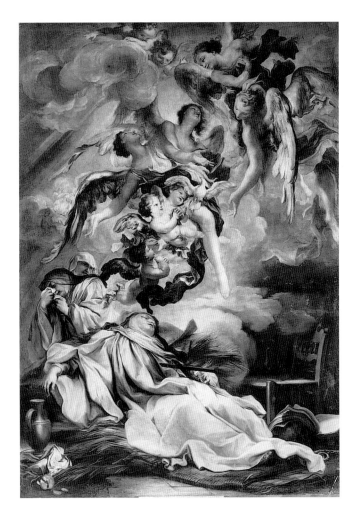

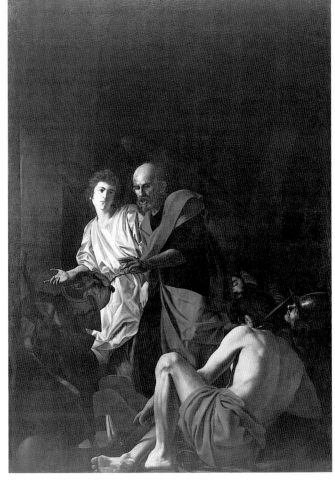

210. Artemisia Gentileschi: *Judith slaying Holofernes, c.* 1620. Florence, Uffizi

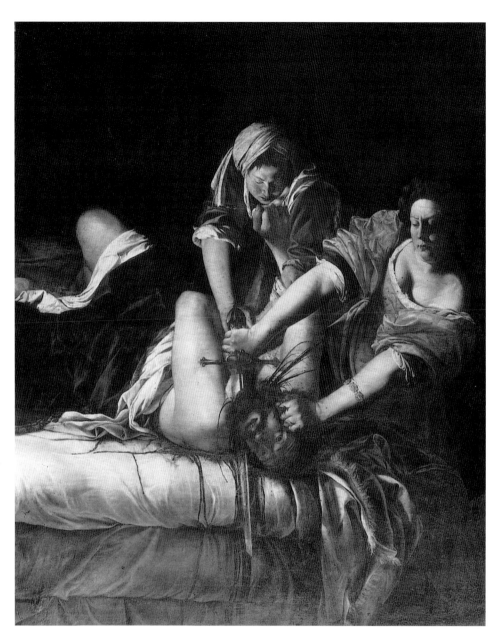

208 (*far left*). Gregorio de Ferrari: *Death of St Scolastica, c.* 1700. Genoa, S. Stefano

209 (*left*). Giovanni Battista Caracciolo: *Liberation of St Peter,* 1608–9. Naples, Chiesa del Monte della Misericordia

Ribera's realism – his permanent contribution to European Seicento painting.[97]

From about 1630 on Naples was drawn into the main stream of Baroque painting owing to the considerable contributions made by painters coming from Rome. It is mainly three different trends that were acclimatized in Naples: Domenichino's Baroque classicism, Lanfranco's intense High Baroque, and the discursive Caravaggism of the second generation.[98] Domenichino's somewhat disappointing activity in Naples has been discussed in a previous chapter (I: p. 49). Lanfranco was more successful; he settled in Naples in 1633 for thirteen extremely active years during which he created, among others, four large fresco cycles: the dome of the Gesù Nuovo (1635–7, only the pendentives preserved), the nave and choir of the Certosa of S. Martino (1637–8), the entire decoration of SS. Apostoli (1638–46), and finally the dome of the Cappella di S. Gennaro in the cathedral (1641–3), where he vied with the pendentives painted by his arch-enemy Domenichino. Despite the hos-

tility of the Neapolitan artists, Domenichino was an immediate success; the dynamic orchestra of Lanfranco's Correggiesque illusionism, by contrast, appealed above all to the masters of the second half of the century[99] and made possible the grand decorative phase of Neapolitan painting which began with Mattia Preti and rose to international importance with Luca Giordano and Solimena. Contact with the younger Caravaggesque trend was made through Vouet, who sent the *Circumcision* in S. Arcangelo a Segno[100] from Rome in 1623 and, more important, through Artemisia Gentileschi (1593–*c.* 1652), Orazio's daughter, who was born in Rome, spent some years in Florence (1614–20) – which were not without influence on the formation of her style – and settled in Naples in 1630, to leave this city only for a brief visit to her father in London (1638–9). An artist of a high calibre and fierce temperament, she showed an inclination for gruesome scenes painted in lively translucent tones and with a meticulous attention to detail [210]. This almost romantic form of Caravaggism impressed the

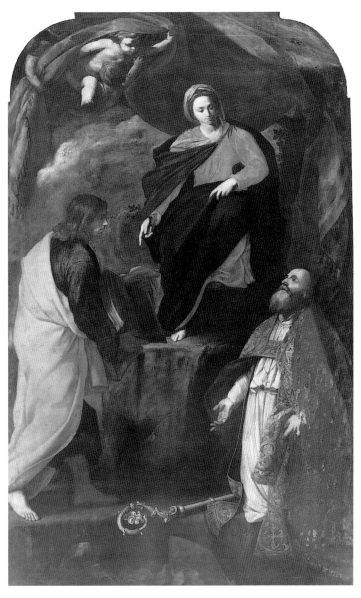

211. Massimo Stanzioni: *Virgin with SS. John the Evangelist and Andrea Corsini*, c. 1640. Naples, S. Paolo Maggiore

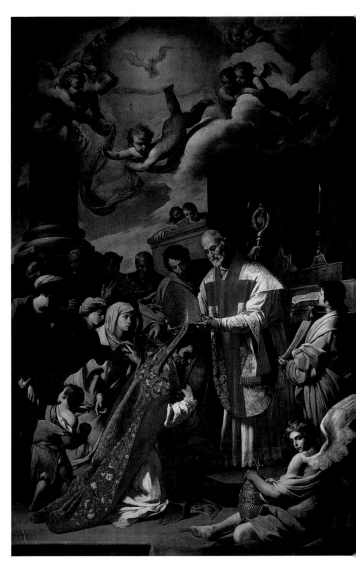

212. Massimo Stanzioni: *Investiture of St Aspreno, First Bishop of Naples, by St Peter*, 1654. Naples, Palazzo Reale

Neapolitans as much or even more[101] than Vouet's decorative Baroque manner, which hardly revealed his early infatuation with Caravaggio.

Long before Domenichino's coming to Naples, Caracciolo had turned to pre-Mannerist and Bolognese models, possibly stimulated by impressions he received during a hypothetical journey to Rome. In any case, his later work from the end of the second decade on, in the Certosa of S. Martino, in S. Maria la Nova, S. Diego all'Ospedaletto, and elsewhere shows the strong impact of Bolognese classicism. Equally, Ribera's early fire subsided in the 1630s, his realism mellowed, his compositions became dry and classicizing, and the chiaroscuro made way for a light palette with cool silvery tones.[102]

Although Neapolitan artists stuck tenaciously to the various facets of Caravaggism – epitomized by the names of Caracciolo, Ribera, and Artemisia Gentileschi – the swing towards Bolognese classicism from the mid 1630s on is a general phenomenon. It may be observed with minor masters such as Francesco Guarino (1611–54)[103] whose early Riberesque manner was followed by classicizing academic works, or Pacecco (Francesco) de Rosa (1607–56), a determined purist, the Sassoferrato of Naples, for whom Domenichino was specially important. Such purist tendencies may also be found in the paintings of Charles Mellin ('Carlo Lorenese', 1597–1649), a Frenchman from Nancy, who lived and died in Rome, but worked in Naples in 1643–7,[104] as well as in those of Giovanni Andrea Coppola (1597–c. 1659) who practised his art in distant Apulia.

A much greater artist than all these, the most important *caposcuola* of the mid century, Massimo Stanzioni (1586–1656), turned in a similar direction. His early development is still unclear;[105] but his Caravaggism is allied to that of Vouet, Saraceni, and Artemisia rather than to that of Caracciolo and Ribera. In his best works, belonging to the decade 1635–45, he displays a distinct sense for subtle chro-

Stanzioni mediates between the art of the older genera-
tion and that of his pupil, Bernardo Cavallino (1616, not
1622, –56).[107] A *Caravaggista* strongly influenced by
Artemisia, Cavallino gave his best in cabinet pictures. His
work is in a category of its own; a great colourist, his ten-
derness, elegance, gracefulness, and delicacy are without
parallel at this moment [213]. Yet *mutatis mutandis* such con-
temporaries as Furini in Florence and Valerio Castello in
Genoa represent a similar stylistic phase. It is interesting to
note that the giants of the Baroque epoch with their massive
energy lived to a ripe old age (p. 119), while these effeminate
artists of the mid century died before they reached maturity.
Their sophisticated art hardly contained the germs to gen-
erate a strong new style.

Other painters had a share in the rich life of the Nea-
politan school during the three decades after 1630. The
more important names should at least be mentioned: Andrea
Vaccaro (1604, not 1598, –1670),[108] who found a rather vul-
gar formula of combining second-hand Caravaggism with
Bolognese classicism (Reni, Domenichino), was a popular
success at his time but a master of the second rank; the
Riberesque Cesare (*c.* 1605–53) and Francesco (1612–*c.* 56)
Fracanzano, sons of Alessandro, the younger brother being
an artist of considerable calibre;[109] Aniello Falcone
(1607–56), the specialist in luminous battle-pieces 'without
a hero',[110] and his pupils Andrea de Leone (1610, not 1596,
–1685)[111] and Domenico Gargiulo, called Micco Spadaro (
1609/10–75), who under Callot's influence produced the
typically Neapolitan topographical genre peopled with great
numbers of small figures. In addition, reference must be
made to the well known 'Monsù Desiderio' – a 'pseudonym'
covering at least three different artists, as recent research has
revealed.[112] The major figure of this trio, François Nomé,
was born at Metz in 1593, came to Rome in 1602, settled at
Naples not later than 1610 and seems to have spent the rest
of his life there (the year of his death is unknown). His
bizarre and ghostlike paintings of architecture, often crum-
bling and fantastic, belong to the world of Late Mannerism
rather that to that of the Seicento, and the suggestion made
by R. Causa that his style is ultimately derived from the
stage settings of Buontalenti and Giulio Parigi has much to
recommend it. The second artist, Didier Barra,[113] also from
Metz, left his native city about 1608 and followed his com-
patriot to Naples, where he was still active in 1647. In con-
trast to Nomé he was a faithful recorder of views, while the
third – hitherto anonymous – artist imitated Nomé's work.
Unduly boosted in our own days, 'Monsù Desiderio'–Nomé
was in fact a minor figure, but it was he who opened up a
taste in Naples for the weird type of cabinet picture and thus
helped to prepare Micco Spadaro's microcosmic views as
well as Salvator's romantic battle-pieces.

All the Neapolitan painters so far mentioned belong
essentially to the first half of the century. The social
upheaval caused by Masaniello's revolt in 1647 also resulted
in some artists leaving the city;[114] but more serious was the
great plague of 1656 during which many of them died.
Pacecco de Rosa, Falcone, and, above all, Massimo
Stanzioni and Cavallino were among the victims. The year
of the plague many therefore be regarded as an important
turning-point.

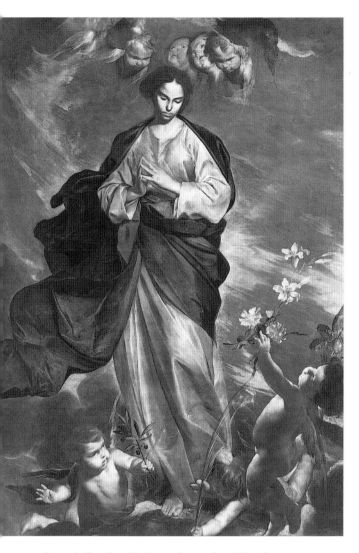

213. Bernardo Cavallino: *The Immacolata, c.* 1650. Milan, Brera

matic values, melodious lines, gracefully built figures, and
mellow and lyrical expressions. Stanzioni was famed as the
'Neapolitan Guido Reni'; and the refined, somewhat tame
and nerveless quality of his art, characteristic of the second
quarter of the century, will be apparent if his *Virgin with SS.
John the Evangelist and Andrea Corsini* [211] is compared
with an equally characteristic work of the second decade
such as Cavedoni's *Virgin with SS. Alò and Petronius* [1: 59].
Stanzioni's painting also shows the Neapolitan blending of
Caravaggism and Bolognese classicism. At the end of his
career the Bolognese note, increasingly noticeable from the
late 1630s on,[106] quelled the subtle qualities of his earlier
manner (see the very late *Consecration of St Ignatius*,
Naples, Palazzo Reale) [212].*

* This painting [212] has now regained its correct title, *The Investiture of St
Aspreno, First Bishop of Naples, by St Peter.*

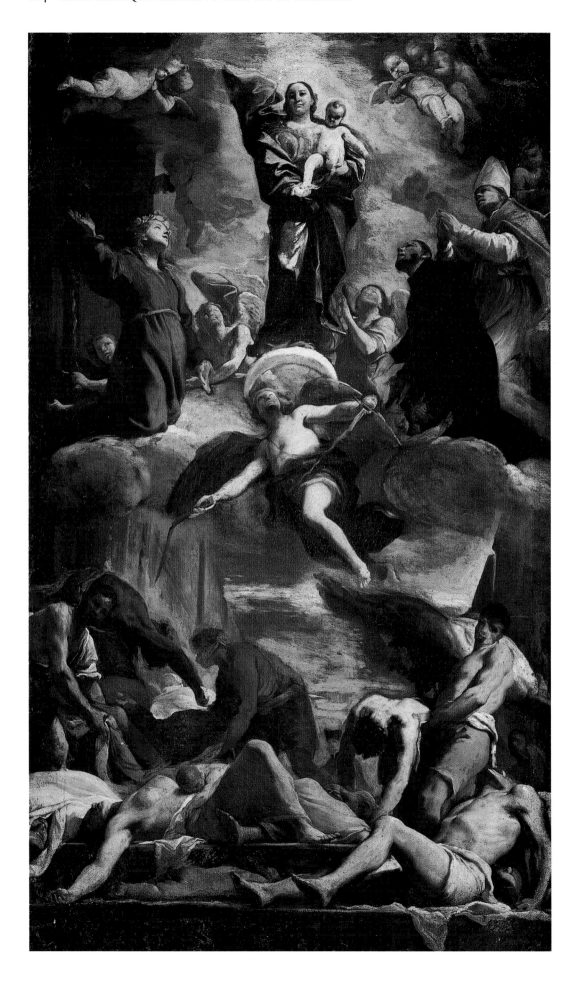

214 (*opposite*). Mattia Preti: *The Plague of 1656*. Naples, Museo Nazionale

215. Mattia Preti: *Decollation of St John the Baptist*. 1661–2, Valletta, Co-Cathedral of St John

216. Giovanni Battista Ruoppolo: *Still life*, late seventeenth century. Naples, Museo di S. Martino

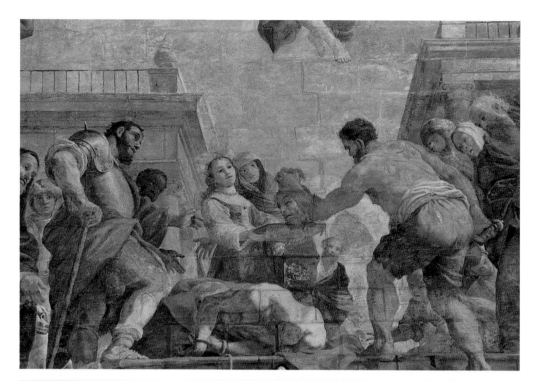

The character of Neapolitan painting in the second half of the century differs indeed considerably from that of the first half. The change is mainly due to two masters of the first rank, Mattia Preti from Calabria ('Cavaliere Calabrese' 1613–99) and Luca Giordano (1634–1705). Although belonging to two different generations, they are similar in that both show in their work an immense vigour, an innate power and dynamic quality almost without parallel in Italy or elsewhere at this moment. They are also similar in that their art received lasting stimuli from Venetian colourism as well as from the Roman grand manner. Moreover, it was with them that Neapolitan painting assumed an intra-Italian and even international status. In other respects they differ most decisively: Preti, grave, problematical, dramatic, a moralist, and throughout his life a *Caravaggista*, is a man typical of the Seicento, while Giordano, in all and everything

the antithesis, truly belongs to the eighteenth century. It is for this reason that more about him will be said later (III: pp. 73–5).

Preti's career took him up and down the peninsula. As early as 1630 he was in Rome painting, it seems, Caravaggesque pictures;[115] between 1640 and 1646 he stayed intermittently in Venice[116] but returned to Rome in 1641–2, 1650–1, and once again, 1660–1. It was during the fifth decade that Sacchi, Domenichino, and Reni attracted him;[117] the frescoes in S. Biagio at Modena, executed between 1653 and 1656, still reveal that influence.[118] In the mature works created during his Neapolitan period (1656–60) he wedded reminiscences of Battistello, Ribera, and Guercino with those of Tintoretto and Veronese; nor was he impervious to Luca Giordano's early work. The result was a powerful dramatic style *sui generis*, the apocalyptic quality of which is well illustrated by the bozzetto [214] for one of the frescoes, now lost, painted as an ex-voto on the city gates during the plague of 1656. In 1661 Preti went to Malta where he stayed, with brief interruptions,[119] to the end of his life. His major work there was the decoration of the immense vault of S. Giovanni at Valletta (1661–6) with frescoes in which Venetian luminosity prevails [215]. But never again did Preti rise to the dramatic height of his Neapolitan period.

His contemporaries Luca Forte (active *c.* 1640–70) and Paolo Porpora (1617–73) open the long line of Neapolitan still-life painters by their sumptuous Caravaggesque flower-pieces, and a few pictures have now also been ascribed to Porpora's teacher, Giuseppe Recco's father Giacomo (1603–54) – with how much justification it is still too early to say.[120] Porpora's most distinguished pupils, Giovan Battista Ruoppolo (1629, not 1620, –93) and Giuseppe Recco (1643–95),[121] both much better known than their teacher, continued the tradition to the end of the century. The name of Giovan Battista Recco, probably Giuseppe's elder brother, has to be added to theirs. A recently discovered painting (signed and dated 1654) of exceptional quality stimulated a tentative reconstruction of Giovan Battista's *œuvre*.[122] Ruoppolo is famed for his vigorous, succulent, and ample flower-pieces [216], monumental like Preti's paintings in the grand manner and thus utterly different from Flemish still lifes with which, however, he must have been conversant.[123] Giuseppe Recco's temperament was less exuberant. His speciality was fish-pieces, painted with impeccable taste and an incomparable sense for tone values. Dominici reports that in his youth Recco spent some time in Milan working with a famous still-life painter. On this slender evidence art historians have concluded that he was trained by Baschenis. True or not, Recco's still lifes often have a Lombard quality of austerity and immobility Intimate and noble rather than extrovert and grand, they seem to presage the age of Chardin.

No such painter arose in Rome, and this is indicative of the future course of events. In the last analysis it was the memory of Caravaggio's conquests, always treasured in Naples in contrast to Rome, that made possible the remarkable ascendancy and variety of the Neapolitan school.

List of the Principal Abbreviations Used in the Notes

Archivi	*Archivi d'Italia*
Art Bull.	*The Art Bulletin*
Baglione	G. Baglione, *Le Vite de' pittori, scultori, architetti . . .* Rome, 1642
Bellori	G. P. Bellori, *Le Vite de' pittori, scultori ed architetti moderni.* Rome, 1672
Boll. d'Arte	*Bollettino d'Arte*
Boll. Soc. Piemontese	*Bollettino della Società Piemontese di architettura e delle belle arti*
Bottari	G. Bottari, *Raccolta di lettere.* Milan, 1822
Brauer-Wittkower	H. Brauer and R. Wittkower, *Die Zeichnungen des Gianlorenzo Bernini.* Berlin, 1931
Burl. Mag.	*The Burlington Magazine*
Donati, *Art. Tic.*	U. Donati, *Artisti ticinesi a Roma.* Bellinzona, 1942
G.d.B.A.	*Gazette des Beaux-Arts*
Golzio, *Documenti*	V. Golzio, *Documenti artistici sul seicento nell'archivio Chigi.* Rome, 1939
Haskell, *Patrons*	F. Haskell, *Patrons and Painters: A Study in the Relations between Italian Art and Society in the Age of the Baroque.* London, 1963
Jahrb. Preuss. Kunstslg.	*Jahrbuch der Preussischen Kunstsammlungen*
J.S.A.H.	*Journal of the Society of Architectural Historians*
J.W.C.I.	*Journal of the Warburg and Courtauld Institutes*
Lankheit	K. Lankheit, *Florentinische Barockplastik.* Munich, 1962
Mâle	É. Mâle, *L'art religieux de la fin du XVIe siècle . . .* Paris, 1951
Malvasia	C. C. Malvasia, *Felsina pittrice.* Bologna, 1678
Passeri-Hess	G. B. Passeri, *Vite de' pittori, scultori ed architetti.* Ed. J. Hess. Vienna, 1934
Pastor	L. von Pastor, *Geschichte der Päpste.* Freiburg im Breisgau, 1901 ff.
Pollak, *Kunsttätigkeit*	O. Pollak, *Die Kunsttätigkeit unter Urban VIII.* Vienna, 1927, 1931
Quaderni	*Quaderni dell'Istituto di storia dell'architettura* (Rome)
Rep. f. Kunstw.	*Repertorium für Kunstwissenschaft*
Riv. del R. Ist.	*Rivista del R. Istituto di archeologia e storiadell'arte*
Röm. Jahrb. f. Kunstg.	*Römisches Jahrbuch für Kunstgeschichte*
Titi	F. Titi, *Descrizione delle pitture, sculture e architetture . . . in Roma.* Rome, 1763
Venturi	A. Venturi, *Storia dell'arte italiana.* Milan, 1933 ff.
Voss	H. Voss, *Die Malerei des Barock in Rom.* Berlin, 1924
Waterhouse	E. Waterhouse, *Baroque Painting in Rome.* London, 1937
Wiener Jahrb.	*Wiener Jahrbuch für Kunstgeschichte*
Wittkower, *Bernini*	R. Wittkower, *Gian Lorenzo Bernini.* London, 1955
Zeitschr. f. b. Kunst	*Zeitschrift für bildende Kunst*
Zeitschr. f. Kunstg.	*Zeitschrift für Kunstgeschichte*

Notes

CHAPTER I

1. First published Perugia, 1606, and many times thereafter.
2. R. Harvey, *Ignatius Loyola*, London, 1936, 257.
3. See, e.g., the many works of Guido Reni's school.
4. For the following see, above all, Hastings's *Encyclopedia of Religion and Ethics*, s.v., and I. von Döllinger and F. H. Reusch, *Geschichte der Moralstreitigkeiten in der römisch-katholischen Kirche seit dem sechzehnten Jahrhundert*, Nördlingen, 1889.
5. On laxism see M. Petrocchi, *Il problema del lassismo nel secolo XVII*, Rome, 1953 (Storia e letteratura, no. 45).
6. M. Petrocchi, *Il quietismo italiano del Seicento*, Rome, 1948 (Storia e letteratura, no. 20); also L. von Pastor, XIV, ii, 985.
7. For the following see the documents published by F. Haskell in *Burl. Mag.*, XCVII (1955), 287.
8. Wittkower, *Gian Lorenzo Bernini*, London, 1955, 12.
9. M. de Chantelou, *Journal du voyage du Cav. Bernin en France*, Paris, 1885, under 23 August 1665.
10. For the text illustrated by Pozzo, see É. Mâle, 442.
11. 'La "rettorica" e l'arte barocca' in *Retorica e Barocco. Atti del III Congresso internazionale di studi umanistici*, Rome, 1955, 9. The ideas of this concise paper have influenced my argumentation.
12. See Sacchi's talk to Francesco Lauri, related by L. Pascoli, *Vite de' pittori* etc., Rome, 1736, II, 82: 'lo stimo, e credo, che i pittori dagli oratori deggian pigliare i precetti'. See also H. Posse, *Andrea Sacchi*, Leipzig, 1925, 118.
13. Little work has been done on these problems. Not very helpful in this context is G. Weise and G. Otto, *Die religiöse Ausdrucksgebärde des Barock* (Schriften und Vorträge der württembergischen Ges. d. Wissensch.; Geisteswissenschaften, Abt. 5, 1938).
14. See the stimulating book by W. Weisbach, *Der Barock als Kunst der Gegenreformation*, Berlin, 1921, which had a lasting influence but also aroused a heated controversy; see, above all, N. Pevsner in *Rep. f. Kunstw.*, XLVI (1925), 243 and XLIX (1928), 225, and Weisbach, *ibid.*, 16.
15. Further for papal patronage, see the relevant chapters in Pastor's *History of the Popes*.
16. For further details see the documents in O. Pollak, *Die Kunsttätigkeit unter Urban VIII*, Vienna, 1931, II, and the catalogues in E. Waterhouse, *Baroque Painting in Rome*, London, 1937.
17. J. Hess in *Illustrazione Vaticana*, VI (1935), 241.
18. For details of the entire 'programme' see Wittkower, *op. cit.*, 19.
19. For papal and other forms of patronage in Rome, see now part 1 of the excellent work by F. Haskell, *Patrons and Painters*, London, 1963.

CHAPTER 2

1. For this chapter see the author's book on Bernini (*Gian Lorenzo Bernini the Sculptor of the Roman Baroque*, London, 1966), with critical *œuvre* catalogue. References will therefore be kept to a minimum.
2. I can neither agree to the attribution of the Santoni bust to Pietro Bernini, as suggested by C. D'Onofrio (*Roma vista da Roma*, 1967, 114 ff.), nor to the dating of the bust to 1610 as I. Lavin (*Art Bull.*, L (1968), 223 ff.) assumes. H. Kauffmann, *G. L. Bernini*, 1970, II, also refutes such an early date.
3. The stone-coloured caryatids of the Farnese Gallery had a formative influence on Bernini's conception of antiquity while he was engaged on the Pluto. The somewhat cold beauty of Proserpina's body is also derived from Annibale Carracci's ceiling. Furthermore, the David is indebted to the figure of Polyphemus in the fresco of *Polyphemus killing Acis*. For further details, see Wittkower, 5 f.
 Recently L. Grassi, *Burl. Mag.*, CVI (1964), 170, emphasized Polidoro da Caravaggio's influence on *the Neptune and Triton* and to a lesser extent on the *Pluto* and *David*.
4. Two almost identical busts exist in the Borghese Gallery. Bernini copied his first bust himself because the marble showed a crack across the forehead shortly before its completion. But the second version lacks the intense animation of the first.
5. It is not generally known that the Angel with the Superscription standing on Ponte S. Angelo is also Bernini's work. For the complicated history of these Angels, see Wittkower, 248 ff.
6. However, a passage in *Kunstgeschichtliche Grundbegriffe*, first published in 1918, shows that Woelfflin was very well aware that Baroque sculpture has a 'picture-like' character and is therefore composed for one viewpoint.
7. Attention may be drawn to the Angel's right leg and Habakkuk's right arm, clearly designed to counterbalance each other; or to the cross of spatial diagonals created by the Angel's arms and his right wing, whose direction is continued in the prophet's right arm.
8. Polychrome settings became common after Sixtus V's chapel in S. Maria Maggiore, see pp. 6–8.
9. This device is fully effective only in the afternoon, when the sun is in the west.
10. In the Teresa group, as in the allegories of the tomb of Pope Urban, marble seems to turn into flesh. But the psychological effect is different; for while here the group has its own mysterious setting, there the allegories stand before the niche, in the spectator's space.
11. A good analysis of the colour scheme in R. Battaglia, *La cattedra berniniana*, Rome, 1943, 75, 80 f.
12. On this and other grounds Bernini's art found a severe critic in Sir Herbert Read (*The Listener*, 24 November 1955). Sir Herbert voiced here opinions held by many.
13. For a further analysis, see Wittkower, 21.
14. See, e.g., Roubiliac's tomb of Lady Elizabeth Nightingale in Westminster Abbey (1761). Roubiliac's dependence on the tomb of Alexander VII cannot be doubted.
15. The former in S. Lorenzo in Damaso, the latter in S. Giacomo alla Lungarna. Further to the history of these monuments, Wittkower, 210 f.
16. The bust was lost in the Whitehall Palace fire of 1698. The best idea of the bust is conveyed by the eighteenth-century copy made from a cast, now at Windsor Castle (Wittkower, figure 48).
17. *Journal du voyage du Cav. Bernin*, ed. Lalanne, Paris, 1885; see Wittkower, *Bernini's Bust of Louis XIV*, London, 1951.
18. Particular reference may be made to Stoldo Lorenzi's Neptune in the Boboli gardens. See B. H. Wiles, *The Fountains of Florentine Sculptors and their Followers from Donatello to Bernini*, Cambridge, Mass., 1933.
 Since the *Neptune and Triton* will not again be mentioned, I may add here that the problem of its *concetto* has aroused much controversy. I first submitted (*Burl. Mag.*, XCIV (1952), 75) that Bernini here intended to illustrate the Virgilian 'Quos Ego' (*Aeneid*, I, 145 f.); J. Pope-Hennessy (*Catal. Ital. Sculpt. in the Victoria & Albert Mus.*, 1964, II, 600) believed that his text was Ovid, *Met.*, I, 330 ff., while W. Collier (in *J.W.C.I.*, XXXI (1968), 438 ff.) thought Ovid, *Met.*, I, 283–4 was shown. H. Kauffmann, *G. L. Bernini*, Berlin, 1970, 39, returned with new arguments to my original interpretation.
19. For the correct date, see D'Onofrio, *Le Fontane di Roma*, Rome, 1957, 191, and H. Hibbard, *Burl. Mag.*, CVI (1964), 168 note.
20. Surviving drawings prove that the rock was designed with great care (Brauer–Wittkower, 47 ff.).
21. Further for the Longinus, see H. Kauffmann, in *Miscellanea Bibliothecae Hertzianae*, 1961, 366.
22. Judging from an illustration only, the terracotta bozzetto of the Constantine published by K. Rossacher, in *Alte und Neue Kunst*, XII, 90 (1967), 2 ff., seems to be suspect.
23. For a full exposition of the *concetto*, see Wittkower in *De Artibus Opuscula XL. Essays in Honor of Erwin Panofsky*, New York, 1961, 497.
24. Further for the iconography of the Four Rivers Fountain, H. Kauffmann in *Jahresberichte der Max Planck Gesellschaft* (1953–4), 55 ff., and more recently, N. Huse, in *Revue de l'Art*, no. 7 (1970), 7 ff., where conclusions are drawn from a text by Michelangelo Lualdi who may have been Bernini's adviser.
 For the *concetto* of the Barcaccia in Piazza di Spagna, see H. Hibbard–I. Jaffé, *Burl. Mag.*, CVI (1964), 159.
25. See W. S. Heckscher in *Art Bull.*, XXIX (1947), 155 ff.
26. K. Rossacher ('Das fehlende Zielbild des Petersdomes, Berninis Gesamtprojekt für die Cathedra Petri', *Alte und Moderne Kunst* (Nov.–Dec. 1967)) argued eloquently that Bernini had planned a representation of the Transfiguration in the window of the Cathedra and claims to have found Bernini's bozzetto for this project, but the author's assumptions do not seem to be supported by historical evidence.
27. Further for the ideas underlying the Cathedra Petri, see H. von Einem in *Nachrichten der Akademie der Wissenschaften in Göttingen*. Philolog.-Hist. Klasse, 1955, 93. For the *concetto* of the Baldacchino see H. Kauffmann in *Münchner Jahrbuch der bildenden Kunst*, VI (1955), 222.
28. *Cod. Ital.* 2084, fol. 195, referred to in Wittkower, 254.
29. Brauer–Wittkower, plate 71A.

30. See Brauer–Wittkower, plates 42–7.

31. See also Wittkower, 'The Role of Classical Models in Bernini's and Poussin's Preparatory Work', in *Studies in Western Art* (Acts of the 20th Internat. Congr. of the Hist. of Art), Princeton, 1963, III, 41.

32. Wittkower, figure 107.

33. E.g. all the early works and the busts of Scipione Borghese, Costanza Buonarelli, Francis I of Este, Louis XIV; further, the Longinus, Daniel, and Habakkuk, S. Bibiana and S. Teresa, and the Angels for the Ponte S. Angelo. These are some examples. No attempt at completeness is made in this and the following notes.

34. The Baldacchino, tomb of Urban VIII.

35. Monument of Countess Matilda; Cappella Raimondi; statues of Urban VIII, Capitol, and of Alexander VII, Siena Cathedral; Angels above the main altar of S. Agostino; balconies in the pillars of St Peter's; decoration of S. Maria del Popolo; chapel of the De Silva family, S. Isidoro; Valtrini and Merenda monuments; tomb of Alexander VII. This group, to which many more works belong, is by no means coherent.

36. St Barbara, Rieti Cathedral; Visitation, Cappella Siri, Savona.
* The relief of the *Visitation* in Savona, within Bernini's altar, is now documented as the work of Matteo Buonarelli (G. Fusconi, E. Mattiauda, *Prospettiva*, 57–60, 1989), pp. 279–93.

37. L. Grassi, *Bernini pittore*, Rome, 1945, with bibliography up to that date. Further, Martinelli in *Commentari*, I (1950), with brief critical but not entirely reliable *œuvre* catalogue, and Wittkower in *Burl. Mag.*, XCIII (1951), 51 ff.

38. The portrait now in the Ashmolean Museum, Oxford (see Wittkower, *op. cit.*), and the self-portrait formerly in the collection of Mrs Richard Ford (D. Mahon and D. Sutton, *Artists in Seventeenth Century Rome*, Exhib. Wildenstein, 1955, no. 5).

39. Early self-portrait, Borghese Gallery, and the half-figures of *St Andrew and St Thomas*, formerly Palazzo Barberini, now National Gallery, London, documented 1627; see Martinelli, *op. cit.*, 99, 104.

40. The most important document of this phase is the *David with the Head of Goliath*, Coll. Marchesa Eleonora Incisa della Rocchetta, Rome. See the pertinent remarks in Mahon's and Sutton's *Catalogue*, no. 7.

41. Between the first self-portrait in the Borghese Gallery of about 1620 and the second in the same museum lie at least twenty years.

42. Grassi's reversal of this relationship (p. 28) is unacceptable.

43. For a full discussion of these compositions and also for the engravings made after Bernini's designs, see Brauer–Wittkower, 151 ff.

44. Waterhouse, 86; Grassi, *op cit.*, 37 ff.; H. Posse, *Der römische Maler Andrea Sacchi*, Leipzig, 1925, 53 f.

45. The same device is used, e.g., in the group of *Pluto and Proserpina*.

46. Further for Abbatini's works, Passeri–Hess, 234 ff., Waterhouse, 45, Grassi, *op. cit.*, 44 ff., Martinelli, *Commentari*, IX (1958), 99, B. Toscano, *Paragone*, XV (1964), no. 177, 36.

47. Passeri–Hess, 234 ff. The pun '. . . ha fatto parere vero effettivo quel falso, che è finto', is difficult to translate.

48. Guglielmo Cortese (Guillaume Courtois) painted in the 1660s in Bernini's churches (see Note 69) but cannot be regarded as one of his studio hands.

49. For Bernini's influence on Gaulli see Pascoli, *Vite*, Rome, 1730–6, I, 195, and R. Soprani and C. G. Ratti, *Vite de' pittori . . . genovesi*, Genoa, 1768–9, 76.

50. See Chantelou's *Diary* on 10 October 1665.

51. The work was finished in 1626; see O. Pollak, *Kunsttätigkeit*, I, 22 ff. Bernini was also responsible for the restoration of the interior. Particularly impressive is the classicizing aedicule above the high altar (Wittkower, *Bernini*, figure 27).

52. For historical data, see Brauer–Wittkower, 19–22, and Wittkower, *Bernini*, 189 f.; for the iconography, H. Kauffmann, 'Das Tabernakel in St Peter', *Kunstgeschichtliche Gesellschaft zu Berlin, Sitzungsberichte* (1954–5), 5–8; also Note 27 above.

53. Bernini designed the decoration of the pillars in 1628. The balconies serve for the exhibition of the most venerable relics on certain festive occasions. Further to this question, Wittkower, *Bernini*, 197 f., and Kauffmann, *loc. cit.*

54. On Borromini's probable contribution to the design, see p. 39.

55. Prototypes for the motif were Early Christian sarcophagi with vines, a reference to the blood of Christ. By substituting laurels (a Barberini emblem) for vines, Bernini turned the traditional into personal symbolism.

56. Shortly before Bernini, Ferrabosco planned such a structure in lieu of the present Baldacchino; see Costaguti-Ferrabosco, *Architettura della basilica di S. Pietro in Vaticano*, Rome, 1684, plate 27.

57. See A. Muñoz in *Vita d'Arte*, VIII (1911), 33; Pulignani in *Illustr. Vaticana*, II, 12 (1931), 23 ff.

58. For the master of the Val-de-Grâce baldacchino, usually wrongly attributed to Bernini, see M. Beaulieu, 'G. Le Duc, M. Anguier et le maître-autel du Val-de-Grâce', *Bulletin de la société de l'histoire de l'art français, année 1945–46*

(1948), 150 and A. Blunt, *Art and Architecture in France*, 250, note 22. For French high altars dependent on Bernini's Baldacchino, see M. Reymond in *G.d.B.A.*, IX (1913), 207 ff.

59. The fullest account of the history of this church and Bernini's other architectural works in Brauer–Wittkower. The book by R. Pane, *Bernini architetto*, Venice, 1953, is uncritical and contains no serious contribution. For Castelgandolfo see also V. Golzio, *Documenti artistici*, Rome, 1939, 402. The church was first dedicated to St Nicholas and, after a change of plan in 1659, to the newly canonized St Thomas of Villanova.

60. The whole height is 1½ times the length of the axis of the church.

61. The medallions reproduce the pictures hung in St Peter's on the day of the saint's canonization, see Brauer–Wittkower, 125.

62. See, e.g., the niche of the tomb of Urban VIII [14] or the apse of the Raimondi Chapel in S. Pietro in Montorio.

63. The niche of Alexander VII's tomb (1671–8) [20] is also decorated in this way.

64. A few eighteenth-century examples may be given: Fuga's Chiesa di S. Maria dell' Orazione e Morte in Via Giulia, Rome; Luigi Vanvitelli's Chiesa dei PP. delle Missioni at Naples; and Juvarra's Superga near Turin.

65. B. M. Apollonj-Ghetti, 'Il Palazzo Chigi all' Ariccia', *Quaderni* (1953), no. 2, 10, with plans and a not very helpful historical note.

66. G. Incisa della Rocchetta, 'Notizie sulla fabbrica della chiesa collegiata di Ariccia', *Riv. del R. Ist.*, I (1929), 281–5. Brauer–Wittkower, 115 ff.

67. *Ibid.*, 120 ff. See also S. Bordini, in *Quaderni*, XIV, 79–84 (1967), 53–84; extracts from a Roman doctoral thesis on Bernini and the Pantheon (1965–6).

68. C. Fontana, *Il tempio vaticano*, Rome, 1694, 451 ff., illustrations on pages 457, 467.

69. The painting is by Guillaume Courtois, who also supplied the altarpieces in S. Tomaso at Castelgandolfo and S. Andrea al Quirinale.

70. Documents published by Donati in *Riv. del R. Ist.*, VIII (1941), 144, 445, 501. For the history of the church see Brauer–Wittkower, 110 ff.; also F. Borsi, *La chiesa di S. Andrea al Quirinale*, Rome, 1967.

71. W. Lotz, 'Die ovalen Kirchenräume des Cinquecento', *Röm. Jahrb. f. Kunstg.*, VII (1955), 55 ff.

72. Wittkower, *Architectural Principles in the Age of Humanism*, 3rd ed., London, 1962, 97 f.

73. See Note 69.

74. About this important church see now W. Lotz, *op. cit.*, 58, and above, 1 Chapter 6, Note 2.

75. It is important to realize that the ground was originally considerably higher. Only three steps led up to the portico; see G. B. Falda's engraving in *Il terzo libro del novo teatro delle chiese di Roma*, Rome [n.d.], 13.

76. See above, Note 74.

77. See I: p. 78.

78. Pollak, *Kunsttätigkeit*, I, 237–40.

79. For the palace at Modena Bernini mainly functioned as consulting architect in 1651; see L. Zanugg, 'Il Palazzo ducale di Modena', *Riv. del R. Ist.*, IX (1942), 212–52.
His contribution to the Quirinal Palace, part of the so-called *manica lunga* (1656–9) along the Via del Quirinale, has now been clarified by J. Wasserman, *Art Bull.*, XLV (1963), 240.

80. Such as the projects for the Piazza del Quirinale (Brauer–Wittkower, 134), for the monument of Philip IV of Spain to be erected under the old portico of S. Maria Maggiore (*ibid.*, 157), and for the apse of S. Maria Maggiore (1669), later executed by C. Rainaldi (*ibid.*, 163; S. Fraschetti, *Il Bernini*, Milan, 1900, 379–84; A. Mercati in *Roma*, XXII (1944), 18, documents).

81. Illustrated in Falda, *Il nuovo teatro delle fabbriche*, I, Rome, 1665, plate 30.

82. Brauer–Wittkower, 126; A. Busiri Vici in *Palladio*, VI (1956), 127.

83. Built for Niccolò Ludovisi, the nephew of Gregory XV, who had married a niece of the Pamphili Pope Innocent X. For the palace, see now the monumental, fully documented work by F. Borsi (and others), *Il Palazzo di Montecitorio*, Rome, 1967.

84. E. Coudenhove-Erthal, *Carlo Fontana*, 71 ff., figure 25, shows what was standing when Fontana began working. It is mainly the central area that must be assigned to him. Vol. 168 of the Fontana papers in the Royal Library at Windsor contains documents and drawings referring to the palace.

85. At the time large parts of the palace were standing. For its history, see Thomas Ashby, 'The Palazzo Odescalchi in Rome', *Papers of the British School at Rome*, VIII (1916), 87 ff.; Brauer–Wittkower, 127; A. Schiavo, *La Fontana di Trevi*, Rome, 1956, 239.

86. In Rome, mainly Antonio da Sangallo's Palazzo del Banco di S. Spirito (1523–34) and Girolamo Rainaldi's Palazzo Senatorio on the Capitol.

87. Examples of indirect derivation: Fuga's Palazzo Cenci-Bolognetti, Piazza del Gesù, Rome (c. 1745); G. A. Veneroni's Palazzo Mezzabarba at Pavia (1728–30); and Juvarra's Palazzo Ferrero d'Ormea at Turin. Outside Italy,

among numerous examples, Martinelli's Liechtenstein Palace and Fischer von Erlach's palace of Prince Eugen, both in Vienna, and the Marble Palais in Leningrad.

88. For the history of the Louvre, see L. Hautecœur, *Le Louvre et les Tuileries de Louis XIV*, Paris, 1927; idem, *Histoire du Louvre*, Paris, 1928. For Bernini's contribution, Josephson, *G.d.B.A.*, XVII (1928), 75–91, and Brauer–Wittkower, 129–33. The whole story summarized in Blunt, *Art and Architecture in France*, 230 ff. See also A. Schiavo in *Bollettino del Centro di Studi per la Storia dell' Architettura*, no. 10 (1956), 23.

For the Louvre projects by Candiani, Rainaldi, and Cortona, see P. Portoghesi, in *Quaderni* (1961), 243.

89. Plan: Brauer–Wittkower, plate 175; east front: Hautecœur, *Le Louvre*, plate 33. Another drawing in Blunt, plate 155B.

90. R. W. Berger, in *Journal Soc. Architect. Historians*, XXV (1966), 170 ff., regards Bernini's first Louvre project as a direct offspring of Antoine Le Pautre's design for an ideal château, published in the latter's *Desseins de plusieurs palais* (1652). But no one who has eyes to see will be able to accept this hypothesis.

91. See Brauer–Wittkower and Josephson, *op. cit.*, 81 (illustration).

92. Illustrated in Muñoz, *Pietro da Cortona* (Bibl. d'arte ill.), Rome, 1921, 15. See below, p. 74.

93. The east front and the plan illustrated in Blunt, plate 155C and figure 24.

94. This was an insufficient answer to the criticism of Colbert, who held that the entrance of the earlier projects was too insignificant.

95. The conversations reported by the Sieur de Chantelou show that Bernini regarded this feature as immensely important (1 July 1665).

96. Bernini regarded the old rooms of the south front as too small and artistically too insignificant to serve as a royal apartment.

97. It is evident that Bernini also wanted to hide the old court façades, the pride of French architecture.

98. See A. Blunt. *op. cit.*

99. Josephson, *op. cit.*, 82–9.

100. But the influence of Bernini's project on general principles of design in France should not be underestimated. The traditional high-pitched roof and the pavilion system disappear after his visit. In addition, his project found a sequel in other countries. Examples: the Czernin Palace in Prague (1669), Sacchetti's Royal Palace in Madrid (1739), and Tessin's Royal Palace in Stockholm (see H. Rose in *Festschrift Heinrich Wölfflin*, Munich, 1924, 245).

101. The only detailed discussion of the history of the Piazza is in Brauer–Wittkower, 64–102. See also V. Mariani, *Significato del portico berniniano di S. Pietro*, Rome, 1935, and the more recent interesting contribution by C. Thoenes, *Zeitschr. f. Kunstg.*, XXVI (1963), 97–145. Bernini's principal assistants were his brother Luigi, Mattia de' Rossi, Lazzaro Morelli, and the young Carlo Fontana.

102. Opposition was centred in reactionary ecclesiastical circles. They supported an elaborate counter-project of which twenty-five drawings survive which time and again are attributed to Bernini himself. For the whole problem see Wittkower in *J.W.C.I.*, III (1939–40). Also Brauer–Wittkower, 96 ff.

103. This made it necessary to pull down Ferrabosco's tower, see above, I: p. 6.

104. See above, I: p. 77.

105. Mainly by Ferrabosco; see D. Frey, 'Berninis Entwürfe für die Glockentürme von St Peter in Rom', *Jahrbuch der kunsthistorischen Sammlungen, Wien*, XII (1938), 220 f., figures 243–5.

106. The complex history of these towers is discussed in Brauer–Wittkower, 37–43; see also Frey, *op. cit.*, and Underwood in *Art Bull.*, XXI (1939), 283; H. Millon in *Art Quarterly*, XXV (1962), 229, summarized the whole question.

107. Brauer–Wittkower, 41 ff., plates 156–7; D. Frey, *op. cit.*, 224 f.

108. Brauer–Wittkower, plate 164B, and Wittkower in *Boll. d'Arte*, XXXIV (1949), 129 ff.

109. Bernini himself talked about this in Paris (Chantelou, ed. Lalanne, 42). Similar arguments also in Bernini's report of 1659–60 (fol. 107v, see Brauer–Wittkower, 70).

110. First used by Pietro da Cortona in S. Maria della Pace.

111. Brauer–Wittkower, 88 ff. Previous discussion of the Scala Regia with partly different results, Panofsky, *Jahrb. Preuss. Kunstslg.*, XL (1919) and Voss, *ibid.*, XLIII (1922).

112. D. Frey, *op. cit.*, 217.

113. The whole material for this question in Wittkower, *Boll. d'Arte, loc. cit.* Also H. Hager, in *Commentari*, XIX (1968), 299 ff.

114. For Carlo Fontana's projects see Coudenhove-Erthal, *op. cit.*, 91 ff. and plate 39. For later and similar projects see T. A. Polazzo, *Da Castel S. Angelo alla basilica di S. Pietro*, Rome, 1948.

115. This statement is true in spite of the fact that this type of colonnade was first devised by Pietro da Cortona, see below, p. 74.

116. There are two passages for pedestrians and between them a wider one for coaches.

CHAPTER 3

1. The name Borromini (without Castelli) does not appear in documents before 1628. For portraits of Borromini, see P. Portoghesi, *Burl. Mag.*, CIX (1967), 709 f.

2. His activity can be followed in documents dating between 1624 and 1633; see Pollak, *Kunsttätigkeit*, II, Muñoz in *Rassegna d'Arte*, XIX (1919), 107 f., and *ibid.*, 'Francesco Borromini nei lavori della Fabbrica di S. Pietro', *Scritti in onore di B. Nogara*, Rome, 1937, 319.

3. Between 1621 and 1623, see N. Caflisch, *Carlo Maderno*, Munich, 1934, 141.

4. Brauer–Wittkower, 27 f.

5. Exact date of the execution of the cloisters: 6 February 1635 to 28 October 1644: see A. Contri in *L'Architettura*, I (1955), 229, with valuable measured drawings.

6. See E. Hempel, *Borromini*, Vienna, 1924, figures 6–9.

7. P. Portoghesi, in *Quaderni* (1954), no. 6, 16, has come to somewhat similar conclusions. See also below, Note 27.

For the wider issues involved see Wittkower, 'Systems of Proportion', in *Architects' Year Book*, V (1953).

8. The pattern is derived from S. Costanza, via the illustration in Serlio's Fourth Book.

9. The name derived from the motto 'Initium sapientiae timor Domini' engraved over the main entrance.

H. Thelen, in his thorough reconstruction of the history of the building (*Miscellanea Bibl. Hertzianae*, 1961, 285–307), convincingly shows that Giacomo della Porta had built the closed arcades of the hemicycle long before Borromini took over.

10. An exhaustive geometrical analysis by L. Benevolo, 'Il tema geometrico di S. Ivo alla Sapienza', *Quaderni* (1953), no. 3.

11. See, e.g., the illustration in Serlio, *Tutte l'opere d'architettura*, Venice, 1566, 62, of a temple 'fuori di Roma'.

12. The string-courses run on across the two other bays C.

13. The feigned coloured marble effect that was given the church under Pius IX in 1859 was removed in a recent restoration and the church was given back its original white appearance.

For the emblematic character of the architecture, see the papers by H. Ost and P. de la Ruffinière du Prey (Bibliography).

For S. Ivo, see also C. Brandi, *Struttura e architettura*, Turin, 1967, 94 ff.

14. Other examples are the 'nymphaeum' in the garden of Sallust (Flavian), perhaps the earliest building of this type; the vestibule, Piazza d'Oro, Hadrian's Villa, Tivoli (c. A.D. 125–35); and, of the same period, the Tempio di Siepe, Campo Marzo, Rome. Illustrations in G. T. Rivoira, *Roman Architecture*, Oxford, 1925.

15. The ruins of Baalbek were already known in the sixteenth century. The 'Grand Marot' of about 1660–70 has a reconstruction of the great temple.

16. W. Born, 'Spiral Towers in Europe and their oriental Prototypes', *G.d.B.A.*, XXIV (1943), 233 ff., has shown that, through the tradition of the Tower of Babel, spiral towers were more common in sixteenth- to eighteenth-century Europe than is generally realized.

17. The twelve Apostles in the tabernacles of the nave (see III: p. 55) and the oval paintings above them belong to the Pontificate of Clement XI. Borromini's plans for portico and façade remained on paper. They were later executed by Alessandro Galilei (III: p. 13–15).

18. For the development of Borromini's project see, above all, K. Cassirer, 'Zu Borromini's Umbau der Lateransbasilika', *Jahrb. Preuss. Kunstslg.*, XLII (1921), 55 ff. In addition, H. Egger in *Beiträge zur Kunstgeschichte Franz Wickhoff gewidmet*, Vienna, 1903, and M. Dvořák, 'Francesco Borromini als Restaurator', *Kunstgeschichtliches Jahrbuch der k.k. Zentral-Kommission*, Vienna, 1907 (Beiblatt), 89 ff.

19. H. Thelen, *Kunstchronik*, VII (1954), 264 ff.

20. On the meaning of the capriccio in seventeenth-century art, see Argan, *Borromini*, 40.

21. For a detailed discussion of all the monuments, see P. Portoghesi, 'I monumenti borrominiani della basilica lateranense', *Quaderni* (1955), no, II, and R. U. Montini in *Palladio*, V (1955), 88 ff.

22. New documents for the history of the church were published by L. Montalto in *Studi Romani*, V (1957), and *Palladio*, VIII (1958). See also F. Fasolo, *L'opera di Hieronimo e Carlo Rainaldi*, Rome, 1960, chapter x, who makes it probable that the planning of the church began as early as 1645–7.

23. See K. Noehles in *Zeitschr. f. Kunstg.*, XXV (1962), 173.

I find a rather high-handed though unspecific critique of my analysis of S. Agnese in G. Eimer's book on S. Agnese (Bibliography under Rome), 114; hence I saw no reason for any changes.

24. This is due to the fact that the frames of the painted pendentives are carried down through the area of the attic. It is worthwhile to compare Borromini's solution with that in St Peter's, where the entablature over the

pilasters of the pillars does not project and where the arch of the vault rests on the entablature without an attic – thus producing neither the unifying verticalism nor the slender proportions of S. Agnese.

25. For a further analysis, see Wittkower, *Art Bull.*, XIX (1937), 256ff.

26. Even Bernini had a hand in some of the decoration; he was responsible for the details of the entablature.

27. For a different opinion, see A. de Rinaldis, *L'arte in Roma dal Seicento al Novecento*, Bologna, 1948, 197. The lantern appears in a ground plan in the Albertina (Hempel, figure 61) drawn into the plan of the 'drum'. This drawing is one of the most interesting documents for Borromini's medievalizing approach to planning. His procedure can be fully reconstructed, since the design contains the complete geometrical pattern carefully drawn. It appears, first, that the essential points of the construction are determined by incommensurable magnitudes and, secondly, that the shape of the lantern is geometrically derived from the drum, and it is this – the geometrical unification of different storeys drawn into one plan – that reveals the closest contact with late medieval principles.

28. For other cherub-herms in Borromini's late work, see the monument of Pope Sergius IV in S. Giovanni in Laterano and the façade of S. Carlo alle Quattro Fontane [54].

29. The coherence of the tiers of the tower is stressed, however, by the placing of all the supporting elements in the diagonals, corresponding to the buttresses of the 'drum'.

Of the whole exterior only the two upper tiers and the crowning feature of the tower were stone-faced and finished.

30. Until recently the design of the church had always been dated in the early 1650s. The revision of the date is due to Paolo Marconi, in *Palatino*, X (1966), 194–200; see also *idem* in *Studi sul Borromini. Atti del Convegno*, Rome, 1967, I, 98.

31. The motif of the straight entablature *cum* arch derives from Hellenistic sources (familiar to Quattrocento architects) and was here first used by Borromini. In 1646 he incorporated it in his project for the Palazzo Pamphili in Piazza Navona and executed it in the gallery of the same palace (see below, Note 45). It is not impossible that more than ten years later this stimulated Pietro da Cortona to his use of the same motif in the façade of S. Maria in Via Lata [91].

32. Here too Borromini worked with similar overlapping rhythms which, starting with the entrance bay, may be expressed as:

A | b′ b b′ | A | b′ b b′ | A | . . .
or: b′ A b′ | b | b′ A b′ | b | . . .

33. It is not certain that anything above the cornice corresponds to Borromini's design. In any case, the interior decoration, including the diamond-shaped simple coffers of the vault (painted), belongs to the restorations of 1845 and 1928–9. See Marconi (above, Note 30) and M. Bosi, *S. Maria de' Sette Dolori*, Rome, 1953.

34. Interior decoration after Borromini's death, mainly by Carlo Fontana's son, Francesco. Complete restoration of the interior in 1815.

35. For the sake of completeness, the following list of minor ecclesiastical works may supplement the buildings discussed in the text: 1638–43, decoration, S. Lucia in Selci, Rome (discussion and documents in P. Portoghesi, *Quaderni*, nos. 25–6 (1958), 2). 1640–2, altar of the Annunciation, SS. Apostoli, Naples, closely resembling the system used for the façade of the Oratory of St Philip Neri. 1656 (not 1664), design of high altar chapel, S. Giovanni de' Fiorentini, with the Falconieri tombs (document published by M. V. Brugnoli, *Boll. d'Arte*, XLV (1960), 341. The high altar of S. Giovanni de' Fiorentini, begun much earlier by Pietro da Cortona (1634), shows the latter's style). Borromini's Falconieri crypt in the same church, only recently discovered, should also be mentioned; see E. Rufini, *S. Giovanni de' Fiorentini* (Le chiese di Roma illustrate, 39), Rome, 1957, 67, 103 (document). 1658, rebuilding of the little chapel S. Giovanni in Oleo near Porta Latina, with a dome hidden behind a cylindrical feature (decorated with a classicizing frieze) and a cone-shaped roof. For other minor work, see Portoghesi, *Quaderni*, nos. 25–6 (1958). For Cappella Spada, see Heimbürger Ravalli, *Architettura, scultura, ed arti minori nel barocco italiano. Ricerche nell' archivio Spada* (Florence, 1977).

36. A. Pernièr, 'La Torre dell' Orologio dei Filippini', *Capitolium*, X (1934), and *idem*, 'Documenti inediti sopra un' opera del Borromini: La fabbrica dei Filippini', *Archivi*, II (1935), 204. See also G. Incisa della Rocchetta, 'Un dialogo del P. Virgilio Spada sulla fabbrica dei Filippini', *Arch. della Soc. romana di storia patria*, XC (1967), 165–211.

37. Borromini laid the main axis through the centre of the courtyards [135], but the long western wing along the Via de' Filippini has no correspondence on the side adjoining S. Maria in Vallicella. Consequently the façade left (west) of the central axis consists of five bays, while the right-hand side (near the church) has only three bays. But the eye does not notice the asymmetry, since the two farthest bays on the left lie outside the quoined edge of the façade proper.

38. We must abstain from a further analysis, particularly of the complex treatment of the walls. Reference may be made to Argan's pertinent remarks about the transformation of functional into decorative elements and vice versa (*Borromini*, 53).

39. In the clerestory above the cornice the wall articulation is taken up and continued in the bands of the flat vaulting – a first step towards the late solution of the church of the Collegio di Propaganda Fide.

40. For the small cloister of S. Carlo, Borromini had chosen a different design: he carried an extremely simple form of the 'Palladio motif' without any interruption across the bevelled corners. See p. 40.

41. For the clock-tower see A. Pernièr in *Capitolium*, X (1934), 413.

42. See also the design in G. B. Montano, *Scelta di varj tempietti antichi*, Rome, 1624, plate 3, which was certainly known to Borromini and which he must have regarded as authentically antique. Heimbürger Ravalli, *op. cit.*, 131 ff., suggests influence of the *quarantore* decorations.

42a. See P. Portoghesi, *Borromini*, Rome, 1967, 174.

43. See O. Pollak's classic article 'Die Decken des Palazzo Falconieri in Rom', *Kunstgeschichtliches Jahrbuch der k.k. Zentral-Kommission* (1911). The whole problem of Borromini's decoration has been discussed by P. Portoghesi in *Boll. d'Arte*, XL (1955), 12–38.

44. Borromini, of course, had knowledge of Vasanzio's loggia in the garden of the Villa Mondragone at Frascati (I: pp. 13).

45. Full discussion of the various plans for the palace by D. Frey, 'Beiträge', *Wiener Jahrb.*, III (1924), 43 ff. Here, too, publication of Borromini's alternative project for the whole palace.

46. A loggia of the courtyard with the richly decorated doorway at its end and the simple spiral staircase behind it, dating from before 1643, were incorporated into the later building. No less than thirty-eight drawings by Borromini for the palace survive (Vienna, Albertina). Full discussion by G. Giovannoni, 'Il Palazzo Carpegna', in *La Reale Insigne Accademia di S. Luca*, Rome, 1934, 35–66. M. Tafuri (in *Quaderni*, XIV, 79–84 (1967), 85 ff.) examined Borromini's contribution again on the basis of documents in the Falconieri–Carpegna archive; Borromini's alterations were executed between 1643 and 1647.

47. A similar idea is to be found in a drawing in the Uffizi, attributed to Borromini, published by Portoghesi, *Quaderni* (1954), no. 6, 28.

Among other domestic buildings by Borromini mention may be made of the Palazzo di Spagna (1640s) where, according to Hempel (133), the vestibule and staircase of three flights survive. The later Palazzo Spada in Piazza di Monte Giordano (about 1660) lost its Borrominesque character in a modernization of the nineteenth century, but the courtyard is extant with alterations. Hempel's attribution of the Palazzo Barberini alli Giubbonari has to be abandoned; see B. Maria Apollonj in *Capitolium*, VIII (1932), 451. Borromini's precise contribution to the Villa Falconieri at Frascati has not yet been determined. An interesting project for the villa of Cardinal Pamphili near Porta S. Pancrazio has been published by Portoghesi in *Quaderni* (1954), no. 6.

48. The inspiration for the giant order probably came once again from Michelangelo's Capitoline Palaces, which influenced Borromini throughout his lifetime; but the closely-set pilasters and narrow bays are reminiscent of Palladio's late style of the Palazzo Valmarana and the Loggia del Capitano.

49. It is true that the attic is later (1704), a fact hitherto overlooked, but use must have been made of a design by Borromini. At the time of Borromini's death there was an iron railing over the cornice; see L. Cruyl's drawing of 1665 in the Albertina (H. Egger, *Römische Veduten*, Vienna, 1931, II, plate 75); G. B. Falda's engraving in *Il nuovo teatro delle fabbriche . . .* , I, [Rome], 1665, plate 9; Falda's plan of Rome of 1676; and the drawing in the Library of Windsor Castle, Albani volume 185, no. 10328.

CHAPTER 4

1. *Pietro da Cortona*, Florence, 1962.

2. See G. Briganti in *Paragone*, XI (1960), no. 123, 33; also Toesca (next Note).

3. His biography in Passeri–Hess, 75; see also I. Toesca in *Boll. d'Arte*, XLVI (1961), 177.

4. Now in the Accademia di S. Luca, Rome.
For Marcello Sacchetti's patronage of Cortona, see Haskell, *Patrons*, 38.

5. Marino had been in Paris for eight years until 1623. He died in 1625. The *Rinaldo and Armida* painted for Marino (Passeri–Hess, 375) has not yet been traced.
For Marino, see G. Ackerman, *Art Bull.*, XLIII (1961), 326.

6. For Cassiano del Pozzo and his collection, see C. C. Vermeule, *Art Bull.*, XXXVIII (1956), 31; *idem*, *Proceedings of the American Philos. Soc.*, CII (1958), 193, and *Transactions of the American Philos. Soc.*, N.S. L, pt 5; F. Haskell and S. Rinehart, *Burl. Mag.*, CII (1960), 318, and the able summary in Haskell's *Patrons*, 98 ff. For Cassiano in Spain, see E. Harris, *Burl. Mag.*, CXII (1970), 364 ff.

7. The frescoes at Frascati and in the Palazzo Mattei, to be discussed later, are the only memorable exception.

8. He may have had some training at Cortona with his uncle Francesco, who was an architect.

9. Voss, 543. Briganti, 111, on the contrary, emphasizes Cortona's unbroken powers as a painter to the very last.

10. Payments to Cortona begin in 1626 and run until 1630. The attribution of the building to Pietro da Cortona is maintained in a series of eighteenth-century drawings by Pier Leone Ghezzi (1674–1755) which gives a valuable general view and plans of the three storeys (London, Coll. Sir Anthony Blunt). In his brief description, Ghezzi calls the house 'casino fatto ad uso di fortezza'.

See also G. Tomassetti, 'Della Campagna Romana: Castelfusano', *Archivio della R. Società Romana di storia patria*, XX (1897); Francesco Chigi, 'La pineta di Castel Fusano', *Vie d'Italia*, XXXVIII (1932).

11. Only the grotto is preserved (see Luigi Càllari, *Le ville di Roma*, Rome, 1943, 266). Views of the villa exist in A. Specchi's *Quarto libro del nuovo teatro . . . di Roma* (1699), plate 44; G. Vasi's *Delle magnificenze di Roma antica e moderna*, V, Rome, 1754, and Percier and Fontaine's *Choix des plus célèbres maisons de plaisance de Rome*, Paris, 1809, plates 39–41. Our knowledge of the villa is considerably furthered by some Ghezzi drawings in the Blunt collection (see last Note): (i) the ground-plan [81], only published once in [Blunt–Wittkower], *Exhibition of Architectural and Decorative Drawings*, The Courtauld Institute (February, 1941), No. 15, plate I; (ii) the section and plan of the grotto; (iii) one of the windows on the first floor at the sides of the central niche. See also Incisa della Rocchetta in *L'Urbe* (1949), no. 3, 9–16.

12. According to Vasi, Cardinal Giulio commissioned the building; according to Specchi's caption it was the Marchese Marcello.

13. A. Marabottini (*Mostra di Pietro da Cortona*, 1956, 34) believes that the pictorial decoration points to a date not earlier than 1630. A. Blunt in *Burl. Mag.*, XCVIII (1956), even suggested 1634–5. Briganti, 191, does not commit himself.

14. Wittkower, 'Pietro da Cortonas Ergänzungs-projekt des Tempels in Palestrina', *Festschrift Adolph Goldschmidt*, Berlin, 1935, 137. For Praeneste, see C. Severati (and others), in *L'Architettura*, XVI (1970), no. 6, 398, and no. 8, 540; valuable for the many illustrations.

15. See the letter written by Cortona's nephew, Luca Berrettini, to Ciro Ferri, 24 March 1679, in G. Gampori, *Lettere artistiche inedite*, Modena, 1866, 510.

16. Only the front with the portal and two windows of characteristically Cortonesque design is standing. A. Blunt, *J.W.C.I.*, XXI (1958), 281, suggests that the theatre was executed between 1638 and 1642.

Also, one of the 'Quattro Fontane', on the side of the Palazzo Barberini, is by Cortona, but it was not finished until the reign of Alexander VII (probably after 1665).

17. Along the main front Cortona indicated in pencil the rooms of the *piano nobile*. The 'sala' occupies 4 octagons, the 'salone' 4 octagons plus the vestibule, and the 'anticamera' 2 octagons. The length of Cortona's Salone would have been 125 feet compared with the 85 feet of the executed one. The note in ink on the left mentions that a corridor should run above from which one could reach all the rooms.

18. A scale in Roman palmi is at the bottom of the sheet. Cortona's ground floor would have been *c.* 3 feet higher than the present one, judging from the diameter of the columns in his plan.

19. O. Pollak in *Kunstchronik*, XXIII (1912) and *idem, Kunsttätigkeit*, I, 163.

20. The documents published by O. Pollak, *op. cit.*, 185 ff. See also G. Giovannoni, 'La Chiesa di S. Luca e il suo restauro', in *La Reale Insigne Accademia di S. Luca*, Rome, 1934, 19–25, with measured ground plan. All earlier work on the church has now been superseded by K. Noehles' excellent monograph (see next Note).

21. An important drawing by Cortona in Munich (Graphische Sammlung), revealing that at first a sepulchral church was planned, was published by H. Keller in *Miscellanea Bibl. Hertzianae* (1961), 375. E. Hubala in *Zeitschr. f. Kunstg.*, XXV (1962), 125, enriched the discussion by publishing some drawings in the Castello Sforzesco, Milan. Keller's and Hubala's results have been corrected by K. Noehles, *La chiesa dei SS. Luca e Martina*, Rome, 1969, 58 ff., who convincingly dates the 'mausoleum' project as early as 1623–4.

22. K. Noehles, *op. cit.*, has, however, shown that the completion of the church dragged on until 1669.

23. The bays adjoining the crossing in the longitudinal axis are wide enough to accommodate doors which have balconies above them. The corresponding bays in the transverse axis contain only niches.

24. Michelangelo's influence was stressed by Hubala, *op. cit.*

25. See, e.g., Michelangelo's projects for the façade of S. Lorenzo, Florence.

26. The plan [83] illustrates that the whole front may be likened to one of the apses flattened out and reversed. The position and motif of the columns corresponds, but while the wall is recessed inside, outside it seems to bulge outward.

27. S. Carlino, begun in the same year, remained for a long time without façade; see p. 43.

28. O. Pollak in *Kunstchronik*, XXIII (1912), 565.

29. In the interior Cortona was above all responsible for the modernization of the old dome. There is good reason to believe that this was not finished in 1657, the date of the inscription of the consecration (see Brauer–Wittkower, 112, note 3). The dome shows once again the combination of ribs and coffers, but the coffers are classical in shape and un-Cortonesque. Since Cortona was absent from Rome in 1658, it is not at all unlikely that the work was left in the hands of the young Carlo Fontana who, at precisely this period, also began to assist Bernini. It is therefore possible that Cortona's design was classicized under Bernini's influence.

30. Illustration 88, redrawn from a preparatory drawing by Cortona in the Vatican Library, shows one street flanking the church on the right and another at an angle to the church on the left. The dotted lines indicate what had to be demolished in order to create the small piazza.

31. The quadrant wing on the right-hand side is a sham structure.

32. The portico is also an impressive landmark when approached from the Via di Parione Pace.

33. Brauer–Wittkower, 74.

34. In actual fact, Cortona permitted himself considerable freedom. The column is not 'correct' Doric, nor is the entablature 'correct' Ionic.

35. The break at right angles of a coherent moulding is essentially a Borrominesque motif. It first occurs at the garden front of the Palazzo Barberini.

For a somewhat different interpretation of the façade of S. Maria della Pace, see H. Sedlmayr, *Epochen und Werke*, 1960, II, 66.

36. N. Fabbrini, *Vita del Cav. Pietro da Cortona*, Cortona, 1896, 118; Luigi Cavazzi, *La Diacona di S. Maria in Via Lata*, Rome, 1908, 130 ff.

37. I have mentioned before that Borromini used the motif more than once (Chapter 3, Note 31) and that Cortona may have been stimulated by him. I have also pointed out that the Hellenistic architecture of the Near East was known during the seventeenth century (Chapter 3, Note 15).

38. Cortona's dome was begun in 1668 but finished after his death, as testified by Luca Berrettini (see above, Note 15). This probably accounts for certain rather dry Cortonesque details which induced some scholars to deny Cortona's authorship of the design altogether. There is no reason to doubt that Cortona also made designs for the interior decoration of the church. For further data relating to S. Carlo al Corso, see Chapter 6, Note 23.

39. The Cappella Gavotti, with powerful motifs compressed into a small area and richly decorated with sculpture by Raggi, Ferrata, and Cosimo Fancelli, is Cortona's latest masterpiece. But he did not live to see it finished: Ciro Ferri completed it after his death. The classicizing altar of St Francis Xavier was completed as late as 1678.

For Ciro Ferri as designer of sculptural and architectural decorations, see K. Noehles in *Miscell. Bibl. Hertzianae* (1961), 429. Also H. W. Kruft, *Burl. Mag.*, CXII (1970), 692 ff.

40. Bottari, I, 418, 419.

41. The problems presented by these drawings are rather complex. Cortona's principal design seems to be Uffizi 2231. K. Janet Hoffman in an unprinted thesis (New York University, 1941) tried to establish the authentic drawings and their chronological sequence.

42. Erected in 1660 and pulled down in the nineteenth century. V. Lugari, *La Via della Pedacchia e la casa di Pietro da Cortona*, Rome, 1885, contains some illustrations.

43. K. Noehles, 'Die Louvre-Projekte von Pietro da Cortona und Carlo Rainaldi', *Zeitschr. f. Kunstg.*, XXIV (1961), 40; see also P. Portoghesi in *Quaderni* (1961), nos. 31–48, 249.

44. Chantelou (ed. Lalanne), 257, and Bottari, II, 51 f. (Ciro Ferri's letter to Lorenzo Magalotti, 17 February 1666.)

45. G. Giovannoni, 'Il restauro architettonico di Palazzo Pitti nei disegni di Pietro da Cortona', *Rassegna d'Arte*, XX (1920), 290; E. Vodoz in *Mitteilungen des kunsthistorischen Instituts in Florenz*, VI (1941), nos. 3–4, 50.

46. See Note 14. Cortona's original drawing is in a volume once belonging to John Talman, purchased before the war by the Victoria and Albert Museum.

47. Illustrated in A. E. Brinckmann, *Theatrum Novum Pedemontii*, Düsseldorf, 1931; see also L. Hoctin in *L'Œil*, no. 97 (1963), 70. Excellent illustrations in A. Pedrini, *Ville . . . in Piemonte*, Turin, 1965, 367 ff.

48. Brauer–Wittkower, 148.

49. Bottari, I, 419.

50. This was, among others, Luca Berrettini's opinion stated in the letter mentioned above, Note 15.

51. Dated, probably correctly, *c.* 1616 by Briganti, 153, who discovered these frescoes. For an early work, perhaps of the same period, see E. Schleier, *Burl. Mag.*, CXII (1970), 752 ff.

52. J. Hess, 'Tassi, Bonzi e Cortona a Palazzo Mattei', *Commentari*, V (1954), 303. For the correct dates (documents), see K. Noehles in *Kunstchronik*,

XVI (1963), 99, and G. Panofsky-Soergel, in *Röm. Jahrb. f. Kunstg.*, XI (1967–8), 142 ff.

Hess attributes the decorative organization of the ceiling to Bonzi, while Noehles believes that Cortona rather than Bonzi was responsible for it.

53. Luca Berrettini reports that Cortona drew all the reliefs of Trajan's Column no less than three times. One of these drawings is preserved in the Gab. Naz. delle Stampe, Rome (*Mostra di Pietro da Cortona*, Rome, 1956, plate 51); others are in a sketchbook by Cortona in the R. Ontario Museum, Toronto, see G. Brett in *Bulletin R. Ontario Mus.* (December 1957), no. 26, 5. According to the sources, Cortona was particularly interested in the engravings of Polidoro da Caravaggio, and echoes of his work are evident in the later Cortona.

54. For the Sacchetti and Barberini patronage of Cortona, see the documents published by I. Lavin (with M. Aronberg Lavin), *Burl. Mag.*, CXII (1970), 446 ff.

55. His life in Passeri–Hess, 168. A list of his paintings in Waterhouse, 51, superseded by A. Sutherland Harris's study (see Bibliography).

56. For Sacchi's contribution see G. Incisa della Rocchetta in *L'Arte*, XXVII (1924), 60, and H. Posse, *Der römische Maler Andrea Sacchi*, Leipzig, 1925, 27. See also A. Sutherland Harris and E. Schaar, *Die Handzeichnungen von Andrea Sacchi und Carlo Maratta*, Kunstmuseum Düsseldorf, 1967, 26.

57. Further to the Castel Fusano frescoes, Note 56 and Posse in *Jahrb. Preuss. Kunstslg.*, XL (1919), 153; Briganti, 177.

58. Before 1625; see Jane Costello in *J.W.C.I.*, XIII (1950), 244; *Mostra di Pietro da Cortona*, Rome, 1956, 3, 25. For the date, see Briganti, 164.

59. Cortona copied after Titian for his patron, Marcello Sacchetti. Sandrart (ed. Peltzer, p. 270) reports that he himself and Cortona, Duquesnoy, Poussin, and Claude studied Titian's *Bacchanals*, then in the Casino Ludovisi. See also above, p. 98.

60. Posse's masterly discussion of the ceiling has not yet been superseded (*Jahrb. Preuss. Kunstslg.*, XL, 1919), and, although we cannot fully agree with him on all points, the reader must be referred to it for further study.

61. The only known preparatory drawing for the system of the ceiling (Munich; Posse, figure 26) shows that Cortona first envisaged it with clearly defined frames for *quadri riportati* still close to the Farnese ceiling.

The large bozzetto in oil in the Galleria Nazionale, Rome (E. Lavagnino, *Boll. d'Arte*, XXIX (1935), 82), corresponds so closely to the execution that it must be a copy rather than a preliminary study.

62. This is already true for Michelangelo's Sistine Ceiling. Characteristic later examples: Pierino del Vaga's Sala del Consiglio, Castel S. Angelo, and Salviati's frescoes in the great hall of the Palazzo Farnese.

63. Detailed description in H. Tetius, *Aedes Barberinae*, Rome, 1642. For an illuminating revision of previous interpretations, see W. Vitzthum, *Burl. Mag.*, CIII (1961), 427, whom I follow.

For the various levels of allegorical meaning read into such works in the seventeenth century, see J. Montagu, in *J.W.C.I.*, XXXI (1968), 334 f.

64. In addition to the frescoes of the Gran Salone, Cortona in the Palazzo Barberini decorated the Chapel and two rooms on the first floor (1632–3). To the same period also belongs the beginning of his work for the Chiesa Nuova (S. Maria in Vallicella, fresco on ceiling of sacristy, 1633–4). Further, in 1633 he began the large cartoons of Constantine's life for the Barberini tapestry works, which he directed from 1630 on (Urbano Barberini, in *Boll. d'Arte*, XXXV (1950), 43, 145). For these tapestries, see now D. Dubon, *Tapestries from the Samuel H. Kress Collection at the Philadelphia Museum of Art*, London, 1964, and the critical review by W. Vitzthum, *Burl. Mag.*, CVII (1965), 262 f.

65. For this and the following see H. Geisenheimer, *Pietro da Cortona e gli affreschi di Palazzo Pitti*, Florence, 1909. Also D. R. Coffin in *Record of the Art Museum Princeton University*, XIII (1954), 33, M. Campbell and M. Laskin, Jr, in *Burl. Mag.*, CIII (1961), 423, W. Vitzthum, *Burl. Mag.*, CVII (1965), 522, and Campbell, *ibid.*, 526 f.

66. The first room – Sala di Venere – was executed in 1641–2. He carried on with the fourth room, the Sala di Giove (1643–5), then with the third, the Sala di Marte (1646), and finally with the second, the Sala di Apollo, which he began only in 1647 shortly before returning to Rome (for a different interpretation of the documents, see Briganti, 236, who believes that Cortona began the Sala di Apollo in 1642–3). It was finished by Ciro Ferri in 1659–60. The latter was entirely responsible for the Sala di Saturno, 1663–5, the decoration of which is only a faint echo of that of the other rooms.

67. The fresco of the Sala di Marte, here illustrated, is the most developed of the series. In the centre, the Medici coat of arms floating through the air like a sumptuous trophy; along the borders the prince's victorious exploits which are rewarded by Justice and Peace.

68. According to Baldinucci (*Notizie de' professori*, Florence, ed. 1846, IV, 428), Raffaello Curradi's pupil, Cosimo Salvestrini, executed the stuccoes of the first room and some of the following ones. On the other hand, James Holderbaum found payments in the Archivio di Stato to the *stuccatori* Battista Frisone, Santi Castellaccio (or Cartellaccio), and Gio. Maria Sorrisi. The latter was one of the *stuccatori* who worked in the Villa Doria-Pamphili in Rome

(Chapter 5, Note 24) – proof that Cortona did not find in Florence the specialists he needed.

69. See A. Blunt, *Art and Architecture in France*, 161, 173, 206, 253.

70. M. Lenzi in *Roma*, V (1927), 495; L. Grassi in *Boll. d'Arte*, XLII (1957), 28.

CHAPTER 5

1. *Art and Architecture in France*, 182.

2. H. Posse's biography of Sacchi (Leipzig, 1925) and his article in Thieme-Becker are first-rate contributions and have not been superseded, but an extensive monograph by A. Sutherland Harris is in the press.

For Sacchi's work in the Collegio Romano, see *idem*, *Burl. Mag.*, CX (1968), 249 ff. but see now A. Sutherland Harris's monograph (1977).

3. A. Sutherland Harris (*Burl. Mag.*, CX (1968), 489 ff.) has made it likely that the *St Romuald* was painted in the early 1630s rather than during the last years of the decade, as was generally assumed.

4. O. Pollak, *Kunsttätigkeit*, I, 141. Waterhouse, plates 10, 11; D. Mahon, *G.d.B.A.*, LX (1962), 65; Harris–Schaar (see above, Chapter 4, Note 56), 45 ff.

5. The most important altarpiece of the 1640s, the *Death of St Anne* (S. Carlo ai Catinari, 1649; see Waterhouse, 91) shows that he preserved his rich and warm palette, in contrast to Poussin.

6. G. Incisa della Rocchetta in *L'Arte*, XXVII (1924), 65. For the problems connected with the dating and with the small replicas, see Jane Costello in *J.W.C.I.*, XIII (1950), 242. For the subject, see Passeri–Hess, 29; H. Tetius, *Aedes Barberinae*, Rome, 1642, 83; Incisa, *loc. cit.*; Posse, *op. cit.*, 38; Haskell, *Patrons*, 50. For this type of allegorical fresco, see E. Gombrich in *J.W.C.I.*, XI (1948), 186. For drawing related to *Divine Wisdom*, see Harris–Schaar, *op. cit.*, 29.

7. M. Missirini, *Memorie per servire alla storia della romana Accademia di S. Luca*, Rome, 1823, III. Mahon (see Note 4), 97, reasonably suggests the year 1636 for these discussions.

8. R. Lee in *Art Bull.*, XXII (1940), 197.

9. The question whether tragic or epic poetry is the higher form of art goes, of course, back to Aristotle's *Poetics*, XXVI.

10. Pascoli, II, 77. See E. Battisti in *Rendiconti Accademia dei Lincei*, VIII (1933), 139.

11. Malvasia (ed. 1678), II, 267.

12. On this point see p. 2.

13. Albani had planned to write an art theoretical treatise together with a Dr Orazio Zamboni (b. 7 January 1606), about whom little is known. Notes for this work, which can be dated between the early 1640s and Albani's death in 1660, were incorporated by Malvasia in his *Felsina pittrice* (II, 244–58).

14. *Trattato della pittura*, Florence, 1652.

15. G. M. Tagliabue, 'Aristotelismo e Barocco', *Atti del III Congresso Internazionale di Studi Umanistici*, Rome, 1955, 119.

16. It will be noticed that Cortona as a decorator (see p. 81) and as a painter had his following on different sides of the fence.

17. The traditional birth-date 1595 has to be changed to 1598; see the document published by A. Arfelli, *Arte Antica e Moderna*, II, no. 8 (1959), 462.

18. There were, however, many in his own generation who held him in high esteem: I mean not only the small circle of close friends, such as Poussin and Sacchi, but foreigners like Blanchard and Van Dyck, who painted his portrait, and Rubens, who wrote him a most flattering letter. R. S. Magurn, *The Letters of P. P. Rubens*, Cambridge, Mass., 1955, 413, 509, rightly refutes J. Hess's opinion that this letter was a seventeenth-century forgery (see *Revue de l'art ancien et moderne*, LXIX (1936), 21).

19. The entire inventory of 1633 of the Ludovisi collection was published by K. Garas, *Burl. Mag.*, CIX (1967), 287 ff., 339 ff.

20. On Algardi as restorer of antiques see M. Neusser in *Belvedere*, XIII (1928). Apart from the unprinted Harvard thesis by E. Barton (1952), no recent study of Algardi exists and reference must be made to the articles by Posse in *Jahrb. Preuss. Kunstslg.*, XXV (1905), 169 and A. Muñoz in *Atti e Memorie della Reale Accademia di S. Luca*, II (1912), 37.

21. If the apocryphal date is correct, the bust was made as early as 1626. In any case, it dates from before – and probably some years before – the Cardinal's death on 7 August 1637. For this bust, see H. Posse, *Jahrb. Preuss. Kunstslg.*, XXV (1905), and J. Pope-Hennessy, *Italian High Renaissance and Baroque Sculpture*, London, 1963, Catalogue, 142, with further references.

22. In the first (hardback) edition I showed on Plate 96A the bust of Francesco Bracciolini (Victoria and Albert Museum), traditionally and – as it seemed to me – correctly attributed to Algardi. A. Nava Cellini, in *Paragone*, VIII (1957), no. 84, 67, attributed this bust to Finelli and reasserted her attribution *ibid.*, XI (1960), no. 131, 19. It now appears that she is right, for there is contemporary evidence for this attribution (see J. Pope-Hennessy, *Catal. of Ital. Sculpture in the Victoria and Albert Museum*, London, 1964, II, 609 ff., no. 643). The bust shows to what extent Finelli was dependent on Algardi.

Together with the bust of Michelangelo Buonarroti the Younger, the Bracciolini must be regarded as his highest achievement as a portrait sculptor.

23. After A. Muñoz's generic discussion of Algardi's portrait busts (*Dedalo*, I (1920), 289), the problem was not treated for forty years. In 1956 O. Raggio (*The Connoisseur*, CXXXVIII (1956), 203) published Algardi's bust of Cardinal Scipione Borghese in the Metropolitan Museum, New York, with some pertinent remarks. Few of the busts are dated and the following sequence, taking into account only part of Algardi's production, is an attempt at a chronological order. The Santarelli seems to be quite early, perhaps the earliest Roman portrait. A group of busts is close to the Millini and should be dated about 1630; mainly the Cardinal Laudivio Zacchia [108] and the so-called Cardinal Paolo Emilio Zacchia Rondanini (Ugo Ojetti, Florence). In contrast to these, the later busts are not only more classical in handling but also show a more balanced relation between the head and the lower part. A date for the later series is supplied by the magnificent busts of Donna Olimpia Pamphili and of the Pamphili prince [109], after 1644, the year of Innocent X's accession to the papal throne. (Bellori called the latter bust 'Benedetto Pamphili', who was the Pope's brother; it is now usually called Panfilo Pamphili but may represent Camillo, the son of Panfilo and Olimpia.) The three posthumous Frangipani busts in S. Marcello al Corso (first mentioned in P. Totti, *Ritratto di Roma moderna*, Rome, 1638) seem to mediate between the early and late group of busts: they clearly display strong classicizing tendencies. Finally, the bust of Mario Millini in S. Maria del Popolo obviously echoes Bernini's Francis I of Este and must date from after 1650; but it was probably executed by a studio hand. My chronology of Algardi's busts is at variance with that suggested by V. Martinelli in *Il Seicento europeo*, Rome, 1957, Catalogue, 246 ff. Another chronology has been attempted by A. Nava Cellini in *Dizionario Biogr. degli Italiani*, II (1960), 350, and *idem*, *Paragone*, XV (1964), no. 177, 15. For Algardi's busts of Innocent X in the Palazzo Doria, formerly attributed to Bernini, see Wittkower, *Bernini*, 211.

* A very different chronology, based in part on new documentary evidence, is proposed in J. Montagu, 1985, pp. 174–8.

24. The list of Algardi's principal commissions during these years is impressive: 1644–8: building and decoration of the Villa Doria-Pamphili (Belrespiro) (Chapter 6, Note 37); the stuccoes of the villa have now been studied in an exemplary paper by O. Raggio, *Paragone*, no. 251 (1971), 3 ff.), 1645–9: fountain, Cortile S. Damaso, Vatican; *bozzetto* for the fountain's relief with *Pope Liberius baptizing Neophytes* in the Minneapolis Institute of Arts, see Wittkower in *The Minneapolis Inst. of Arts Bulletin* (1960), 29; 1646–53: Attila relief, St Peter's; 1649–50: entire stucco decoration of S. Ignazio; statue of Innocent X, Capitol; 1651–4: sculptural decoration of the main altar, S. Nicolò da Tolentino (finished after Algardi's death by Guidi, Ferrata, and Francesco Baratta).

25. Documents in O. Pollak, *Kunsttätigkeit*, II. Contract 21 July 1634; the figures were finished in 1644, but the monument was not unveiled until 1652. Peroni and Ferrata, on the strength of Passeri traditionally quoted as the artists responsible for the execution of the two allegories, did not join Algardi's studio until the tomb was practically completed.

26. The relief celebrates a papal triumph over worldly powers. Leo's reign had lasted only twenty-seven days (1605) and offered little scope for a suitable subject. The scene chosen shows Henry IV of France signing the peace with Spain. With one hand on the Gospels, the king affirms the sanctity of the treaty in the presence of Leo XI, then papal legate at the French court.

* The relief shows both the signing of the peace treaty, and, (at right) the King's abjuration of protestantism. It is more plausible that the tomb shows the pope as peace-maker.

27. The idea was derived from ancient or Early Christian sarcophagi, but the trapezoid shape was a novelty.

28. The great model was finished for the Holy Year 1650 and placed in position. It is one of the few such models that have survived (now Biblioteca Vallicelliana). Domenico Guidi's collaboration (Passeri) seems to be noticeable in the right half of the relief. It is less certain whether Ferrata had a share in the execution, as Baldinucci maintains.

29. See Heimbürger Ravalli, *op. cit.* (Chapter 3, Note 35), 37 ff.

30. See also Correggio's *Martyrdom of S. Placidus and S. Flavia* (Parma, Gallery).

31. In an illuminating paper, J. Montagu convincingly demonstrated the novelty of Algardi's last work, the high altar in S. Nicolò da Tolentino, where he showed 'a deep niche containing figures carved in varying degrees of relief' (*Burl. Mag.*, CXII (1970), 282 ff.).

32. Fulvio Testi, in a letter of 1633 to the Duke of Modena, called him the best sculptor in Rome after Bernini (Fraschetti, *Bernini*, 75). On Duquesnoy see M. Fransolet's monograph (Brussels, 1942), which is far from being conclusive.

How difficult it sometimes still is to keep Algardi and Duquesnoy apart has been demonstrated in a model paper by J. Montagu (in *Bulletin des Musées royaux d'art et d'histoire*, Brussels, XXXVIII–XXXIX (1966–7), 153 ff.) in which she investigates the well-known bronze group of the *Flagellation of Christ*, known

in many similar versions, some of which (she claims) are attributable to Duquesnoy and others to Algardi.

33. He died at Leghorn, on his way to Paris, where he was travelling in response to the offer of a position as court sculptor and director of the Academy of Sculpture.

34. According to Passeri, he was responsible for some of the putti in the foliage of the columns. Payments refer to the models of the angels above the columns, in which, among others, Finelli also had a share (see O. Pollak, *Kunsttätigkeit*, II).

35. Finished in 1633. Documents published by E. Dony, 'François Duquesnoy', *Bulletin de l'institut historique belge de Rome*, II (1922), 114. See also Fransolet, *op. cit.*

36. The figure is now standing in the wrong niche, on the left-hand and not on the right-hand side of the altar. Consequently the gesture of the hand, pointing away from the altar, has lost its meaning.

37. Compare, for instance, the left hands on the two statues; the one with dimples, agile and supple, the other neutral, a hand of stone.

38. See Sobotka in Thieme-Becker; also A. Muñoz in *L'Arte*, XIX (1916), 137. For the famous, often discussed bust in wax in the Musée Wicar in Lille, see Sobotka in *Berliner Kunstgeschichtliche Gesellschaft, Sitzungsberichte* (1910), no. vii, 40. In this context the marble bust in the Museo Estense, Modena, should also be mentioned; see R. Salvini in *Burl. Magi.*, XC (1948), 93.

39. B. Lossky, 'La Ste Suzanne de Duquesnoy et les statues du 18e s.', *Revue belge archéologique et historique de l'art*, IX (1939), 333.

40. M. Fransolet, 'Le Saint André de François Duquesnoy', *Bulletin de l'institut belge de Rome*, IV (1993). Duquesnoy made a small bozzetto for the St Andrew between June 1627 and March 1628. The large model was in position as early as November 1629, while work on the Susanna did not begin until a month later.

41. J. Hess in *Revue de l'art ancient et moderne*, LXIX (1936), 34.

For other busts by Duquesnoy, see A. Nava Cellini, *Paragone*, VII (1956), no. 65, 27 f., K. Noehles, *Arte Antica e Moderna*, no. 25 (1964), S. and H. Röttgen, *The Connoisseur* (Feb. 1968), 94 ff.

42. A reflection of this can be found in the many pictures, particularly of the Dutch school, in which works by Duquesnoy are shown; see, for instance, Frans van Mieris, Detroit; Adriaen van der Werff, Heylshof Coll., Worms; Netscher, The Hague (No. 127); and above all G. Dou's pictures, Altman Coll., New York; Duke of Rutland, Belvoir Castle; Uffizi, Vienna, Dresden, Louvre; Nat. Gall., London, etc. Still in the late eighteenth century Nollekens valued his Duquesnoy models very highly; see J. T. Smith, *Nollekens and his Times*, London, 1949, 234.

43. However, the design of the Vryburch monument with the spread-out skin, on which the inscription is placed, is comparatively Baroque, while that of the later van den Eynde monument is comparatively classical [116].

D. Mahon, *G.d.B.A.*, LX (1962), 73, read into my text that I regard the Vryburch putti as less 'painterly' than those of the van den Eynde monument, while I was, in fact, concerned with Duquesnoy's turn from an Italian (Titianesque) to a native (Rubenesque) taste. For Duquesnoy's stylistic development, see also K. Noehles, 'Francesco Duquesnoy; un busto ignoto e la cronologia delle sue opere', *Arte Antica e Moderna*, VII, no. 25 (1964), 86.

44. As an example we may mention the *Cupid as Archer* (described by Bellori; ivory, Musées Royaux d'Art et d'Histoire, Brussels) which corresponds almost exactly in reverse to the archer in Titian's *Bacchanal of Children*; the same figure was used by Poussin in the Dresden *Venus and Cupid* of about 1630.

45. Date: 1640–2. We show in illustration 119 the charming bozzetto in Berlin. The similarity of these putti to those of Rubens was first pointed out by A. E. Brinckmann.

It need hardly be emphasized that Duquesnoy's small representations of children are not genre. Just like Rubens, he drew constantly on ancient texts and ancient prototypes, see, for example, the *Cupid chipping the Bow* (marble, Berlin) in which he corrected Parmigianino's painting of the same subject in Vienna by reference to the Lysippian Eros; or the relief of *Putti and Nymph mocking Silenus* (illustrating Virgil's sixth Eclogue), which was in the collection of Cassiano del Pozzo (versions Berlin, Brussels (private coll.), Dresden, Victoria and Albert Museum); or the *Amor divino e profano* after Philostratus's text (original model Palazzo Spada, Rome; original marble Villa Doria Pamphili, Rome, see I. Faldi, *Arte Antica e Moderna*, II (1959), 52; replicas Victoria and Albert Museum, Detroit, Prado, etc.).

46. Among Duquesnoy's few pupils there was Orfeo Boselli (*c.* 1600–67), who venerated his master as the 'angelic sculptor' and the 'phoenix of our age'. Boselli is of particular interest because he left a (still unpublished) manuscript of absorbing interest for the history of sculpture entitled 'Osservazioni della Scultura Antica' (Bibl. Corsiniana, Rome, MS. 1391); see M. Piacentini, in *Boll. del R. Istituto di Archeologia e Storia dell'Arte*, IX, i–vi (1939), and P. Dent Weil, in *Studies in Conservation*, XII (1967), 81 ff., with a partial translation of Boselli's Fifth Book on the restoration of antique sculpture.

CHAPTER 6

1. In Bologna he executed the vaulting of S. Petronio, S. Lucia with unfinished façade (1623), and SS. Girolamo ed Eustachio, of which little survives. His is also a project for the façade of S. Petronio, a fantastic cross-breed between Mannerism and Gothic (1626). In Parma the vaulting of Fornovo's SS. Annunziata was due to him, and in Modena he had an important share in the design of the Palazzo Ducale (1631–4) [134]. For Girolamo and Carlo Rainaldi, see now the somewhat unwieldy monograph by F. Fasolo (1961), which contains, however, a great deal of material and should be consulted for this section.

2. See the synopsis in Fasolo, *op. cit.*, 420. Girolamo's most important work is the Carmelite church of S. Silvestro at Caprarola near Rome (1621, Fasolo, 65).

3. See D. Frey in *Wiener Jahrb.*, III (1924), 43 ff.

4. Wittkower in *Art Bull.*, XIX (1937), 256. Some scholars disagree with me and attribute the project to Girolamo; see L. Montalto in *Palladio*, VIII (1958), 144, and K. Noehles, *Zeitschr. f. Kunstg.*, XXV (1962), 168

We can follow Carlo's career from 1633 onwards (G. Matthiae in *Arti Figurative*, II (1946), 49). His project for the towers of St Peter's and the modernization of the façade, dating from 1645, shows him dependent on his father's Mannerism. Between 1650 and 1653 he made a number of plans for the Square of St Peter's which are rather pedestrian and traditional (Brauer–Wittkower, 67).

5. Further on the history of S. Maria in Campitelli, Wittkower in *Art Bull.*, XIX (1937). See also Bassi in *Riv. d'Arte*, XX (1938), 193, and Argan, *Commentari*, XI (1960), 74.

6. In addition, for the motif of the double columns he was indebted to Cortona's S. Maria della Pace.

7. See, e.g., Gallo da Mondovì's S. Maria dell' Assunta at Carrù (1703–18).

8. Carlo had a special interest in the Capitol. His father was in charge of the construction of the palace on the left (1646), which was completed by the son in the reign of Alexander VII.

It is worth observing how the outside bays of S. Maria in Campitelli are integrated with the rest of the façade: Rainaldi used the small order also for the main entrance and repeated the shape of the pediment of the windows over the central window of the upper tier. At the same time, he gave the pilasters at both ends of the front a typically Mannerist double function: they belong as much to the church as to the adjoining palaces.

9. In Rome itself, see, e.g., the façades of S. Apollinare, S. Caterina della Ruota, and SS. Trinità in Via Condotti. Rainaldi's own unfinished façade of S. Angelo Custode at Ascoli Piceno (1684–5) was planned on the same scheme but with a colossal order; the Chiesa del Carmine also at Ascoli Piceno has a simple aedicule façade in two tiers (1687); for these churches, see Fasolo, 372.

An interesting adaptation of the façade of S. Maria in Campitelli is that of the cathedral at Syracuse (1728), probably designed by Don Andrea Palma from Palermo and not by Pompeo Picherali as usually maintained (see F. Meli, *Archivio Storico per la Sicilia*, IV–V (1938–9), 341). The grandest example in Venice is S. Maria degli Scalzi by Giuseppe Sardi (1672–80), who gave the type a characteristically Venetian note.

For the history of the aedicule façade, see now also N. T. Whitman, in *Journal Soc. Architect. Historians*, XXVII (1968), 108 ff.

10. The façade was executed between 1661 and 1665. For illustrations of the various designs, see Wittkower, *Art Bull.*, XIX (1937), figures 17, 20–3, and F. Fasolo in *Palladio*, I (1951), 34–8.

11. Fontana, in fact, received payments in January 1662; see Fasolo, *loc. cit.* Fasolo, *Rainaldi*, 1961, 379 f., objects to Fontana's participation without valid reasons. K. Noehles, *Zeitschr. f. Kunstg.*, XXV (1962), 175, returns to my interpretation of the eivdence.

12. The greatest width of the oval dome lies further back in the wedge-shaped area than that of the circular dome, namely at a point where the diameter of the oval equals that of the circle.

13. Carlo Fontana was responsible for parts of the drum, the dome, and the choir.

14. I have tried (in *Art Bull.*, XIX (1937), 235) to disentagle the complex history of these churches. V. Golzio published new documents (*Archivi*, VIII (1941), 122) which allow the establishment of correct dates, but he obscured the whole problem by insisting on the exclusion of Fontana's participation in 1662 because at that time his name does not appear in the documents. Golzio overlooked, however, that the façade of S. Andrea della Valle is evidence of a collaboration of Rainaldi and Fontana at this period. These and other problems have now been resolved by H. Hager in his fully documented history of the two churches, in *Röm. Jahrb. f. Kunstg.*, XII (1967–8), 191 ff.

Bernini's name appears in the documents for the first time on 18 December 1674. But there can be little doubt that it was he who provided the *disegno nuovo* for S. Maria di Monte Santo which was used after the fall of 1673.

15. Rainaldi used the columns from Bernini's dismantled tower of St Peter's (Golzio, *Archivi*, X (1943), 58).

16. I mention the tomb of Clement IX in S. Maria Maggiore (1671), the Ceva (1672) and Bonelli (1673) tombs in S. Venanzio and S. Maria sopra Minerva respectively; the richly decorated fountains in the garden of the Palazzo Borghese (1672–3, see Chapter 7, Note 40) and the loggia facing the Tiber in the same palace (1675); the high altars in S. Lorenzo in Lucina (1675) and SS. Angeli Custodi (1681, destroyed); the completion of the façade of S. Maria in Via (1681), and the little church of S. Sudario (about 1685); finally, the undistinguished Palazzo Mancini-Salviati al Corso, executed, according to L. Salerno's suggestion (in *Via del Corso*, Rome, 1961, 244), by Sebastiano Cipriani after Rainaldi's death in 1690. The Borrominesque entrance doors to the Palazzo Grillo have always been attributed to Carlo Rainaldi. The addition of the domed portion to Soria's cathedral of Monte Compatri, usually attributed to C. Rainaldi (Hempel, Mandl, Matthiae, Wittkower), was executed in the nineteenth century, as Howard Hibbard has convincingly pointed out to me.

K. Noehles, *loc. cit.*, 176 (see above, Note 11), has correctly observed that Rainaldi's late work is flat rather than spatial and sculptural. In this respect Rainaldi leads on to the classicizing tendencies of the end of the century.

17. Archivio di Stato, Rome, Cart. 80, R. 537. See also *Roma*, XVI (1938), 477. The church itself is not by Longhi, as has wrongly been maintained. An interesting project by Longhi for the façade of S. Giovanni Calibita over a concave columnar plan in the Albertina, Vienna, dating from 1644, and thus preceding SS. Vincenzo ed Anastasio, was published by J. Varriano, in *Art Bull.*, LII (1970), 71.

18. It is precisely the relatively little projection from one column to the next that forces the eye to see the triad as a unit.

19. If, according to the well-informed Passeri (Hess, 235), some sculptural decoration was planned on the large scale wall surfaces, now bare, it would certainly not have been reliefs of excessive dimensions, for the appearance of plain wall at these points is very important to set off the columnar motif.

20. The staircase has, of course, an articulating function. It not only stresses the unity of the whole front, but also knits together the columns framing the outside bays (rising steps) as well as the whole central arca (landing).

21. It is interesting that such a shrewd observer as Gurlitt (*Geschichte des Barockstiles*, Stuttgart, 1887, 400) describes the façade as if this were so. If the arch of the larger pediment is prolonged downwards, it meets exactly the edge of the capital of the third column. See also H. Sedlmayr's interpretation of this façade (*Epochen und Werke*, 1960, II, 57).

22. Recently destroyed. For an illustration see Wittkower, *Art Bull.*, XIX (1937), figure 64.

23. For the history of S. Carlo, see mainly B. Nogara, *SS. Ambrogio e Carlo al Corso* (Chiese di Roma illustr.), Rome, 1923. Foundation stone: 29 January 1612. Onorio Longhi died in 1619. In 1635 the nave is vaulted (*Rome*, XVI (1938), 119). 1651: the high altar unveiled (*ibid.*, 528), *c.* 1656: cessation of Martino Longhi's activity. 1662: Tommaso Zanoli and Fra Mario da Canepina appointed as architects (see documents published by L. Salerno in *Via del Corso*, 1961, 146 ff., also for the following). Salerno denies any participation of Carlo Fontana who, according to O. Pollak's unusually reliable Cortona article in Thieme-Becker, received payments from 1660 onwards). 1665 ff.: Cortona directs construction of transept and choir. 1668–72: drum and dome executed from Cortona's design, who also designed the stucco decorations of nave, transept, and choir. Payments for C. Fancelli's stuccoes between 1674 and 1677 (see also Titi, ed. 1674, 403). 1672: church mainly completed, but finally in 1679 (Pastor, XIV, ii, 691). 1682–4: façade (insignificant) by Giovan Battista Menicucci from Cardinal Omodei's design.

Longhi's façade of S. Antonio de' Portoghesi, begun after 15 December 1629 (Hibbard, *Boll. d'Arte*, LII (1967), 113, no. 167), but left unfinished when he moved during the last years of his life to Milan, shows a considerable increase in sculptural decoration as compared with SS. Vincenzo ed Anastasio but is architecturally less remarkable, in part because he refrained entirely from the use of columns (finished 1695 by Cristoforo Schor, son of Giovan Paolo; see *Descrizione di Roma moderna*, 1697, 486; also Ansaldi in *Capitolium*, IX (1933), 611 ff., and U. Vichi, in *Il Santo*, VII (1967), 339–54).

Of importance among Longhi's work are the staircase (*c.* 1640) in Ammanati's Palazzo Caetani (now Ruspoli) on the Corso and, above all, the even more interesting staircase hall in the Palazzo Ginetti at Velletri (after 1644, largely destroyed during the last war).

Longhi's will was published by V. Golzio in *Archivi*, V (1938), 140.

24. Vincenzo, who was a papal architect, had an architect son, Felice (*c.* 1626–77). It was Felice (and not Vincenzo, as usually maintained, also in the first ed. of this book) who worked in the Palazzo Chigi on the Piazza Colonna (courtyard and staircase) and who was concerned with a systematization of the Piazza Colonna for Alexander VII; see Incisa della Rocchetta in *Via del Corso*, 1961, 185. He was also employed by the Chigi for their palace in Piazza SS. Apostoli (Brauer–Wittkower, 127 ff.; Golzio, *Documenti*, 4 ff.; also above, Chapter 2, Note 85).

25. See Bianca Rosa Ontini, *La Chiesa di S. Domenico in Roma*, Rome [n.d.,

c. 1952]. Nicola Turriani was probably the brother of the better-known Orazio (Donati, *Art Tic.*, 355). Vincenzo della Greca only added the portal, without any regard for the architecture of Turriani's façade.

26. O. Pollak in *Kunstg. Jahrb. der k.k. Zentral-Kommission*, III (1909), 133 ff.

27. The decoration of the gallery by Carlo Fontana's nephew, Girolamo, was not finished until 1703. The gallery makes, therefore, a later impression than is warranted by its architecture. For the frescoes of the vaulting, see p. 145.

28. I. Faldi, *Il Palazzo Pamphily al Collegio Romano*, Rome (Associazione Aziende Ordinarie di Credito), 1957, with good illustrations.

29. About 1665 Antonio del Grande was engaged on the rebuilding of the Colonna palaces at Genazzano and Paliano. In 1666 and 1667 he was paid for work in S. Agnese in Piazza Navona. On his part in the Palazzo di Spagna, see E. Hempel, *Borromini*, Vienna, 1924, 129 f.

30. For Carcani's stucco decoration, see below, III: p. 53. It must be pointed out that the traditional date 'after 1650' for Rossi's architecture is probably too early. Titi, in his edition of 1674, 244, still mentions Maderno's chapel and only in the edition of 1686, 195, remarks that it has been replaced by that of G. A. de' Rossi. For all works by G. A. de' Rossi, the monograph by G. Spagnesi (see Bibliography) has now to be consulted.

Rossi's earliest work was probably the little church S. Maria in Publicolis.

31. Titi, ed. 1686, 332. Worthy of note is the little forecourt, skilfully squeezed into the restricted site. M. Bosi, *S. Maria in Campo Marzio* (Le chiese di Roma illustrate, 61), Rome, 1961, is not very useful so far as Rossi's architecture is concerned. But new material (drawings and documents) has been published by H. Hager, in *Commentari*, XVIII (1967), 329 ff.

32. On the site was an older chapel built by Maderno. Rossi's authorship of the present chapel is attested by Pascoli (1, 317) and Titi (ed. 1686, 98), who saw it in course of construction and mentions the splendid incrustation with coloured marbles. Carlo Francesco Bizzacheri finished the chapel, especially the decoration of the oval dome, between 1695 and 1707.

33. A. Mezzetti, *Palazzo Altieri*, Rome, 1951; V. Martinelli, *Commentari*, X (1959), 206. Also A. Schiavo, *The Altieri Palace*, Rome, 1965. The older palace alone is shown in Lieven Cruyl's drawing in the Albertina (H. Egger, *Römische Veduten*, II, plate 89); see also Falda, *Nuovi disegni dell'architettura* (before 1677), plate 38. The important staircase was finished in 1673 (Pastor, XIV, i, 626). Carlo Fontana also made projects for the extension of this building (Coudenhove-Erthal, *Carlo Fontana*, 30). Fontana's Palazzo Bigazzini on Piazza S. Marco (before 1677, pulled down 1900) was dependent on the Palazzo Altieri.

34. The palace, overlooking the Piazza Venezia, was built for Francesco D'Aste: contract 7 June 1658 (see L. Salerno, in *Via del Corso*, 1961, 256). Finished probably before 1665 (see Cruyl's drawing, Egger, *Römische Veduten*, II, plate 90).

Worthy of note also De' Rossi's Palazzo Carpegna at Carpegna, published by M. Tafuri, in *Palatino*, XI (1967), 133 ff.

35. See below, III: p. 9.

36. See *Roma antica e moderna*, Rome, 1675, II, 254; also Salerno, *op. cit.*, 220.

37. Among the lesser figures active in Rome at this period may be mentioned:

i. *Paolo Maruscelli* (1594–1649), architect of the Congregation of St Philip Neri until 1637 (Pollak, *Kunstätigkeit*, I, 423), whom we have mentioned as Borromini's competitor. He has to his credit the Palazzo Madama (according to Ferrerio, *Palazzi di Roma*, Rome [n.d.], plate II, to be dated 1642) with top-heavy window frames and a decorative arrangement of the mezzanine under the cornice; remarkable because the top floor is more important than the *piano nobile*.

ii. *Mattia de' Rossi* (1637–95), although much younger, may here be mentioned because he worked for Bernini for almost a whole generation, serving many times as his clerk of works. As an architect in his own right he built mainly chapels and altars without special distinction. His largest work, the façade of S. Francesco a Ripa (1692 f.), is a frigid, classicizing affair.

iii, iv. The names of the papal architects, *Luigi Arigucci* and *Domenico Castelli*, often recur in documents, but they were officials rather than creative masters. Arigucci's most notable building is the dry double tower façade of S. Anastasia, often wrongly ascribed to Bernini (Battaglia in *Palladio*, VII (1942), 174–83). Castelli (d. 1658), in the papal office of works from 1623 to 1657, is responsible for the rebuilding of S. Girolamo della Carità (1652–8, docs. in Fasolo, *Rainaldi*, 1961).

v. *Domenichino* had pretensions as an architect and architectural drawings by him for S. Ignazio and other schemes (J. Pope-Hennessy, *The Drawings of Domenichino*, London, 1948, 121) are not without proficiency.

vi. *Andrea Sacchi* also regarded architecture as a sideline. In 1637 he is first called 'architect'. N. Wibiral (*Palladio*, v (1955), 56–65) has made it probable that he designed the Acqua Acetosa, often attributed to Bernini.

vii. The Jesuit *Orazio Grassi* (1583–1654), depending on a Maderno-Borromini project, designed and executed the church of S. Ignazio, one of the

largest in Rome (1626–50). At different stages of the erection, commissions of specialists were called in: 1627 for the plan; 1639 for the sacristy; 1642 for the façade, which has often been wrongly attributed to Algardi; and 1677 for the dome, which remained unexecuted. See C. Bricarelli, 'O. G. architetto', *Civiltà Cattolica*, LXXIII (1922), 13 ff.; D. Frey in *Wiener Jahrb.*, III (1924), 11 ff.; C. Montalto in *Boll. del Centro di studi per la storia dell' architettura*, no. II (1957), 33.

viii. Although O. Pollak (*Zeitschrift f. Geschichte d. Architektur*, v, 1910–11) seemed to have deflated the view, going back to Passeri, that *Alessandro Algardi* was a practising architect, more recent research has vindicated the contemporary tradition. In any case, the Villa Doria-Pamphili outside Porta S. Pancrazio (executed mainly in 1646–8) is owed to him, while the Bolognese painter Giovan Francesco Grimaldi served as his clerk. Apart from its size – the villa is the largest in Rome – the building has not much to recommend it. It is a rather dry, unimaginative structure, distinguished, however, by its high-class stucco decoration. The question of the Villa Pamphili and its stuccoes has now been fully investigated in a brilliant paper by O. Raggio, in *Paragone*, no. 251 (1971), 3–38. Recently F. Fasolo (*Fede ed Arte*, XI (1963), 66 ff.) suggested that Algardi made the plans for S. Nicolò da Tolentino, previously attributed to G. M. Baratta.

ix. *Giovan Battista Mola* (1585–1665), born at Coldrerio near Como; from 1612 to 1616 in Rome; in 1616 appointed 'architetto della camera apostolica'. His few buildings in a retardataire style are discussed by K. Noehles in the Introduction to his edition of Mola's important Roman guide-book published from the signed Viterbo manuscript of 1663 (*Roma l'anno 1663 di Giov. Batt. Mola*, Berlin, 1966).

38. Avanzini's most important work is the rather charming modernization of the Ducal Palace at Sassuolo.

The problems concerning the Palazzo Ducale at Modena have been discussed with great circumspection by L. Zanugg in *Riv. del R. Ist.*, IX (1942), 212.

39. By Giuseppe Tubertini, 1787. Luigi Acquisti's sculptural decoration also dates from this period. The façade was built in 1905.

40. Bergonzoni goes a step beyond Borromini by opening up the pillars under the pendentives into chapels and *coretti*. Also the decorative detail of the *coretti* has a Late Baroque quality.

41. The biography of Longhena by C. Semenzato (*L'architettura di B. Longhena*, Padua, 1954) is not very satisfactory. E. Bassi's chapter on Longhena in *Architettura del Sei e Settecento a Venezia*, 1962, 83–185 (the backbone of her book), is infinitely better.

42. See among others the old but still basic work by G. A. Moschini, *La chiesa e il seminario di S. Maria della Salute*, Venice, 1842; further V. Piva, *Il tempio della Salute*, Venice, 1930, and R. Wittkower, 'S. Maria della Salute: scenographic Architecture and the Venetian Baroque', *Journal of the Society of Architectural Historians*, XVI (1957), and *idem* in *Saggi e Memorie di storia dell' arte*, III (1963).

43. See Bramante's S. Maria di Canepanova at Pavia (begun 1492?) or Battaglio's S. Maria della Croce near Crema (1490–1500). Even the high drum with two round-headed windows to each wall section stems from this tradition.

R. Pallucchini, in a review of my book in *Arte Veneta*, XIII–XIV (1959–60), 250, seems to infer that I overlooked the importance of Sanmicheli's S. Maria di Campagna near Verona as prototype of the Salute. But S. Maria di Campagna is not closer to the Salute than churches of the Bramantesque tradition and, like them, moreover, lacks the ambulatory. E. Bassi, too (*op. cit.*, 174), rejects the influence of the Madonna di Campagna on Longhena.

The reader may also be referred to G. Fiocco's critical remarks in *Barocco europeo e Barocco veneziano*, Florence, 1963, 89.

44. The oddly shaped units lie behind the large pillars of the octagon and are, therefore, visually of no consequence whatsoever.

45. For instance, the arch of the octagon is repeated in the arch of each chapel and again in that of the segmental window. Moreover, all the orders tally and supplement each other; see illustration 137.

46. The window below is contained in an arched 'Palladio motif', the rectangular one above by an aedicule frame.

47. See Palladio's S. Giorgio Maggiore, where a system of small orders is seen through the screen of columns framing the altar.

48. P. Bjurström in his informative and thoughtful book *Giacomo Torelli and Baroque Stage Design*, Stockholm, 1961, 104, 106, has discussed the close affinity of Torelli's stage sets to Longhena's architecture. Torelli, born at Fano in 1608, worked in Venice from 1640 to 1645; for the next fifteen years he was stage designer at the Paris court. In 1661 he returned to Fano, where he died in 1678.

49. Wittkower, *Architectural Principles in the Age of Humanism*, 3rd ed., London, 1962, 97.

50. The conception of both churches is basically different: the one is a typical Renaissance 'wall structure', the other (as shown in the text) a 'skeleton structure'. In a very direct sense the Salute is constructed like a Gothic building. W. Lotz (*Röm. Jahrb. f. Kunstg.*, VII (1955), 22) has demonstrated that

Labacco published Antonio da Sangallo's project for S. Giovanni de' Fiorentini, Rome.

51. It is likely that Longhena followed Michelangelo's design for the dome of St Peter's also for the false inner lantern which lies between the two shells of the dome. But it may be recalled that there was a long North Italian tradition for treating the inner and outer lantern independently of each other.

52. I have left unmentioned that the rich sculptural decoration contributes considerably to the picturesque impression of the building. For a full understanding of the structure, the programme of the decoration must be considered.

53. See III: pp. 8–9.

54. J. Tiozzo, La Cattedrale di Chioggia, Chioggia, 1929.

55. C. Montibeller, 'La Pianta originale inedita della chiesa dei Padri Carmelitani Scalzi di B. Longhena', Arte Veneta, VII (1953), 172. For the façade by G. Sardi, see above, Note 9.

56. E. Bassi, 'Gli architetti dell'Ospedaletto', Arte Veneta, VI (1952), 175.

57. An example of his early Scamozzesque style is the Palazzo Giustinian-Lolin (after 1625).

58. The Palazzo Rezzonico, the more restrained of the two, was going up in 1667. The top floor was built by Giorgio Massari, 1752–6 (see G. Mariacher, in Boll. Musei Civici Veneziani, IX (1964), no. 3, 4 ff.). The Palazzo Pesaro was begun between 1652 and 1659. Progress was slow. In 1676 the façade was begun. In 1679 the piano nobile was finished, but the palace was completed by Antonio Gaspari only in 1710. See G. Fiocco, 'Palazzo Pesaro', Riv. mensile di Venezia (1925), 377; also G. Mariacher in Ateneo Veneto, CXXXV (1951); G. Badile in Arte Veneta, VI (1952), 166; and, above all, E. Bassi in Saggie Memorie di storia dell'arte, III (1963), 88 (with new documents). For other works by Longhena, see E. Bassi, in Critica d'Arte, XI (1964), 31; XII (1965), no. 70, 43 and no. 73, 42.

For Gaspari (c. 1660–1749), see Bassi's basic study, in Saggi e Memorie (above), 55–108.

59. D. Giovannozzi in L'Arte, XXXIX (1936), 33, and W. and E. Paatz, Die Kirchen von Florenz, Frankfurt-on-Main, 1940–54, III, 335, 471, where the whole question is lucidly summarized. See also Panofsky's interesting remarks on Silvani's 'compromise solution' (Meaning in the Visual Arts, New York, 1955, 193).

60. Documents for Parigi's share in R. Linnenkamp, Riv. d'Arte, VIII (1958), 55, 59. Giuseppe Ruggieri added the northern and southern wings in 1764 and 1783 respectively; the latter was not finished until the beginning of the nineteenth century. See also F. Morandini, 'Palazzo Pitti, la sua costruzione e i successivi ingrandimenti', Commentari, XVI (1965), 35 ff.

On the strength of a Callot drawing of 1630, Sir Anthony Blunt (The French Drawings at Windsor Castle, London, 1945, 19) has made it probable that all the extensions were derived from a Buontalenti project made for Ferdinand I.

61. There is no satisfactory modern work on Silvani. Apart from the brief chapter in Venturi (XI, 2, 624), the reader must be referred to R. Linnenkamp's publication of a contemporary Life of Silvani (Riv. d'Arte, VIII (1958), 73–111) which Baldinucci used for his Vita.

62. Foundation stone: 1604. The general lines of the plan seem to have been worked out by the Theatine Don Anselmo Cangiani. Some time between 1604 and 1628 Nigetti worked on the structure, without much effect. The present church is to all intents and purposes Gherardo Silvani's work; see Baldinucci, ed. 1846, IV, 353; Paatz, Kirchen von Florenz, IV, 181; Berti in Riv. d'Arte, XXVI (1950), 157. Inscription on the façade: 1645. Consecration of the church: 1649. The ornamental detail of the façade is by Alessandro Neri Malavisti. The statues of the 1680s are by Balthasar Permoser, Anton Francesco Andreozzi, and Carlo Marcellini. Lankheit, 172, dates them 1687–8.

63. A particularly good example of this style is the Badia, rebuilt between 1627 and 1631 (Paatz, op. cit., I, 267) by Matteo Segaloni, about whom little is known. Here also the characteristic screening-off of the monks' choir by the so-called Palladio-motif, which had a home in Florence from the mid sixteenth century onwards. Prominent examples before the Badia: Giambologna's Cappella di S. Antonio in S. Marco (1578–89) and Giovanni Caccini's chancel of S. Domenico at Fiesole (1603–6).

64. Reliefs and figures are later, mainly by Foggini and his school. S. Gaetano is the best place to study Florentine sculpture of the late Seicento. For the names of the sculptors and the problem of dating, see Lankheit, 71 f.

65. Baldinucci, ed. 1846, IV, 427.

66. The technique had been developed in Rome. It was introduced into Naples by Dosio, who probably began the marble incrustation of the Certosa of S. Martino (Wachler in Röm. Jahrb. f. Kunstg., IV (1940), 194). It was Fanzago and others such as Dionisio Lazzari (d. 1690), the architect of the dome of St Philip Neri, who gave this decorative technique the Neapolitan imprint. Thus transformed, it was assimilated through Fanzago in other Italian cities (Venice, Bergamo).

67. Documents prove that Fanzago, and not Dosio, made the design; see P. Fogaccia, Cosimo Fanzago, Bergamo, 1945.

68. For Fanzago see the unsatisfactory work by Fogaccia, with further references.

69. Chiesa dell'Ascensione a Chiaia (1622–45), S. Maria dei Monti (early), S. Trinità delle Monache (after 1630, destroyed), S. Teresa a Chiaia (1650–62), S. Maria Maggiore ('La Pietrasanta', 1653–67), an improved version of the Ascensione plan with oval satellite chapels instead of square ones, S. Maria Egiziaca (1651–1717).

70. This is supported by his Latin-cross plans, such as S. Maria degli Angeli alle Croci (1639) and the even more interesting S. Giorgio Maggiore (1640–78), the design of which owes much to Venice.

71. U. Prota-Giurleo, 'Lazare veni Foras', Il Fuidoro, IV (1957), 90 ff., published a list dated 1653 from the Naples notarial archive enumerating works of the Lazzari shop (above Note 66), and this list includes the façades of both the Sapienza and the Palazzo Firrao.

72. U. Prota-Giurleo, 'Alcuni dubbi su Fanzago architetto', Il Fuidoro, III (1956), 117 ff., attributes the Palazzo Donn'Anna to Bartolomeo Picchiati (see next Note). On the latter's death Onofrio Gisolfi continued the palace; see F. Strazzullo, Architetti e ingegneri napoletani dal '500 al '700, Naples, 1969, 181 f. I owe the last two notes to the kindness of Fred Brauen.

73. Among other Neapolitan architects of this period the names of Bartolomeo Picchiati (d. 1643) and his son, Francesco Antonio (1619–94), should at least be mentioned. The former began a design Domenico Fontana's clerk of works and designed later S. Giorgio dei Genovesi (1626) and S. Agostino alla Zecca (1641), which was given its extravagant apse a hundred years later (1756–61) by Giuseppe Astarita and Giuseppe de Vita. The son designed the Guglia di S. Domenico (1658, finished 1737 by D. A. Vaccaro), the church and palace of the Monte della Misericordia (1658–70), and the churches of S. Giovanni Battista and S. Maria dei Miracoli (1661–75).

CHAPTER 7

1. No less than thirty-nine masons and sculptors were employed, among them all the well-known names of the Bernini studio – Giacomo Balsimello, Matteo Bonarelli, Francesco Baratta, and Niccolò Sale; further the more distinguished Bolgi, Ferrata, Raggi, Cosimo and Giacomo Antonio Fancelli, Girolamo Lucenti, Lazzaro Morelli, Giuseppe Peroni, and others.

2. Among other works, he carried out the four winged victories for Bernini's tower of St Peter's (1640–2), which were later used for Innocent X's coats of arms in the aisles of the basilica. A catalogue of his œuvre was published by V. Martinelli in Commentari, IV (1953), 154.

3. He joined, in fact, Pietro Bernini's studio, but was straightaway employed by Gianlorenzo on the Apollo and Daphne group.

4. Finelli in these years executed mainly the bust of Cardinal Ottavio Bandini (1628, S. Silvestro al Quirinale) and the Cortonesque St Cecilia (1629–33, S. Maria di Loreto), the counterpart to Duquesnoy's Susanna.

Passeri (ed. Hess, 248), in his well-informed Life of Finelli, writes in detail about the cabals in Rome, and later in Naples.

5. His most important works in Naples are the two marble statues of St Peter and St Paul, left and right of the entrance to the Cappella del Tesoro, Cathedral (1634–c. 1640), and eleven bronze statues inside the same chapel (finished 1646; see A. Bellucci, Memorie stor. ed artistiche del Tesoro etc., Naples, 1915); the figures of Cesare and Antonino Firrao, princes of S. Agata, in the left transept of S. Paolo Maggiore (1640), which follow the type of Naccherino's Pignatelli tomb in S. Maria Mater Domini; and the sculptural decoration of the Cappella Filomarini is SS. Apostoli, with the exception of Duquesnoy's putto relief (c. 1642–7). In addition, he made the kneeling figures of the viceroy, the Count of Monterey, and his wife for the church of the Agustinas Recoletas at Salamanca (1636), which also follow Naccherino's Pignatelli.

6. See his tombs of Giuseppe and Virginia Bonanni in S. Caterina da Siena a Monte Magnanapoli (A. Muñoz in Vita d'Arte, XI (1913), 33, and Dedalo, III (1922), 688). The male portrait is the better of the two; it dates, according to inscription, from 1648, and the weaker female portrait from 1650.

For Finelli's portrait busts, see the informative article by A. Nava Cellini in Paragone, XI (1960), 9–30.

7. Documents in O. Pollak, Kunsttätigkeit, II.

8. For Bolgi's work under and with Bernini, see Wittkower, Bernini, Catalogue, nos 21, 25, 29, 33, 36, 40, 46, 47. For Bolgi's portrait busts, see A. Nava Cellini in Paragone, XIII (1962), no. 147, 24.

9. See the bust of Francesco de Caro and the praying figure of Giuseppe de Caro (signed and dated 1653) in the Cappella Cacace in S. Lorenzo.

V. Martinelli in Commentari, X (1959), 137, judges Bolgi's Neapolitan career rather more positively. Martinelli's paper (with œuvre catalogue) contains a number of attributions and suggestions (mainly regarding the collaboration with Bernini) to which I cannot fully agree. Cellini's criticism in Paragone (last Note) seems to me entirely justified.

10. Taking up an eighteenth-century tradition, John Pope-Hennessy (in Stil

und Überlieferung in der Kunst des Abendlandes, Akten des 21. Internat. Kongresses für Kunstgeschichte, Bonn, 1964, II, 105) attributed the Palestrina Pietà (as by Michelangelo in the Accademia, Florence) to Menghini. I doubt the correctness of this attribution and also that suggested by Ettore Sestieri (in *Commentari*, XX (1969), 75 ff.), who varied Pope-Hennessy's hypothesis; he does not exclude Menghini's participation, but introduces as *deus ex machina* Bernini, who would have invented this piece in imitation of Michelangelo and started it.

11. There is no reason to doubt Pascoli's information in his Life of Caffà (I, 256) that the artist was born in 1635. The date of his death (before 10 September 1667) has been established by E. Sammut in *Scientia*, XXIII (1957), 136.

* It is more likely that he was born in 1630, the date given on what probably correctly purports to be a self-portrait drawing (see R. Preimesberger, in D.B.I.).

12. A bozzetto for this figure in the Palazzo Venezia, Rome, was published by R. Preimesberger, *Wiener Jahrb.*, XXII (1969), 178 ff.

13. The *St Catherine* was probably finished in 1667. (A drawing for the *St Catherine* at Darmstadt was published by G. Bergsträsser, in *Revue de l'Art*, no. 6 (1969), 88 f.). The St Thomas of Villanova Chapel in S. Agostino was begun in 1661, and Caffà's group was finished by Ferrata after 1668 (see Note 15). The relief in S. Agnese, begun in 1660, was also finished by Ferrata with the assistance of the weak Giovan Francesco Rossi. The date 1669 which appears with Caffà's signature on the *St Rosa* at Lima (see J. Fleming, *Burl. Mag.*, LXXXIX (1947), 89) must have been added by another hand since Caffà was dead at the time, and consequently the figure was probably not finished by the artist himself. In addition, the impressive memorial statue of Alexander III in the cathedral at Siena was once again finished by Ferrata (W. Hager, *Die Ehrenstatuen der Päpste*, Leipzig, 1925, 25), while G. Mazzuoli, Caffà's only pupil, executed the commission given to Caffà for the *Baptism of Christ* for the high altar of the cathedral at Valletta, Malta (Wittkower, *Zeitschr. f. b. Kunst*, LXII (1928–9), 227). Caffà's signed bronze bust of Alexander VII has been acquired by the Metropolitan Museum, New York; see Wittkower in *The Metrop. Mus. of Art Bulletin* (April 1959). Another fine version in Siena Cathedral; see V. Martinelli, *I ritratti di pontefici di G. L. Bernini*, Rome, 1956, 45.

14. The present reliefs by Pietro Bracci (1755) are isolated features and cannot accord with Caffà's original project.

15. The female figure in the execution is considerably more classical than in the bozzetto, and this change was certainly due to Ferrata after Caffà's death. I cannot agree with A. N. Cellini (*Paragone*, VII (1956), no. 83, 23) who attributes the execution of the 'Charity' to Caffà. In fact, Ferrata finished the 'Charity' only in May 1669, because it had been merely roughed out by Caffà.

16. A. Nava Cellini, 'Contributo al periodo napoletano di Ercole Ferrata', *Paragone*, XII (1961), no. 137, 37.

17. The two lesser allegories in flat relief are also by Ferrata. Mari worked for Bernini mainly in the 1650s. His principal work is the *Moro* in the Piazza Navona (1653–5) from Bernini's design.

18. Participation in the decoration of S. Maria del Popolo (1655–9); collaboration on the Cathedra (1658–60); statue of St Catherine for the Cappella Chigi in the cathedral at Siena as counterpart to Bernini's Magdalen and Jerome and Raggi's St Bernard (1662–3); execution of the Elephant carrying the Obelisk, Piazza S. Maria sopra Minerva (1666–7); Angel with the Cross for Ponte S. Angelo (1667–9).

19. The mother and child in the left-hand corner are also types borrowed from Domenichino.

20. V. Golzio in *Archivi*, I (1933–4), 304; L. Montalto in *Commentari*, VIII (1957), 47.

21. Payments to Raggi for work on Algardi's sculptural decoration of the Villa Doria-Pamphili have recently come to light; see A. Nava Cellini in *Paragone*, XIV (1963), no. 161, 31. (For the villa, see Chapter 6, Note 37.)

22. Important work for Bernini includes the *Noli me Tangere* in SS. Domenico e Sisto (1649); the figure of Danube for the Four Rivers Fountain in Piazza Navona (1650–1); the Virgin and Child, Notre-Dame, Paris (*c.* 1652); Charity on the tomb of Cardinal Pimentel, S. Maria sopra Minerva (1653); a large part of the decoration in S. Maria del Popolo (1655–9); the stucco decoration in the Sala Ducale, Vatican (1656); collaboration on the Cathedra (1658–64); the sculptural decoration of the church at Castel Gandolfo (1660–1); statue of Alexander VII, Cathedral, Siena (1661–3); St Bernard, Chigi Chapel, Cathedral, Siena (1662–3); most of the stuccoes in S. Andrea al Quirinale (1662–5); the Angel with the Column on the Ponte S. Angelo (1667–70); etc.

23. Since the publication of the article by A. Nava in *L'Arte*, N.S. VIII (1937), it has become customary to underestimate Raggi's achievement, and also to find in his work a 'neo-Cinquecentesque' revivalism, which should, however, be considered with due caution. Good illustrations in Donati, *Art. Tic.*

24. It is this that may be interpreted as a Mannerist revival.

25. They represent different countries paying homage to the Name of Jesus (Philippians, 2, 10).

26. Retti (active 1670–1709), whom I have mentioned before (p. 125), can best be studied in the curiously brittle, luminous relief with over-long, boneless figures on the tomb of Clement X (*c.* 1686, St Peter's). For Michele Maglia, see p. 129. Naldini (1619, not 1615, –91) first belonged to the circle of Sacchi and Maratti and was in opposition to Bernini. His main work at this period is the many stuccoes in S. Martino ai Monti (payments between 1649 and 1652; see A. B. Sutherland, *Burl. Mag.*, CVI (1964), 116). Later he became closely associated with Bernini. He was responsible for the sculptural decoration of Bernini's church at Ariccia (1664) and on the upper landing of the Scala Regia (1665). He also had a share in the Cathedra (1665). In the Gesù the colossal figures of Temperance and Justice under the dome are his work.

27. Works by him are at Bologna, Faenza, Forlì, Genoa, Modena, Naples, Perugia, Pisa, and Torano.

28. L. Bruhns has studied exhaustively the history of tombs with the dead in 'eternal adoration'; see *Röm. Jahrb. f. Kunstg.*, IV (1940).

29. A. Grisebach, *Römische Porträtbüsten der Gegenreformation*, Leipzig, 1936, 162.

30. *Ibid.*, 170.

31. The architectural setting, also designed by Algardi, is flat, additive, and classicizing.

32. The figure was sent from Naples; the setting, made in Rome, is extraordinarily retrogressive. The church of S. Lucia was demolished in 1938 but has recently been rebuilt.

33. The architectural detail, however, is classicizing. Execution before 1675.

34. The sculptural decoration was not finished until after 1686. The first tomb on the left, representing Ercole and Luigi Bolognetti, is by Michele Maglia; the first on the right of Pietro and Francesco is by Francesco Aprile (the lively bozzetto for it is shown as illustration 160). The second tombs left and right of Giorgio and Francesco Maria Bolognetti are by Francesco Cavallini. The stucco statues of saints above the tombs are by Cavallini, Maglia, and Ottoni; the sculptural decoration of the high altar by Cavallini, Naldini, and Mazzuoli.

35. His only pupil of any standing was Vincenzo Felici, his son-in-law, who inherited his studio. Other sculptors like Michele Maglia and Filippo Carcani occasionally worked for Guidi.

36. Pascoli (I, 251) says of him that 'he had no luck with pupils, few coming out of his school and none of particular talent'.

37. Ferrata's studio abounded in study material. The elaborate, highly interesting inventory of the studio was published by V. Golzio, *Archivi*, II (1935), 64.

38. Aprile's *œuvre* is small but distinguished. He seems to have worked for no more than a decade. The information in Thieme-Becker that he was active from 1642 onwards is incorrect.

39. See M. Nicaud in *L'Urbe*, IV (1939), 13. See also below, III: Chapter 4, Note 1.

40. In S. Maria della Pace, for instance, where Ferrata's kneeling St Bernardino and Fancelli's St Catherine frame the latter's Cortonesque bronze relief. Equally close in style are Ferrata's Charity and Fancelli's Faith on the tomb of Clement IX in S. Maria Maggiore (1671). Giacomo Antonio's masterpiece is the decoration of the Cappella Nobili in S. Bernardo alle Terme with busts of the family in Cortonesque frameworks and the over life-size statue on the altar of St Francis receiving the stigmata.

Most of the minor masters here mentioned collaborated in 1672–3 on the fountains in the garden of the Palazzo Borghese, namely Cosimo and Francesco Fancelli, Retti, Cavallini, Maglia, and Carcani (see III: p. 53). Giovan Paolo Schor (see II: Chapter 8, Note 33), who worked under Carlo Rainaldi, was probably responsible for the design. H. Hibbard has published the documents for this enterprise (*Burl. Mag.*, C (1958), 205) and also for the Galleria of the palace (*ibid.*, CIV (1962), 9), where Cosimo Fancelli executed the stucco reliefs between 1674 and 1676 in the Cortonesque setting designed by Giovan Francesco Grimaldi.

* The St Bernardino is by Raggi (J. Montagu, 'Antonio Raggi in S. Maria della Pace', *Burl. Mag.*, CXXXVI (1994), 836–9). The stucchi in the Palazzo Borghese were designed by Pietro Santi Bartoli (D. Batorska, 'Designs for the Galleria in Palazzo Borghese in Rome: New Proposals', *Paragone*, s.3, 14 (1997) 26–45).

41. Since the distribution of these angels among the different hands is often confused, a list may be helpful: Bernini, Angels with the Crown of Thorns and the Superscription (now in S. Andrea delle Fratte); replacement, now on the bridge, of the first by Naldini, of the second by Bernini himself (this angel was prepared by Cartari); Ferrata, Angel with the Cross; Raggi, Angel with the Column; Guidi, Angel with the Lance; Naldini, Angel with Garment and Dice; Fancelli, Angel with the Sudarium; Morelli, Angel with the Scourge; A. Giorgetti, Angel with the Sponge; Lucenti, Angel with the Nails. See H. G. Evers, *Die Engelsbrücke in Rom*, Berlin, 1948; Wittkower, *Bernini*, 232.

42. So far as possible, Jennifer Montagu (*Art Bull.*, LII (1970), 278 ff.) has

disentangled the lives, works, and styles of Antonio and Gioseppe Giorgetti. Antonio died young, in 1669, before his angel for the bridge was entirely finished. His more mediocre younger brother Gioseppe, who made a living mainly from the restoration of antique sculpture, worked his St Sebastian (J. Montagu convincingly argues) from a design by Ciro Ferri.

43. Lucenti was a highly qualified bronze caster. He cast all the bronzes of Bernini's altar of the Cappella del Sacramento in St Peter's (1673–4) and the figure of Death of the tomb of Alexander VII (1675–6).

The strange, archaic, and picturesque Sicilian sculptor Francesco Grassia is a completely isolated phenomenon in Bernini's Rome. Little is known about him. He probably died in 1683. His few known works have been published by L. Lopresti in *L'Arte*, XXX (1927), 89, and I. Faldi in *Paragone*, IX (1958), no. 99, 36.

44. G. Walton, 'Pierre Puget in Rome: 1662', *Burl. Mag.*, CXI (1969), 582 ff.

45. Between 1659 and 1660 he executed a large wooden model of the porticoes and between 1661 and 1672 at least twenty statues above the porticoes.

46. His best pupil was his cousin Giuseppe Giosafatti (1643–1731) who handed on the tradition to his son, Lazzaro (1694–1781). The continuity of Bernini's manner can be traced here in a direct line over a period of almost 150 years. Lazzaro Giosafatti renewed contact with Rome by studying under Camillo Rusconi. G. Rosenthal (*Journal of the Walters Art Gallery*, V, 1942) published a relief by Lazzaro. For the Giosafatti, see G. Fabiani, *Artisti del Sei-Settecento in Ascoli*, Ascoli-Piceno, 1961, 35–54.

47. Among them was Paolo Naldini; see Nardicci in *Buonarotti*, V (1870), 122. Failing proper statistics, we do not know how many of them were painters, sculptors, or artisans, nor how poor they were.

48. G. Campori, *Artisti estensi*, Modena, 1855, 66. The Roman scudo was probably worth at least £1 (present value).

49. Archivio della Fabbr. di S. Pietro, Giustific. 369 (14 December 1671) and Uscità 417 (7 June 1725). Cornacchini drew additional payment for work connected with the monument.

50. Venturi, X, iii, 873.

51. Lankheit, 36. Without a knowledge of the correct attribution, I had stated in the first ed. that 'the relief can hardly date from before 1670'.

52. See illustrations in P. Fogaccia, *Cosimo Fanzago*, 1945, figures 8 and 9.

53. See above, Chapter 6, Note 66.

CHAPTER 8

1. For G. Gimignani, see the full treatment by G. di Domenico Cortese, in *Commentari*, XVIII (1967), 186–206. The number of Cortona's pupils, and of those directly and indirectly influenced by him, is legion. The most important Roman *Cortoneschi* of the next generation are Lazzaro Baldi (1623–1703), Guglielmo Cortese (Guillaume Courtois, 1627–79), Ciro Ferri (1628/34–89), and the pair Giovanni Coli (1636–80) and Filippo Gherardi (1643–1704). Even the Sienese Raffaello Vanni (1587–1673), pupil and son of Francesco, came later under Cortona's influence.

Among his minor pupils, reponsible for spreading his manner, may be mentioned Adriano Zabarelli, called Palladino, from Cortona (1610–81), Carlo Cesi from Rieti (1626–86), Pietro Paolo Baldini (active c. 1660), Pietro Locatelli (c. 1634–1710), Francesco Bonifazio (b. 1637), who painted mainly at Viterbo, Giovanni Marracci (1637–1704), whose work is to be found at Lucca, and Camillo Gabbrielli, Ciro Ferri's pupul, who painted at Pisa. Of the above-mentioned Pietro Locatelli (or Lucatelli) several hundred drawings have been identified in the Berlin Print Room; these have been discussed in a splendid paper by P. Dreyer (*Jahrb. d. Berliner Museen*, IX (1967), 232–73), who also concerns himself with the close cooperation between Ciro Ferri and Lucatelli.

For other Tuscan *Cortoneschi*, see below, Note 65.

2. For the early Cozza, see his *St Joseph and Angels* in S. Andrea delle Fratte with signature and date 1632 which appeared when the painting was cleaned; see *Attività della Soprintendenza alle Gallerie del Lazio*, X, Settimana dei Musei, Rome, 2–9 aprile 1967, no. 11, figure 15.

3. See R.-A. Weigert in *Art de France*, II (1962), 165. Perhaps Romanelli's series of Dido and Aeneas cartoons for the tapestries woven by Michel Wauters belong to the Paris period. Six Romanelli cartoons were sold at Sotheby's in March 1969 and purchased by the Norton Simon, Inc. Museum of Art, California; see the scholarly paper by R. Rubinstein, in *Art at Auction: The Year at Sotheby's & Parke Bernet, 1968–69*, London, 1969, 116 ff.

4. Only fragments are preserved of Lanfranco's *Immaculate Conception*, once over the high altar and finished as early as 1630.

5. E. Waterhouse, *Baroque Painting*, 25, 27, first discussed the archaizing tendencies of the 1640s. For Giacinto Gimignani's later style, see his frescoes in the Palazzo Cavallerini a via dei Barbieri; L. Salerno, in *Palatino*, VIII (1964), 13 f.

6. For the Bambocciani, see Briganti's contributions. For Codazzi, R. Longhi, *Paragone*, VI (1955), no. 71, 40, E. Brunetti, *ibid.*, VII (1956), no. 79, 61

and *idem*, *Burl. Mag.*, C (1958), 311; also H. Voss, *ibid.*, CI (1959), 443, and U. Prota-Giurleo, *Pitt. nap.*, Naples, 1953, 76.

7. G. J. Hoogewerff, *De Bentveughels*, The Hague, 1952.

8. According to Haskell, *Patrons*, 139 (note), the collaboration between Cerquozzi and Codazzi began after 1647.

9. See A. Sutherland Harris, in *Paragone*, XVIII (1967), no. 213, 42, where the date of 1611 is regarded as probable, however, a baptismal record of 18 June 1612 was subsequently found (M. Boschetto, *Paragone*, 217, 1968, pp. 65–6).

10. L. Montalto, *Commentari*, VI (1955), 224. For different interpretations of Mola's early itinerary see E. Schaar, *Zeitschr. f. Kunstg.*, XXIV (1961), 184, and A. B. Sutherland, *Burl. Mag.*, CVI (1964), 363 (new documents), and 378, in reply to S. Heideman, 377 f.

11. His most famous painting of this class is the *St Bruno*, existing in many versions, a work not uninfluenced, however, by Sacchi's *St Romuald*. For Mola, see Arslan, *Boll. d'Arte*, VIII (1928), 55; Wibiral, *ibid.*, XL (1960), 143; Martinelli, *Commentari*, IX (1958), 102; and Sutherland's revised chronology (last Note). The important problem of various versions of the same subject in Mola's work has been discussed by A. Czobor, *Burl. Mag.*, CX (1968), 565 ff., 633.

12. A. S. Harris published a number of studies for this work in *Revue de l'Art*, no. 6 (1969), 82–7.

13. Wittkower, *Born under Saturn*, 1963, 142.

14. The etching shows a young man reaching Parnassus by the torch of Wisdom, which disperses Ignorance, Envy and other vices. The contrast between the classicality of individual figures and the non-classical *horror vacui* should be observed. On Testa's etchings, A. Petrucci, *Boll. d'Arte*, XV (1935–6), 409. For the problem of interpretation, see, e.g., T.S.R. Boase, *J.W.C.I.*, III (1939–40), 111. The most penetrating discussion of some of Testa's etchings in A. Sutherland Harris and C. Lord, *Burl. Mag.*, CXII (1970), 15 ff., 400. For Testa's chronology, see A. Sutherland Harris, *Paragone*, XVIII (1967), no. 213, 35 ff., and E. Schleier, *Burl. Mag.*, CXII (1970), 665 ff.

15. Rosa's early education is still a problem, and above all his relation to Falcone. A teacher-pupil relationship probably existed, although Falcone's rather restrained battle-pieces are very different from Rosa's fiery mêlées; see F. Saxl, *J.W.C.I.*, III (1939–40), 70; also A. Blunt, *Burl. Mag.*, CXI (1969), 215.

16. Rosa's anticlericalism was emphasized by L. Salerno, *Salvator Rosa*, 1963, 23. It can, however, not be maintained that Rosa, through his extravagance, created 'almost single-handed the image of the artist as being apart' (Haskell, *Patrons*, 22). For the history of this concept, see Wittkower, *Born under Saturn*. For Rosa's conception of his genius, see R. W. Wallace, in *Art Bull.*, XLVII (1965), 471 ff. For his stoicism, *ibid.*, and Haskell, 143.

17. R. Wallace, *Burl. Mag.*, CIX (1967), 395 ff., has shown that Rosa selected the unusual theme of the 'Death of Atilius Regulus' for a painting in support of his claim that he was above all a history painter.

18. Institute of Art, Detroit, from the Palazzo Colonna, Rome; see Paul L. Grigaut, *Bull. Detroit Inst. of Art*, XXVII (1948), 63.

Rosa's classicism was emphasized in a remarkable note by B. Nicolson, *Burl. Mag.*, C (1958), 402.

19. H. W. Schmidt, *Die landschaftsmalerei Salvator Rosas*, Halle, 1930, gives an account of Salvator's relation to the landscape tradition and his development as a landscapist.

20. Further to G. Dughet's development, A. Blunt, *French Art etc.*, 201; Wibiral, *Boll. d'Arte*, XL (1960), 134; the important paper by D. Sutton, *G.d.B.A.*, LX (1962), 268–312; M. R. Waddingham, *Paragone*, XIV (1963), no. 161, 37; Sutherland, *Burl. Mag.*, CVI (1964), 63. Here the correct date for the S. Martino ai Monti frescoes is given: 1649–51. See also A. Sutherland Harris, *Burl. Mag.*, CX (1968), 142 ff., and M. Chiarini, *Burl. Mag.*, CXI (1969), 750 ff.

For Gaspar's pupil, Crescenzio Onofrio (1632–98), see I. Toesca, *Paragone*, XI (1960), no. 125, 51.

After J. Hess's pioneering book, the literature on Tassi has steadily grown; see E. Schaar in *Mitteilungen des Florent. Inst.*, IX (1959–60), 136; E. Knab in *Jahrb. d. kunsthist. Slg. Wien*, XX (1960), 84; M. R. Waddingham, *Paragone*, XII (1961), no. 139, 9, and *ibid.*, XIII (1962), no. 147, 13.

21. See, among others, his frescoes in the Palazzo Santacroce (Waterhouse, 74), in the Villa Doria-Pamphili (1644–8), where he also worked as architect (II: Chapter 6, Note 37), and in S. Martino ai Monti (1648; Sutherland, *loc. cit.*). For Grimaldi as decorator in the Palazzo Borghese, see II: Chapter 7, Note 40.

For the connexion between Grimaldi and Dughet, see Wibiral, *op. cit.*, 137.

22. This manuscript, now at Düsseldorf, was skilfully discussed by A. Marabottini, *Commentari*, V (1954), 217. For Testa's art theory, see also M. Winner, *Jahrb. Preuss. Kunstslg.*, IV (1962), 174.

23. It may be noted that the *Blind Belisarius* in the Palazzo Pamphili, until recently always attributed to Salvator, has been shown to be a work by Francesco Rosa (1681), whose activity between 1638 and 1687 has been reconstructed by L. Montalto, *Riv. dell' Istituto*, III (1954), 228. See also E. Battisti, *Commentari*, IV (1953), 41.

Some of Rosa's most interesting works are concerned with stoic, macabre, and proto-romantic subjects; for this side of his activity, see the stimulating

papers by R. W. Wallace (Bibliography) and N. R. Fabbri, in *J.W.C.I.*, XXXIII (1970), 328–30.

24. On Bellori, see Schlosser, *Kunstliteratur*; E. Panofsky, *Idea*, Florence, 1952; K. Donahue, *Marsyas*, III (1943–5), 107; F. Ulivi, *Galleria di scrittori d'arte*, Florence, 1953, 165.

25. I believe this has never been commented on.

26. E.g. Guarini's churches or S. Maria della Salute. The oil paintings planned for the dome of the latter church were clearly a last afterthought; see, however, E. Bassi, *Critica d'Arte*, XI (1964), fasc. 62, 4.

27. For his intense desire to return to Rome as early as 1640, see E. Schleier, in *Master Drawings*, V (1967), 35 ff.

28. See B. Canestro Chiovenda, *Commentari*, X (1959), 16.

29. 1672–4: frescoes of the dome; in 1679 the frescoes of the nave were unveiled; those of the apse after 1679; see A. M. Brugnoli, *Boll. d'Arte*, XXXIV (1949), 236; P. Pecchiai, *Il Gesù di Roma*, Rome, 1952, 126 ff.; also R. Enggass, *Baciccio*, 1964, 31.

For Antonio Gherardi, Mola's pupil, who had spent years in Venice and distinguished himself also as an architect (III: p. 9), see A. Mezzetti, *Boll. d'Arte*, XXXIII (1948), 157.

To the same period belong Giovanni Coli's and Filippo Gherardi's frescoes in the dome of S. Nicolò da Tolentino (1669–70, dependent on Cortona's dome of S. Maria in Vallicella) and their paintings inserted in the ceiling of S. Croce dei Lucchesi (c. 1674). Lodovico Gimignani's dome frescoes in S. Maria delle Vergini date from 1682; G. D. Cerrini's frescoes in the dome of S. Maria della Vittoria (undated) may belong in the 1670s.

30. The frescoes in the apse are by Gaulli's pupil, Giovanni Odazzi; see H. Voss, 328.

31. Waterhouse, 71.

32. Giacinto Brandi (1623–91), Lanfranco's pupil, a prolific but facile painter who remained faithful to his master's style, contributed little that deserves special attention.

Francesco Allegrini (1624–63) was one of the minor Cortona followers.

33. Of German descent, Egidio and Giovan Paolo (1615–74); the latter, the more important of the two, was a versatile artist whose paintings as well as designs for applied art have a Cortonesque flavour; on a number of occasions he worked for Bernini (see III: Chapter 4, Note 1). G. P. Schor has recently been given the attention he deserves, see G. Aurenhammer, *Die Handzeichnungen des 17. Jahrhunderts in Österreich*, Vienna, 1958, 13, 103; H. Hibbard, *Burl. Mag.*, C (1958), 205; A. Blunt and H. L. Cooke, *The Roman Drawings at Windsor Castle*, London, 1960, 110. Interesting additions in Wibiral, *Boll. d'Arte*, XL (1960), 144.

34. Their names are Angelo Canini, Carlo Cesi, Fabrizio Chiari, Bartolomeo Colombo, Filippo Lauri, Francesco Murgia and, in addition, the more considerable Jan Miel (c. 1599–1663), a Fleming, who first belonged to the circle of the Bamboccianti in Rome, but turned in Turin to the grand manner in fresco and came under Cortona's influence in the last years of his life.

The complicated history of the Quirinal Gallery has been disentangled in an excellent paper by N. Wibiral, *op. cit.*, 123–65, which also contains valuable new information on all the participating artists. See also W. Vitzthum in *Boll. d'Arte*, XLVIII (1963), 96, who warns against over-estimating Grimaldi's rôle. – For Lauri (1623–94), Caroselli's pupil, see B. Riccio, *Commentari*, X (1959), 3.

35. See the fully documented article by L. Montalto, *Commentari*, VI (1955), 267. For Mola's destroyed *Stanza dell'aria* frescoes of the Pamphili villa at Valmontone, see R. Cocke, *Burl. Mag.*, CX (1968), 558 ff.

36. By him the Jupiter ceiling of the large room on the first floor (1675), attributed by Waterhouse, 48, to N. Berrettoni, and correctly named Canuti by E. Feinblatt, *Art Quarterly*, XV (1952), 51.

37. In addition to these may be mentioned Romanelli's frescoes in the Palazzi Lante (1653) and Barberini (1660), Antonio Gherardi's impressive *Stories of Esther* in the Palazzo Naro (1665–70?) and the frescoes in the Villa Falconieri, Frascati, by Ciro Ferri, N. Berrettoni, and C. Maratti (before 1680).

38. See N. Pevsner, 'Die Wandlung um 1650 in der italienischen Malerei', *Wiener Jahrb.*, VIII (1932), 69. C. Refice Taschetta, *Mattia Preti*, Brindisi, 1961, 83, dates these frescoes incorrectly in 1653. She overlooked that the date 1661 is assured by Preti's own statement (see Ruffo, *Boll. d'Arte*, X (1916), 255). He painted the frescoes in the Palazzo Doria Pamphili at Valmontone on the occasion of his brief visit to Rome, before going to Malta.

39. L. Montalto, *Commentari*, VII (1956), 41, with documents. See also L. Mortari, *Paragone*, VII (1956), no. 73, 17, and J. Offerhaus in *Bull. van het Rijksmuseum*, X (1962), 5.

40. Gaulli has been thoroughly studied after the Second World War, mainly by A. M. Brugnoli, R. Enggass, and F. Zeri. All the older research in Enggass's recent monograph (1964). In addition, see R. Enggass, *Burl. Mag.*, CVIII (1966), 365 f., and R. E. Spear, *ibid.*, CX (1968), 37 f. Of the older literature may be mentioned Brugnoli's article in *Boll. d'Arte*, XXXIV (1949), 236 (with *œuvre* catalogue).

41. Documents published by E. Feinblatt (see Note 36).
For Canuti, see Malvasia, *Vite di pittori bolognesi*, ed. A. Arfelli, Bologna,

1961, 13–35. Canuti had been in Rome in 1651 (or earlier) and stayed on until 1655 (see unpublished thesis by L. Zurzolo, University of Bologna, 1958–9, 31) before he returned in 1672.

42. Despite chronological difficulties I still believe that Canuti learned the new mode of organizing a large fresco (stimulated by Bernini's genius) in Rome rather than vice versa. Meanwhile E. Feinblatt (*Art Quarterly*, 1961) has shown that Canuti operated with large dark and light areas in his fresco of the hall of the Palazzo Pepoli, Bologna, as early as 1669; after his Roman interlude, he practised similar principles in the frescoes of the library (1677–80) and dome of S. Michele in Bosco (1682–4) in Bologna. Gaulli, on the other hand, did not begin the Gesù frescoes until 1672.

43. For Pozzo's work on perspective, see G. Fiocco, *Emporium*, XLIX (1943), no. 1, 3. For his work in Tuscany, P. della Pergola, *Riv. del R. Istituto*, V (1935/6), 203.

On Pozzo as painter, see Marini's monograph (1959) and his paper in *Arte Veneta*, XII–XIV (1959–60), 106, and on Pozzo as architect, Carboneri's monograph (1961). See also A. de Angelis, 'La Scenografia sacra di A. P. a Roma e a Frascati', *Studi romani*, VI, 2 (1958), 160; L. Montalto, 'A. P. nella chiesa di Sant'Ignazio', *ibid.*, VI, 6; A. M. Cerrato in *Commentari*, X (1959), 24 (with *œuvre* catalogue).

B. Kerber's monograph (1971; see Bibliography) has now to be consulted for all questions concerning Pozzo.

For the problem of the viewpoint of the S. Ignazio frescoes and other Baroque ceilings, see W. Schöne in *Festschrift Kurt Badt*, Berlin, 1961, 344, and Kerber's objections (102 ff.) to Schöne.

In 1703 Pozzo settled in Vienna and his work there (Jesuit church; Liechtenstein Garden Palace) had a strong influence on Austrian and German fresco painting.

Pozzo's frescoes in S. Ignazio found immediate following; see, e.g., Giuseppe Barbieri's frescoes in the dome, nave, and transept of S. Bartolomeo at Modena, executed 1694–8 (N. Carboneri, in *Arte in Europa. Scritti di Storia dell'Arte in onore di Edoardo Arslan*, Milan, 1966, 737 ff.).

44. On the ceiling three scenes illustrating events in the life of Marcantonio Colonna. The victory of Lepanto shown in our illustration was won under him.

For Coli and Gherardi, see A. M. Cerrato in *Commentari*, X (1959), 159 (with *œuvre* catalogue).

45. See the otherwise irrelevant article by E. Feinblatt, *Art Quarterly*, X (1947), 237.

46. This may be the place to mention Giovanni Maria Morandi (1622–1717), who has recently attracted attention (Waterhouse, see Bibliography). Born in Florence, he settled early in Rome and paintings by him are known from the late 1650s onwards. While as a portrait painter he competed with Gaulli, his altarpieces are often close to Maratti's.

47. The high cove of the ceiling is now white and one is reminded of the contrast between the painted field and the surrounding whiteness at the period of Reni's *Aurora*, but surviving drawings (and Bellori's text) prove that Maratti planned frescoes also for the vaulted part of the ceiling; see F. H. Dowley, *Burl. Mag.*, CI (1959), 71; W. Vitzthum, *ibid.*, CV (1963), 367; J. Bean, *ibid.*, 511; Harris-Schaar, Düsseldorf Catalogue, 1967, nos. 256–76.

48. See the excellent article by O. Kutschera-Woborsky, 'Ein kunsttheoretisches Thesenblatt des Carlo Maratti', *Graphische Künste, Mitteilungen* (1919), 9.

49. On Agucchi and his theory, see above, I: p. 14, with further references.

50. A fully documented modern treatment of Maratti (with *œuvre* catalogue) is now available; see A. Mezzetti, *Riv. dell'Istituto*, IV (1955). For the painting shown as illustration 220 see F. H. Dowley, 'Some Maratti Drawings at Düsseldorf', *Art Quarterly*, XX (1957), 174.

51. I. Matalon, *Riv. d'Arte*, XII (1930), 497; G. Testori, *Paragone*, III (1952), no. 27, 24.

Del Cairo, court artist in Turin from 1633 onwards, is now a well-defined artistic personality of considerable importance. New ground was broken at the *Mostra del manierismo piemontese . . . 1955*, where the often reproduced *St Francis* in the Castello Sforzesco, previously attributed to Morazzone, was given to Del Cairo. The whole question is reviewed in M. Gregori's Morazzone Catalogue of 1962, 48, 108, with other valuable material for Del Cairo; see also the *St Francis* paintings by Cerano (*Mostra del Cerano*, 1964, 100).

52. E. S. Natali's paper on the artist in *Commentari*, XIV (1963), 171, is disappointing.

53. The new assessment of Reni's late manner, foreshadowed as early as 1937 in O. Kurz's pioneering article (*Jahrb. d. kunsthist. Sammlungen*, Vienna, XI, 1937), was one of the important results of the Reni Exhibition of 1954.

'Sbozzata solo' (i.e. left unfinished) according to Malvasia, the *Girl with a Wreath* shows the characteristic condition of a number of pictures of this period, for which see comment in C. Gnudi–G. C. Cavalli, *Guido Reni*, Florence, 1955, 100.

For all the painters mentioned in this paragraph, see the Exhibition Catalogue of the *Seicento Emiliano*, Bologna, 1959, and Bibliography under individual painters.

54. F. Arcangeli, *Paragone*, I (1950), no. 7, 38.
Cantarini's pupil, the strong Flaminio Torri (1621–61), may here also be mentioned; see G. Raimondi in *Studi in onore di Matteo Marangoni*, Florence, 1957, 260. The weak Reni follower Francesco Torriani (1612–81), who worked mainly in Mendrisio, was given the undeserved honour of a one-man Exhibition; see G. Martinola, *Francesco Torriani. Catalogo della mostra*, Mendrisio, Palazzo Nobili Torriani, 1958.

55. M. Zuffa in *Arte Antica e Moderna*, VI, no. 24 (1963), 358, has reconstructed the artist's itinerary from documents and has established that his name is Cagnacci (not Canlassi, Thieme-Becker) and that he died in 1663 (not 1681).
For Cagnacci's Viennese career, see G. Heinz in *Jahrb. d. kunsthist. Slg. in Wien*, LIV (1958), 173, 183.

56. For Pasinelli, whose art is attracting increasing attention, see C. Volpe, *Paragone*, VIII (1957), no. 91, 30, 36; C. Baroncini, *Arte Antica e Moderna*, no. 2 (1958); D. C. Miller in *Burl. Mag.*, CI (1959), 106. For Canuti's pupil Giuseppe Rolli (1643–1727), the painter of the important ceiling of S. Paolo in Bologna (1695), see F. de' Maffei, in *Scritti di storia dell'arte in onore di Mario Salmi*, Rome, 1963, III, 325, and E. Feinblatt, in *Burl. Mag.*, CVI (1964), 569ff. Also *idem*, in *Master Drawings*, VII (1969), 164ff.

57. According to Baldinucci (ed. 1846, IV, 682), he called this type of perspective 'vedute non regolate da un sol punto'. Further to this problem, J. Schulz in *Burl. Mag.*, CIII (1961), 101, according to whom the *quadratura* painters Cristoforo and Stefano Rosa from Brescia used multiple vanishing points as early as the sixteenth century. Colonna worked in the Palazzo Pitti between November 1637 and June 1639 and again in 1641; see M. Campbell, *Art Bull.*, XLVIII (1966), 135f. Further for Colonna see S. de Vito Battaglia, *L'Arte*, XXXI (1928), 13. E. Feinblatt, *Art Quarterly*, XXI (1958), 265, discusses the ceilings in the Villa Albergati–Theodoli at Zola Predosa (near Bologna); Colonna's most extensive work during the period of collaboration with Giacomo Alboresi (1632–77), Mitelli's pupil, whom he took on as collaborator after Mitelli's death.
For Mitelli, see now E. Feinblatt's Introduction to the Mitelli Exhibition in Los Angeles (see Bibliography).

58. For the following F. Sricchia, 'Lorenzo Lippi nello svolgimento della pittura fiorentina della prima metà del '600', *Proporzioni*, IV (1963), 243–70; M. Gregori in *Paragone*, XV (1964) no. 169, 16; and *idem*, *70 pitture e sculture del '600 e '700 fiorentino*, Florence, 1965; also Hibbard–Nissman, *Florentine Baroque Art*, 1969 (see Bibliography).

59. C. del Bravo in *Paragone*, XII (1961), no. 135, 28.

60. See G. Briganti, *Paragone*, I (1950), no. 7, 52.

61. Cecco Bravo is emerging as one of the most unconventional Florentine artists of his generation. G. Ewald was the first to give back to him a number of pictures previously attributed to S. Mazzoni (*Burl. Mag.*, CII (1960), 343, CIII (1961), 347). A. R. Masetti's monograph (1962) with *œuvre* catalogue and bibliography contains a document for Bravo's hitherto unknown birth-date. The painting of illustration 197 has previously been attributed to S. Mazzoni, but Ewald and others are in agreement that it has to be given back to Cecco Bravo.
For Pietro Ricchi (1606–75) and Mario Balassi (1604–67), the first from Lucca, the second from Florence, who both owed Venice a formative influence, see H. Voss in *Kunstchronik*, XIV (1961), 211. Further for Ricchi, see R. Pallucchini, *Arte Veneta*, XVI (1962), 132, and A. Rizzi, *ibid.*, 171.

62. M. Gregori (Note 58) offers a more positive assessment of Giovanni da San Giovanni's art; see also M. Campbell, *Art Bull.*, XLVIII (1966), 133ff.

63. M. Winner, *Mitteilg. d. kunsthist. Instit. Florenz*, X (1963), 219, discusses the interesting iconography of this cycle (documents).

64. His *œuvre* has first been reconstructed by G. Ewald, *Burl. Mag.*, CVI (1964), 218.

65. Among the Cortona followers in Florence worth mentioning are the Fleming Lieven Mehus (1630–91); Vincenzo Dandini (1607–75) and his nephew, Pier Dandini (1646–1712), who in his later work, however, broke away from his early Cortonesque manner; in addition Salvi Castellucci from Arezzo (1608–72) and Lorenzo Berrettini, Cortona's nephew and pupil, who worked mainly at Aquila. See also Berti, *Mostra di Pietro da Cortona*, Rome, 1956.

66. Demonstrated in a thoughtful article by G. Heinz in *Jahrb. d. kunsth. Slg. in Wien*, LVI (1960), 197.

67. See A. Blunt, *The Drawings of G. B. Castiglione and Stefano della Bella at Windsor Castle*, London, 1954, 89, with further references. See also Alexandre de Vesme's standard catalogue of Stefano della Bella's prints, reprinted with corrections and annotations by P. Dearborn Massar, New York, 1970; also the same author's 'Stefano d. B.'s Illustrations for a Fireworks Treatise', *Master Drawings*, VII (1969), 294ff., dating from 1649; and F. Viatte and W. Vitzthum, *Arte Illustrata*, III, nos. 34–6 (1970), 66ff., who offer new material to the question of Stefano della Bella's journey to the Levant.

68. For the following see mainly G. Fiocco's pioneering work, published in 1929; also the challenging remarks by E. Arslan, *Il concetto di luminismo . . .*, Milan, 1946; and *La Pittura del Seicento a Venezia*, Catalogue, Venice, 1959, with full bibliography.

69. Arslan, *op. cit.*, 24; G. Fiocco, *Arte Veneta*, IV (1950), 150; L. Fröhlich-Bum and R. Longhi, *Paragone*, III (1952), no. 31, 34; N. Ivanoff, 'Giorgione nel Seicento', in *Venezia e l'Europa*, Venice, 1956, 323.

70. Arslan, 29, 42. For Carpioni's dates, see Zorzi, *Arte Veneta*, XV (1961), 219. G. M. Pilo's monograph (1962) contains all previous research. See also *idem*, 'Giulio Carpioni e Vicenza', *Odeo Olimpico*, V (Vicenza, 1964–5), 55ff.

71. See also G. M. Pilo, in *Il mito del classicismo nel seicento*, Florence, 1964, 227.

72. G. Fiocco, *Dedalo*, III (1922), 275; J. Zarnowski and F. Baumgart, *Boll. d'Arte*, XXV (1931–2), 97; R. Pallucchini, *ibid.*, XXVIII (1934), 251.

73. N. Ivanoff, *Boll. d'Arte*, XXXVIII (1953), 321.

74. G. Ewald in *Critica d'Arte*, VI (1959), 43, and *Boll. Musei Civici Veneziani*, 1959, 1.

75. A. Rizzi's monograph (1960) with *œuvre* catalogue (completely illustrated) supersedes all previous research.

76. See Ivanoff's Catalogue of the Maffei Exhibition, 1956, with further bibliography. In addition, R. Marini, 'Il dare e l'avere tra Pietro Vecchia e Maffei', *Arte Veneta*, X (1956), 133; L. Magagnato's excellent review of the Exhibition, *ibid.*, 245; F. Valcanover, *Emporium*, CXXIII (1956), 150; Haskell, *Burl. Mag.*, XCVIII (1956), 340; R. Marini, *Arte Veneta*, XV (1961), 144 (attempt to clarify chronology).

77. C. Gnudi, *Critica d'Arte*, I (1935–6), 181; N. Ivanoff, *Arte Veneta*, I (1947), 42, and *idem* in *Saggi e Memorie di storia dell'arte*, II (1958–9), 211–79 (basic study).

78. A. M. Mucchi and C. della Croce, *Il pittore Andrea Celesti*, Milan, 1954, with *œuvre* catalogue and contribution by N. Ivanoff.

79. G. M. Pilo, *Arte Veneta*, XVII (1963), 128.

80. See Arslan, *op. cit.*, 32.

81. A. M. Pappalardo, *Atti dell'Istituto Veneto di Scienze . . .*, CXII (1953–4), 439.
Two artists who came under Bolognese influence should at least be mentioned: Giannantonio Fumiani (1650 (not 1643)–1710, see Arslan, 44) and Gregorio Lazzarini (c. 1660/2–1720), Tiepolo's first teacher. For Lazzarini, see G. M. Pilo in *Arte Veneta*, XI (1957), and *Critica d'Arte*, V (1958), 233.

82. The equally mediocre Antonio Busca (1625–86), director of the Accademia Ambrosiana in 1669, may at least be mentioned; see C. Rossi o.p., in *Arte Lombarda*, IV (1959), 314. For C. F. Nuvolone, see U. Ruggeri, in *Arte Lombarda*, XII (1967), 67ff. For the Nuvolone family, see N. Ward Neilson, *Burl. Mag.*, CXI (1969), 219f.

83. Longhi–Cipriani–Testori, *I pittori della realtà in Lombardia*, Milan, 1953, with bibliography; G. Testori, *Paragone*, IV (1953), no. 39, 19.

84. See Arslan's (Note 68, 24) relatively negative assessment of Strozzi; also A. M. Matteucci, *Arte Veneta*, IX (1955), 138.

85. E. Falletti, *Commentari*, VII (1956), 158.

86. A. M. Goffredo, *ibid.*, 147. Among Strozzi's pupils in Genoa may be mentioned Antonio Travi (1608–65), who later made his name by concentrating on the popular genre and on landscapes with ruins.

87. B. Riccio, *Commentari*, VIII (1957), 39.

88. M. Bonzi, *Pellegro Piola e Bartolomeo Biscaino*, Genoa, 1963. Pellegro or Pellegrino Piola (1616–40), who had been apprenticed with Gio. Domenico Cappellino, practised an antiquated, cinquecentesque manner; see also *Mostra dei pittori genovesi . . .*, Genoa, 1969, nos. 41, 42.
Of other painters who died of the plague, I mention Orazio de Ferrari (1606–57), who stems from Ansaldo and Assereto (M. Labò, *Emporium*, CI (1945), 3), and Silvestro Chiesa (1623–57), whose only known picture (S. Maria dei Servi, Genoa) reveals him as a master of uncommon power (A. Morassi, *Mostra della pittura . . . Liguria*, 1947, 57).

89. I am following mainly Anthony Blunt's reconstruction of Castiglione's career; see *J.W.C.I.*, VIII (1945), 161 and *The Drawings of G.B.C. at Windsor*, London, 1954. For interesting new results, see A. Percy, *Burl. Mag.*, CIX (1967), 672ff. See also E. Waterhouse, 'An *Immaculate Conception* by G.B.C.', *The Minneapolis Institute of Arts Bulletin*, LVI (1967), 5ff., with new ideas on Castiglione's chronology.

90. O. Grosso, *Dedalo*, III (1922–3), 502.

91. M. Marangoni, *I Carloni*, Florence, 1925. Giovanni Battista, the more important of the two brothers, was a prolific fresco painter. His work is to be found in the Gesù, S. Siro, the Chiesa dell'Annunziata where he collaborated with Giovanni Andrea, etc. Trained under Passignano in Florence, he was later strongly influenced by Rubens. His son Andrea (1639–97), who worked in Maratti's studio in Rome, brought back to Genoa (1678) a fluid Cortonesque manner. For his work in the Palazzo Altieri, Rome (1674–7), see E. Gavazza, *Arte Lombarda*, VIII (1963), 246.
Giulio Benso (1601–68) may also be mentioned; his frescoes in the Annunziata (partly destroyed during the war) reveal him as an able painter with a special interest in *quadratura* and determined *sotto in su* compositions.

92. For Piola see G. V. Castelnovi, *I dipinti di S. Giacomo alla Marina* (Quaderni della Soprintendenza alle Gallerie . . . della Liguria), Genoa, 1953; also E. Malagoli, *Burl. Mag.*, CVIII (1966), 503ff.

93. A. Griseri, *Paragone*, VI (1955), no. 67, 22. E. Gavazza in *Arte Antica e Moderna*, VI, no. 24 (1963), 326, makes the tentative suggestion that de Ferrari met Gaulli at Parma in 1669. See also *Disegni di G. de F.*, Exhibition, Palazzo Rosso, Genoa, 1963, and A. Griseri, *Gregorio de Ferrari* (I maestri del colore, 135), Milan, 1966.

94. Bolognese *quadratura* had been introduced in Genoa by Colonna's fresco decoration in the ex-Palazzo Reale (formerly Balbi) in 1650.

95. In addition to the basic articles by R. Longhi (1915) and H. Voss (1927), see R. Causa, *Paragone*, I (1950), no. 9, 42, R. Carità, *ibid.*, II (1951), no. 19, 50, and F. Bologna, *ibid.*, XI (1960), no. 129, 45.

For the following, see, apart from A. de Rinaldis's book (1929), S. Ortolani's remarkably perceptive Introduction to *La mostra della pittura napoletana*, Naples, 1938, and R. Causa's excellent survey (1957).

96. See E. du Gué Trapier's monograph (1952) and D. F. Darby's review, *Art Bull.*, XXXV (1953), 68. Also U. Prota-Giurleo, *Pitt. nap.*, 1953, 91. Ribera's date of birth is usually wrongly given as 1588. J. Chenault, *Burl. Mag.*, CXI (1969), 561 ff., has published documentary proof of Ribera's stay in Rome in 1615 and 1616 (the year he probably returned to Naples) and of his trip north about 1630.

97. Giovanni Dò (1604–56), like Ribera born at Játiba in Spain, settled in Italy *c.* 1623 and married the sister of Pacecco de Rosa (1626). His impressive *Adoration of the Shepherds* (Chiesa della Pietà dei Turchini, Naples) – the only picture known by him – is entirely Riberesque. Among the minor Ribera pupils Bartolomeo Passante (1618–48) from Brindisi may be mentioned. On Passante, see J. H. Perera, *Archivo Español de Arte*, XXVIII (1955), 266, and the criticism by F. Bologna, *F. Solimena*, 1958, 30. On these artists R. Longhi wrote one of his last papers (*Paragone*, XX 1969), no. 227, 42, in which he also revived the almost forgotten 'naturalista' Giovan Battista Spinelli (d. *c.* 1647).

98. Reni's abortive stay at Naples in 1622 lasted about a month. His magnificent *Adoration of the Shepherds* in the Certosa di S. Martino, painted shortly before his death (1641?), came after the critical moment in the history of Neapolitan painting. But less important works of an earlier period (*c.* 1622) were in the Chiesa di S. Filippo Neri.

99. A list of frescoes painted by minor artists in Lanfranco's manner in Ortolani, *op. cit.*, 79.

100. According to W. R. Crelly, *The Painting of Simon Vouet*, New Haven and London, 1962, this 'first full announcement of his post-Italian altarpieces' (p. 36) is signed and dated 1623 (184, no. 79).

But if it were correct that in 1620 Vouet had painted the *Virgin appearing to St Bruno* for the Certosa of S. Martino, as Crelly and others (A. Blunt, *Art and Architecture in France*, 167; Briganti, *P. da Cortona*, 1962, 49) believed, he would already then have drifted away from Caravaggio. Critical opinion, however, now dates this painting later: D. Posner, *Art Bull.*, XLV (1963), 291, *c.* 1623; B. Nicolson, *Burl. Mag.*, CV (1963), 310, *c.* 1627; G. Dargent and J. Thuillier, *Saggi e Memorie di storia dell'arte*, IV (1965), 47, no. A31, *c.* 1624–6.

101. All the major Neapolitan artists felt her influence, but she also took from them. Among the second-rate artists, Paolo Finoglia (*c.* 1590–1656), who had started his career under Battistello in the Certosa of S. Martino, was much indebted to her; see M. d'Orsi, *Paolo Finoglia, pittore napolitano*, Bari, 1938.

Another 'belated' *Caravaggista* should here be mentioned, Matthias Stomer from Amersvoort, Holland (*c.* 1600–*c.* 1650), who appeared in the early 1630s in Rome and soon transferred his activity to Naples and Sicily. Reputedly closely connected with Honthorst, his style shows affinities with Terbrugghen, Baburen, and even Vouet; see R. Longhi, *Proporzioni*, I (1943), 60.

102. F. Bologna (in *Bulletin, Musées Royaux des Beaux-Arts, Bruxelles* (1952), no. 2, 47) stressed the influence of Van Dyck's palette on Ribera and other Neapolitan painters from about 1635 on. Ribera's *Communion of the Apostles* (Certosa of S. Martino) with the disproportionately large putti in the sky and the large empty areas is an example of his weak late manner (dated 1651).

103. His career has been reconstructed by F. Bologna, *Opere d'arte nel Salernitano*, Naples, 1955; M. Grieco, *Francesco Guarini da Solofra*, Avellino, 1963.

104. For Mellin, see J. Bousquet in *Revue des Arts*, V (1955), 55.

105. In his otherwise unsatisfactory monograph on Stanzioni (1937), H. Schwanenberg established the date 1623 for the *St Anthony in Glory* in S.

Lorenzo in Lucina, Rome. But Stanzioni was working in Rome even five years earlier. E. Borsook (*Burl. Mag.*, XCVI (1954), 272) published payments to him between October 1617 and April 1618 for a (lost) picture for S. Maria della Scala. Stanzioni's large dated cycles begin in 1631 with the decoration of the Bruno Chapel in the Certosa of S. Martino, finished 1637. Stanzioni had a large school; among his pupils were Agostino Beltrami and Giacinto de Popoli (see Ortolani, *op. cit.*, 72).

106. His 'classicism' is fully developed in the *Rest on the Flight into Egypt* and the *Annunciation of the Birth of the Virgin*, both in S. Paolo Maggiore, dated 1643–4 by R. Causa, *La Madonna nella pitt. del '600 a Napoli*, Naples, 1954, 33.

107. In addition to the older literature, see C. Refice, *Emporium*, CXIII (1951), 259.

108. M. Commodo Izzo, *Andrea Vaccaro*, Naples, 1951, with *œuvre* catalogue and bibliography.

109. For the Fracanzano problem see F. Bologna (Note 103), 55, and *idem*, *F. Solimena*, 1958, 28.

110. The phrase is F. Saxl's, *J.W.C.I.*, III (1939–40), 70.

111. M. S. Soria, *Art Quarterly*, XXIII (1960), 23.

It seems appropriate to mention here the German painter Johann Heinrich Schönfeld (1609–82/3), who was in Italy from 1633 to 1651 and spent twelve years in Naples. In his early Neapolitan years (about 1640) his work is close to that of Gargiulo and Aniello Falcone; later his palette darkens and his style approaches Bernardo Cavallino's (mid 1640s). Like Elsheimer, Schönfeld excelled by virtue of the intensity of poetical narration and there can be little doubt that he left his mark on Neapolitan painting. This great artist was rediscovered in the 1920s, primarily through H. Voss (monograph Bierach, 1964) and has now acquired fuller contours through a splendid exhibition; see H. Pée, *J. H. Schönfeld*, Ulm, 1967.

112. R. Causa, *Paragone*, VII (1956), no. 75, 30. This article makes the older literature on Monsù Desiderio obsolete (see A. Scharf's *Catalogue* of the Sarasota Exhibition, 1950; G. Urbano's monograph, Rome, 1950; F. G. Pariset, *Commentari*, III (1952), 261). See also next Note.

113. F. Sluys, *Les Beaux Arts*, Brussels, 4 June 1954; *idem*, *Didier Barra et François de Nomé*, Paris and New York, 1961.

114. Codazzi, e.g., went to Rome and Ribera fled.

115. Longhi, *Proporzioni*, I (1943), 60: reconstruction of this phase with *œuvre* catalogue. C. Refice Taschetta, *Mattia Preti*, Brindisi, 1961, 45, does not accept such an early Caravaggesque phase; she is certainly correct in claiming a strong impact of Guercino on the early Preti. Her monograph, however, is far from being definitive; see above, Note 38.

116. M. Fantuzzo, *Boll. d'Arte*, XL (1955), 275.

117. See above, p. 135. The *St Charles Borromeo giving Alms* of 1642 in S. Carlo ai Catinari, Rome, already shows his dependence on Sacchi and Domenichino.

118. R. Causa, *Emporium*, CXVI (1952), 201. C. Refice Taschetta, *op. cit.*, 54, favours the older dating: not later than 1650.

119. In 1664 (not 1653) he painted the badly preserved frescoes in the dome of S. Domenico Soriano, Naples, which abound with Correggiesque reminiscences; see C. Refice, *Boll. d'Arte*, XXXIX (1954), 141.

120. For Porpora, see R. Causa, *Paragone*, II (1951), no. 15, 30; for Luca Forte, *idem*, *ibid.*, XIII (1962), no. 145, 41; for Giacomo Recco, *idem*, *Arte Antica e Moderna*, IV (1961), 344; for Giacomo and Giuseppe Recco, S. Bottari, *ibid.*, 354; further attributions to Forte and Giacomo Recco in Bottari, *ibid.*, VI, no. 23 (1963), 242.

121. See last Note, and also Zeri, *ibid.*, III (1952), no. 33, 37; N. di Carpegna in *Boll. d'Arte*, XLVI (1961), 123.

122. Carpegna, *loc. cit.*

123. Dominici (ed. 1844, III, 558) records that Ruoppolo painted many pictures for Gaspar Roomer, which the latter sent to Flanders. Roomer, an immensely rich Flemish merchant, had made Naples his home; he had a large gallery and patronized contemporary artists (M. Vaes, *Bull. inst. hist. belge*, V (1925), 184; F. Saxl, *J.W.C.I.*, III (1939–40), 80). It was in his gallery that Ruoppolo and the other Neapolitan still-life painters had excellent opportunities of studying Flemish still lifes.

Index

A cumulative index to all three volumes appears at the end of volume III

PHOTOGRAPHIC ACKNOWLEDGEMENTS

AKG London 16, 139, 140, 142, 157, 180; Archivi Alinari 2, 7, 8, 10, 11, 14, 18, 20, 23, 24, 27, 37, 45, 55, 63, 65, 66, 68, 76, 79, 82, 87, 92, 95, 97, 98, 99, 100, 101, 104, 105, 113, 124, 125, 130, 134, 143, 144, 145, 148, 152, 153, 154, 155, 159, 162, 163, 164, 174, 175, 179, 183, 184, 185, 186, 187, 188, 189, 190, 192, 195, 196, 197, 201, 209, 210, 211, 213, 216; Alterocca 47; © Bildarchive Preussische Kulturbesitz, 1989/Jörg P. Anders 107, 119; Osvaldo Böhm 194; Bulloz 205; Canali Photobank 133, 149, 165, 168, 199, 212; The Conway Library, Courtauld Institute of Art, London 106, 117, 122, 150, 161; Gabinetto Fotografico Nazionale 1, 25, 26, 38, 75, 84, 91, 94, 103, 114, 116, 147, 169, 171, 176, 177, 178, 181; A.F. Kersting 72, 85, 129, 137, 138, 141; Paul Larsen 32, 57, 62; Eric de Maré 46; Paolo Portoghese 62, 78, 86; Photo RMN – Gérard Blot 22; Saskia Ltd. 115; Oscar Savio 69, 71; Scala 3, 5, 9, 35, 36, 52, 54, 88, 96, 111, 127, 172, 191, 214; Schneider-Lengyal, by permission of the Phaidon Press 6, 12, 13; V&A Picture Library 118, 160; Vasari, Rome 4, 57, 59, 70; Foto Archivio Fabbrica di San Pietro in Vaticano 112, 167.